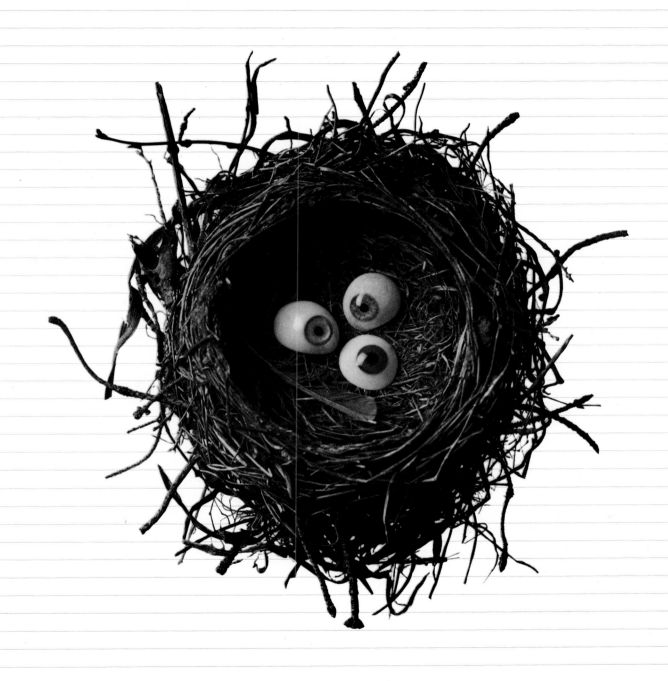

CREATIVE·SOURCE

A PUBLICATION OF
Wilcord Publications Limited

PRESIDENT: Peter Cordy
SECRETARY: Geoff Cannon
TREASURER: Peter Tatay

PUBLISHER: Peter Cordy
VICE PRESIDENT SALES: Geoff Cannon
SALES COORDINATOR: Marie MacDonald

DESIGN: Peter Cordy
JACKET PHOTO: Bert Bell
JACKET TYPOGRAPHY: Les Usherwood
TYPESETTING: (Titles) Typsettra Limited
(Ad Pages) XY Typesetting Limited
PRODUCTION: Jaeger Graphics
COLOR SEPARATIONS & PRINTING:
Scanner Art Services Inc

ISSN-0709-7727
ISBN-0-920986-03-X
Printed in Hong Kong

DISTRIBUTED BY:

CANADA:
General Publishing Co. Limited
30 Lesmill Road, Don Mills, Ontario
Canada M3B 2T6 (416) 445-3333
Telex: 06-986664

UNITED STATES:
Robert Silver Associates
95 Madison Avenue, New York, New York
10016 USA (212) 686-5630

ALL OTHER COUNTRIES:
Fleetbooks S.A. c/o Feffer and Simons, Inc.
100 Park Avenue, New York
New York 10017 USA

PUBLISHED ANNUALLY BY:
Wilcord Publications Limited
501 Eglinton Avenue East, Suite 203
Toronto, Ontario, Canada M4P 1N4
(416) 487-4762/63

CONTENTS

PUBLISHER'S·MESSAGE

You hold in your hands the Fourth Annual Edition of Creative Source–a work of love, and, we trust, a work of art as well.

It is Canada's only up-to-date annual reference of creativity. On every page, you will see brilliant examples of the remarkable Canadian imagination that has sparked international praise.

As practical as it is artistic, Creative Source continues to serve two ever-widening publics: those who produce excellence and those who appreciate it.

Aristotle placed both at the highest level of Man.

Peter Cordy

PETER CORDY,
PUBLISHER

"....truly amazing! One look at Creative Source reassures you, that the Canadian product is as good as any in the world...."
JOHN BILNEY, CREATIVE DIRECTOR
MCCANN-ERICKSON, MELBOURNE

"....it will be one of the first references I turn to when looking for professional creative services. It is an excellent publication...."
JOHN G. CAPLAN, DIRECTOR
OF COMMUNICATIONS
PEAT, MARVICK, MICHELL & CO.

"....having no ideas of my own, I find myself flipping through Creative Source frequently for things I can steal. I only hope no one else gets it so I can maintain my charade..."
TERRY HILL, CREATIVE DIRECTOR
GREY ADVERTISING, TORONTO

"....extraordinary quality and scope. It is an invaluable resource for creative inspiration..."
JOHN SELLERS, CHAIRMAN OF VISUAL COMMUNICATIONS
SYRACUSE UNIVERSITY, NEW YORK

"....it seems to me you only need two things to do advertising in Canada. A current issue of Creative Source and a telephone..."
LARRY GILMORE, CREATIVE DIRECTOR
KETCHUM ADVERTISING, SAN FRANCISCO

CONTENTS

CONTENTS

CONTENTS

CONTENTS

INDEX

INDEX

INDEX

I N D E X

Art & Design Sudios Ltd.
68 Merton St.
Toronto, Ontario
Canada
M4S 1A1

(416) 481-6461

The services of Art & Design Studios Limited include design and production of literature, catalogues, sales promotion material, corporate design programs, national and retail advertising and audio visual presentations. All the facilities of ADS are located in one modern working complex covering 36,000 square feet.

Photography: Yoshi Wadano
Contact: Adair D. Gilmour

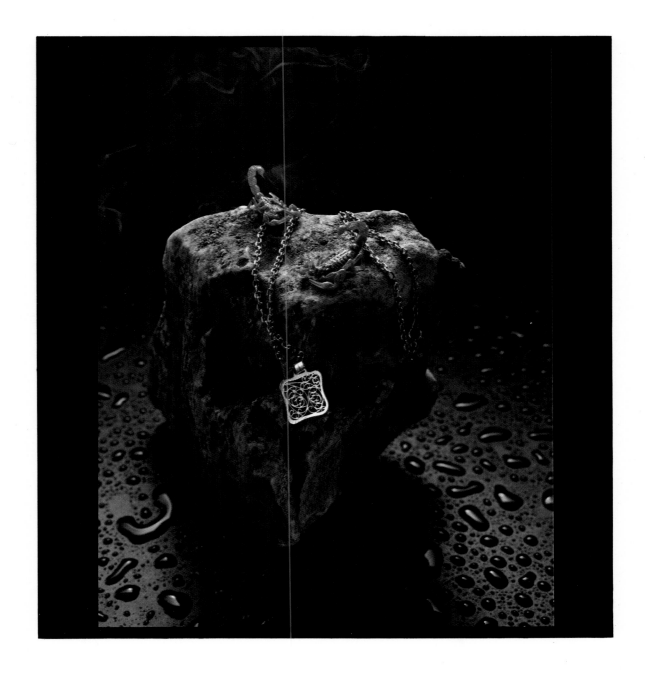

Art & Design Sudios Ltd.
68 Merton St.
Toronto, Ontario
Canada
M4S 1A1

(416) 481-6461

Photography: David Rozel
Contact: Adair D. Gilmour

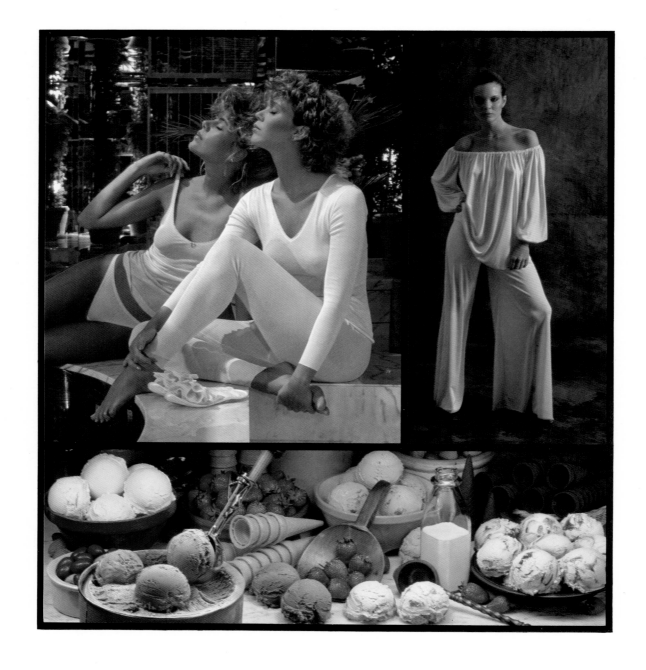

Art & Design Sudios Ltd.
68 Merton St.
Toronto, Ontario
Canada
M4S 1A1

(416) 481-6461

Photography: Doug Smale
Contact: Adair D. Gilmour

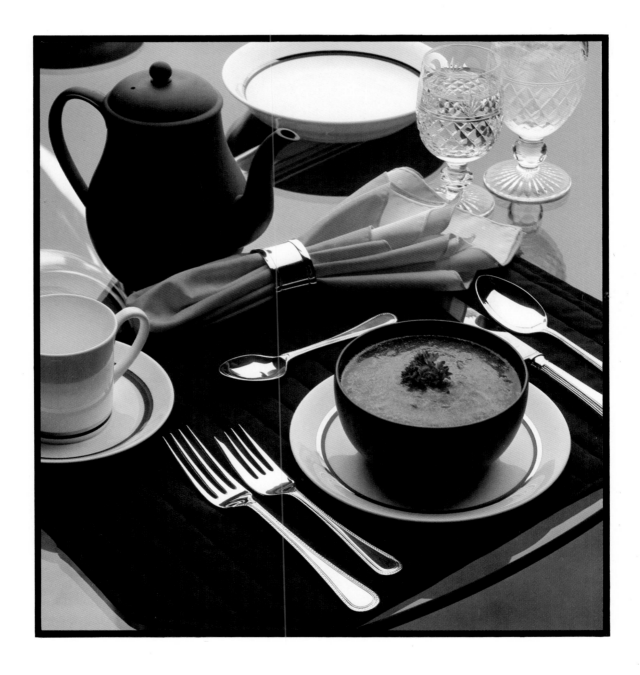

Wayne Sproul
AGS Photography Inc.
309 Lesmill Road
Toronto, Ontario
Canada
M3B 2V1

(416) 441-3444

Ideas to film…

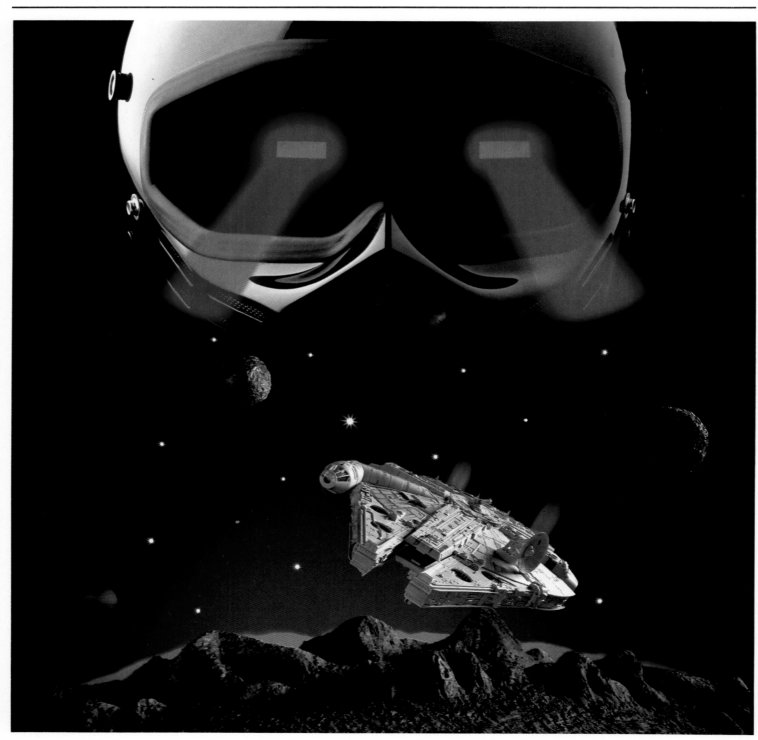

**Action Photographics
Incorporated**
466 Bathurst Street
Suite 4
Toronto, Ontario
M5T 2S6
(416) 968-0000

Miles S. Nadal
President

**Stock Photography
Available Exclusively
Through Masterfile**

At Action Photographics Incorporated, we strive to be the most efficient and professional Photographic Agency in the industry. Specialists in corporate, industrial, product, audio visual and sports photography, we also have an automated custom photo-finishing plant on our premises. This allows us to handle most photographic asignments with same day results.

Since opening in 1979, we have had the opportunity to work with many major Advertising Agencies and Canadian Corporations, such as Bell Canada, British Airways, Gulf Oil, C.C.M., Cadillac Fairview, Panasonic and Molson Breweries.

For a better insight into the services we can provide, you are invited to tour our facilities, meet our staff and aquaint yourself with the elements that make Action Photographics Incorporated "the Leader in Photographic Excellence."

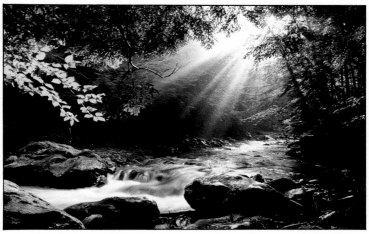

Casimir Bart Photographics
246 Adelaide St. West
Toronto, Ontario
M5H 1X6

(416) 598-3577

Casimir Bart

CAPIC

Presenting a package on the theme gives me an opportunity to play with the subject and the idea they represent.
Behind pieces of machinery, food products, fashion – there is a story to be told or seen.

Casimir Bart Photographics
246 Adelaide St. West
Toronto, Ontario
M5H 1X6

(416) 598-3577

Casimir Bart

CAPIC

Toronto based Casimir Bart has worked as a commercial photographer both in Europe and North America.
His Canadian clients include Barber–Ellis, Bombardier, Danesco, Dominion, Eatons, Fabergé, Kimberly-Clark, Molson, Sidbec-Dosco, Maclean-Hunter and other Canadian publications – for whom he has conceptualized products as well as ideas for advertising, publicity, promotion or editorials.

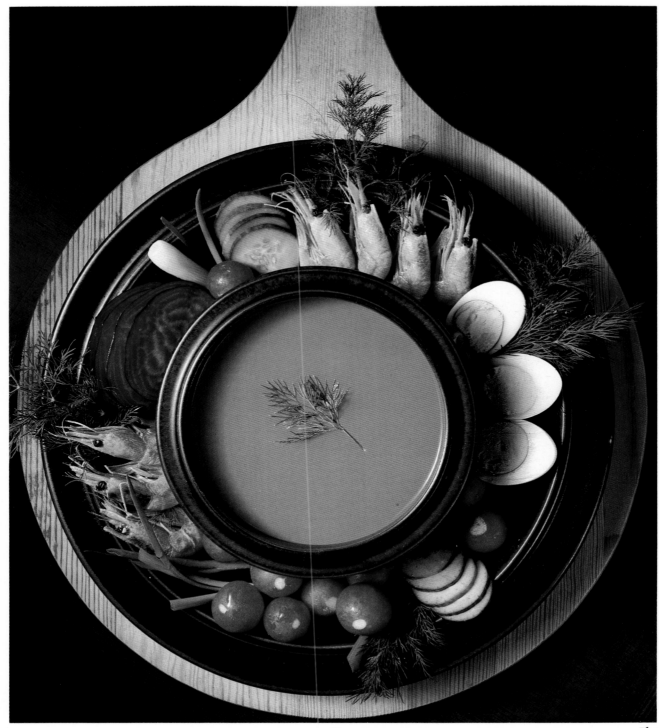

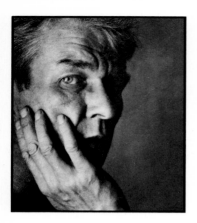

Bert Bell
52 Shaftesbury Avenue
Toronto, Ontario
M4T 1A2

(416) 961-9304

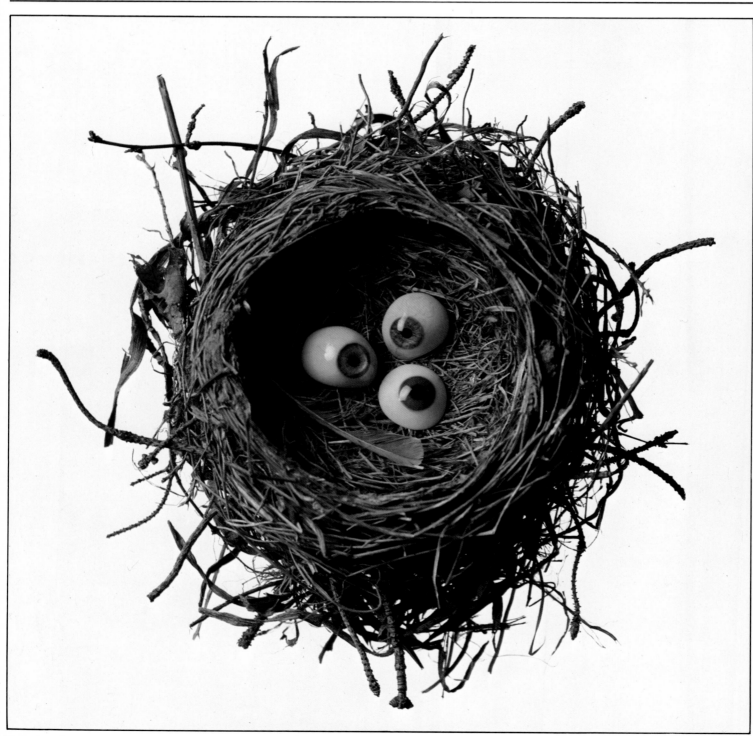

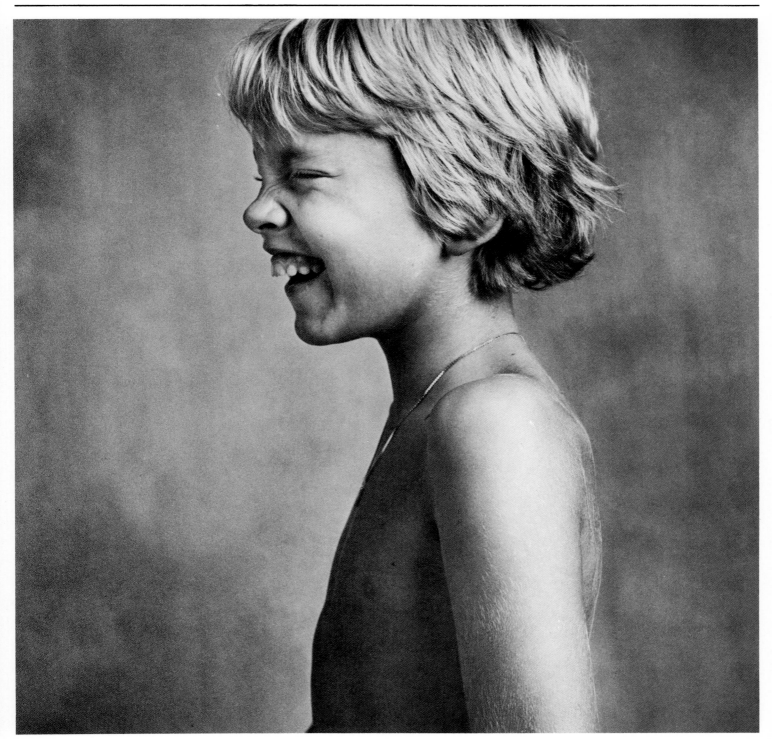

Richard Brown
6 High park blvd
suite two
Toronto, Canada
M6R 1M4

(416) 535-8717

member A.S.M.P.
CAPIC

1967 Alexey Brodivitch Design Lab, N.Y.C.
1968 Opened my studio in Montreal. **National Ad's & Fashion**
1970 35,000 miles of **Travel & Editorial photography.**
1976 Olympics – the lighting of the flame in Olympia and it's run to Athens.
1977 Move to Toronto. New directions; **Audio Visual, Annual Reports, Food.**
1978 Two T.V. commercials for Montreal Gazette.
Food photographer for weekly cooking magazine Telecuisine
1982 Audio/Visuals; In Grand Bahama & Colombia for A.E.S.
In studio for Sears and The Bay, location and product photography for Johnson & Johnson.
Videotapes available....

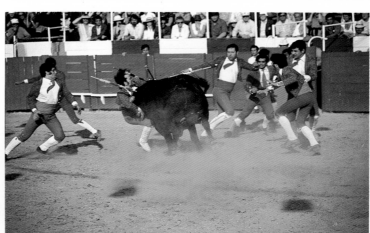

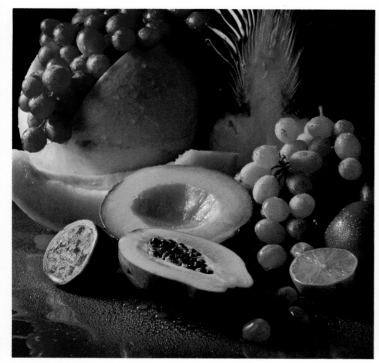

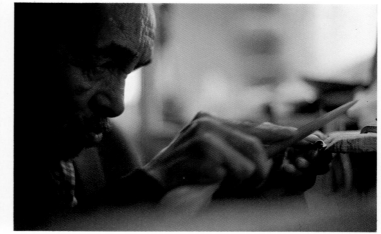

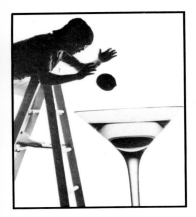

Joseph Chiu Photography
77 Mowat Avenue
Suite 410
Toronto, Ontario
M6K 3E3

(416) 535-0302

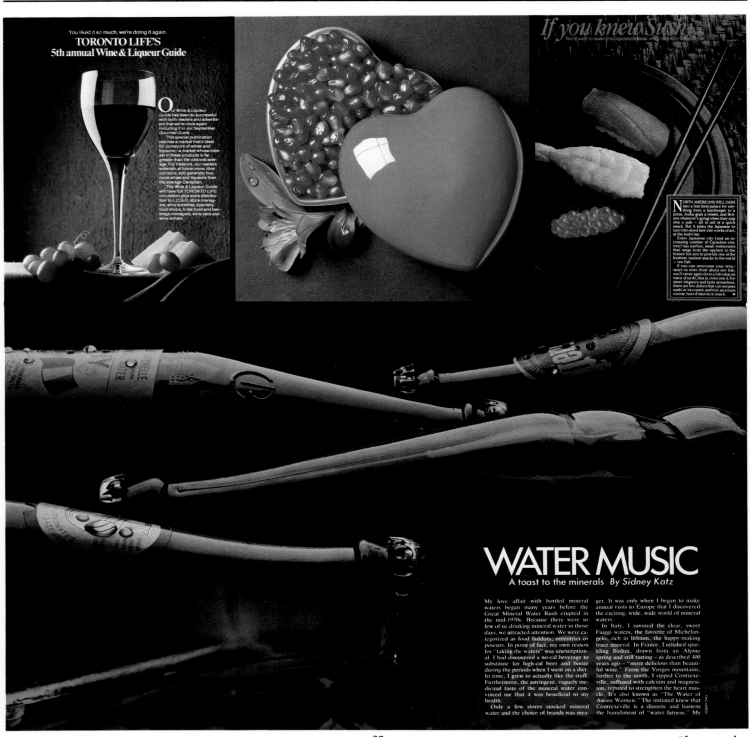

Ian Campbell Photography
524 Wellington St. West
Toronto, Ontario
M5V 1H5

(416) 593-9266

Represented by:
Poet Farrell

(416) 968-6788

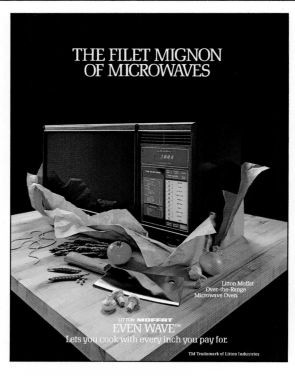

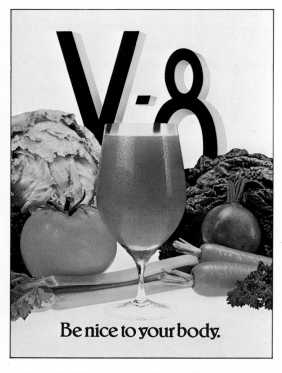

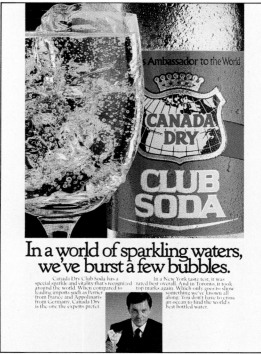

Ian Campbell Photography
524 Wellington St. West
Toronto, Ontario
M5V 1H5

(416) 593-9266

Represented by:
Poet Farrell

(416) 968-6788

Ken Davies
Suite 335
67 Mowat Avenue
Toronto, Ontario
M6K 3E3

(416) 531-8290

**Fraser Day
Synoptics**
345 Carlaw Av.
Toronto, Ontario
M4M 2T1

(416) 463-9052

**Representative:
Jill O'Lavery**
(416) 463-9052

Fraser specialises in location photography in the following areas: advertising, annual reports, architectural, editorial, fashion, illustrative, interiors, industrial, legal, product, travel.

His list of clients has included: Campeau Corporation, Canadian Interiors, Canadian Tire, City & Country Home, Commerce Space, Costain, Creative Circle, Csagoly Miller, Arthur Erikson Architect, Gage Publishing, General Paperbacks, Harrowsmith, Holt Rinehart & Winston, Hooper & Angus Consulting Engineers, Lamont Advertising, Shell Oil, Sipco Oil.

Fraser did the photography for the book **Solar Houses for a Cold Climate''**, co-published by John Wiley & Sons in Canada and Scribners in New York.

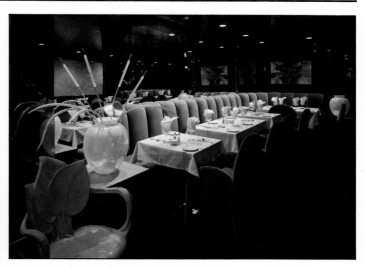

S.C. Dean
Dean Photographic Inc.
67 Mowat Avenue
Toronto, Ontario
M6K 3E3

(416) 530-1147

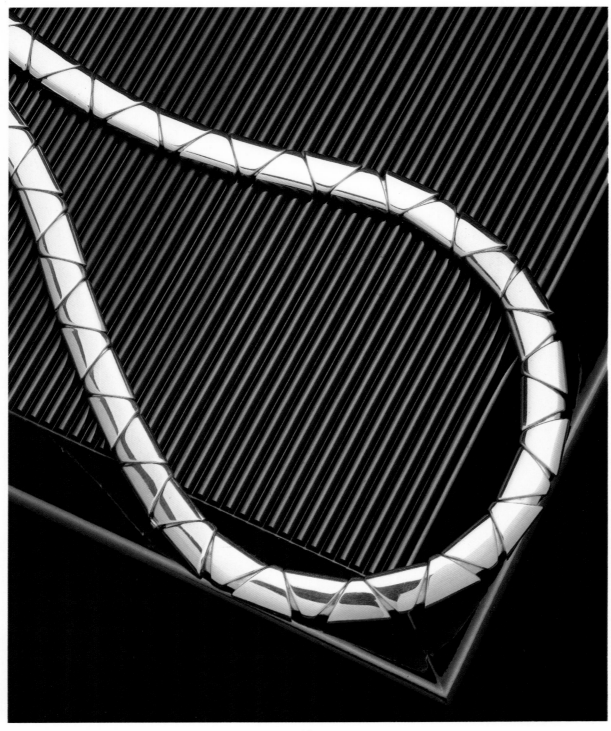

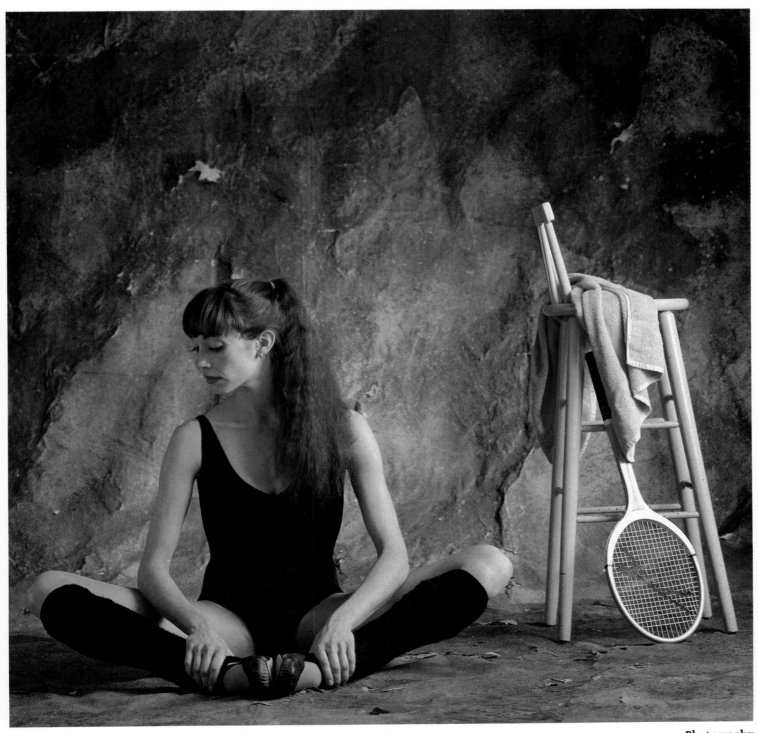

Nigel Dickson
15 Elm St.
Toronto, Ontario
M5G 1H1

(416) 597-0767

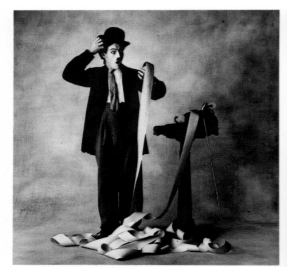

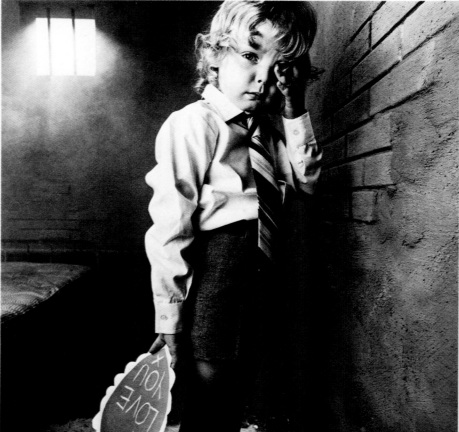

Nigel Dickson
15 Elm St.
Toronto, Ontario
M5G 1H1

(416) 597-0767

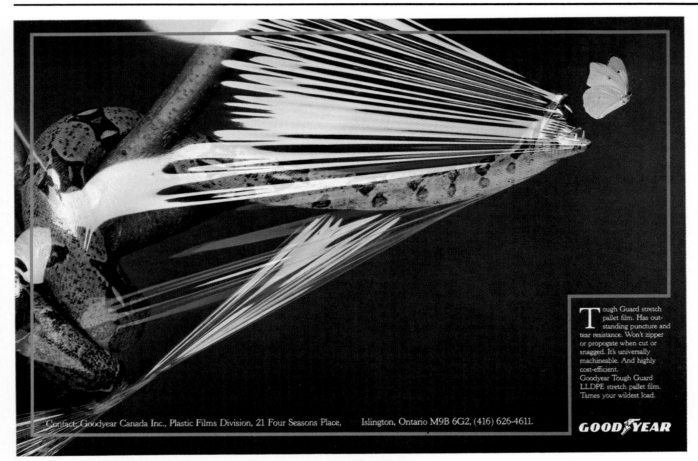

Tough Guard stretch pallet film. Has outstanding puncture and tear resistance. Won't zipper or propogate when cut or snagged. It's universally machineable. And highly cost-efficient. Goodyear Tough Guard LLDPE stretch pallet film. Tames your wildest load.

Contact: Goodyear Canada Inc., Plastic Films Division, 21 Four Seasons Place, Islington, Ontario M9B 6G2, (416) 626-4611.

GOODYEAR

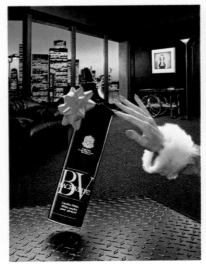

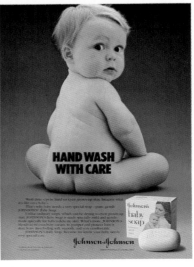

HAND WASH WITH CARE

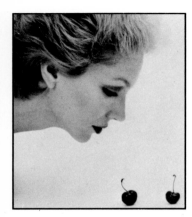

Michael Day Studio Inc.

49 Spadina Ave.
Toronto, Ontario
M5V 2J1

(416) 596-6773

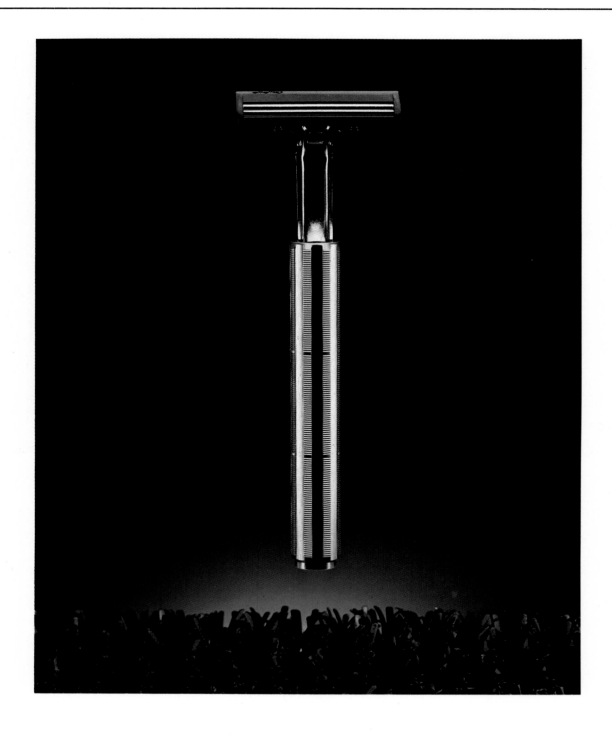

Yuri Dojc Inc.
Photography
66 Portland Street
Toronto, Ontario
M5V 2M8

(416) 366-8081

Portfolios available on request for:

— annual reports
— editorial
— fashion
— advertising

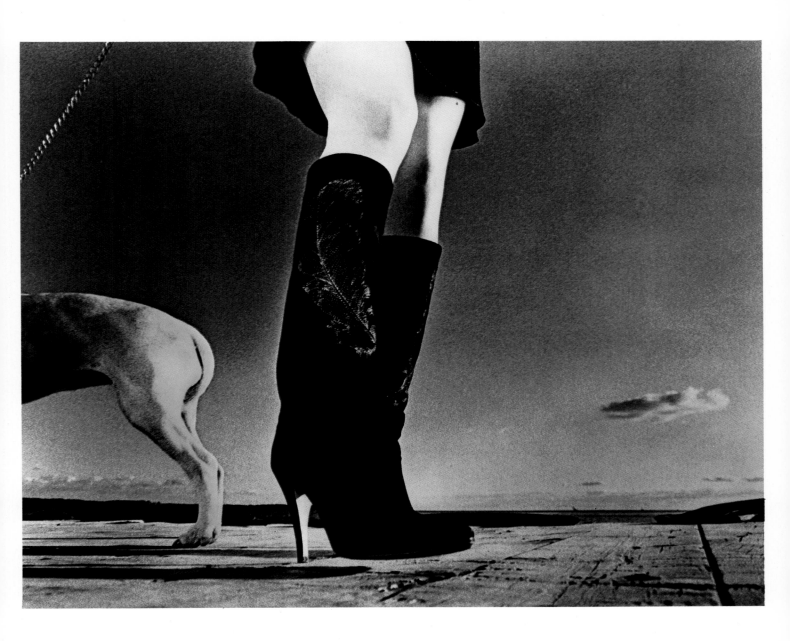

**Warren Fisher
Photography**
1515 Matheson Blvd.
Unit C-11
Mississauga, Ontario.
L4W 2P5

(416) 625-2404

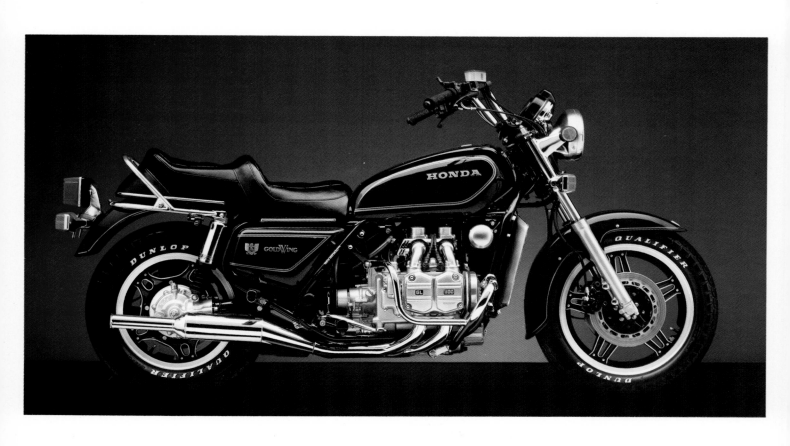

**Warren Fisher
Photography**
1515 Matheson Blvd.
Unit C-11
Mississauga, Ontario.
L4W 2P5

(416) 625-2404

Graham French
443 King St. West
Toronto, Ontario
M5V 1K4

(416) 596-6439

Represented by
Stan Olthuis

(416) 534-1115

Graham French
443 King St. West
Toronto, Ontario
M5V 1K4

(416) 596-6439

Represented by
Stan Olthuis

(416) 534-1115

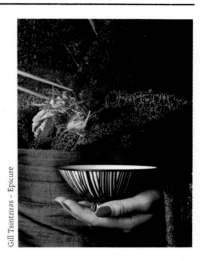

Gill Tsintziras – Epicure

Gill Tsintziras – Todays Women

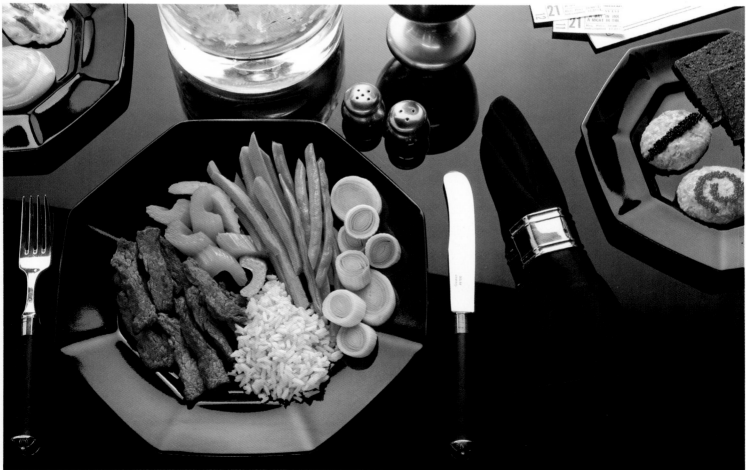

Graham French
443 King St. West
Toronto, Ontario
M5V 1K4

(416) 596-6439

Represented by
Stan Olthuis

(416) 534-1115

Give Scholl your tired, your poor, your aching feet.

It doesn't take much for feet to start aching for attention.
It also doesn't take much to make them feel great again.
 Like soaking them for a few minutes in a relaxing,
skin-softening Scholl Creme Foot Bath. Or taking a little
time to smooth away callouses or heel bumps with
a Scholl Foot Beauty Stone. Or giving them a quick
massage with Scholl Rough Skin Remover, which
gently rubs away built-up layers of rough, dry skin.
 There are all kinds of Scholl foot care products,
on display at a store near you. All designed to make
your tired, aching feet feel great again.

Scholl

Now doesn't that feel better!

Chris Tsintziras – Darcy

Graham French
443 King St. West
Toronto, Ontario
M5V 1K4

(416) 596-6439

Represented by
Stan Olthuis

(416) 534-1115

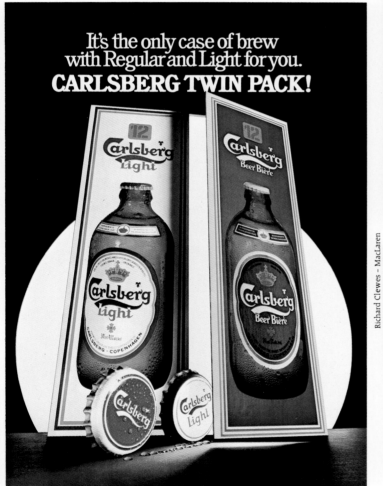

It's the only case of brew
with Regular and Light for you.
CARLSBERG TWIN PACK!

David Purser – O & M

Derek Timmerman – Carverhill, Russell & Timmerman Design

Richard Clewes – MacLaren

**Futura Photographic
Company Limited**
296 Richmond St. W.
Toronto, Ontario
M5V 1X2

(416) 593-9362

Doug Workman
Photographer

A comprehensive portfolio of advertising and packaging in product, food and fashion is available for inspection.

Thanks to Keith Rushton of Keith Rushton and Associates and to Dupont Canada Inc. for the opportunity to work on the assignment below.

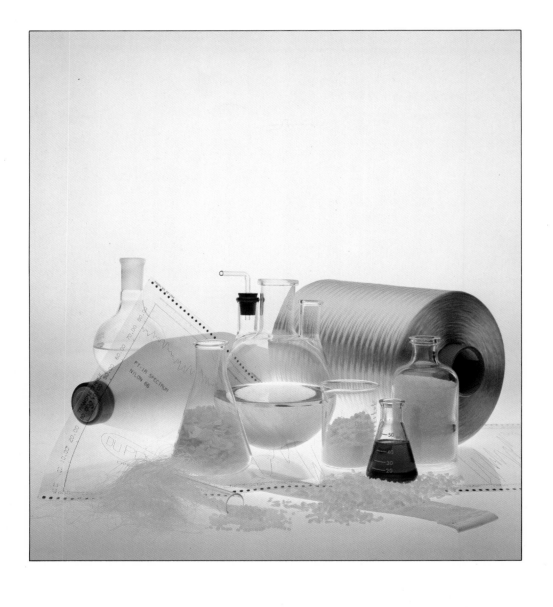

Futura Photographic Company Limited
296 Richmond St. W.
Toronto, Ontario
M5V 1X2

(416) 593-9362

Doug Workman
Photographer

Thanks to Mr. Samuel Dayan and Marnier-Lapostolle, Paris-France for the opportunity to create the photograph below.

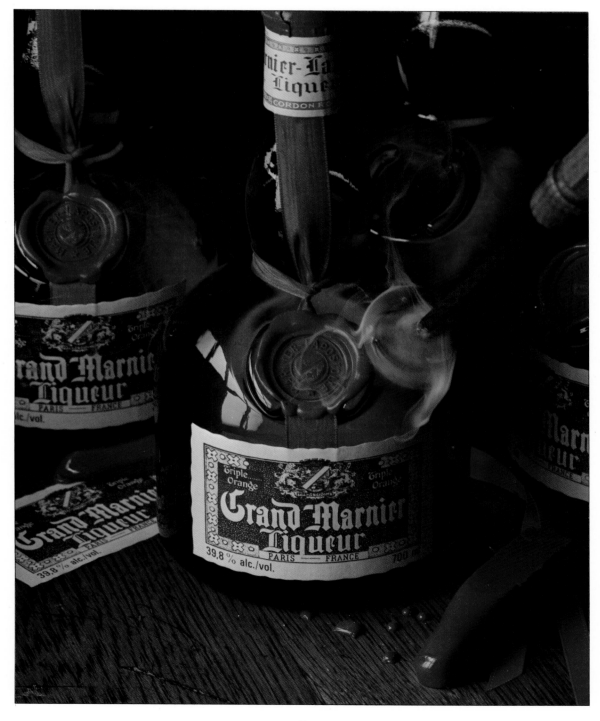

Frank Grant
G/W Photography Limited
67 Mowat Avenue
Suite 449
Toronto, Ontario
M6K 3E3

(416) 537-1225

"A photographer must listen to his clients – focus in on their needs, solve their problems, and most importantly, give them what they want. In addition he should bring an extra-special excitement and enthusiasm to his work".

Worldwide Travel, Corporate/Industrial, Advertising & Editorial Photography.

Stock file available.

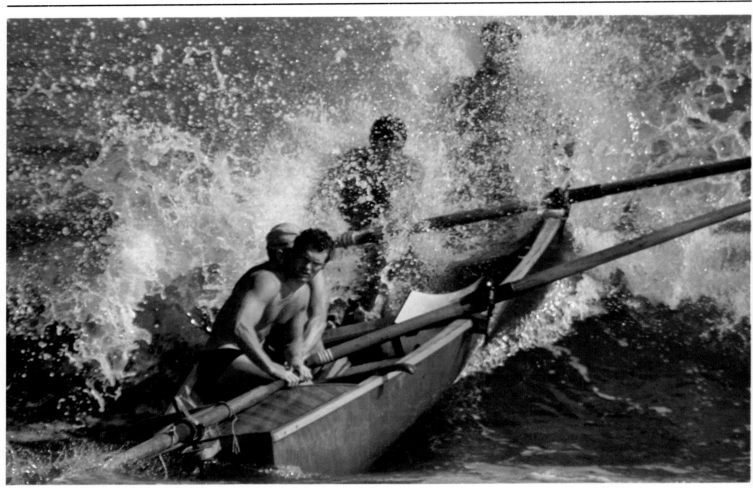

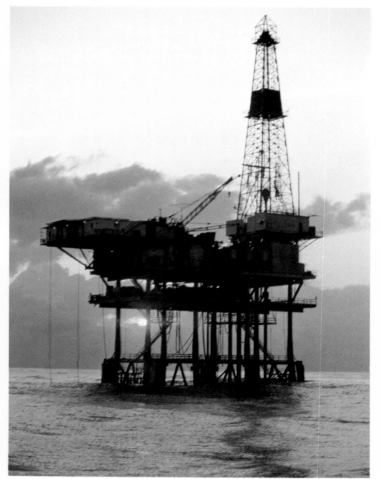

Gilbert Studio
170 Davenport Rd.
Toronto, Ontario
M5R 1J2
(416) 923-1995

Al Gilbert
F.R.P.S. F.I.I.P.
Master of Photography (USA)
Fellow American Society of
Photographers
Master of Photographic Arts

Executive Portrait Portrayals for Corporate Reports by internationally
acclaimed photographer Al Gilbert.

Canadian Imperial Bank of Commerce
Canadian Pacific Ltd.
The Consumers' Gas Company Ltd.
Deere & Company
Denison Mines Ltd.
General Foods Inc.
Hiram Walker Resources Ltd.
Merrill Lynch Royal Securities Ltd.
The Molson Companies Ltd.

Norcen Energy Resources Ltd.
The Oshawa Group
The Quaker Oats Company
Robin Hood Multifoods Inc.
Roman Corporation Ltd.
The Royal Bank of Canada
Traders Group Ltd.
Trans Canada Pipelines
United Co-Operatives of Ontario

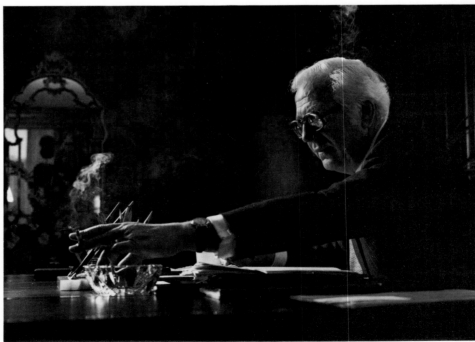

Al Gilbert
F.R.P.S. F.I.I.P.

Ken Elliott
56 The Esplanade
Unit 403
Toronto, Ontario
M5E 1A7

(416) 363-2974

Stock Photography:
StockMarket Inc.
(416) 362-7767

Illustration: McRae

Elliott, staff photographer for fifteen years with *The Canadian* and *Today* Magazines, covering every kind of assignment, now tends towards people pictures.

George Gooderham Photography
51 Borden Street
Toronto, Ontario
M5S 2M8

(416) 925-0774

Stock available
Miller Services
(416) 925-4323

CAPIC

Photo by Renzo

Imaginative solutions to locations worldwide. Annual reports. Advertising, Audio-visuals, and Editorials.
Clients include: Goodyear, Bell Canada, Canadian National Rail, Volkswagen, Wardair and major A-V producers.

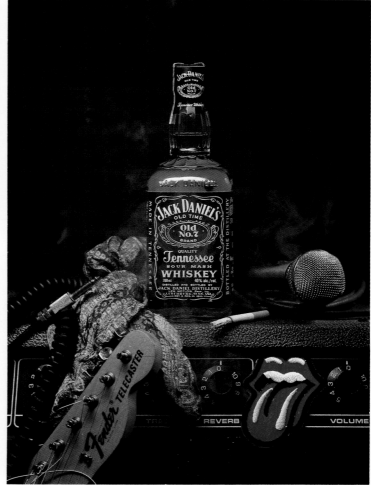

Sharon Green

Windward Productions
682 North Shore Blvd., E.
Burlington, Ontario
L7T 1X2

(416) 681-0512
(416) 632-3705

U.S.A.
385 Georgetown Road
Weston, CT. 06882
(203) 277-8803

Over the past five years Sharon Green has become one of Canada's foremost marine photographers. Her photography has captured rare moments in international competitive sailing and has been featured in and on the covers of: *Yacht Racing Cruising, Sail, Yachting, Sailing, Canadian Yachting* and *Sailing Canada*. Others include: *Hydraulics and Pneumatics, Design Engineering* and *Canadian Business*.

Photographs and produces the annual "**Ultimate Sailing Calendar**"
Professional involvement in the production of multi media presentations.
Film and Television.
Coordinator Locations and productions.

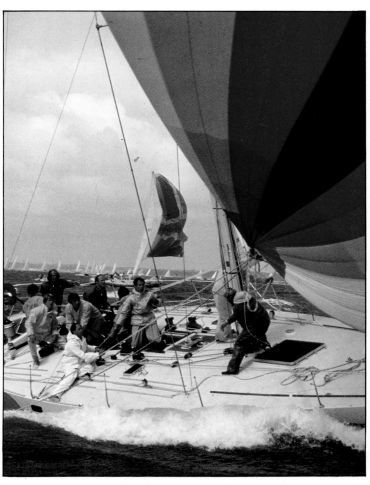

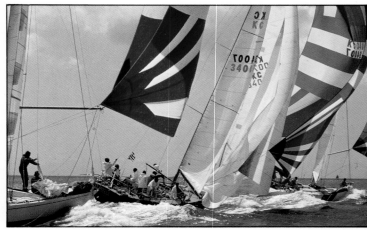

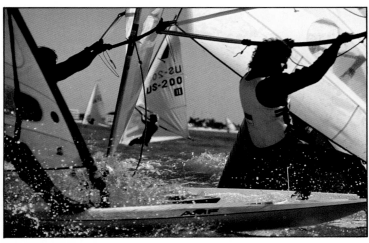

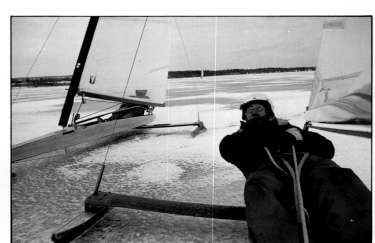

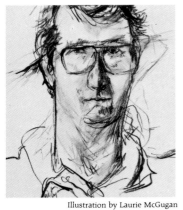

Richard Hill
Photographer
1179A King St. W.
Suite 109
Toronto, Ontario
M6K 3C5

(416) 533-6634

CAPIC

People and Products
Advertising and Editorial
Location and Studio

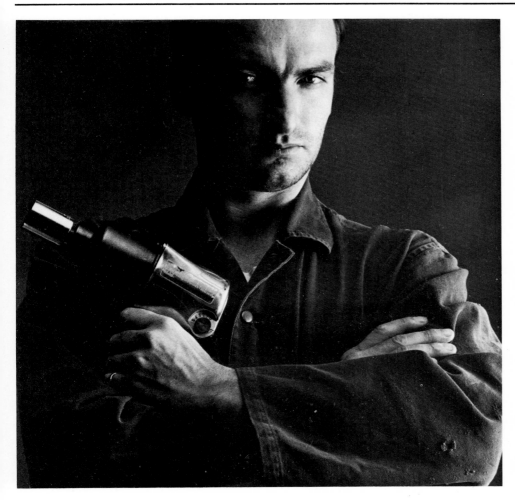

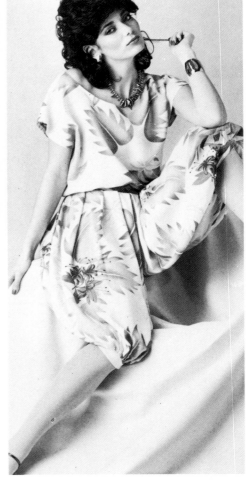

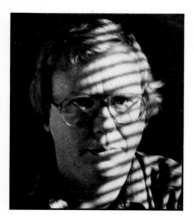

Dave Hill Photography Limited
296 King St. East
Toronto, Ontario
M5A 1K4

(416) 365-1660

Dave Hill

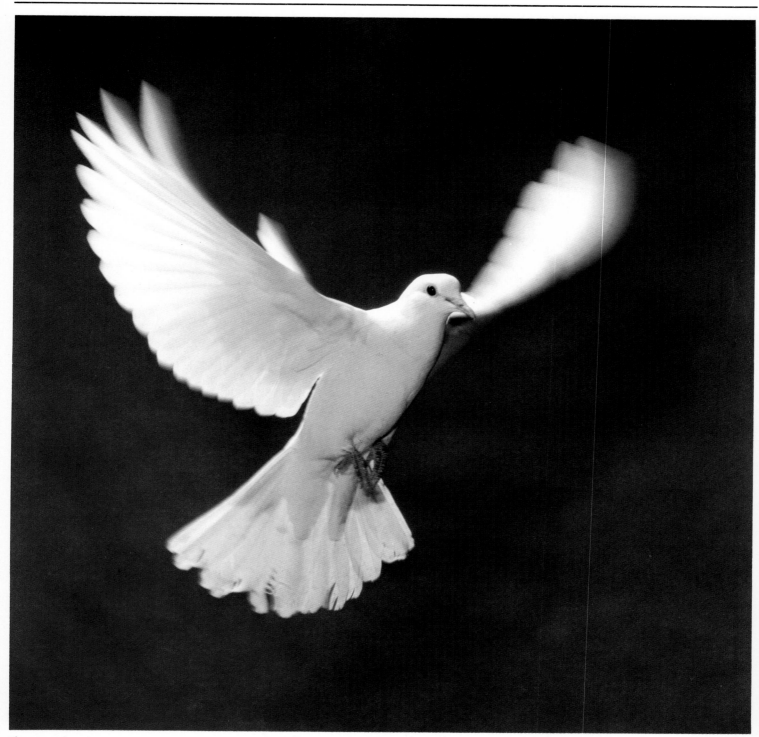

Dave Hill

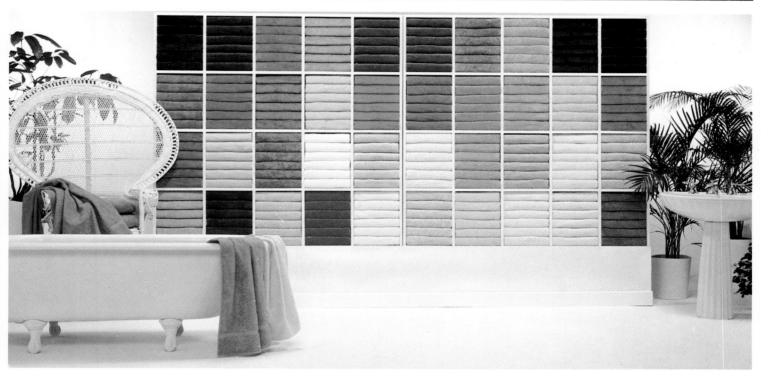

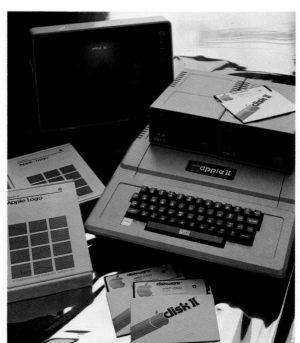

Horan Photography

584 Melbourne Avenue
Ottawa, Ontario
K2A 1W8

(613) 729-0724

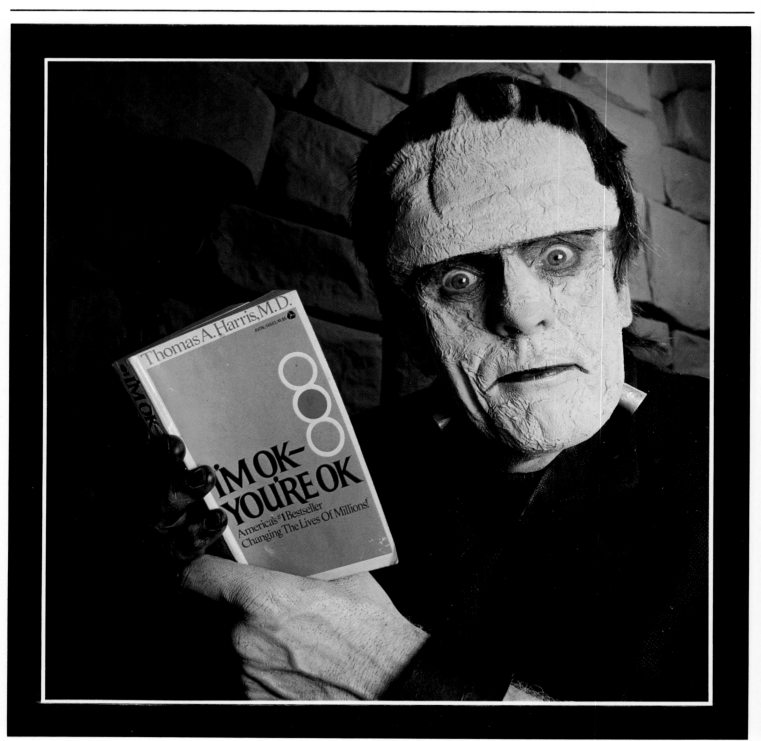

Kineblok Inc.
Image Manipulations
and Audiovisuals

398 King Street East
Toronto, Ontario
M5A 1K9

(416) 947-0169

Oscar Guzman
Creative Director

Mary Ripley
Vice President Marketing

We create images with high visual impact.

General manipulations: Block transformations, artificial colour and laser generated effects.

Manipulations for audio visuals: Animations using the above effects, rotation of 3-D object (3 axis rotations).

Recent Clients: IBM, Capitol Records, Anthem Records, Southam, Spar Aerospace, Northern Telecom.

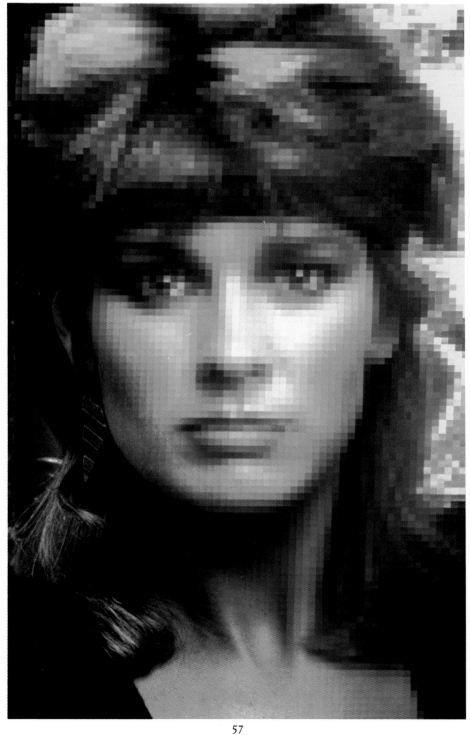

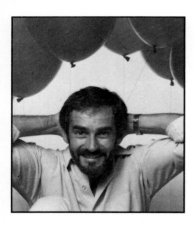

Pat LaCroix Photography Limited
The Brant Group
25 Brant Street
Toronto, Ontario
M5V 2L9

(416) 864-1858

Recently I have discovered one thing that is more arduous than doing advertising photography. That is renovating a building in which to do advertising photography. A task that is truly frought with ardour. However we are now moved in and the studios are beautiful. We call it the Brant Group. Come up and see us sometime.

Thanks to Jackie Young from Ink for this assignment.

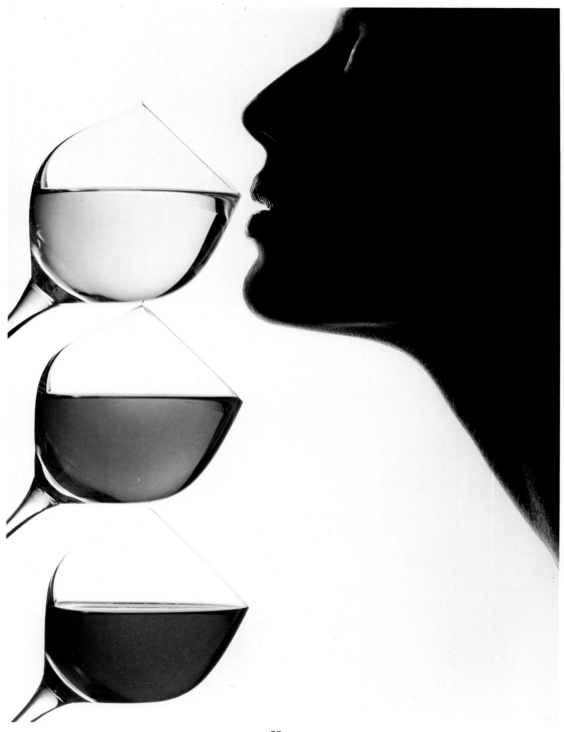

**David Harper Long
Photographer**
1515 Matheson Blvd.
Unit C-11
Mississauga, Ontario
L4W 2P5

(416) 625-4531

"Res ipsa loquatur" *

*Let the matter speak for itself

Photo By John Harquail

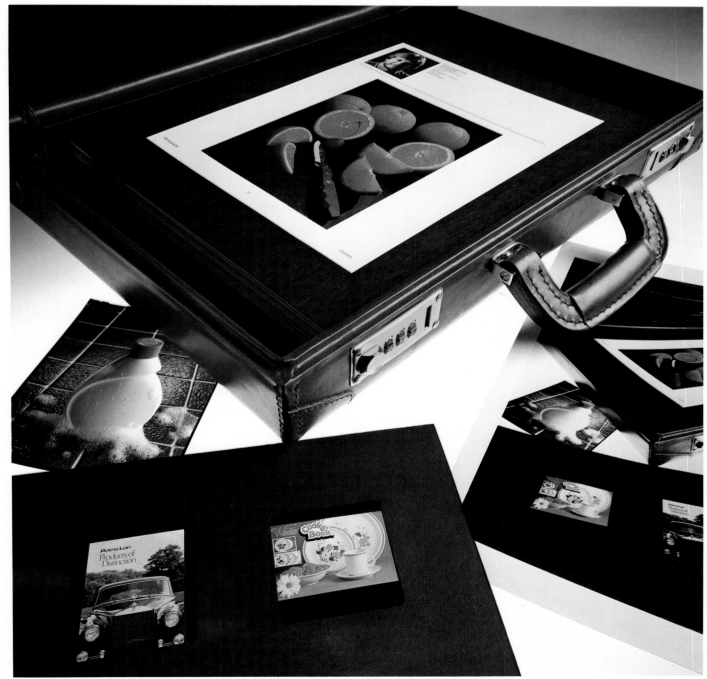

Ian Leith Associates
1515 Matheson Blvd., C11
Mississauga, Ontario
L4W 2P5

(416) 625-2410

CAPIC

When your efforts require more than just documentation, I am available to transport your interiors and exteriors into the two dimensional world without the loss of drama and atmosphere that they demand.

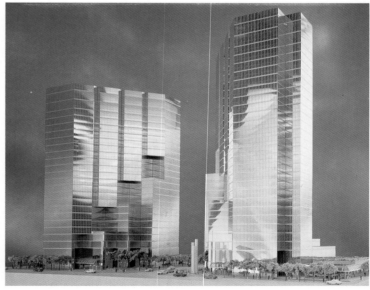

Illustration: Laurie McGaw

Ian Leith Associates
1515 Matheson Blvd., C11
Mississauga, Ontario
L4W 2P5

(416) 625-2410

CAPIC

Thanks to my faithful clients who have allowed me to expand the studio to 5,000 sq. ft. and my visual horizons to infinity.

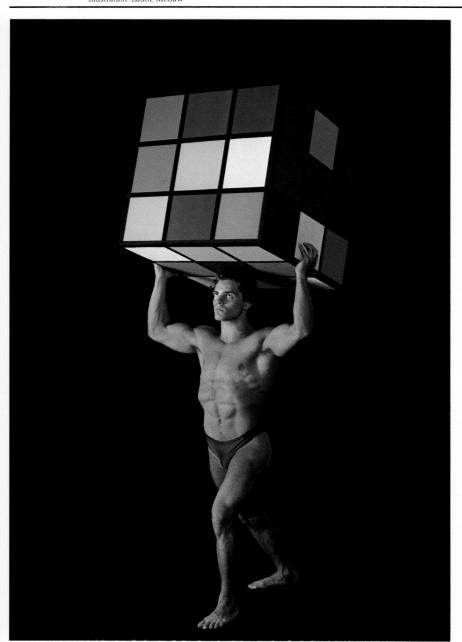

**Paul Orenstein
Photography Ltd.**
317 Adelaide St. W.
Suite 603
Toronto, Ontario
M5V 1P9

(416) 593-9200

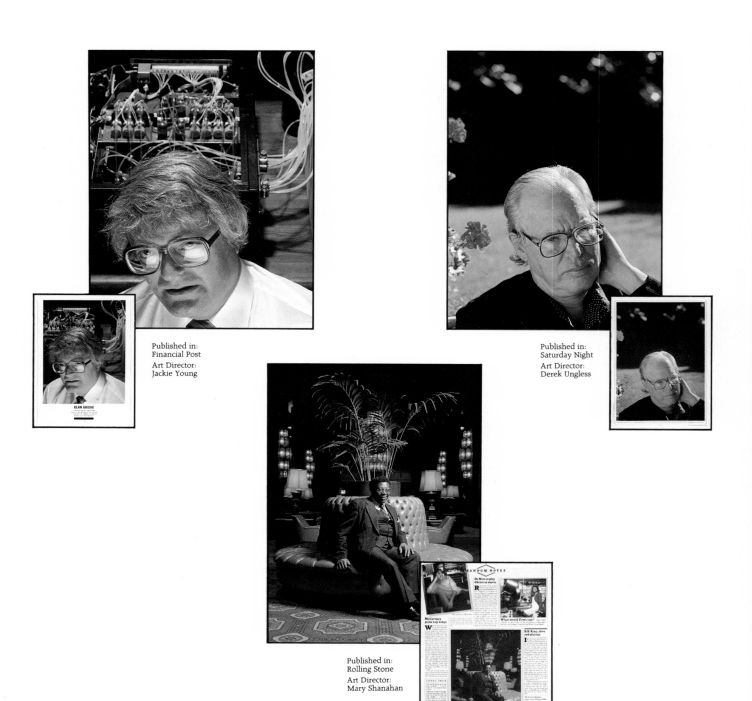

Published in:
Financial Post
Art Director:
Jackie Young

Published in:
Saturday Night
Art Director:
Derek Ungless

Published in:
Rolling Stone
Art Director:
Mary Shanahan

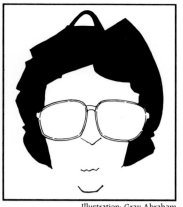

Illustration: Gray Abraham

**Paul Orenstein
Photography Ltd.**
317 Adelaide St. W.
Suite 603
Toronto, Ontario
M5V 1P9

(416) 593-9200

Published in:
Toronto Life

Art Director:
Jim Ireland

Published in:
Saturday Night

Art Director:
Derek Ungless

Published in:
Radio Guide

Art Director:
B.J. Galbraith

Larry Miller
Photography

821 Queen St. East
Suite 204
Toronto, Ontario
M4M 1H8

(416) 461-5013

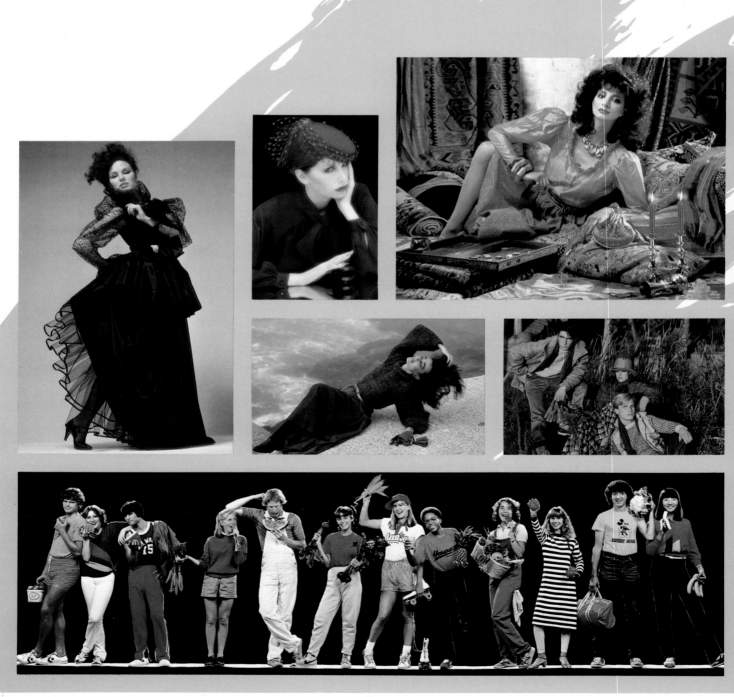

Michael Kohn/Oyster Studio
67 Mowat Avenue
Suite 332
Toronto, Ontario
M6K 3E3

(416) 588-1889

Still life, product, people, editorial. Studio and location.

Top left: Strata Design
Top right: Barbara Solowan – Art Director
Bottom: Martine Gourbault – Art Director

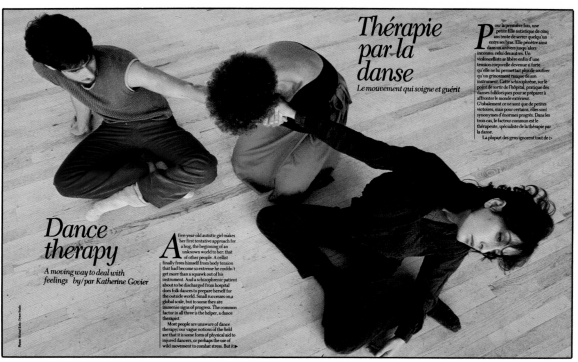

Thérapie par la danse
Le mouvement qui soigne et guérit

Pour la première fois, une petite fille autistique de cinq ans tente de serrer quelqu'un entre ses bras. Elle pénètre ainsi dans un univers jusqu'alors inconnu: celui des autres. Un violoncelliste se libère enfin d'une tension corporelle devenue si forte qu'elle ne lui permettait plus de soutirer qu'un grincement rauque de son instrument. Cette schizophrène, sur le point de sortir de l'hôpital, pratique des danses folkloriques pour se préparer à affronter le monde extérieur. Globalement ce ne sont que de petites victoires, mais pour certains, elles sont synonymes d'énormes progrès. Dans les trois cas, le facteur commun est le thérapeute, spécialiste de la thérapie par la danse.

La plupart des gens ignorent tout de ▷

Dance therapy
A moving way to deal with feelings by/par Katherine Govier

A five-year-old autistic girl makes her first tentative approach for a hug, the beginning of an unknown world to her; that of other people. A cellist finally frees himself from body tension that had become so extreme he couldn't get more than a squawk out of his instrument. And a schizophrenic patient about to be discharged from hospital does folk dances to prepare herself for the outside world. Small successes on a global scale, but to some they are immense signs of progress. The common factor in all three is the helper, a dance therapist.

Most people are unaware of dance therapy; our vague notions of the field are that it is some form of physical aid to injured dancers, or perhaps the use of wild movement to combat stress. But it ▶

Photo by Denise Robinson

Richard Pierre
21 Fairview Blvd.
Toronto, Ontario
M4K 1L8

(416) 466-4063

Clients: Corporations, government departments, advertising agencies and every major consumer magazine.

Objective: Solving problems on location, indoors or out. Shooting anyone or anything anywhere. Travel, executive portraits, heavy industry, high-tech or editorial.

Richard Pierre: One of Canada's most published photographers during the past decade.

CAPIC

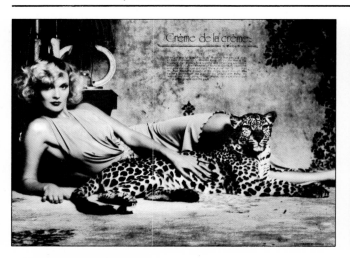

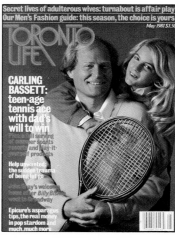

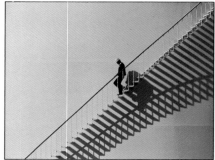

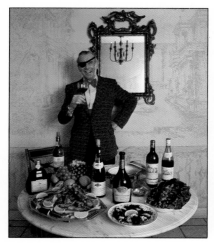

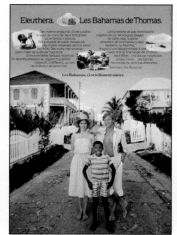

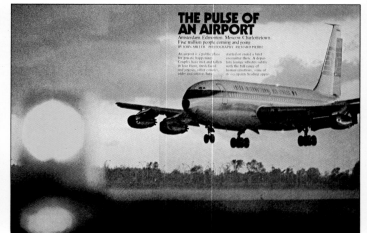

Plum Studios Incorporated
P.O. Box 456
Station "A"
Toronto, Ontario
M5W 1E4

(416) 593-1433

Bruce Cole
Member of P.P.O.C.
Member of C.A.M.E.R.A.

C A P I C

Our Work: Advertising, Annual Reports and Corporate Brochures, Editorial, Audio-Visual and Public Relations photography for Corporations, Film and Television, B & W and Colour lab facilities available.

Our Goal: To Solve Your Communication Problems

Our Clients: Special thanks to *Sheraton Triumph* – Toronto, *Extendicare* – Gibson House – Toronto and *Pam Pam Restaurant* – Montreal – York-Hanover Hotels (Restaurant Division) and to all the Advertising and Public Relations agencies and Designers we have worked with.

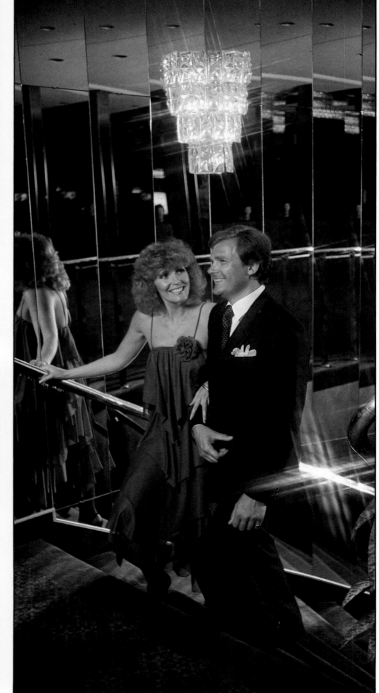

Taffi Rosen
Photography
524 Wellington St. W.
Toronto, Ontario
M5V 1H5

(416) 593-9266

CAPIC

Azzaro Perfume — Louis Azzaro
Annual Report — CCL Industries
Self Promotion
Flare Magazine — Maclean Hunter

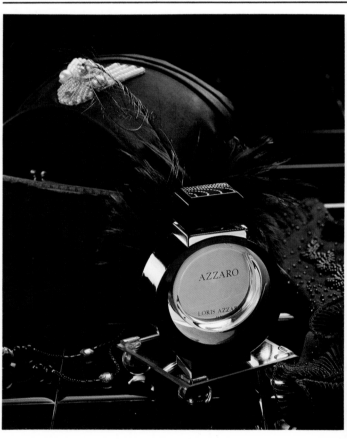

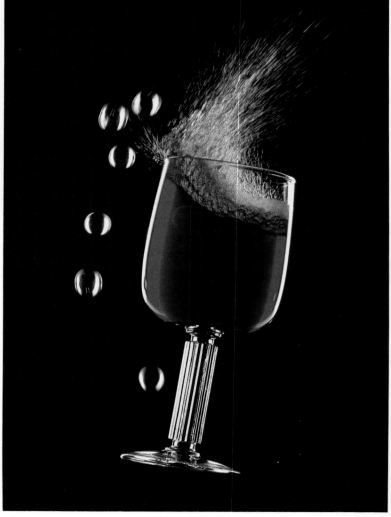

Deborah Samuel
Photography
317 Adelaide St. West
7th Floor
Toronto, Ontario
M5V 1P9

(416) 598-3918

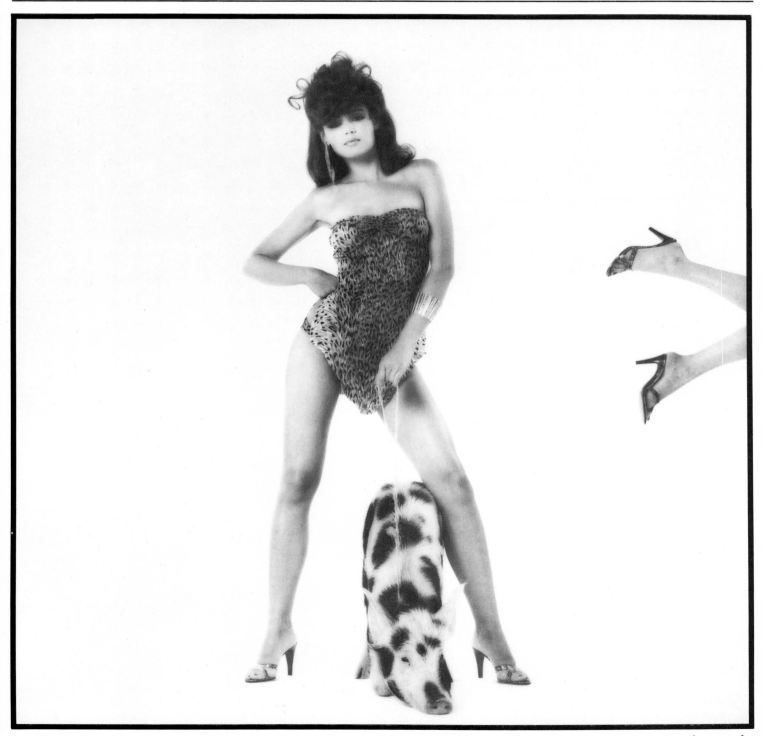

Philip Rostron Studios Inc.
443 King St. West
Toronto, Ontario
M5V 1K4

(416) 596-6587

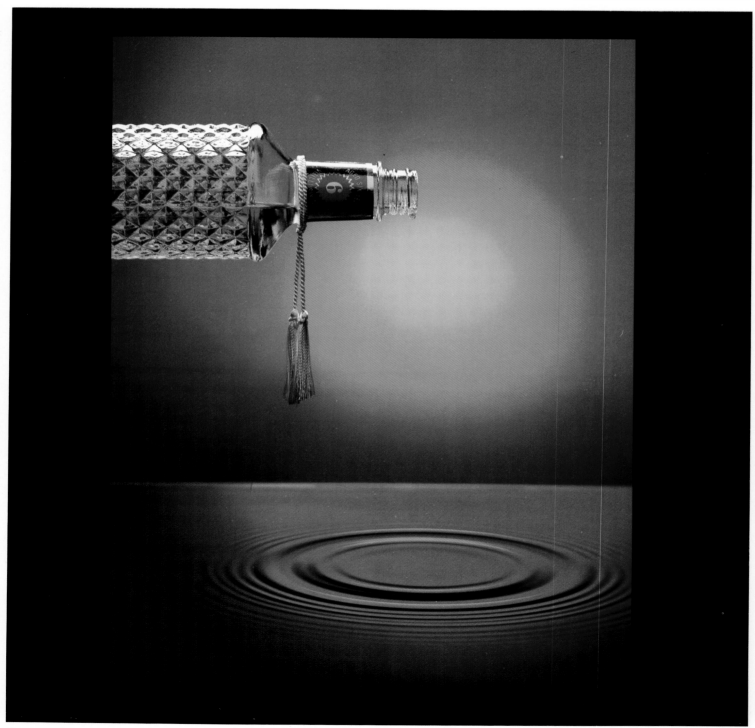

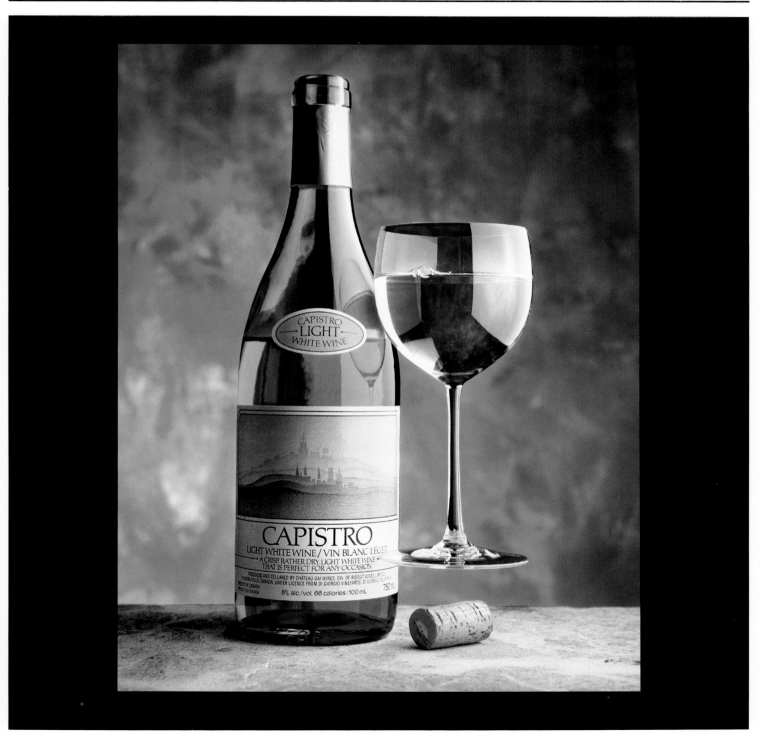

Tim Saunders
T. Saunders and Associates
Limited
163A Manning Avenue
Toronto, Ontario
M6J 2K6

(416) 368-1611

Represented by:
Poet Farrell
(416) 968-6788

Carlsberg
Ogilvy Mather Ltd.
AD Katherine Knox

Homemaker's Magazine
COMAC Communications
AD Georges Haroutian

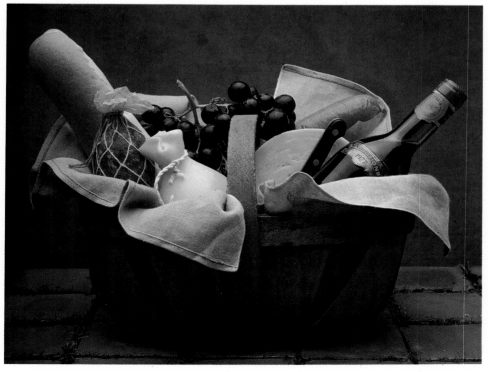

Tim Saunders
T. Saunders and Associates
Limited
163A Manning Avenue
Toronto, Ontario
M6J 2K6

(416) 368-1611

Represented by:
Poet Farrell
(416) 968-6788

Estee Lauder Mailer
Estee Lauder NY
AD Anelle Miller

Grand Cuvee
Baker Lovick Ltd.
AD Katherine Knox

Yardley of Canada
Burns Cooper Hynes Ltd.
AD Dawn Cooper

Ivor Sharp Inc.
60 Sumach St.
Toronto, Ontario
M5A 3J7
(416) 363-3991

Ivor Sharp
Photographer

June Sharp
Producer

We're a small but expandable stills production unit and we work mainly for agencies.

We shoot people, in the studio or in their own place, but believable people. We do it with fun and excitement and emotion and we aim to get some human quality that actually touches and motivates.

That's what we do, and we do it under the gun, and usually under budget. We love doing the smaller creative stuff, but find ourselves doing a lot of the bigger assignments, the ones based on big research, with big media buys, working with big pressures and responsibilities.

If you want to know more about us ask some of the people we've worked with over the years.

Represented worldwide for stock and assignment by Image Bank, New York

THE WONDERFUL FOLKS WHO BROUGHT YOU THIS:

Ron Cockroft/F.H. Hayhurst

Mike Tott/J. W. Thompson

Graham Gauntlett/Foster

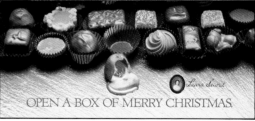

Gerry Monsier/F.H. Hayhurst

Larry Anas/Vickers & Benson

Ann Holland/J. Walter Thompson

Jane Pritchard/J. Walter Thompson

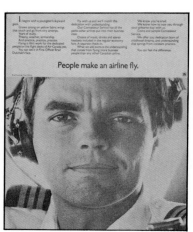

Jim Burt/Burt/Watt

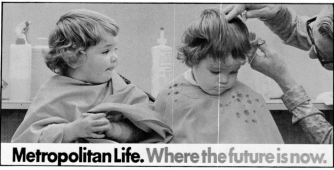

Tom Peck/Young & Rubicam

NOW BRING YOU THE CAT.

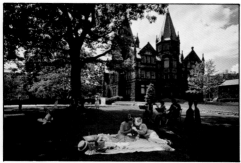

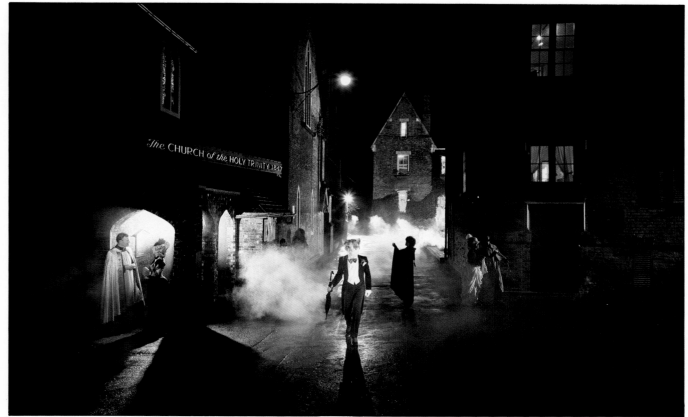

The Secret City Calendar

George Simhoni
296 King Street East
Toronto, Ontario, Canada
M5A 1K4
(416) 365-1660

Stock Photography:
The Stock Market Inc.
(416) 362-7767

Represented by:
Stephen Epstein/Stanley Boigon
ADvice Ltd.
(416) 964-3454

**Studio Two
Photographers Inc.**
1297 Matheson Blvd.
Mississauga, Ontario
L4W 1R1

(416) 624-6322

Walter Riss: Over 25 years of European and Canadian experience.
Served his photographic apprenticeship with a large studio in Stuttgart,
Germany.
Emigrated to Canada in 1965 and gained Canadian experience by
working for 3 years for several Large Toronto studio's.
Started Studio Two Photographers in 1968 with his partner
After many successful years of operation in Hamilton, Ontario, their
studio is now conveniently located in Mississauga. Their present facilities
include a large 76 × 50 general studio with a 36 ft., coved wall as well as
a smaller studio with complete kitchen facilities for food photography.
Other services include, colour retouching, emulsion stripping and black
and white as well as colour assembly.

60 Sumach
60 Sumach Street
Toronto, Ontario
M5A 3J7

(416) 864-1314

60 Sumach…a group of name photographers, all under one roof.

60 Sumach was formed to provide the same level of service as "major studios", while retaining that feeling of working with the photographer that you chose for that specific job.

60 Sumach means six full-size studios, direct access to car studios, full prop service, home economist, two full kitchens, as well as a full service colour lab on the premises.

Three full time reps are handling everything from client contact to art services, and any other production requirements that arise during the course of a job.

Photographers:
Derek Case
Terry Collier
Richard Heyfron
Don Miller
Ken Walley
Michael Waring

Sales Reps:
John Heyfron
Shelley Yampolsky
Frank Kitching

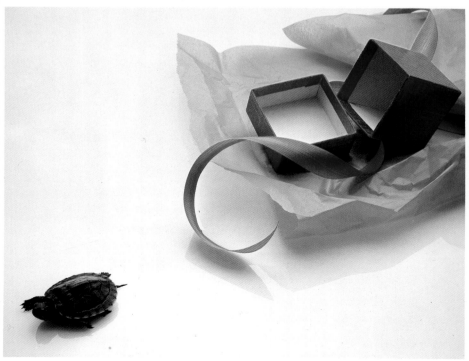

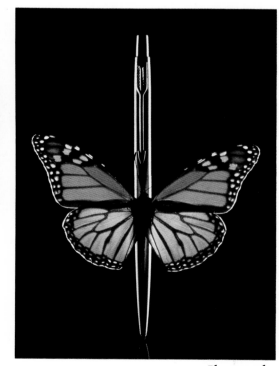

Robert Wigington
Photographer
4 Clinton Place
Toronto, Ontario
M6G 1J9

(416) 533-7938

Represented by:
Fleming & Assoc.

(416) 276-9373

Still life, food, drink, product, decor.
Editorial, Advertising, Packaging, etc.
Clients include: Agriculture Canada, Canada Packers, Campbell's, CN Tower Ltd., Carnation, General Foods, Kraft, Thos. J. Lipton Co., Labatt's, Ontario Milk Marketing Board, Pillsbury, Quaker, Seagram Distillers, J.M. Schneider, Toronto Life and Reader's Digest. Posters for Helico Graphics.

Other examples of my work have appeared in: *Creative Source* Vols. 1, 3. *Art Director's Index to Photographers* Vols. 4, 5, 6, 7.

Existing food stock photography available upon request.

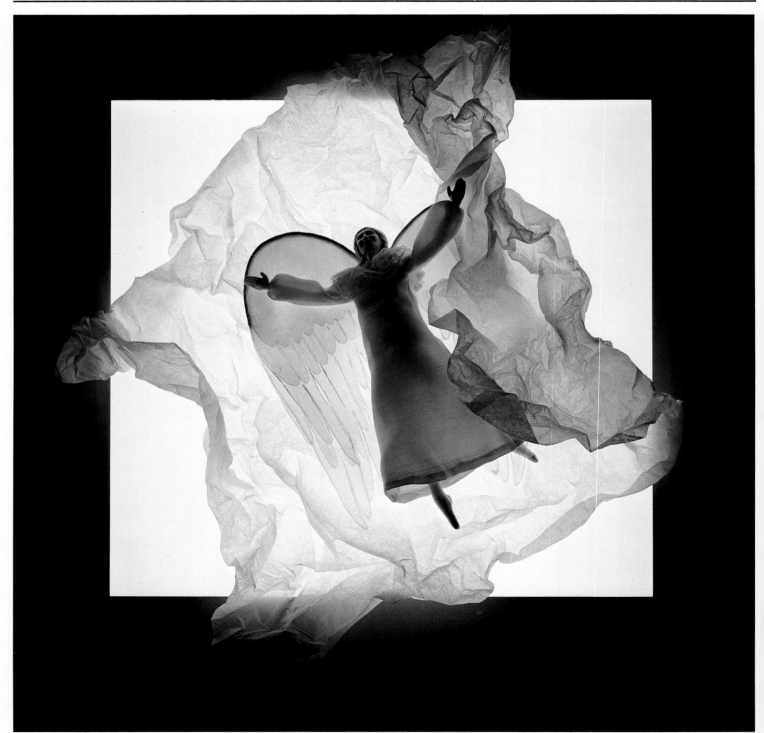

Robert Wigington
Photographer
4 Clinton Place
Toronto, Ontario
M6G 1J9

(416) 533-7938

Represented by:
Fleming & Assoc.

(416) 276-9373

Still life, food, drink, product, decor.
Editorial, Advertising, Packaging, etc.
Clients include: Agriculture Canada, Canada Packers, Campbell's, CN Tower Ltd., Carnation, General Foods, Kraft, Thos. J. Lipton Co., Labatt's, Ontario Milk Marketing Board, Pillsbury, Quaker, Seagram Distillers, J.M. Schneider, Toronto Life and Reader's Digest. Posters for Helico Graphics.

Other examples of my work have appeared in: *Creative Source* Vols. 1, 3. *Art Director's Index to Photographers* Vols. 4, 5, 6, 7.

Existing food stock photography available upon request.

Stephen Yarkun
66 Portland Street
Toronto, Ontario
M5V 2M8

(416) 366-8081

**Sidney A. Tabak
Photography**
40 Lombard Street
Suite #203
Toronto, Ontario
M5C 1M1

(416) 363-3428

Contact:
Diana Savard

Annual Reports, Portraiture,
Editorial and Architectural.

Assignments.

Member–American Society of
Magazine Photographers

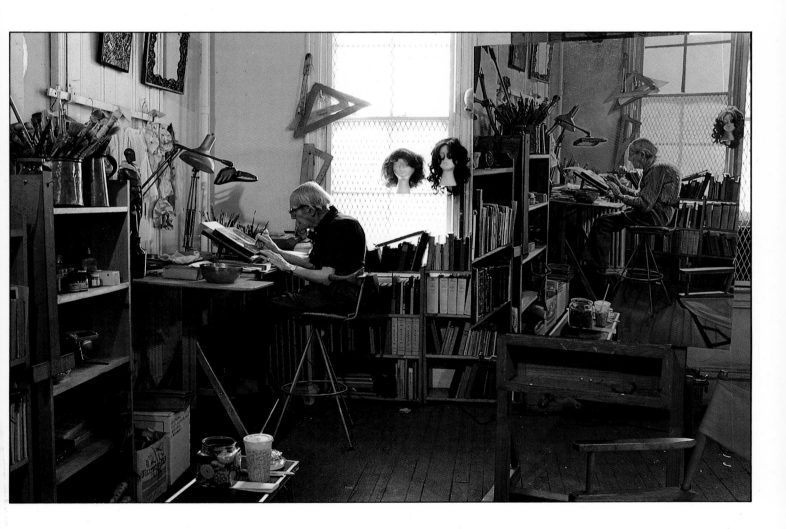

Ray Chen
1420 rue Notre-Dame Ouest
Montréal, Québec
H3C 1K9

(514) 931-2203

Stock photography
available from
Masterfile
(416) 977-7267

Ray Chen
1420 rue Notre-Dame Ouest
Montréal, Québec
H3C 1K9

(514) 931-2203

Stock photography
available from
Masterfile
(416) 977-7267

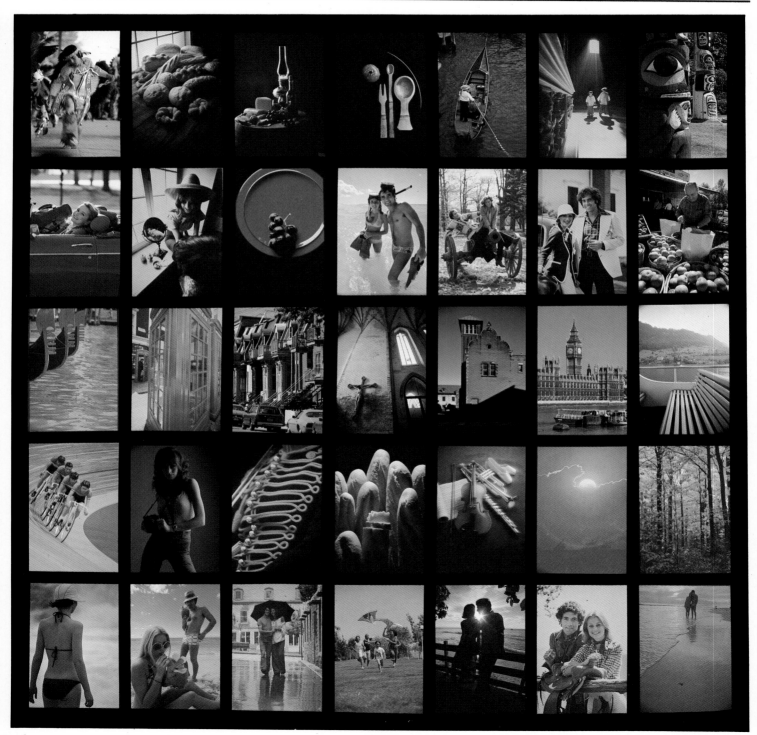

Karen Coshof
63 Prince Arthur East
Top Floor
Montreal, Quebec
H2X 1B4

(514) 842-1393

Represented by:
Susan Dewilde
(914) 684-0464

The demonstrable fact is that this lady is a director and producer of complex photo situations which drive most photographers nuts. This doesn't imply numbed sensitivity; she simply has a very skilled group of pros to call upon, to deliver your shot on time…Multi-lingual co-ordinators, designers, casting people, fork-lift operators, make uppers, choreographers, security guards, animal trainers, carpenters, costumers, client-calmers and surrogate teeth-gnashers… "All this in a city famed for its international beauties, low prices, superb locations, great cuisine, and all-round swell people…"

Adrien Duey
1030 St. Alexandre
Suite 812
Montreal, Quebec
H2Z 1P3

(514) 879-1848

CAPIC

Illustrative Photography-Advertising,
Industrial, Interior Design, Corporate & Audio Visual Assignments.
In the studio and on location.

Photographie D'Illustrations–
Contrats Publicitaires, Industriels, Corporatifs, Audio-Visuels,
Et De Design Intérieur.
En Studio Et Sur Locations.

Les Productions Lumière
1030 St. Alexandre
Suite 812
Montréal, Québec
(514) 879-1848

Benoît Chalifour
Photographe

Benoît Chalifour voyage partout dans le monde sur demande.
Photographie éditoriale, touristique, publicitaire et aérienne.

Benoît Chalifour travels world-wide on assignments.
Editorial, tourism, publicity and aerial photography.

Stock photography available upon request

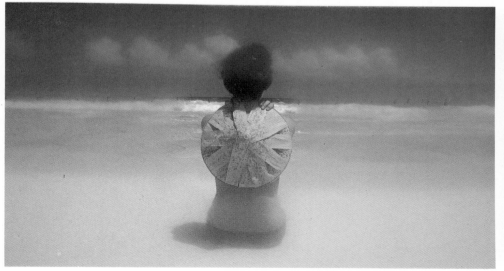

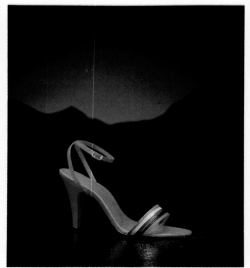

John O'Hara
P.O. Box 276
Montreal, Quebec
H3P 3C5

(514) 737-4872

Represented by
Pro Creation Canada Inc.
Montreal: **(514) 341-3752**
Toronto: **(416) 593-4666**

Member: CAPIC
 AMI
 PPofA

Audio-Visual, Advertising and **Corporate** photography.
Clients include Avon to Zellers with emphasis on people and product.
Set Design and organizational ability displayed via portfolio presentation.
Full location and studio capabilities from **8 × 10 to pin-registered 35mm.**
Call! We'll come running.

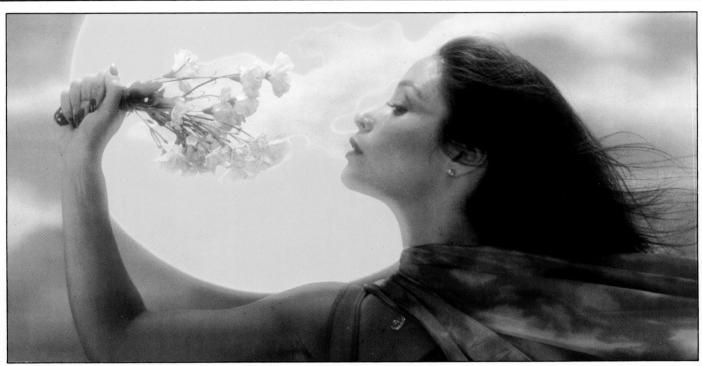

Danny Singer/Animotion Inc.
1850 Notre-Dame West
Montreal, Quebec
H3J 1M5

(514) 935-8749

Special effects photography, color graphics in real or surreal time. Combine product photography with inner normal or outer space events, motion control and computer technology, mat work and combination of multiple elements.

CAPIC

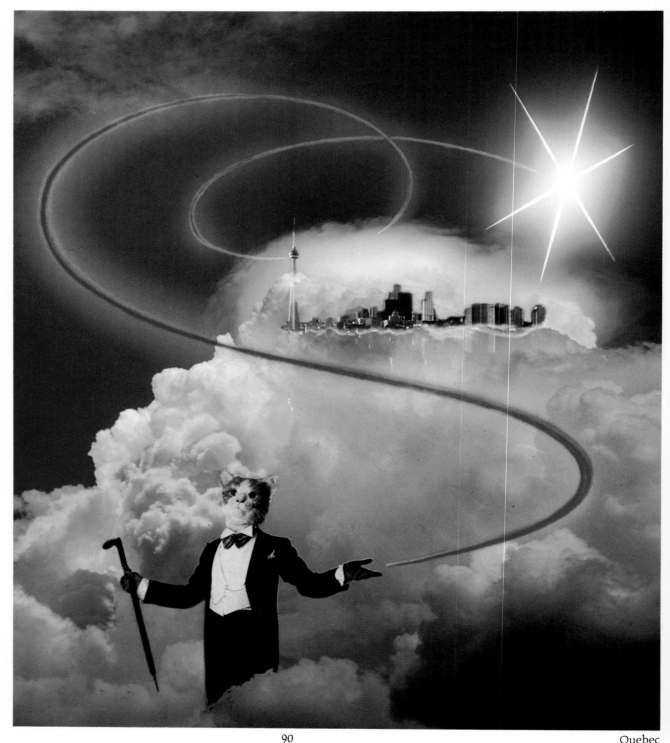

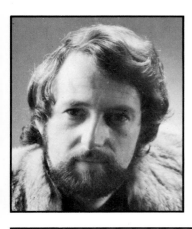

**David Travers
Photography Inc.**
980 St. Paul West
Montreal, Quebec
H3C 1M9
(514) 861-9107

David Travers
AIIP. ARPS

CAPIC

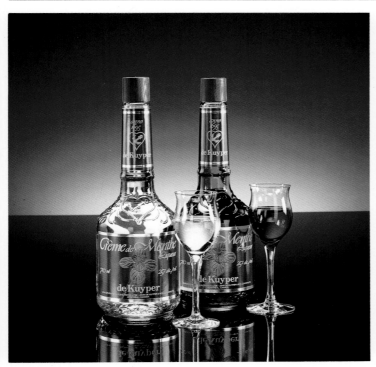

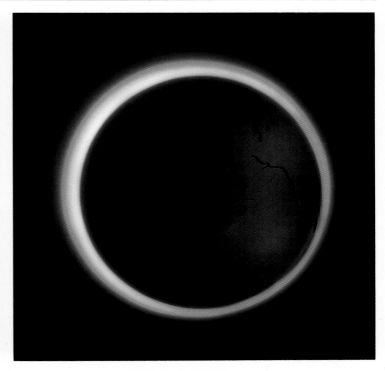

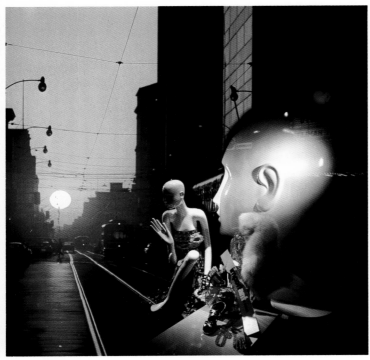

Barrett & MacKay
P.O. Box 2385
Charlottetown, P.E.I.
C1A 8C1

(902) 675-3383

Wayne Barrett and Anne MacKay are professional photographers working out of their studio in St. Catherines P.E.I. Both are willing to assept a wide range of photographic assignments and specialize in environmental and industrial photography.

Major publications include: **Prince Edward Island**, **King's Landing: Country in Early Canada**, **The St. John River Valley**, **Spirit of Place**: Lucy Maud Montgomery and Prince Edward Island. Presently working on new books.

Stock Photography:
MASTERFILE (416) 977-7267

**ABL Photographic
Techniques Ltd.**
1336 – 11 Avenue, S.W.
Calgary, Alberta
T3C 0M6

(403) 245-6626

Reg Anaka
Peter Bolli

A distinctive group of professional photographers insure the demanding market of a quality, consistent and imaginative product in every concievable industry.

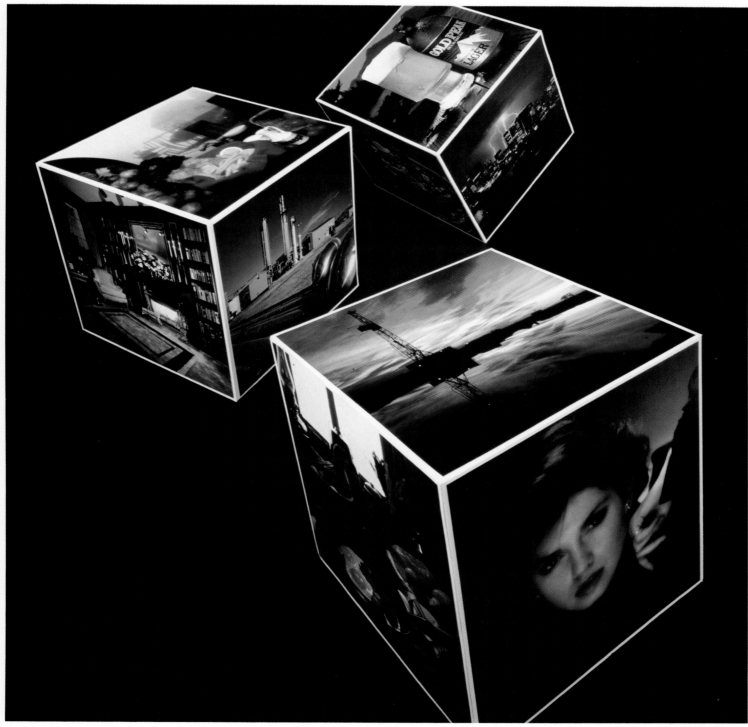

BAKO/BECQ INC.

Andrew Bakó/Jean Becq
3047–4th Street S.W.
Calgary, Alberta
T2S 1X9

(403) 243-9789

A.S.M.P.

Worldwide: corporate/industrial, advertising and editorial asignments.

Clients include: Bank of Nova Scotia, Norcen Energy Corporation, Mobil Oil, Olympia & York, Nova Corporation, CBS Graphics.

BAKÓ/ BECQ

BAKO/BECQ INC.

Andrew Bakó/Jean Becq
3047–4th Street S.W.
Calgary, Alberta
T2S 1X9

(403) 243-9789

A.S.M.P.

Worldwide: corporate/industrial, advertising and editorial asignments.

Clients include: Amoco, Gulf Oil, Bank of Montreal, Benton & Bowles Ltd., Cadillac Fairview, Pan Canadian, Shell Oil.

**Philip Hersee
Photography Inc.**
155 Water St. Gastown
Vancouver, B.C.
V6B 1A7

Tel. 687-2921

Philip Hersee works with the major ad agencies in Canada and abroad,
a specialist with people.
Fashion, Travel, Illustration, Annual Reports.
Awards: Popular Photography New York
 Great Photographers of Women–1972
 Graphica Club Montreal–1976
 PPABC Jan de Hass Award
 Best Creative Colour–1978
 Hall of Fame U.S.A.–1980

Stock library, available at the studio.

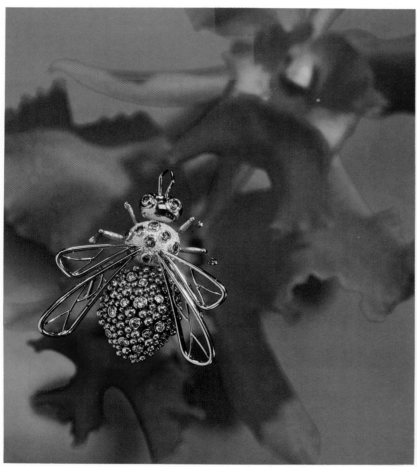

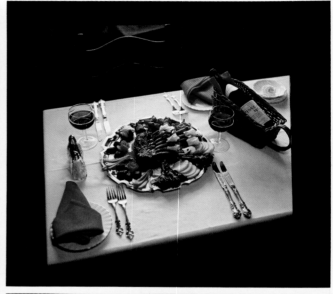

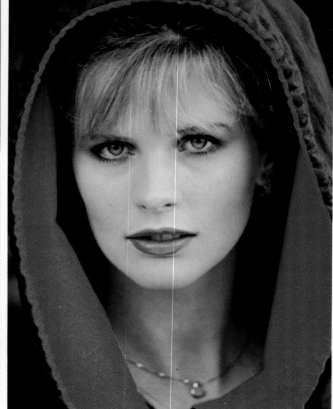

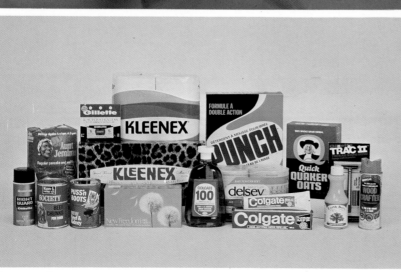

Picture This Photography
4928 Rundlewood Rd. N.E.
Calgary, Alberta
T1Y 1B4

(403) 280-9709

Larry Fisher
Photographer

Past experience as *Managing Editor* and *Advertising Director* of a newspaper in the **proposed 1988 Olympic area**, allows **Mr. Fisher** the versatility and experience necessary for the challenging area of commercial photography. Areas of expertise include *Advertising, Photojournalism, Architectural, Scenic, Sports* and *Aviation Photography*. Additional qualifications include a Canadian commercial Pilots License (Multi engine instrument ratings), and mountaineering (Rock and glacier).

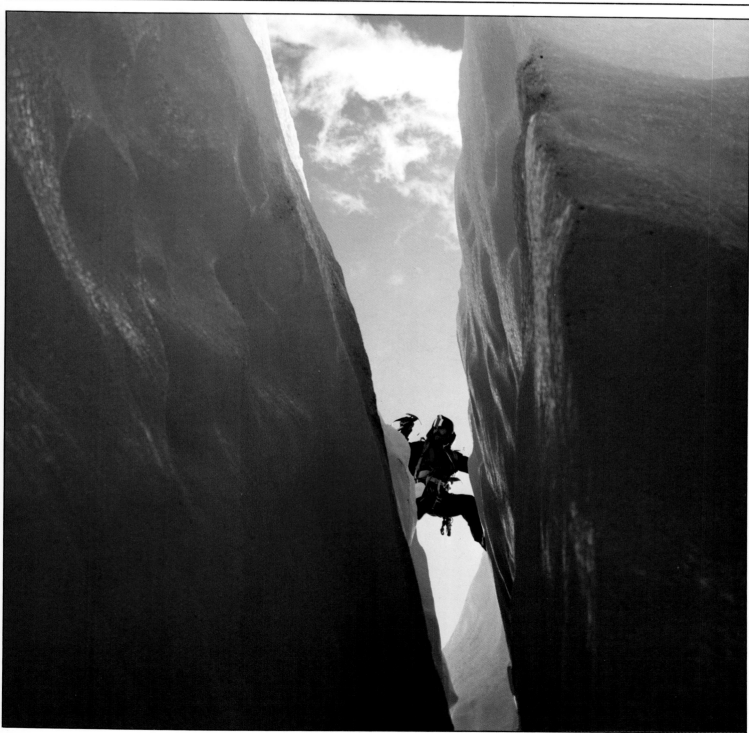

**Derik Murray
Photography Inc.**
1128 Homer Street
Vancouver, British Columbia
Canada
V6B 2X6

(604) 669-7468

Derik Murray
Advertising Illustration

Howard Fry
Glamour

Representatives:
Calgary
Susan R.J. Messett
1908 – 33rd Ave. S.W.
Calgary, Alberta
T2T 1Z2
(403) 242-0512
Edmonton
Jennifer A. Swan
#101 11220 – 99th Avenue
Edmonton, Alberta
T5K 2K6
(403) 488-9263

Representatives:
Seattle –
Harry Cartales
2203 4th Avenue North
Seattle, Washington 98109
(206) 285-5366

Toronto –
60 Sumach
Toronto, Ontario
M5A 3J7
(416) 864-1314

Clients: Amax Inc., B.C. Hydro, B.C. Telephone, Baker Lovick, Burns, C.P. Air, C.D.C. CanOcean Resources, Chemetics, Chevron, Christine Morton, Cockfield Brown, Corkscrew, Daiwa, Dairyland, Delta Hotels, Eatons, F.H. Hayhurst, Fletchers, Foster Advertising, Jantzen, Kentucky Fried Chicken, Labatts, MacMillan Bloedel, McKim Advertising, Mustang Sportswear, Nalley's Nordstrom, P.D. & A., Pacific Centre, Pentax, Ronalds Reynolds & Co., Simons Advertising Ltd., Sports Illustrated, Sun Rype, Suzuki, Texaco, Tourism B.C., Ullrich Schade & Associates, Vancouver Canucks Hockey Club, Vancouver Magazine, West Can Communications, Workers Compensation Board…

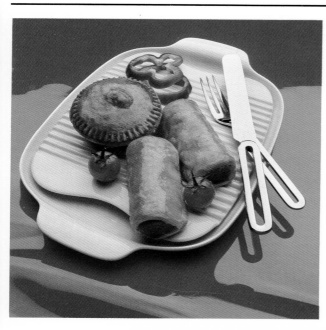

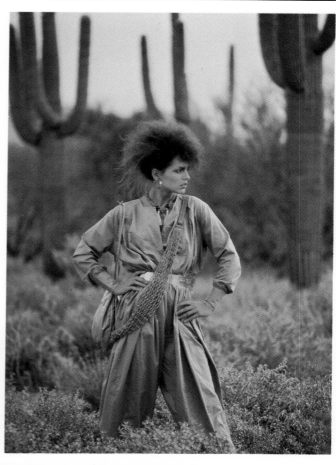

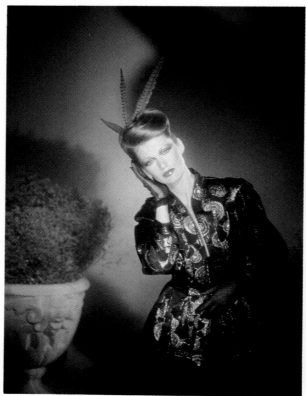

Rudolfi Photography Ltd.

15006-116 Avenue,
Edmonton, Alberta
T5M 3T4

(403) 455-8138

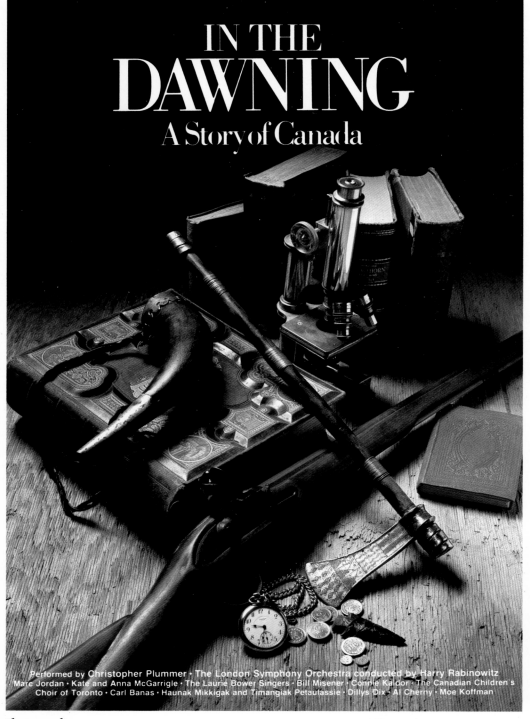

IN THE
DAWNING
A Story of Canada

Performed by Christopher Plummer · The London Symphony Orchestra conducted by Harry Rabinowitz
Marc Jordan · Kate and Anna McGarrigle · The Laurie Bower Singers · Bill Misener · Connie Kaldor · The Canadian Children's
Choir of Toronto · Carl Banas · Haunak Mikkigak and Timangiak Petaulassie · Dillys Dix · Al Cherny · Moe Koffman

**Stirling Ward
Photographic Design**
1020 Hamilton Street
Vancouver, B.C.
V6B 2R9

(604) 687-3554

Stirling Ward Photographic Design is....

...a team of award winning photographers who combine over 30 years of experience

...a fully equipped studio operating in all major formats

...a stock image bank

...professional photographers specializing in all aspects of commercial, industrial and fashion photography

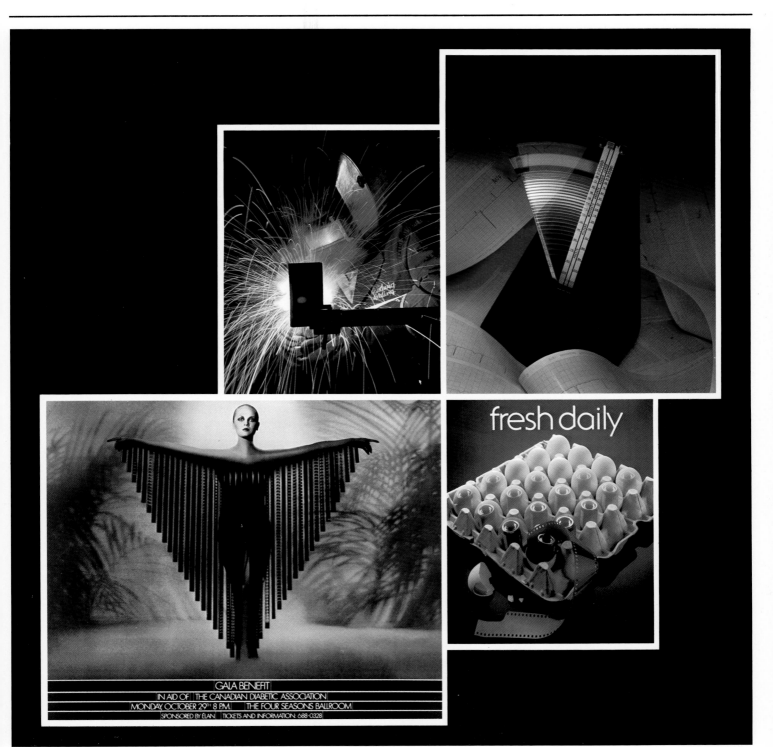

CAPIC
ACPIP

**The Canadian
Association of
Photographers and
Illustrators in
Communications**

**L'Association Canadienne
de Photographes
et Illustrateurs
de Publicité**
15 Toronto Street
Suite 702, Toronto. Ont.
M5C 2E3
(416) 364-1223

PHOTOGRAPHERS AND ILLUSTRATORS. ISN'T IT TIME YOU JOINED C.A.P.I.C.?

C.A.P.I.C. is Canada's only association for professional
photographers and illustrators. It is dedicated to promoting
good ethics and professionalism in the communications
business, and safeguarding the interests of its members.
In addition, C.A.P.I.C. is working on behalf of all
photographers and illustrators to get Canada's antiquated
copyright laws revised.
C.A.P.I.C. has newsletters, meetings, speakers and an annual
show of members' work plus group health, dental, disability
and equipment insurance programs that will save you more
than twice your membership fee alone.
Can you afford not to be a member of C.A.P.I.C.?

PHOTOGRAPHES ET ILLUSTRATEURS IL EST TEMPS DE VOUS JOINDRE À l'A.C.P.I.P.

L'A.C.P.I.P. est la seule association, au Canada, pour
photographes et illustrateurs de publicité; elle vise à
promouvoir l'éthique et le professionnalisme dans le
domaine des communications publicitaires, tout en
sauvegardant les intérêts de ses membres. De plus l'A.C.P.I.P.
fait des démarches, au nom de tous les photographes et
illustrateurs, afin que soient révisées les lois canadiennes
sur le droit d'auteur, lois aujourd'hui désuètes.
L'A.C.P.I.P. vous offre bulletins d'actualités, réunions,
conférences; elle organise une exposition annuelle des
oeuvres de ses membres; elle vous offre également des
programmes collectifs d'assurance-maladie, dentaire,
d'invalidité et d'équipement qui, à eux seuls, vous
permettront de réaliser des économies équivalant à plus
du double de votre cotisation.
Pourquoi attendre encore…devenez dès aujourd'hui
membre de l'A.C.P.I.P.!

2

Art & Design Sudios Ltd.
68 Merton St.
Toronto, Ontario
Canada
M4S 1A1

(416) 481-6461

The services of Art & Design Studios Limited include design and production of literature, catalogues, sales promotion material, corporate design programs, national and retail advertising and audio visual presentations. All the facilities of ADS are located in one modern working complex covering 36,000 square feet.

Illustration: Fred Oakley
Design: Don Murray
Contact: Adair D. Gilmour

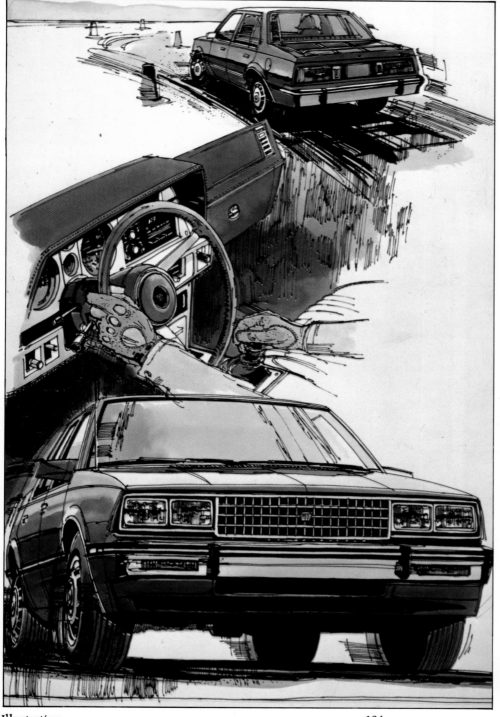

Illustration

104

Ontario

Anodos Studios
c/o Trade Typeseting
30 Duncan St.
Toronto, Ontario
M5V 2C2

(416) 977-4477

Pamela Williams

Illustration: high realism to high fantasy. Airbrush and multi-media or watercolour. Black and white using various pen techniques, and pencil for line or halftone reproduction. Delivered on time.

In addition, Anodos is associated with **The Graphic Network**, which provides complete production and creative services on a cost-efficient freelance basis. The **Network** is a synergistic group of highly-skilled, established professionals committed to maximizing dependable, top quality service to our clients, at realistic prices.

Whatever your graphic needs, the **Network** has the answer. Overnight service for rush jobs is a specialty – billed at regular rates. Also check us for book production and editorial, copy writing, marketing, advertising planning and media. Before you say it can't be done, call 977-4477 for **The Graphic Network**.

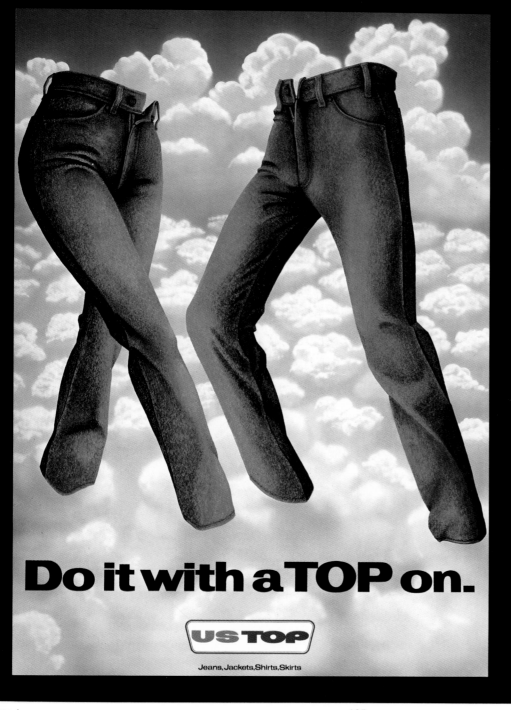

Do it with a TOP on.

US TOP

Jeans, Jackets, Shirts, Skirts

Don Anderson
65 Forest Manor Rd.
Apt. 1811
Willowdale, North York
Ontario
M2J 1M5

(416) 496-1467

- Canadian International Air Show
- Air Forces Reunion, commemorating
 40th anniversary, Battle of Britain

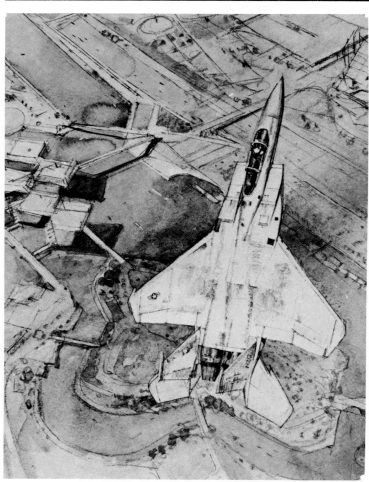

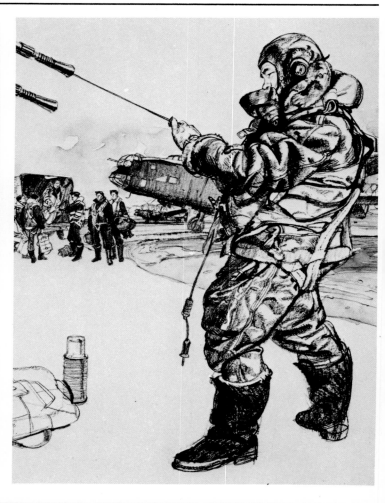

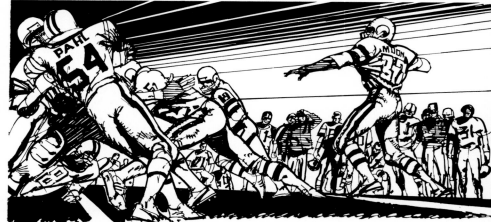

Illustration

Ontario

107

R. Baviera
P. Morin
Illustration & Design
3098 Keynes Cres.
Miss., Ontario
L5N 3A1

Rocco Baviera
(416) 1-522-1684

Paul Morin
(416) 824-1291

Two illustrators working individually towards the same goal. Advertising, corporate, promotional & editorial illustration and design from concept to finished art.

M. Schymkiw

1

2

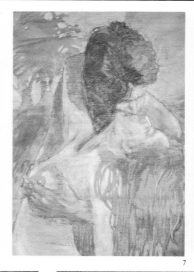
7

8

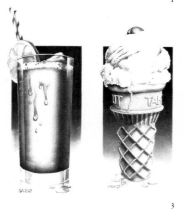
3

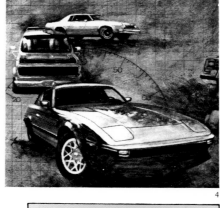
4

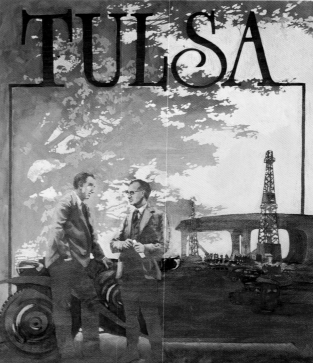
9

5

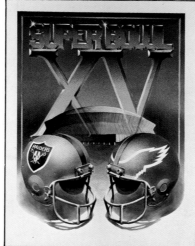
6

Baviera – 1–6
Morin – 7–9

Illustration

108

Ontario

blackshaw & associates limited

Blackshaw & Associates Limited
52 Hayden Street
Toronto, Ontario
M4Y 1V8
(416) 922-8182

A technical art service, presenting a complete range of publication services for industrial communications.

Exploded, cutaway, schematic and pictorial illustration for operator and parts manuals, airbrush rendering for promotional literature and industrial trade magazine advertising.

Blackshaw proudly offers cost-effective, precise, quality artwork with service.

Call or write for brochure.

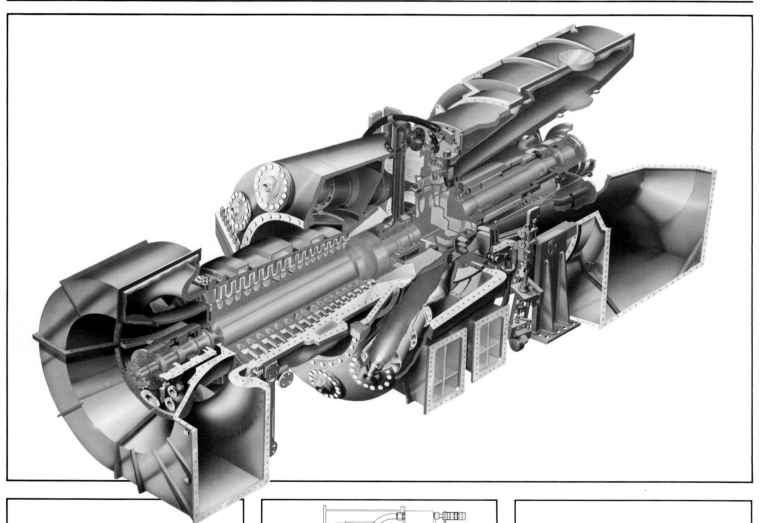

Tom Bjarnason Inc.
63 Yorkville Ave.
Toronto, Ontario, Canada
M5R 1B7
(416) 960-0834

Tom Bjarnason

Grestock & Marsh Ltd.
15 Heddon Street
London, England
W1R 7LF
01-437-5788/9

CAPIC

Readers Digest

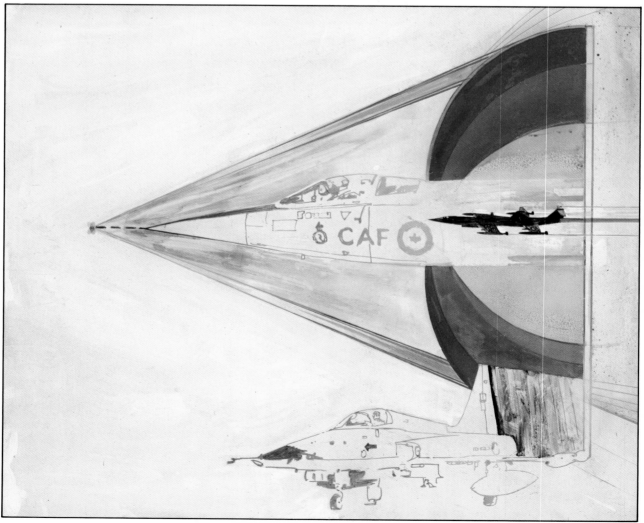

Illustration 110 Ontario

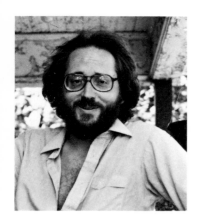

Julius Ciss Illustration Inc.
73 Pauline Avenue
Toronto, Ontario
M6H 3M7

(416) 534-5268

Julius Ciss
Illustrator

CAPIC

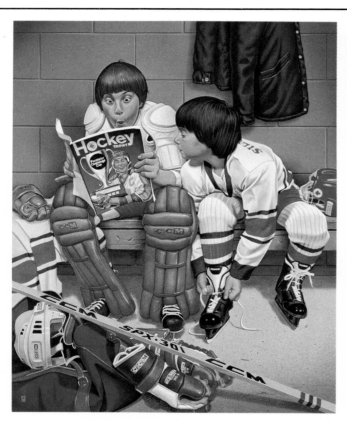

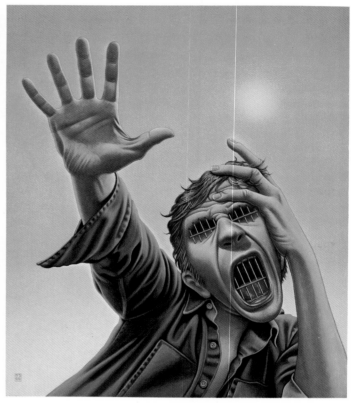

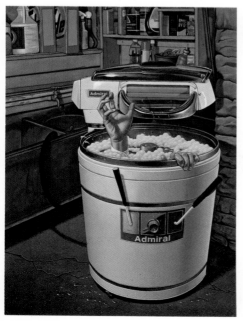

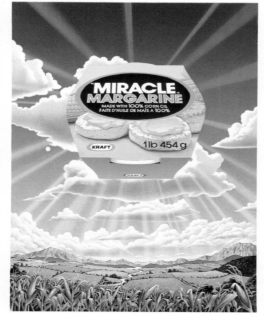

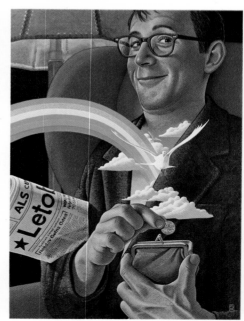

Illustration

Ontario

Julius Ciss Illustration Inc.
73 Pauline Avenue
Toronto, Ontario
M6H 3M7

(416) 534-5268

Julius Ciss
Illustrator

CAPIC

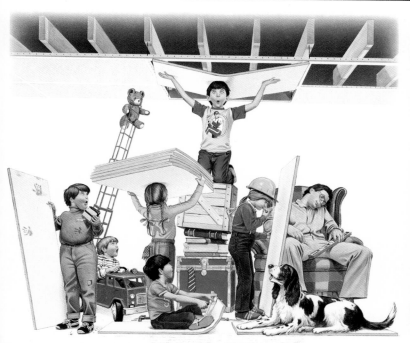

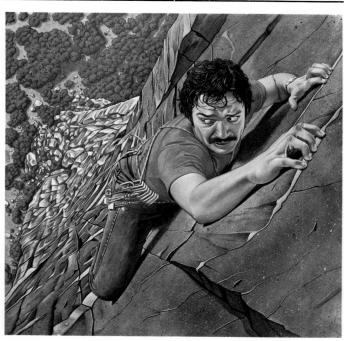

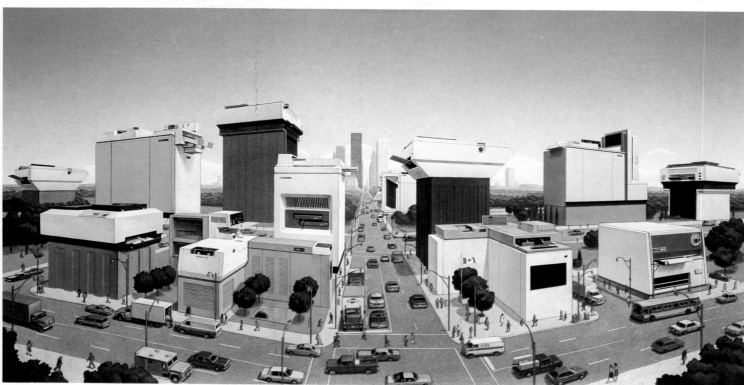

Bill Chapman

Represented by:
Fleming & Associates

(416) 276-9373

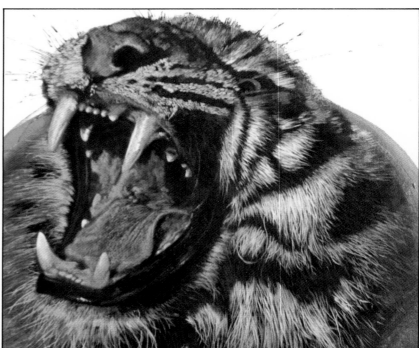

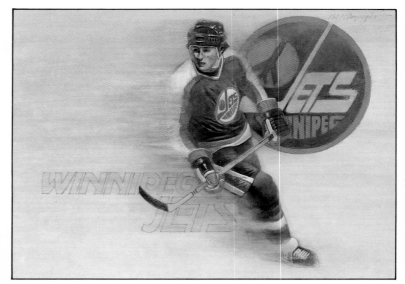

Illustration 114 Ontario

Commins Associates
Technical Illustrators

Suite 206
31 Brock Avenue
Toronto, Ontario
M6K 2L1

(416) 535-8145

Challenge us with complicated ideas;
we'll illustrate them, illuminate them,
simplify them for your Visual Presentation.

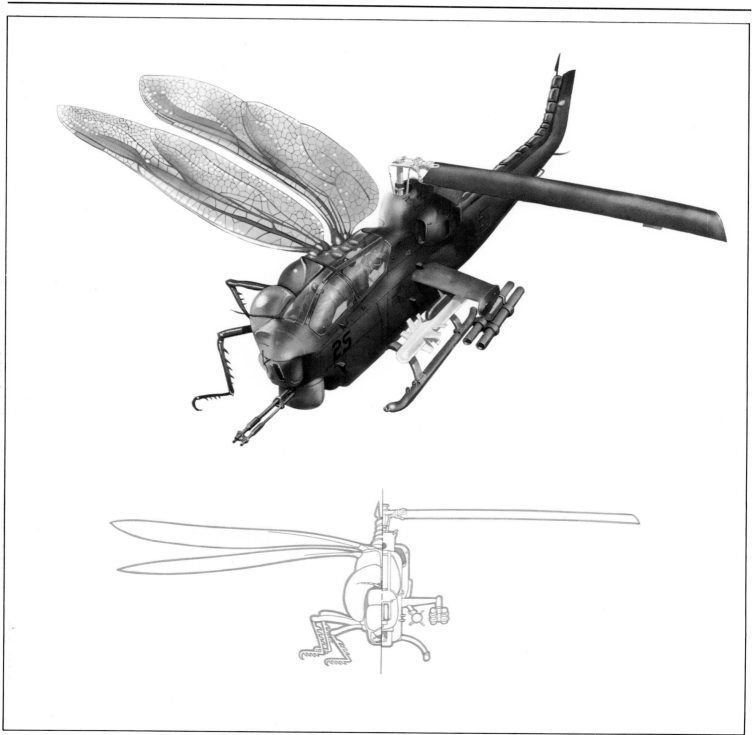

David Craig
267 Wellington St. W.
Toronto, Ontario
M5V 1E1

(416) 277-3908
(416) 275-6693

David Craig
267 Wellington St. W.
Toronto, Ontario
M5V 1E1

(416) 277-3908
(416) 275-6693

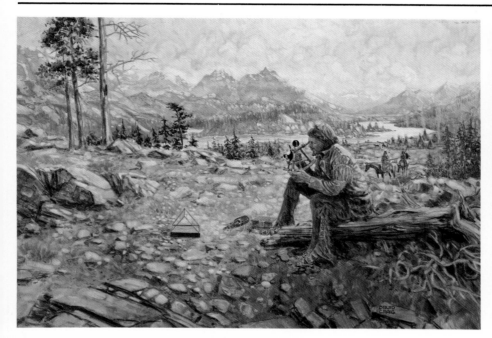

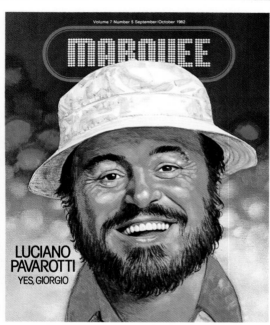

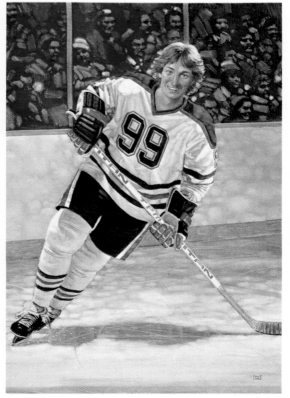

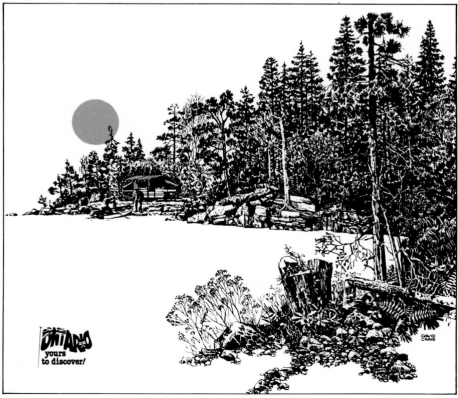

Gabriel Csakany

Represented by:
Fleming & Associates

(416) 276-9373

Born in Budapest, studied painting in Europe and North America. Since 1960, a professional illustrator living in Toronto. Worked for all major advertising agencies in Toronto.
My work is also known in Europe and the U.S.A.

Exhibited with the Society of Illustrators in New York and was selected to show in 200 Years of American Illustration. Won numerous awards both here and Europe.

Clients include: Time (cover), Look, The Beach Boys, Twen, General Motors, Eatons, Simon & Shuster, Kimberly Clark, Stern, Film Plan International ("Scanners"), Honda, Ministry of Tourism, Levi's, American Motors, Chatelaine, Proctor & Gamble, Royal Trust, etc.

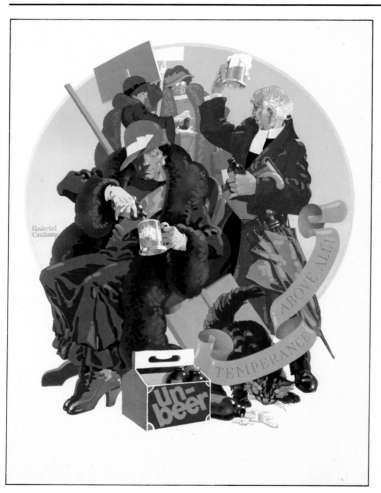

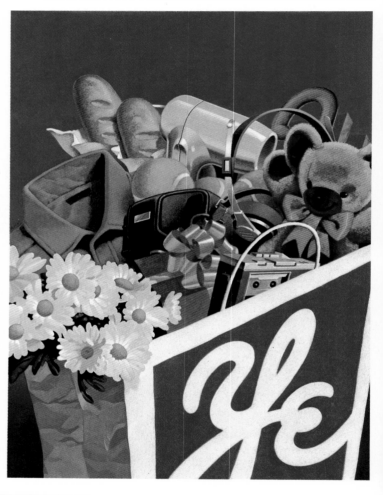

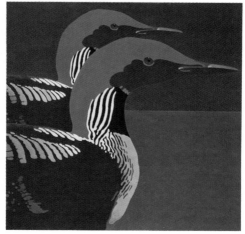

Sylvie Daigneault
350 Walmer Road
Toronto, Ontario
M5R-2Y4

(416) 961-0681

Pronounced : Day-knee-oh!

Translates : A good sort with talent for detailed conceptual illustration

Showcase : Chatelaine, Homemakers, Leisure Ways
Children's illustration: Gage Publishing, TVOntario.

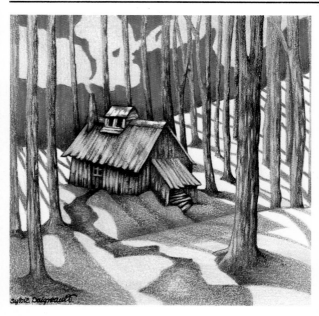

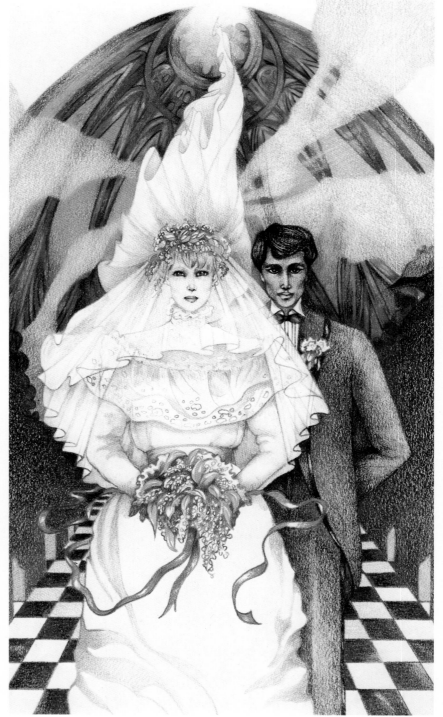

Will Davies
63 Yorkville Ave.
Toronto, Ontario, Canada
M5R 1B7

(416) 925-8191

CAPIC

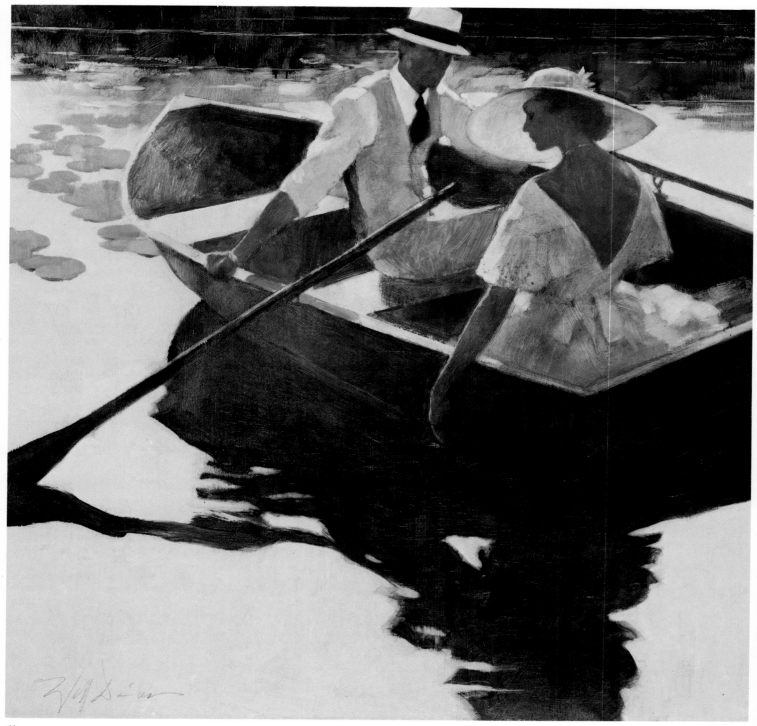

Illustration

Ontario

Rick Fischer
369 Queen St. W., 3rd floor
Toronto, Ontario
M5V 2A4

(416) 593-0419
 593-0920

Art Director: Dave Kelso

Illustration 122 Ontario

Rick Fischer is
Represented by:
Cheryl Thrasher
(416) 593-0419
694-1237

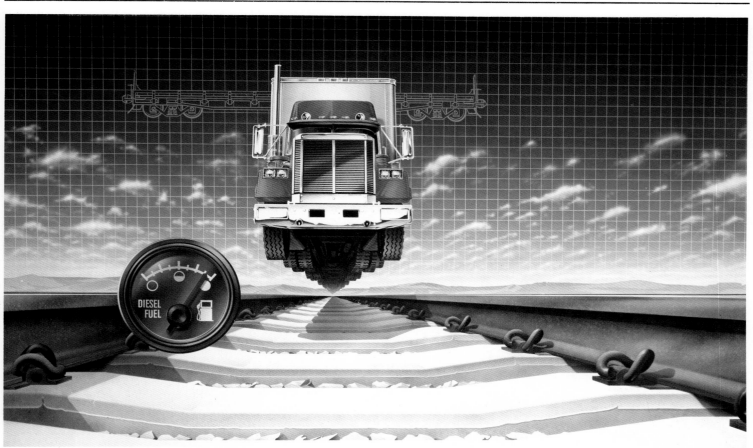

Art Director: Eric Bell

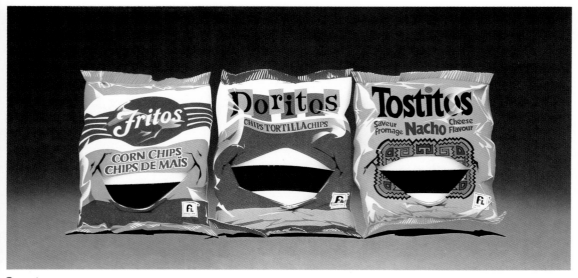

Art Director: Derek Chapman

Gale Flemington

Mailing address:
RR #6
Brantford, Ontario
N3T 5L8

Toronto Studio
(416) 977-0776
or
(416) 967-9195

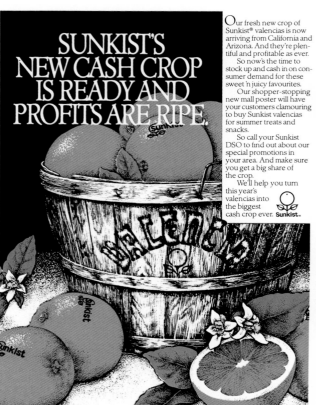

SUNKIST'S
NEW CASH CROP
IS READY AND
PROFITS ARE RIPE.

Our fresh new crop of Sunkist® valencias is now arriving from California and Arizona. And they're plentiful and profitable as ever.

So now's the time to stock up and cash in on consumer demand for these sweet 'n juicy favourites.

Our shopper-stopping new mall poster will have your customers clamouring to buy Sunkist valencias for summer treats and snacks.

So call your Sunkist DSO to find out about our special promotions in your area. And make sure you get a big share of the crop.

We'll help you turn this year's valencias into the biggest cash crop ever. **Sunkist.**

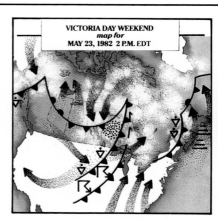

VICTORIA DAY WEEKEND
map for
MAY 23, 1982 2 P.M. EDT

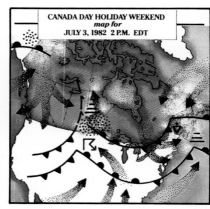

CANADA DAY HOLIDAY WEEKEND
map for
JULY 3, 1982 2 P.M. EDT

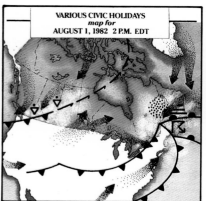

VARIOUS CIVIC HOLIDAYS
map for
AUGUST 1, 1982 2 P.M. EDT

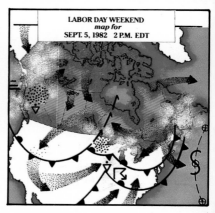

LABOR DAY WEEKEND
map for
SEPT. 5, 1982 2 P.M. EDT

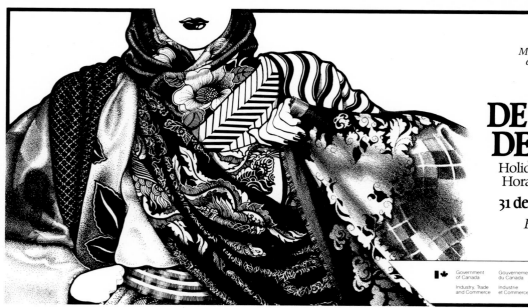

*Miren el color y comprueben
el tejido de Canada en la*

FERIA
DE TEXTILES
DE CANADA

Holiday Inn, Santiago, Chile
Horario: 15,00–21,00 horas

31 de MARZO-2 de ABRIL

*El mejor de Canada
para ustedes.*

AMG 81-135

Government of Canada Gouvernement du Canada

Industry, Trade and Commerce Industrie et Commerce

Canadä

Illustration 124 Ontario

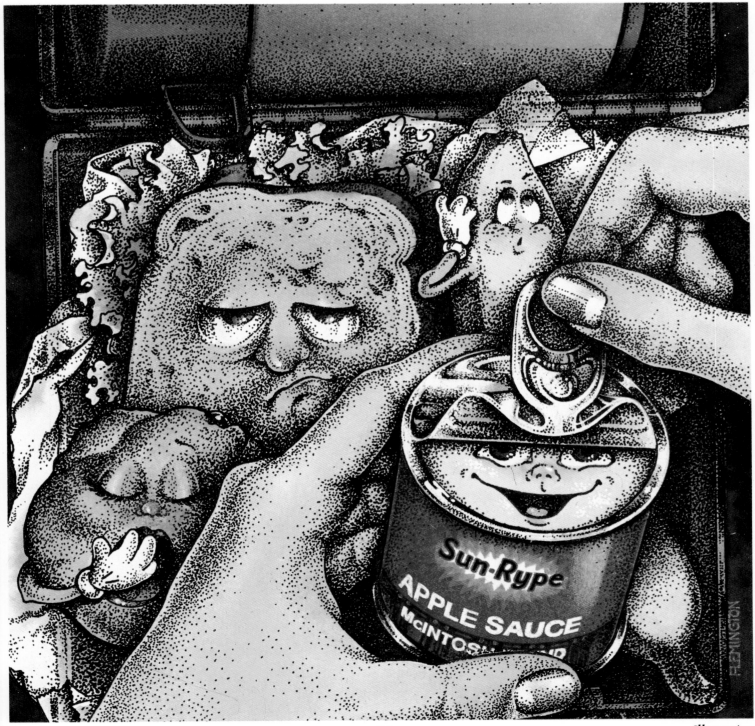

Audra Geras
Illustration and Design
44 Charles St. W.
Suite 4505
Toronto, Ontario
M4Y 1R8

(416) 928-2965

Pharmaceutical, consumer, and editorial illustration.

Elected member of the international Association of Medical Illustrators.

Exclusive illustrator and creative director:
Illustrated Medicine magazine • New York

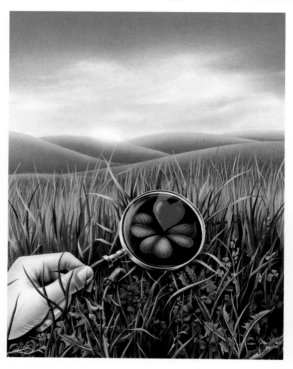

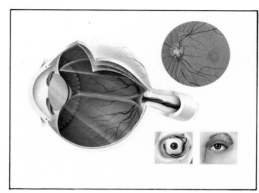

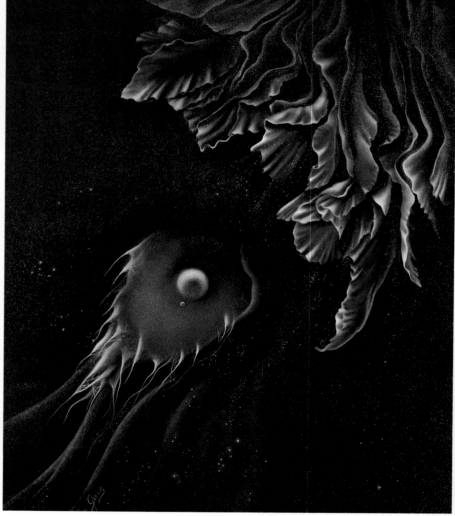

Illustration

Ontario

James Hill

Represented by:
Fleming & Associates

(416) 276-9373

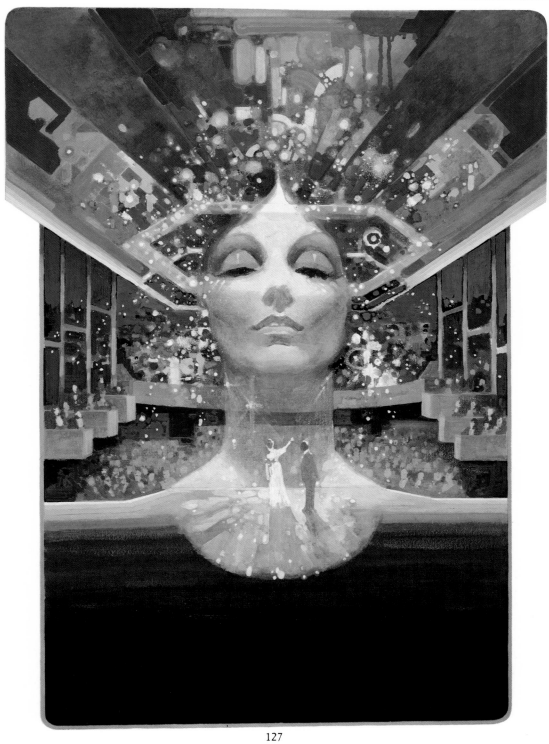

Tina Holdcroft
100 Spadina Road
Suite 803
Toronto, Ontario
M5R 2T7

(416) 968-3697

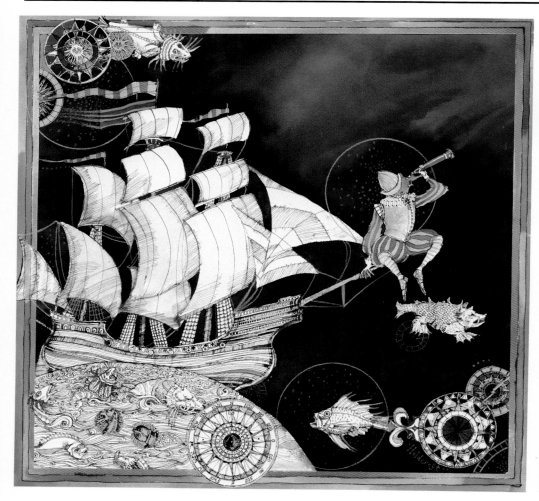

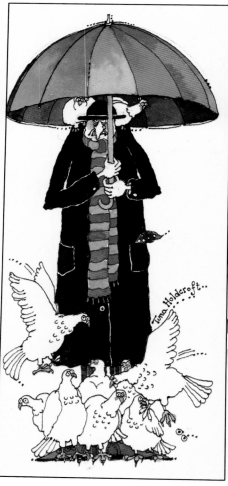

Illustration　　　　　128　　　　　Ontario

James Hill

Represented by:
Fleming & Associates

(416) 276-9373

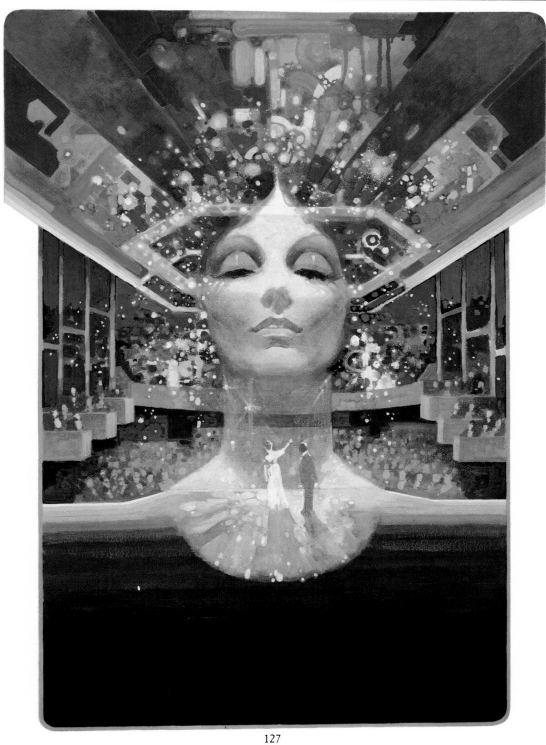

Tina Holdcroft
100 Spadina Road
Suite 803
Toronto, Ontario
M5R 2T7

(416) 968-3697

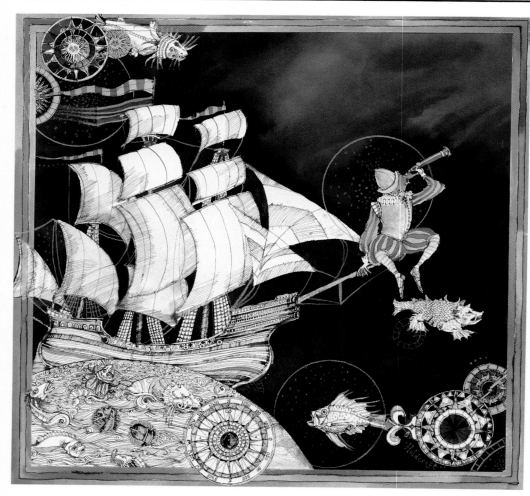

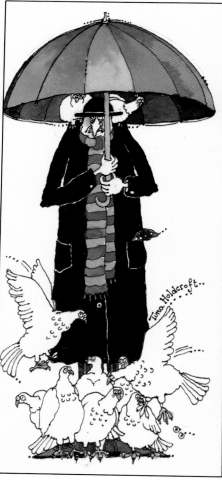

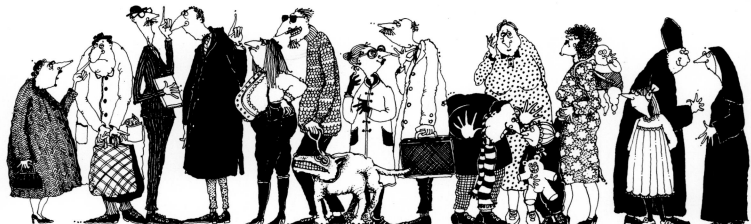

Tina Holdcroft
100 Spadina Road
Suite 803
Toronto, Ontario
M5R 2T7

(416) 968-3697

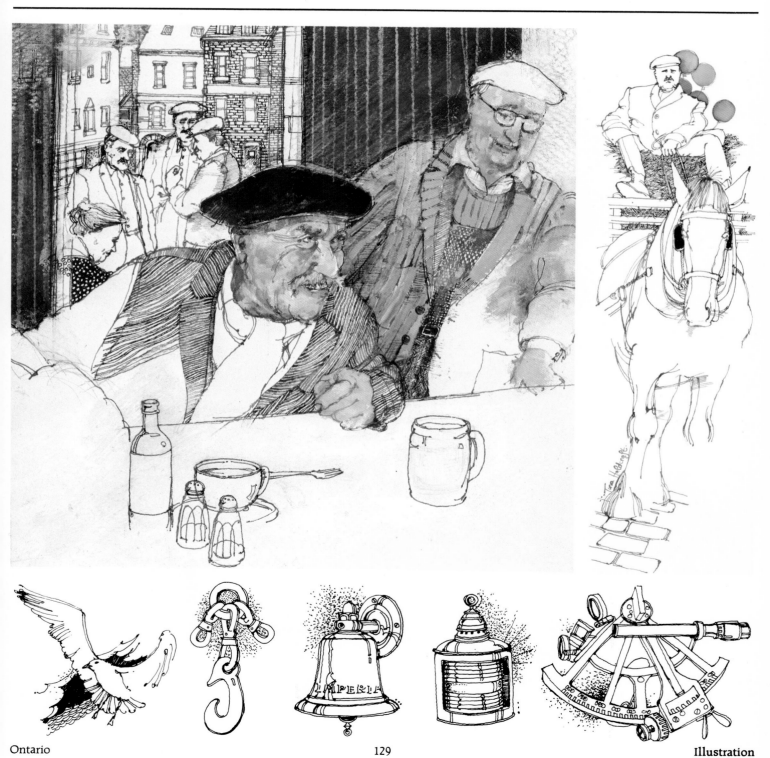

Ontario

Illustration

High Noon Studios
1957 Queen St. E.
Suite 4
Toronto, Ontario
M4L 1H7

(416) 699-2210

Gary Cooper
Airbrush Illustration

Two years old and growing.

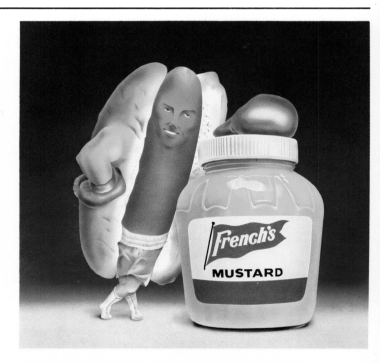

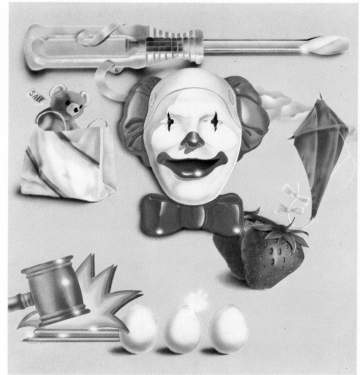

Illustration 130 Ontario

Sarie Jenkins
325 Clinton St.
Toronto, Ontario, Canada
M6G 2Y7

(416) 535-6911

CAPIC

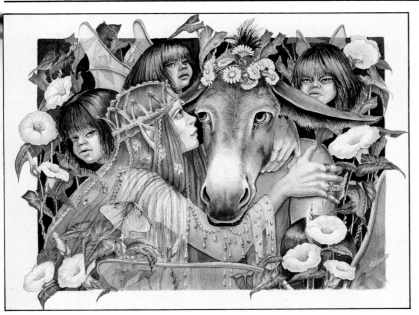

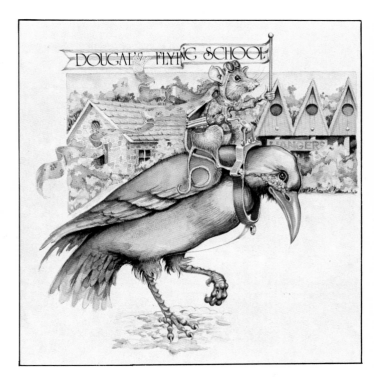

Danielle Jones
20 St. Patrick Street
Toronto, Ontario
M5T 2Y4

(416) 977-7357

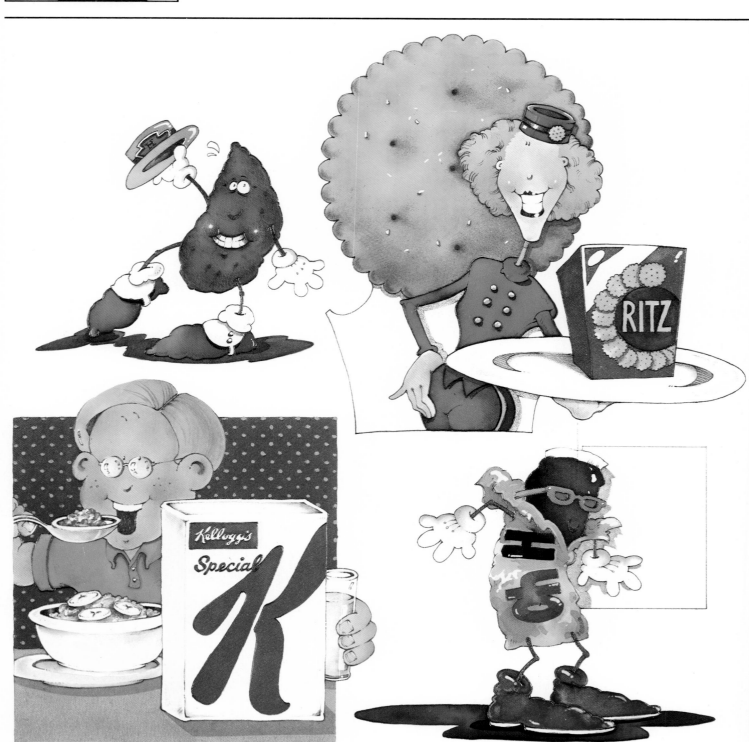

Barbara Klunder
14 Fernbank Ave.
Toronto, Ontario
M6H 1W1

Represented by
Stan Olthuis
Sharpshooter Studios
(416) 534-1115

I have been illustrating for kids books, record jackets, magazines, advertisements, posters and newspapers in a variety of styles over the years.

My hand-knit fantasy sweaters have been shown at Ontario Craft Council Gallery and Textile Museum and sell in New York, Toronto, Montreal.

Now also designing stationery, posters, toys, products and clothes that are kid-related, for brand-name clients as well as under my own label.

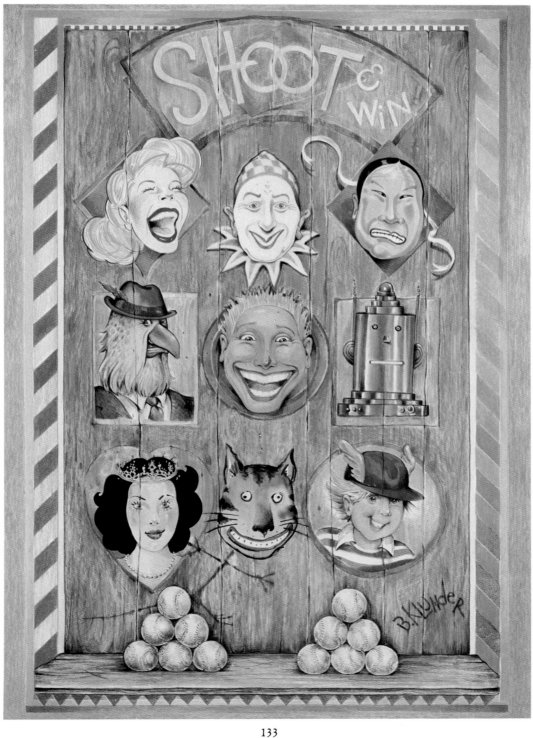

June Lawrason
69 Berkeley St.
Toronto, Ontario
M5A 2W5

(416) 368-4134

CAPIC Travel montage of Germany

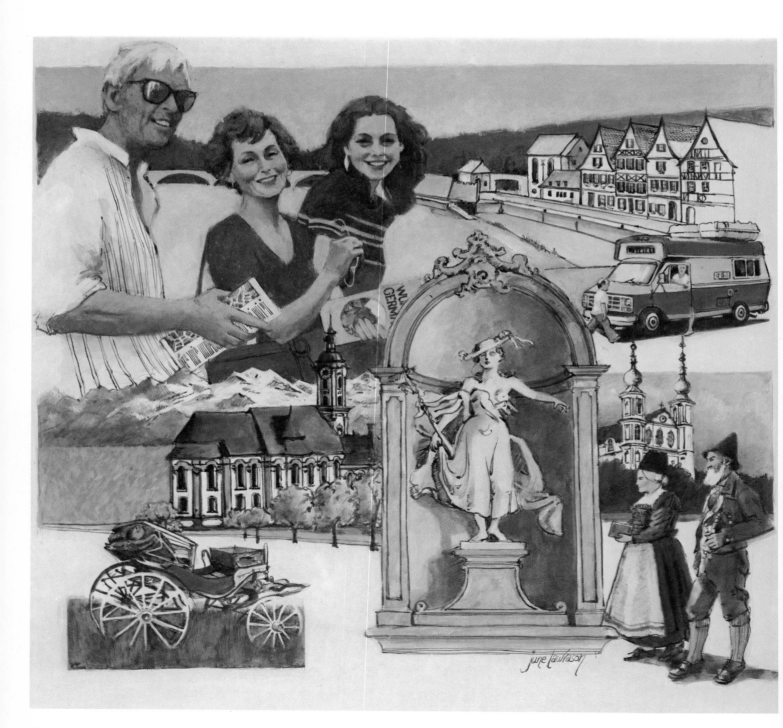

Illustration 134 Ontario

June Lawrason
69 Berkeley St.
Toronto, Ontario
M5A 2W5

(416) 368-4134

CAPIC

TOP
Star Week: Eleanor Roosevelt, Golda Meir and Jackie Kennedy
CAPIC Show 1981: "Le Pain et le Vin"

BOTTOM
The Bay: Toronto Life
The Bay: Globe and Mail
Unpublished

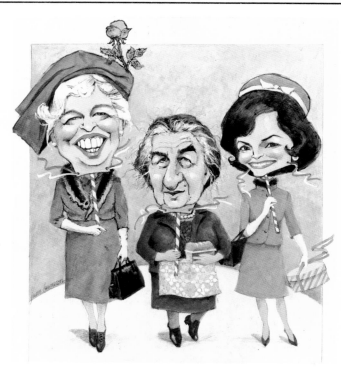

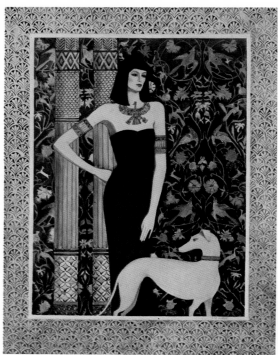

Anita Kunz
135 Winchester St.
Toronto, Canada
M4X 1B3

(416) 925-6816

Represented by **Stan Olthuis
Sharpshooter Studios**

(416) 534-1115

CAPIC

Top left: **Conversion of the Jews**, Saturday Night Magazine. A.D.; Derek Ungless
Top right: **An Actor in the White House**, Penthouse Magazine, New York. A.D.; Julio Vega
Bottom left: **The Science of Miracles**, Newscientist Magazine cover, London, England. A.D.; Chris Jones
Bottom right: **Thoroughly Modern Orphans**, City Woman magazine, A.D.; Louis Fishauf
Portrait: Brian Smale

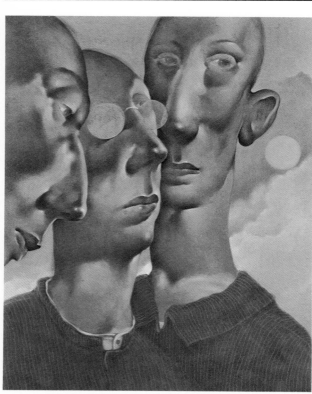

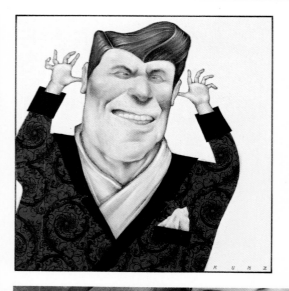

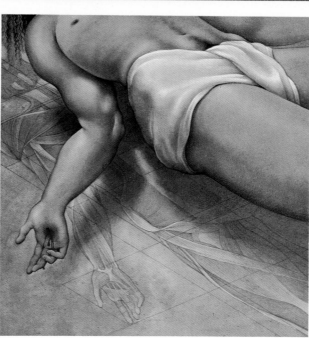

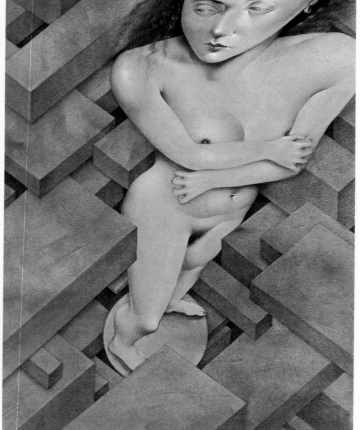

Illustration 136 Ontario

Wes Lowe
46 Murison Blvd.
Scarborough, Ontario
M1B 2B2

(416) 284-2522

CAPIC

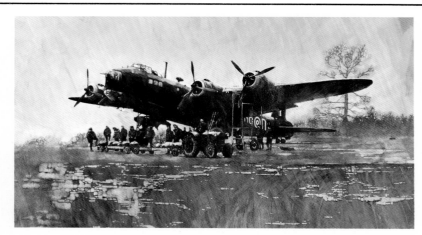

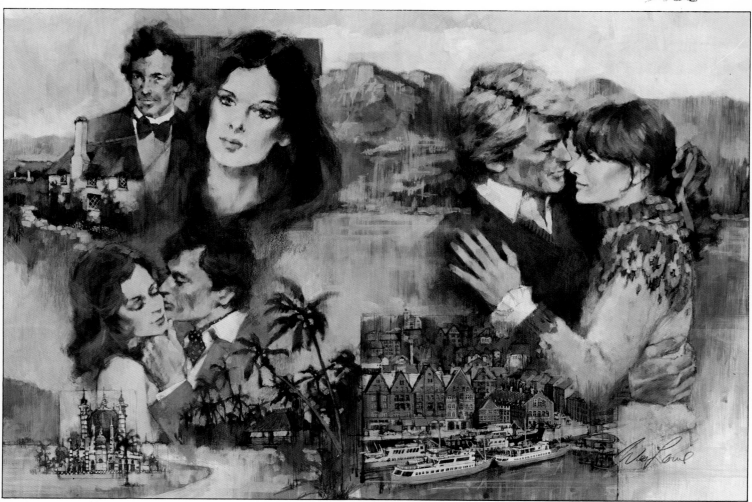

John Mardon
27 Colonsay Road
Thornhill, Ontario
L3T 3E9

(416) 881-5854

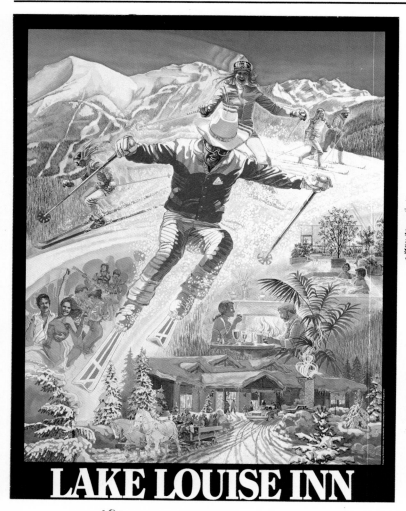

LAKE LOUISE INN

Illustration 138 Ontario

Susan Mark
Design & Illustration
2001 Bloor St. W.
Suite 203
Toronto, Ontario
M6S 1M6

(416) 767-6484

All through highschool I was hell bent and determined to be a nurse. Mom said "Sue, you throw up too easily and you can't wear platform shoes around a hospital." (I am rather short) "Go to Art College" she exclaimed "and get all your paints, brushes and messy stuff out of here!" So off I went and here I am.

I love to illustrate in detail and with a sense of humour. A great deal of my work revolves around food, children's illustrations, anything organic and of course animals, birds and insects. I try to combine sensitivity with a slightly graphic aspect to portray realism or sometimes surrealism.

Thanks Mom!

Dick Marvin
Illustrator Incorporated
63 Yorkville Avenue
Toronto, Ontario
M5R 1B8

(416) 961-5831

R.R. #1
Moffat, Ontario
L0P 1J0

(519) 822-9378

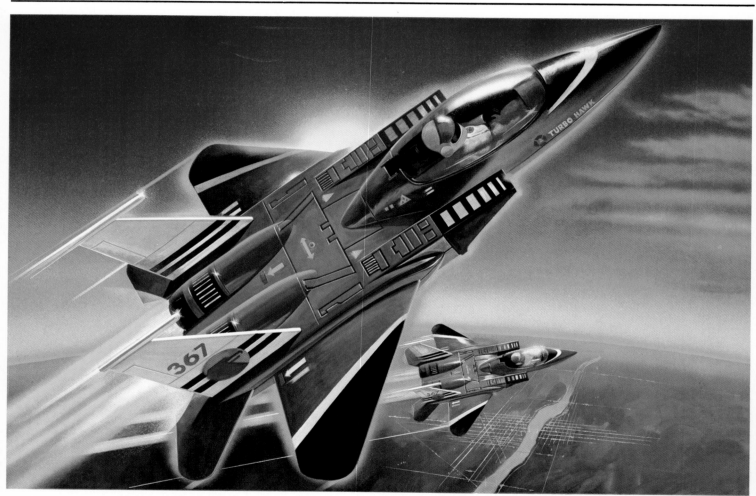

Illustration

Ontario

Tim Mason – Illustration
1034 St. Clair Ave. West
Toronto, Ontario
M6E 1A4

(416) 651-0676

Tim Mason
Illustrator

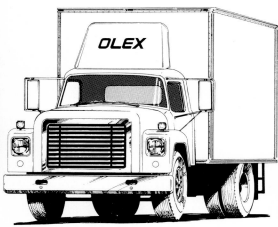

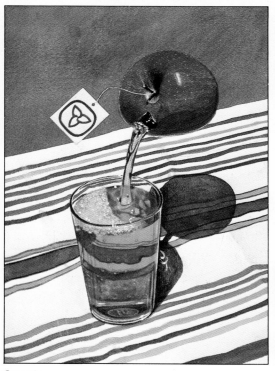

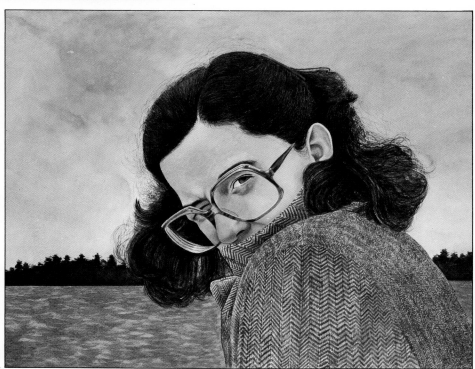

Paul M^cCusker
48 Grenoble Dr.
Suite 906
Don Mills, Ontario
M3C 1C9

(416) 421-9847

Paul M^cCusker

Photography – Peter M^cCusker

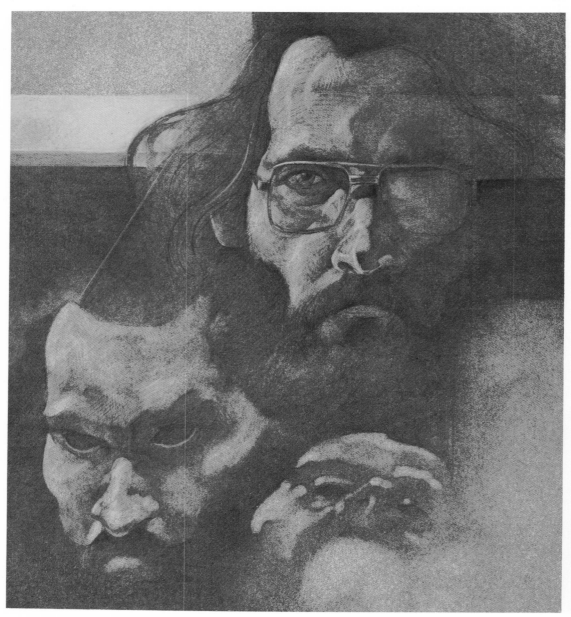

Illustration 142 Ontario

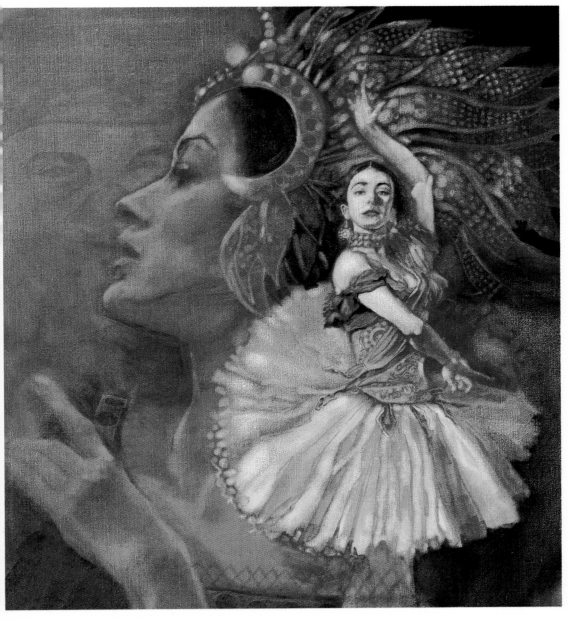

Laurie McGaw
69 Berkeley St.,
Toronto, Ontario
M5A 2W5

(416) 363-0767

CAPIC

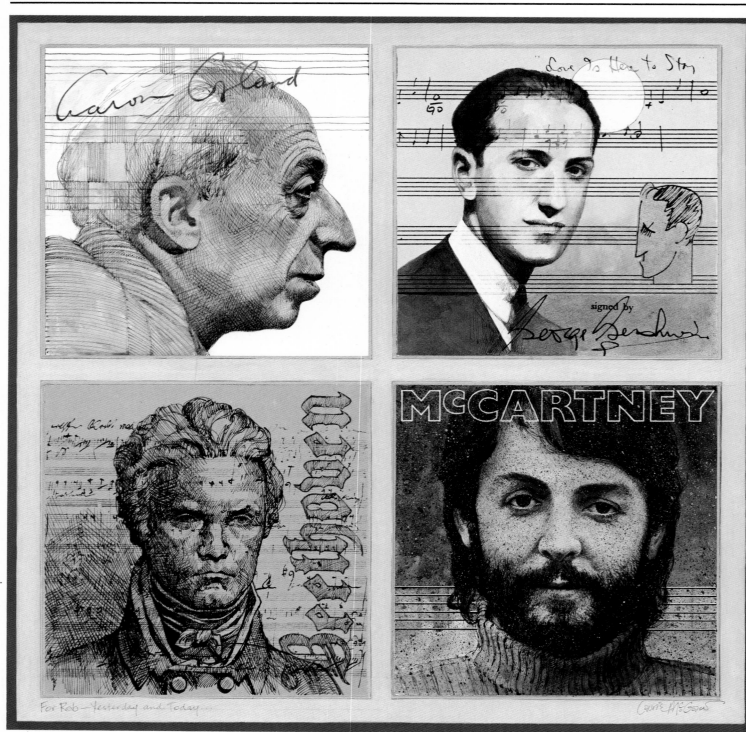

Illustration 144 **Ontario**

Sheila McGraw
509 Broadview Ave.
Toronto, Canada
M4K 2N5

(416) 465-8274

I work in editorial and advertising fashion, jewelry, and accessories illustration, in black and white or colour. I fully understand garment design, the retail market and the properties of fashion advertising. A full studio service can be provided. Some clients…Creeds, Ira-Berg, Celine, La Belle Boutique, Chez Catherine, Ada MacKenzie, John Alexander, Pennington's, Liz Porter, Alan Goouch, Brick Shirt House, Sinardi…

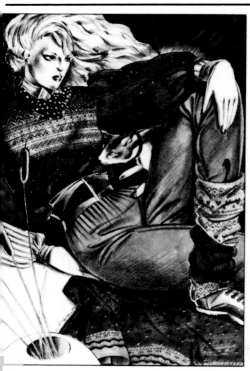

Mike McKeever
137 Broadview Ave.
Toronto, Ontario
M4M 2E9

(416) 465-4013

Represented by
SCF Ltd.
169 Carlton St.
Toronto, Ontario
M5A 2K3

(416) 924-8183

Doug Hall

Illustration 146 Ontario

Doug Hall

Mike McKeever
137 Broadview Ave.
Toronto, Ontario
M4M 2E9

(416) 465-4013

Represented by
SCF Ltd.
169 Carlton St.
Toronto, Ontario
M5A 2K3

(416) 924-8183

Illustrations:
 Top row: **Glenway Builders** and **Firestone**.
 Bottom row: **Glenway Builders** and **Manufacturers Life Insurance**.

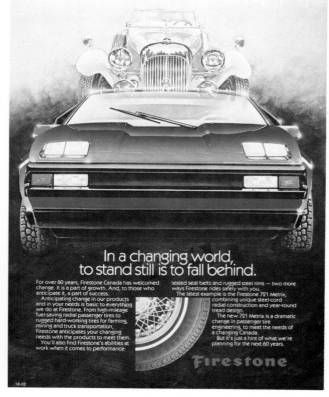

Gary McLaughlin
Illustration
541 Blackthorn Ave.
Suite 910
Toronto, Ontario
M6M 5A6

(416) 651-7228
Represented by:
SCF LTD
169 Carlton St.
Toronto, Ontario M5A 2K3

(416) 924-8183
CAPIC

Photo: Peter Coons

Clients include: Imperial Oil, Manulife Insurance, De Beers Diamonds, Maclean-Hunter, Canadian Motorsport, Chimo Magazine, Harlequin Publishing.

Top left : Baker, Lovick Advertising: A.D. Colin Priestley
Bottom left : Maclaren Advertising, A.D. Paul Hains
Right : Unpublished

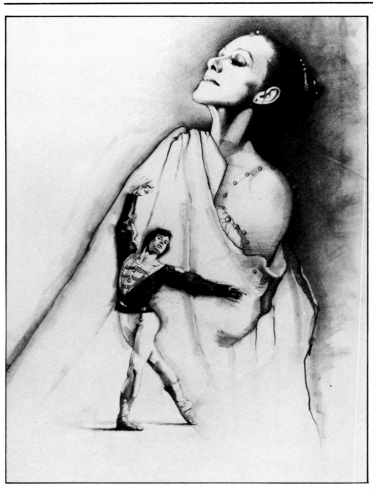

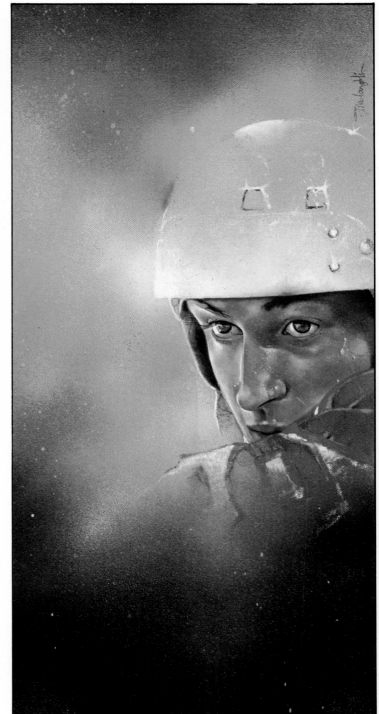

Illustration 148 Ontario

Tom M^cNeely
Illustration Inc.
63 Yorkville Avenue
Toronto, Ontario
M5R 1B7

(416) 925-1929

Tom M^cNeely
Illustrator

CAPIC

Left: 1982 Calendar celebrating **The Salvation Army's 100th Anniversary.** Twelve collage illustrations featuring the historical, religious and social programs of the Army across Canada during the past 100 years.

Right: **TransCanada PipeLines** corporate book. Six illustrations showing the diversified operations of TransCanada in North America.

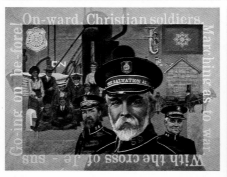

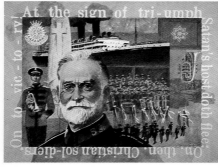

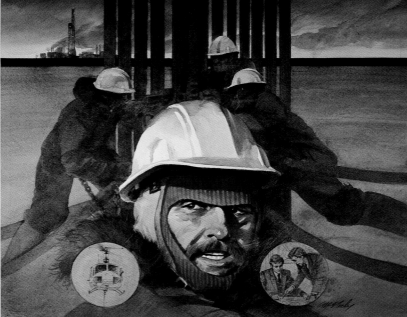

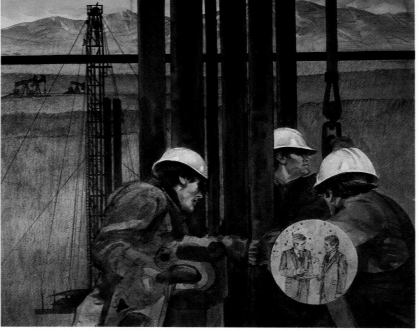

Ted Michener Limited
12 Sullivan St.
Toronto, Ontario
M5T 1B9

(416) 596-8420

Ted Michener
New York Representative
Joe Mendola
Mendola Ltd.
(212) 986-5680

Ted and Pat Michener have been a creative team for fifteen years. During this span they have covered a multitude of graphic areas – everything from caricatures, advertising, to editorial art.
Award of Excellence, New York Society of Illustrators
Andy Award of Distinction, Advertising Club of New York
Awards of Merit, Silver Medal, Art Director's Club of Toronto
Hostex Menu Award
Certificate for Merit – Society of Illustrators

MR. HINE

DARE TO BE DIFFERENT? THAT'S US.

In Bramalea malls, we don't just do things differently for the sake of being different. We do them deliberately to maximize traffic, sales and shopper appeal ...to reduce operating costs and tenant recharges. But mainly we do them to make more money for ourselves and our merchants. This may not be different, but it sure is a reality. Ask any merchant in any of our 42 shopping centers in the United States and Canada.

If you dare to be different too, give us a call. We'd like to show you the different Bramalea ways to a better bottom line for you and for us.

Bramalea Limited

Illustration 150 Ontario

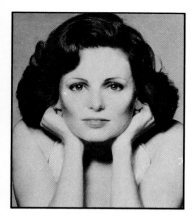

Jean Miller
Medical Illustrator

Richmond Hill,
Ontario, Canada

(416) 883-4114

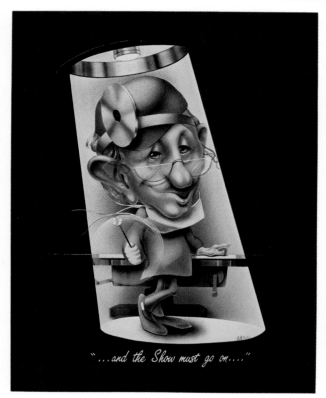

"...and the Show must go on...."

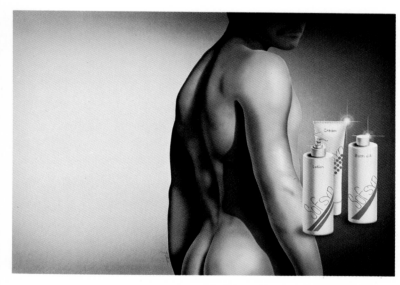

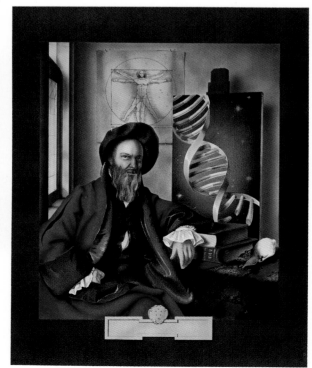

David Milne
79 Orton Park Road
Scarborough, Ontario
M1G 3G7

(416) 431-0254

Illustration 152 Ontario

Mixed Nuts Inc.
320 Queen St. W., 2nd fl.
Toronto, Ontario
M5V 2A2

(416) 593-0845

Bill Boyko

Description of Illustrations below:
1. Toronto Life Magazine
 Article on California Wines
2. Maze Records
 Album Cover. Reference photo Stephen Yates.
3. Sparx running shoes
 1 Transit card in a series of 3. "Be Spotted in Sparx"
4. Starweek Magazine
 "J.R. Beaver" Canadian content in American television

Please note our new phone number. *again!*
Bill Boyko is also represented by Sharpshooter Productions.
Photo by Brian Smale. *Thanks*

1

2

3

4

234 Eglinton Ave. E.
Suite 501
Toronto, Ontario
M4P 1K5

(416) 488-5062/63

Kalman J. Molnar
G.D.C., CAPIC
President

Advertising and Editorial Illustration

Barbara Griffin, Illustrator A.O.C.A., CAPIC
Sharin Barber, Illustrator A.O.C.A., CAPIC

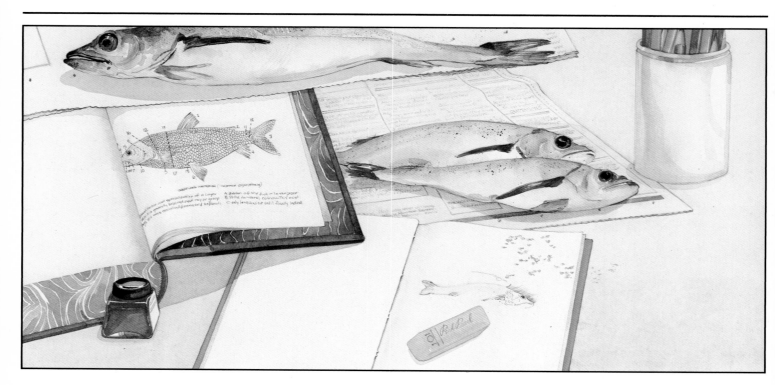

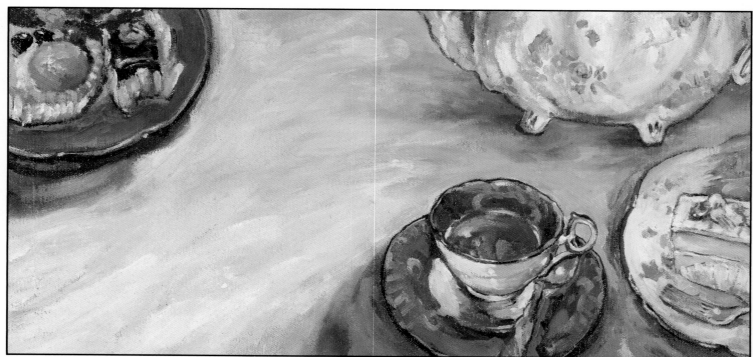

Illustration 154 Ontario

**Okada & Csafordi
Incorporated**
2 Clinton Place
Toronto, Ontario
M6J 1C5

(416) 530-1951

Andrew Csafordi
Illustrator

Okada & Csafordi is a designer/illustrator team specializing in print. Illustration, design, consultation, or full service production of trade and retail ads, promotions, P.O.P., direct mail and corporate design. Stress is on quality product, unique ideas and professional attitude.

Colour separations courtesy of SQS Inc., Toronto, Canada (416) 363-7088

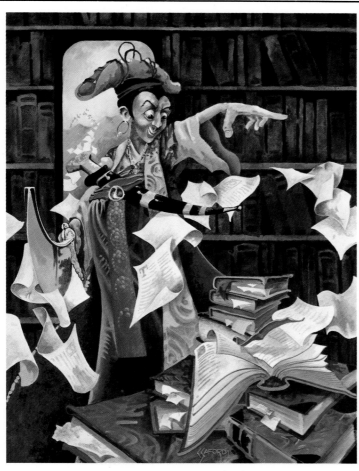

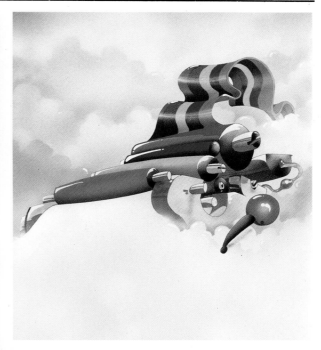

Rick Ormond
Illustrator

68 Merton Street
Toronto, Ontario
M4S 1A1

(416) 484-6645

42 Portland Cres.
Newmarket, Ontario
L3Y 6A5

(416) 895-9238

Posters
Cartoons
Fashion
TV Story Boards
Product
Automotive

Illustration 156 Ontario

Photo: Greg Lawson

Leoung O'Young
272 Berkeley St.
Toronto, Ontario
M5A 2X3

(416) 967-4660

Canadian Business Magazine
Fanfare, The Globe and Mail
Unpublished
Shell Jackrabbits Poster

Doug Panton Inc.
341 Wellesley St. East
Toronto, Ontario
M4X 1H2

(416) 920-5612

panton

Illustration 158 Ontario

Stephen Quinlan Illustration Ltd.
1665 Bathurst St.
Toronto, Ontario
M5P 3J8

(416) 593-1375
(416) 481-5494

CAPIC

Stephen Quinlan. Commercial and editorial illustrator. Graduate of both Sheridan and the Ontario College of Art. Art Studio and international agency experience.

Stephen's clients include: 1. Ogilvy & Mather (Canada) Ltd., 2. Ontario Egg Marketing Board, 3. Seagrams, 4. Vickers & Benson Ltd., 5. Cockfield Brown Inc. as well as other major international advertising agencies, Canadian corporations, magazines and art studios.

1

4

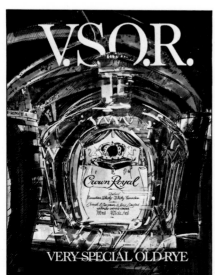

2

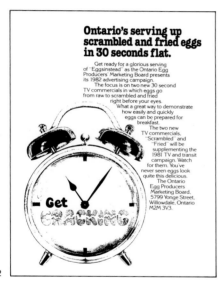

3

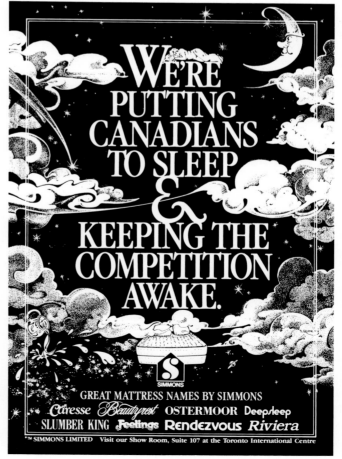

5

Paper Works Productions
2069 Salvator Blvd.
Oakville, Ontario
L6L 1M9

(416) 947-0956
(416) 827-2297

David Chang
Mark Craig

A delicate balance: the result of giving equal weight to concept and image. Paper Works specialize in bas-relief and three dimensional paper illustrations. Though, in whatever way we can, we'll make paper work for you.

Photography by Michael Kohn/Oyster Studio

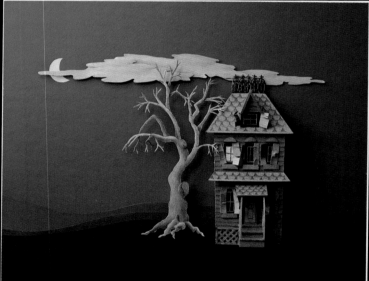

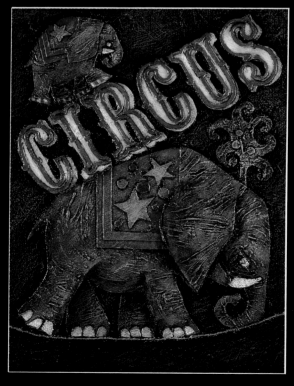

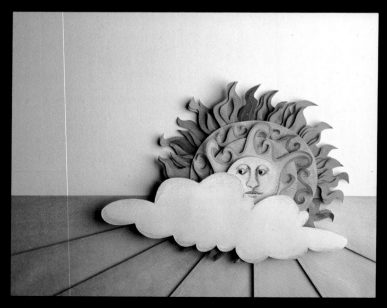

Illustration 160 Ontario

Medical Illustration
Rasa Skudra
David MacLeod

represented by
Bruce Billinghurst
RPB Associates
627A Bay Street
Toronto, Ontario
M5G 1M7

(416) 595-1880

Rasa Skudra *(Upper right, Lower left)*, one of Canada's leading Medical Artists, has been a recipient of both the Maria T. Wishart Award forExcellence in Medical Illustration and an Award of Merit. Rasa's illustrations have appeared in Today and City Woman magazines, and in pharmaceutical advertising for Smith Kline and French, Geigy and Lederle Pharmaceuticals.

David MacLeod *(Upper left, Lower right)* winner of a Maria T. Wishart Award of Merit, has recently returned to Medical Art after a short hiatus to put together a one-man show of his unique paintings. David's fresh illustrative style has been utilized in pharmaceutical advertising aids for Smith Kline and French, Ortho and Lederle Pharmaceuticals.

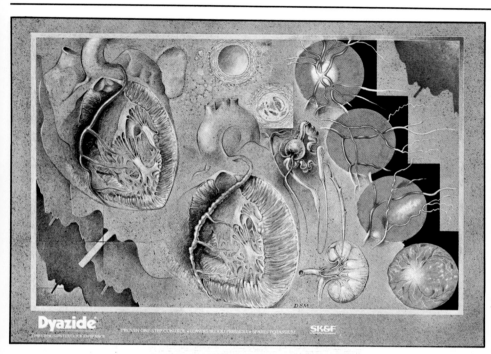

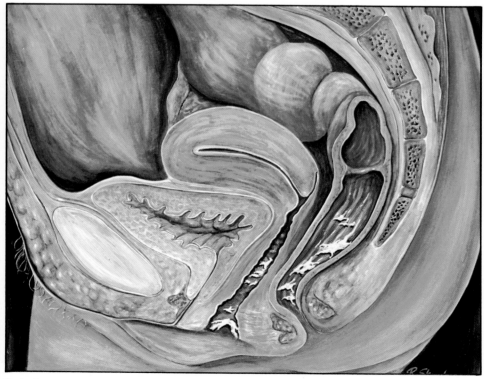

Reactor Art & Design Limited
51 Camden Street
Toronto, Ontario
M5V 1V2
(416) 362-1913

Bill Grigsby
artist's representative

Louis Fishauf
designer

Award winning illustration and design.

Reactor is Bill Grigsby, Louis Fishauf, Bob Berger, Karen Cheeseman, Blair Drawson, Bob Fortier, Clancy Gibson, Margaret Hathaway, Tom Hunt, Jeff Jackson, Jerzy Kolacz, Miro Malish, Doug Martin, Ken Stampnick, and Rene Zamic.

Clients include: Canadian Opera Company, Comac Communications, Doyle Dane Bernbach, Esquire Magazine, Government of Ontario, McCann-Erickson, Ogilvy & Mather, Rolling Stone Magazine, Ronalds-Reynolds, Saturday Night Magazine, Vickers & Benson, Gimlets.

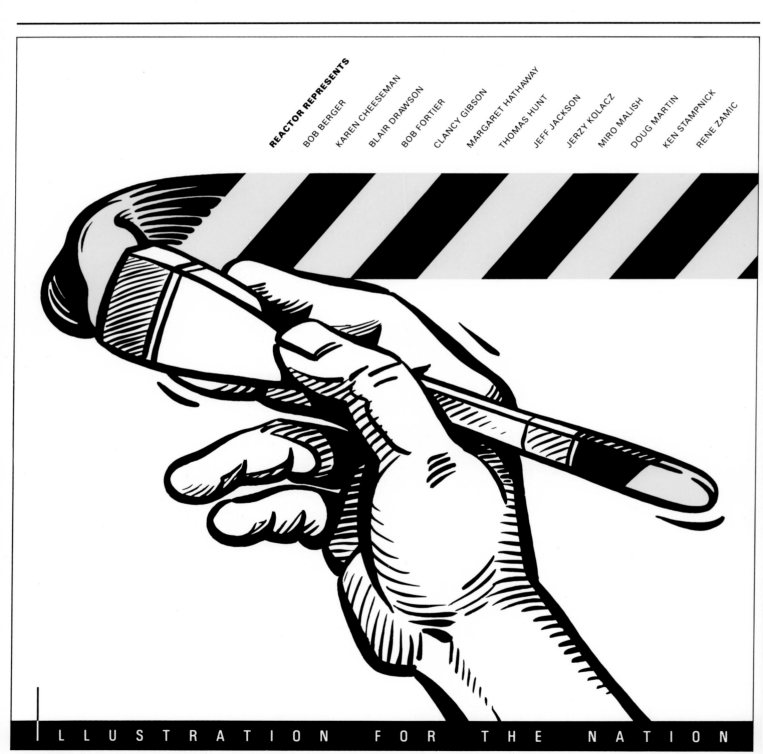

REACTOR REPRESENTS: BOB BERGER, KAREN CHEESEMAN, BLAIR DRAWSON, BOB FORTIER, CLANCY GIBSON, MARGARET HATHAWAY, THOMAS HUNT, JEFF JACKSON, JERZY KOLACZ, MIRO MALISH, DOUG MARTIN, KEN STAMPNICK, RENE ZAMIC

ILLUSTRATION FOR THE NATION

Illustration 162 Ontario

Richard Row
Illustrator

3 Victor Avenue
Toronto, Ontario
M4K 1A7

(416) 466-9069
(416) 481-4640

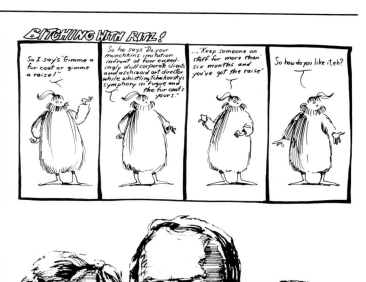

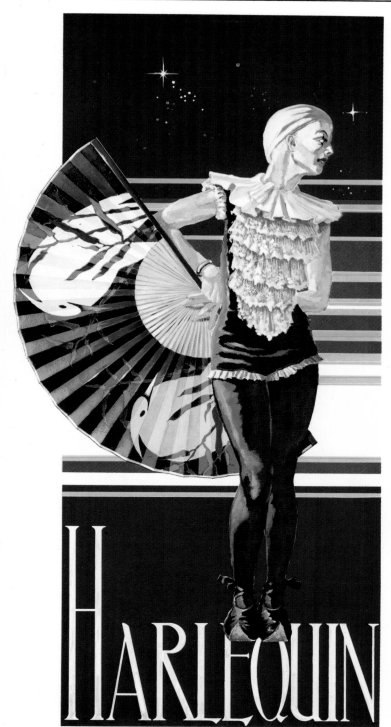

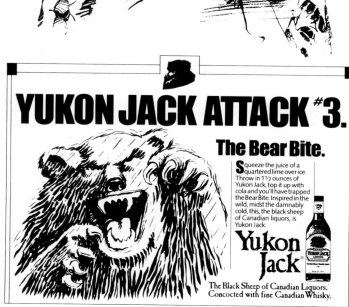

Ken Ryan
4 Hartham Place, #10
Toronto, Ontario
M3K 1P3

(416) 633-3555

Don Hood

Give me a call; I will be pleased to show you my portfolio.
See you soon!

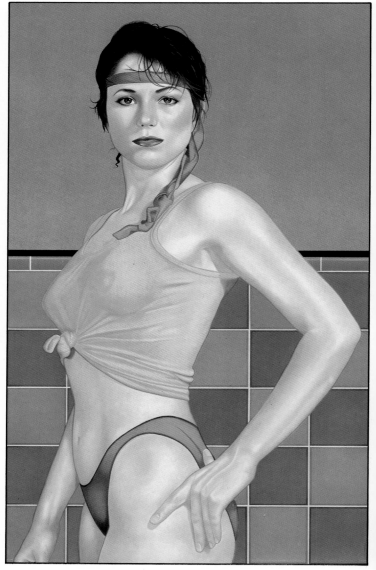

Illustration 164 Ontario

Hassan Sakr
30 Gloucester St.
Suite 1908
Toronto, Ontario
M4Y 1L6

(416) 921-4815

Stewart Sherwood
625 Yonge Street
Toronto, Ontario
M4Y 1Z5

(416) 925-8528

CAPIC

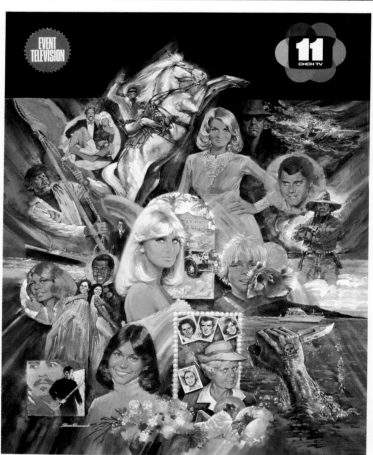

CHCH 11 Subway Poster

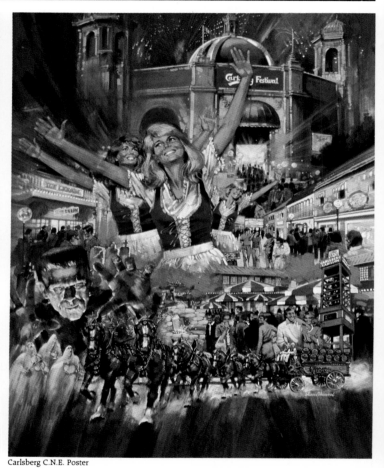

Carlsberg C.N.E. Poster

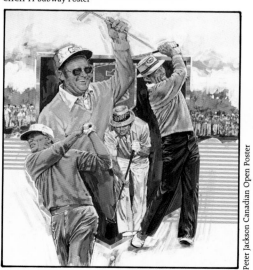

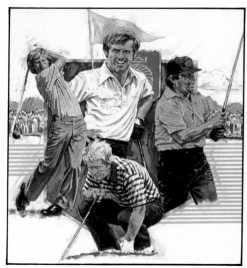

Peter Jackson Canadian Open Poster

Illustration

Ontario

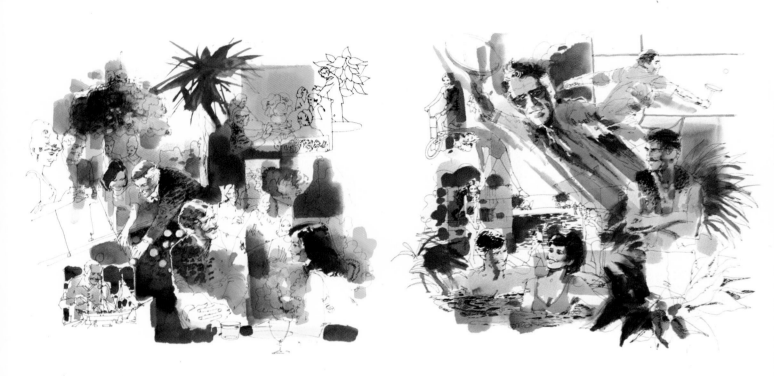

Tridel Construction

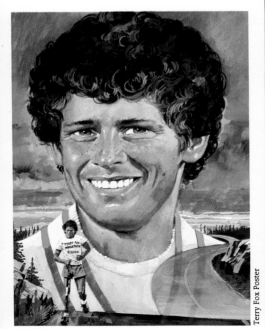

Terry Fox Poster

Macleans's Cover

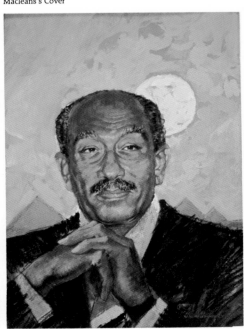

Toronto Star

Terry Shoffner
Illustrator Inc.
11 Irwin Ave.
Toronto, Ontario
M4Y 1L1

(416) 967-6717

Terry Shoffner

CAPIC

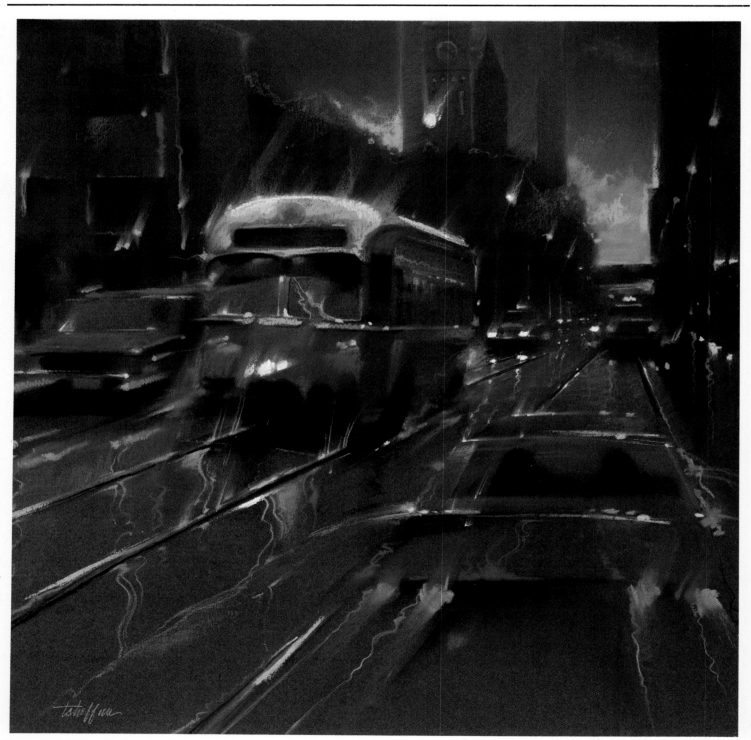

Illustration 168 Ontario

Sullivan Studios Inc.
51 Bulwer Street
Toronto, Ontario
M5T 1A1

(416) 593-0543

Judy Hulme
Fran Moore

Sullivan Studios produces architectural illustrations for presentation and reproduction in a variety of techniques.

A background in interior design enables them to work from plans or imagination.

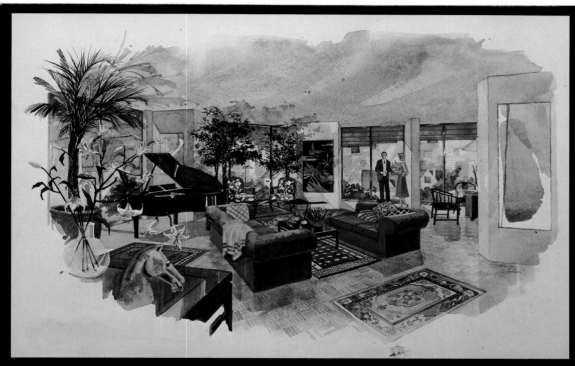

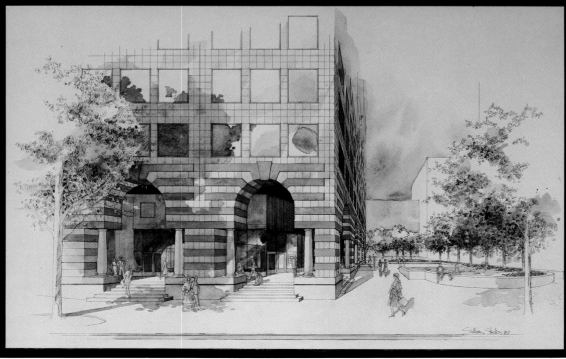

Mark Summers
Burlington, Ontario

(416) 681-0907

"There are two styles of Portrait painting: the serious and the smirk."

Charles Dickens

I can give you both — in scratchboard (below), oils, acrylic, watercolour, airbrush or any combination thereof.

Illustration

Ontario

Hugh Syme Inc.
195 Church Street
Toronto, Ontario
M5B 1Y7

(416) 363-9788

Hugh Syme
Illustration and Design

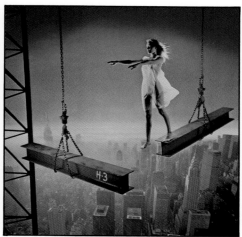

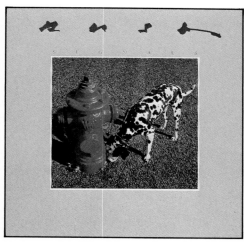

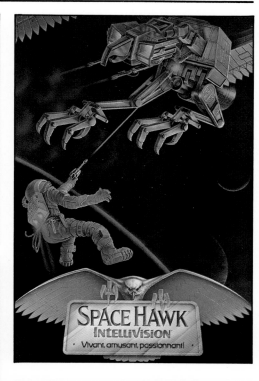

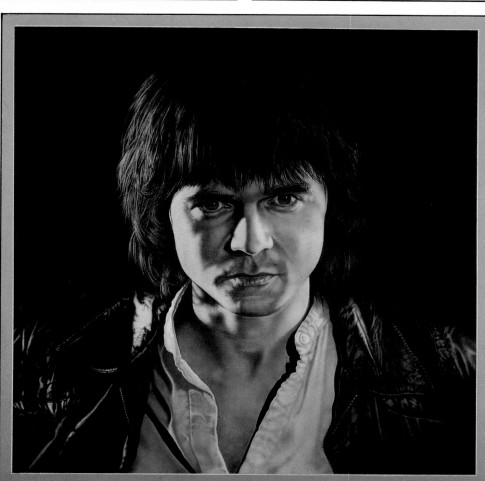

Tom Taylor
169 Carlton St.
Toronto, Ontario

Represented by
SCF Ltd.
Contact: **Richard Symes** or
Marv Fagan

(416) 924-8183

Illustrations for
Top left: **CN Express**
Top right: **Mattel Toys**
Bottom left: **Glenway Builders**
Bottom right: **Anglo Canadian Motors Ltd.**
Edmonton/Jaguar British Leyland

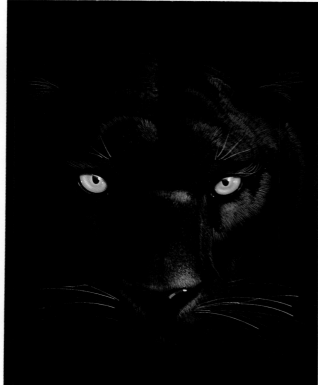

Wendy Whitemore
28C Forester Crescent
(Nepean) Ottawa, Ontario
K2H 8W8

(613) 828-8914

Wendy Whitemore
Illustrator Designer

CAPIC

Muriel Wood

Represented by:
Fleming & Associates

(416) 276-9373

Illustration 174 Ontario

Thach Bùi (*tak booy*)
Illustrator
128 Stephenson Ave.
Toronto, Canada
M4C 1G4

(416) 694-8147

From disarmament talk to baby talk, **Thach's** drawings are conceptually strong, humourous and always on time.

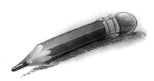

Ludmilla
2335 Sherbrooke St. W.
Montreal, Quebec
H3H 1G6

(514) 932-3715

Contacts:
Idées Design Montreal
(514) 965-6035
Susanne Dewilde, New York
(914) 946-6893

CAPIC

Conceptual Illustration
Portraiture
Children's Books
Editorial Art
Fashion

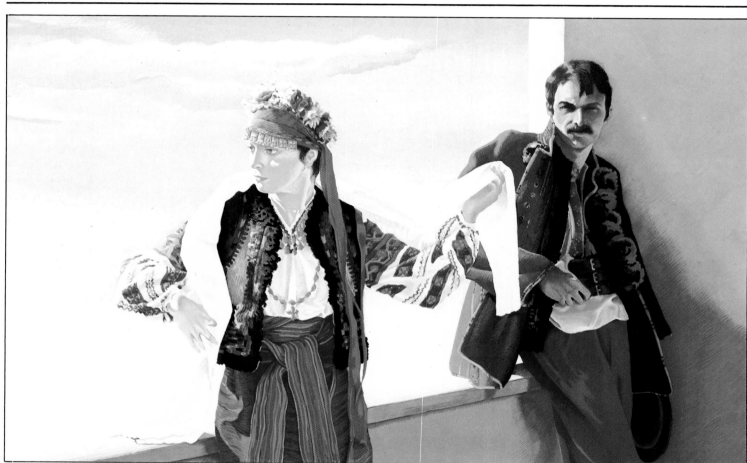

Illustration

Quebec

John Martin Gilbert
4797 Highway
West Vancouver, B.C.
V7W 1J6

(604) 925-1049

"Let your creations speak for themselves", John Gilbert's Brainchildren admonish. *"Mmmmph"*, he agrees.

First, the problem. Then a lightning-quick concept sketch. And a Thing is born. One which may achieve wild mobility through motors, strings and bits of crazed clockwork.

For print series, an obvious hit. In tv and film, these award winners move both themselves and the viewer. (Ask Ford U.S.A., Schaefer Beer, AT&T or NBC/TV.) In corporate exhibits, the larger sculptures are show-stoppers. Far out? Not with telecopier. Idea sketches are a phone call away. Fast finish, with a 4 × 5 transparency sent by airpack. Priced on a par with fine illustration.

Call. And if a muffled man answers, don't hang up.

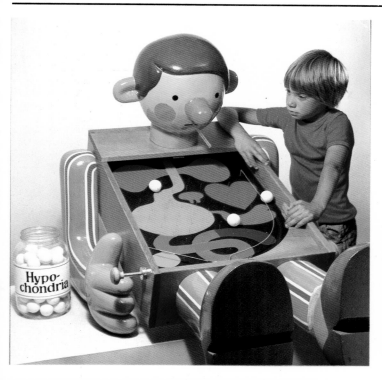

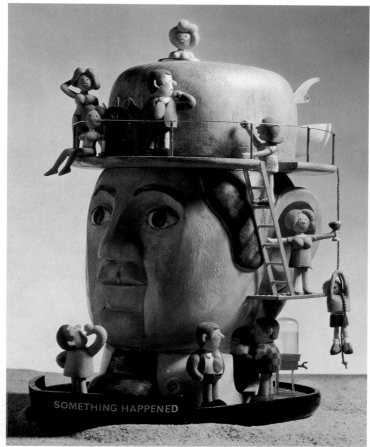

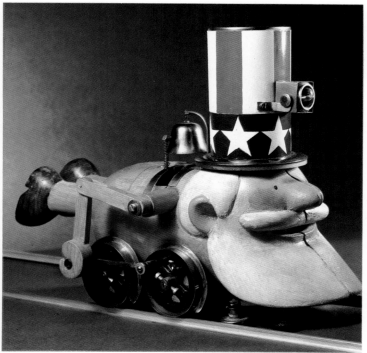

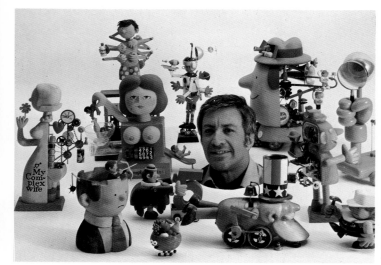

Grant W Leier
Illustration
1615–7 A Street N.W.
Calgary, Alberta
T2M 3K2

(403) 289-6502

So you wanna' be wholesome.
Combining personal fantasy and realism with an open hand, Grant's illustration can give visual form to most any narrative. Grant graduated from the Alberta College of Art and the Illustrator's Workshop in New York in 1978. Some clients include: Edmonton Magazine, Calgary Magazine, Alberta Culture–Visual Arts, Saskatchewan Department of Health, City of Calgary Parks and Recreation and the City of St. Albert.

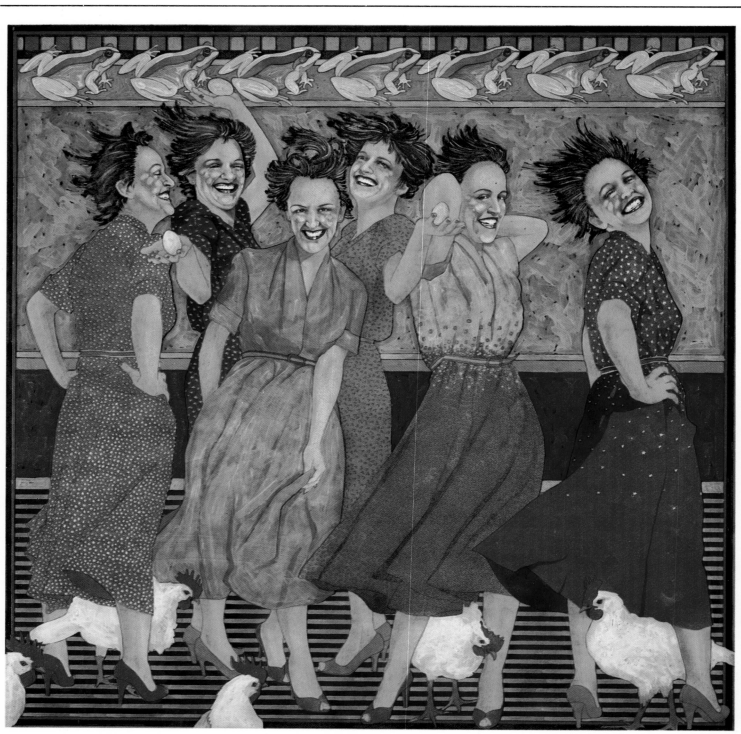

Illustration

Western Canada

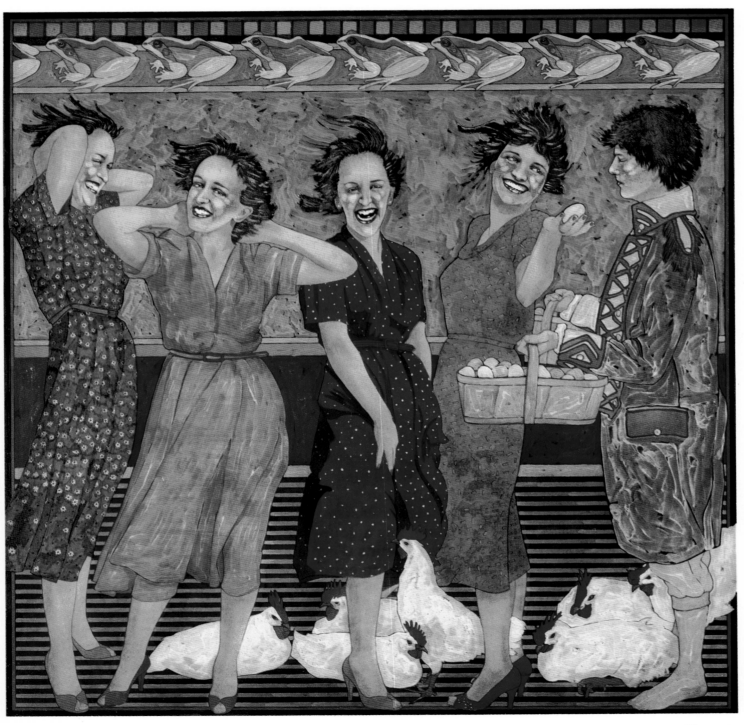

CAPIC
ACPIP

The Canadian
Association of
Photographers and
Illustrators in
Communications

L'Association Canadienne
de Photographes
et Illustrateurs
de Publicité
15 Toronto Street
Suite 702, Toronto, Ont.
M5C 2E3
(416) 364-1223

PHOTOGRAPHERS AND ILLUSTRATORS. ISN'T IT TIME YOU JOINED C.A.P.I.C.?

C.A.P.I.C. is Canada's only association for professional
photographers and illustrators. It is dedicated to promoting
good ethics and professionalism in the communications
business, and safeguarding the interests of its members.
In addition, C.A.P.I.C. is working on behalf of all
photographers and illustrators to get Canada's antiquated
copyright laws revised.
C.A.P.I.C. has newsletters, meetings, speakers and an annual
show of members' work plus group health, dental, disability
and equipment insurance programs that will save you more
than twice your membership fee alone.
Can you afford not to be a member of C.A.P.I.C.?

PHOTOGRAPHES ET ILLUSTRATEURS IL EST TEMPS DE VOUS JOINDRE À l'A.C.P.I.P.

L'A.C.P.I.P. est la seule association, au Canada, pour
photographes et illustrateurs de publicité; elle vise à
promouvoir l'éthique et le professionnalisme dans le
domaine des communications publicitaires, tout en
sauvegardant les intérêts de ses membres. De plus l'A.C.P.I.P.
fait des démarches, au nom de tous les photographes et
illustrateurs, afin que soient révisées les lois canadiennes
sur le droit d'auteur, lois aujourd'hui désuètes.
L'A.C.P.I.P. vous offre bulletins d'actualités, réunions,
conférences; elle organise une exposition annuelle des
oeuvres de ses membres; elle vous offre également des
programmes collectifs d'assurance-maladie, dentaire,
d'invalidité et d'équipement qui, à eux seuls, vous
permettront de réaliser des économies équivalant à plus
du double de votre cotisation.
Pourquoi attendre encore...devenez dès aujourd'hui
membre de l'A.C.P.I.P.!

Illustration 180 Creative Source 4

Rowennie Cheng Design
334 King Street East
Suite 208
Toronto, Ontario
M5A 1K8

(416) 861-1339

Graphic Design
Corporate identity programs
Packaging
Art direction

Cash for Life	Q107	The Energy Workshop
Ben Lee Restaurant	PC Party Conference	CP Hotels
Stevenson & Kellogg	Kaufman	Decor International
RoyWest Bank	Half Back	Rae Brothers

Freeman Communications
11 Gloucester Street
Toronto, Ontario
M4Y 1L8

(416) 967-6970

Bert Freeman G.D.C.
President

Ann MacPhee
Dave Kelly
Account Executives

Freeman Communications is a unique full-service creative group working under one roof. We have developed a broad portfolio of corporate clients in diverse fields including insurance, energy, packaging, retail, service, recreation and financial institutions, and have worked extensively with 12 provincial government ministries. From concept and copywriting through all phases of production, our creative people work as a team and when you call on our services, you become the most important part of that team...producing communications that are imaginative, appropriate, functional and cost-effective.

Complete in-house production facilities include digital typesetting with page composition and telecommunications capabilities.

Graphic Directions Ltd.

663 Carlaw Avenue
Toronto, Ontario
M4K 3K7

(416) 465-3403

Dennis Goddard

1) Success Magazine 1973
2) Le Maze Poster Store 1970
3) IBM Canada Ltd. 1980
4-5-6) Lovecraft Limited 1974
7-8) Imperial Oil Limited 1981
9) Maclean-Hunter Limited 1979
10) IBM Canada Ltd. 1980
11) Ontario Ministry of Health 1982
12) Federal Government of Canada 1981
Illustrations – Muriel Wood

Photographer Steve Yarkun

1

2

3

4

5

6

7

8

9

10

11

12

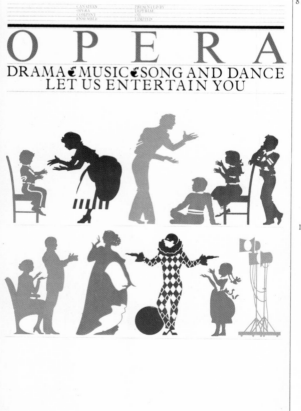

Infinity Graphics Limited
744 Dundas Street East
Toronto, Ontario
M5A 2C3

(416) 363-3251

Infinity Creative Services

Infinitype Systems

in·fin'·i·ty: A full-service studio providing in-house concept, design, copy, phototypesetting, art production and photography.

Corporate image, logo and poster design • Point-of-purchase and trade show promotion • Brochure design and production • Magazine phototypesetting • Newspaper and magazine advertising • Restaurant and hotel menu/specialties • Package design • Fashion and catalogue photography... we do them all often — and well.

Creative director: Alex Smith
Phototypesetting: Jan Dorland
Associate art director: Jon Gillette
Software engineering: Robert Scarlett

Art production: Glenn Osborne
Photography: Doug Johnson

Jaeger Graphics
961 Eglinton Ave. E.
Toronto, Ontario
M4G 4B5

(416) 421-5227

David Jaeger

Virginia Jaeger

Photography: Jim Stevenson

Kyron Marketing Limited
247 Frederick St.
Kitchener, Ontario
N2H 2M7
(519) 743-2631

Howie Wright
President

H.W.: What kind of photograph will best depict the true flavour of our company?
Staff: How about a blank space?
H.W.: No, no! Something that shows dedication, discipline and efficiency – something dignified and yet creative.
Staff: Gotcha! Wear your dad's suit tomorrow, for the shoot.

Concept, design and execution for print, radio, T.V., A/V, P.O.P., packaging and display.

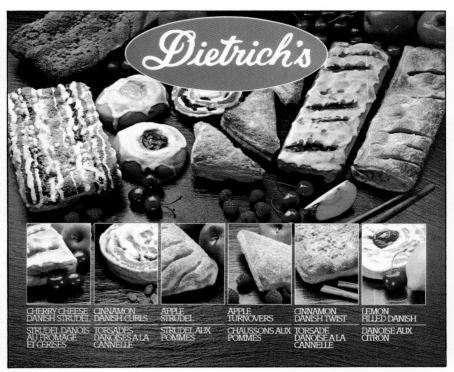

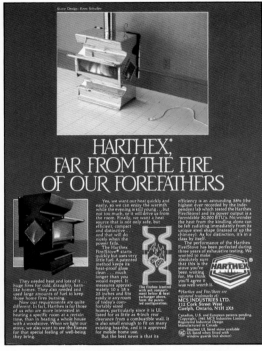

HARTHEX, FAR FROM THE FIRE OF OUR FOREFATHERS

NEW CHOICES FROM AN OLD FRIEND

Weston's Country Harvest

WHEAT BERRY WITH HONEY

100% STONE MILLED

GRANOLA

HARVEST WHITE

7 GRAIN

TRY WESTON'S COUNTRY HARVEST BREAD

Granny's Apple Pies
Tartes aux pommes

Ontario
Maple
Syrup

Stephen Laskoski Designers Inc.
Third Floor
120 Cumberland Street
Toronto, Ontario
M5R 1A6
(416) 928-9090

Stephen Laskoski A.C.I.D., G.D.C.
President & Creative Director

Photography: Casimir Bart

Partial list of Consulting and/or Design projects for:

Canada	W.C.B. Ontario	Bittner's	Fielding Chemicals
Office of Design	Dominion Stores	Bahamas	El-En Packaging
Budweiser	Bectin Dickenson	Port Authority	Horizon Ceramics
Robin Hood	Quaker Oats	Vermont	Stelco
Multifoods Ltd.	Stony Brook U.	Travel Bureau	Sherway Gardens
Art Gallery of	Canada Post	Regina	C.G.E.
Ontario	Kimberly-Clark	Centennial Centre	Shell
Sobeys Stores	Canadore College	U.B.C.	Crystal Springs

Award of Excellence from National Design Council. Various International Awards of Distinction for Corporate and Packaging Design. Member of Association of Canadian Industrial Designers. Member of Society of Graphic Designers of Canada.

Logos
Identity by design Ltd
3146 Lakeshore Blvd W
Toronto, Ontario
M8V 1L5

(416) 259-7834

Brian Smith
President

A corporate identity when used properly – that is
thoroughly, sensitively, carefully and above all
permanently – is vital to any successful business.
We've worked directly or on a freelance basis
with S.C. Johnson, Quaker Oats, Hershey's,
Ray-O-Vac, Sears, Stanley Doors, Lever Brothers,
Canadian Tire, the Salvation Army and others...
and won awards doing it!

Jesus is Lord!

Richard Male
Design Associates Ltd.
120 Adelaide St. East
Toronto, Ontario
M5C 1K9

(416) 362-1646

Richard Male

EDA: Consultancy N.B. Hathaway Associates

RED ROSE: Agency JWT Direct Illustration Clarence Porter

KALMAN MOLNAR LIMITED

234 Eglinton Ave. E.
Suite 501
Toronto, Ontario
M4P 1K5

(416) 488-5062/63

Kalman J. Molnar
G.D.C., CAPIC
President
Barbara Griffin
A.O.C.A., CAPIC

Design of All Sorts!

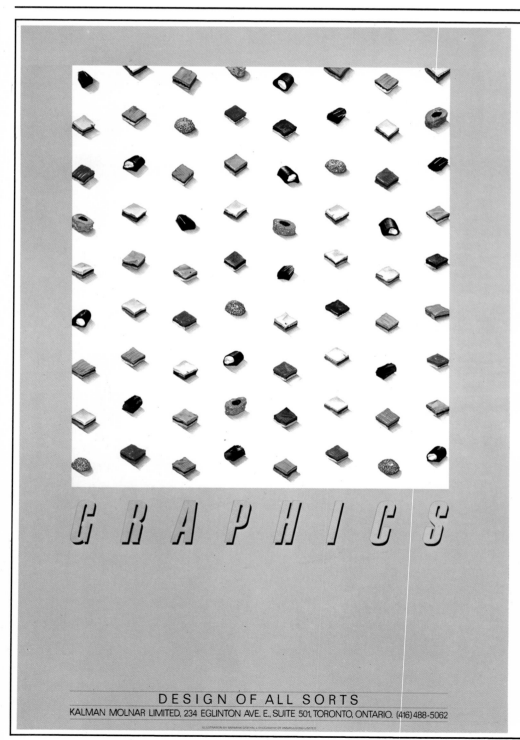

GRAPHICS

DESIGN OF ALL SORTS
KALMAN MOLNAR LIMITED, 234 EGLINTON AVE. E., SUITE 501, TORONTO, ONTARIO. (416) 488-5062

LE PRIX DE LA LIBERTÉ

RESOURCEBOOK
1983 EDITION

All the World is a Stage for Children's Creations
What did the Saturn Space Probe Reveal?

Have You Considered a Career in Oceanography?
Stepping Back in Time at the Fortress of Louisbourg
Child Abuse: The Hidden Crime
Plus: Snacks That Smack of Good Taste

R.K. Studios Limited
410 Dundas Street East
Toronto, Ontario
M5A 2A8
(416) 964-6991

Ron Kaplansky
Advertising Designer

First Choice Mark/Jim Donoahue
Mariposa Illustrations/Dick Marvin
Photography/Taffi Rosen

Ron Kaplansky develops his design ideas through teamwork. He believes that good design requires time and communication with the client at the concept stage. His sensitivity and intuition combine with a solid background in graphic design to direct you to the best visual approach for your needs.

He'll sit down with you to find out who you are and what you want to communicate to your audience. You'll exchange ideas and discuss concrete visual suggestions. When the approach has been agreed upon, Ron will complete all phases of production including printing supervision, if required.

Ron's work, which has included annual reports, educational displays, posters, large and small publications, and advertisements, is distinguished by its simplicity and clarity.

REACTOR

Reactor Art & Design Limited
51 Camden Street
Toronto, Ontario
M5V 1V2
(416) 362-1913

Louis Fishauf
design director

Bill Grigsby
representative

Award winning design, art direction, and illustration.

Clients include: Saturday Night Magazine, Gulf Canada, Canadian Opera Company, Canada Post, Comac Communications, Ryerson Film & Photography, Gimlets.

Reactor represents: Bob Berger, Karen Cheeseman, Blair Drawson, Bob Fortier, Clancy Gibson, Margaret Hathaway, Tom Hunt, Jeff Jackson, Jerzy Kolacz, Miro Malish, Doug Martin, Ken Stampnick, and Rene Zamic.

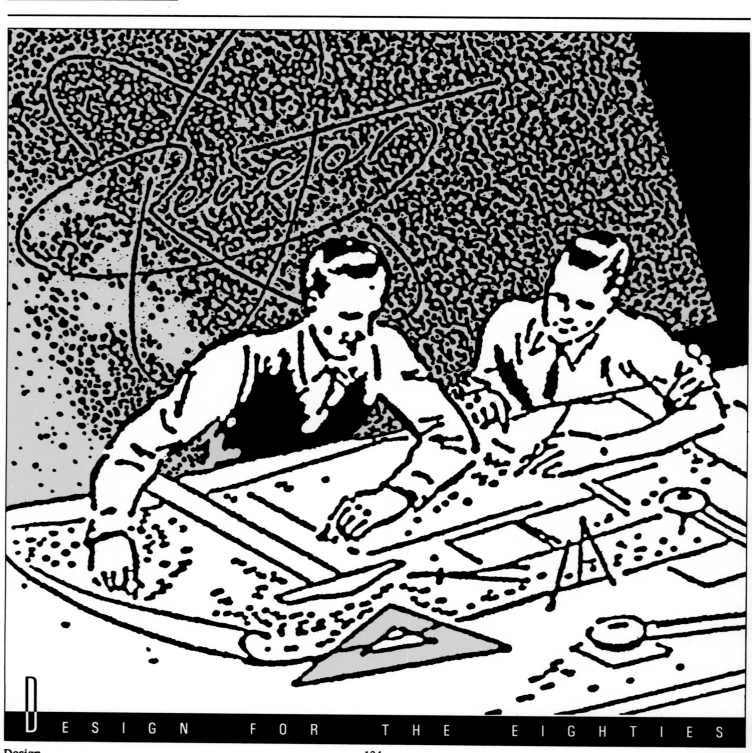

DESIGN FOR THE EIGHTIES

Warren Advertising Graphics
720 Spadina Avenue
Suite 404
Toronto, Ontario
M5S 2T9

(416) 922-8388

David Warren

A marketing/design service providing conceptual work in advertising and corporate design, and through affiliated companies, a complete marketing package.

Warren Advertising Graphics was founded in 1974. Prior to that, David acquired a total of 13 years experience with major agencies in Toronto, among them: J. Walter Thompson, MacLaren, and Vickers and Benson. Currently interested in advertising and design assignments from small to mid-size accounts seeking a sound blend of cost efficiency and excellence in design.

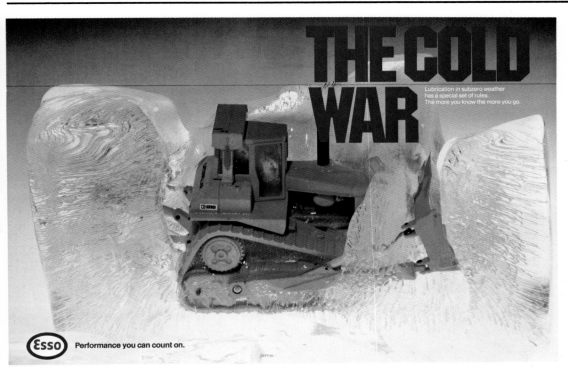

Barry Weinstock
Design + Photography
111 Avenue Road
8TH floor
Toronto, Ontario
M5R 3J8

(416) 960-3423

Barry Weinstock

Photo: Tony Amor

Barry Weinstock is a creative designer with a strong commitment to rational design. That means every project is special; every project is different; and every project commands his total concentration of talent, experience and skill. Over the past 16 years, Barry Weinstock has assembled an outstanding portfolio of corporate design programs, annual reports, institutional graphics, catalogues and promotional materials for such diverse clientel as Ivaco Inc., the Government of the Province of Ontario, Ronalds-Federated, Cadillac Fairview, Bank of Montreal, Ontario Hydro, City of North York, Borough of Scarborough, Top Drug Mart, R-O-R Associates, the Art Gallery of Ontario, C.A.D.P., Prime Computers and the Baycrest Centre.

1 **Phasor Consultants Inc.** –
Electrical Engineering
2 **Ontario Renews** –
Government of Ontario Program
3 **Training** and **Research Institute** for
Advanced Driver Development Inc.
4 **Down Right** – Manufacturer of
down-filled outerwear
5 **Canadian Association** for
Ethiopian Jews
6 **Flicks** – Video cassette and
recorder rentals
7 **Toronto International Studios** –
unpublished

Werle Design Limited
740 Huron St.
Toronto, Ontario
M4V 2W3

(416) 923-6614

Stuart Werle A.O.C.A.
President/Creative Director

When you deal with us, you deal directly with the designer. We believe that direct communication between client and designer maximizes effectiveness in targeting on the objectives.

Design should be innovative as well as sensitive to the needs and demands of the market place.

We're considered package and corporate image design specialists. Our approach is imaginative, functional and cost effective.

See for yourself.

Photography: John James Wood

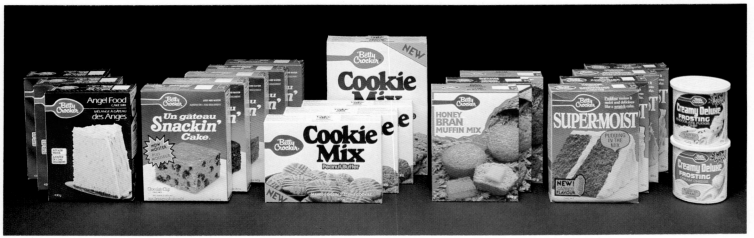

**Paul Gilbert
Design Limited**
334 MacLaren Street
Ottawa, Ontario
K2P 0M4
(613) 233-6259

Paul Gilbert
President

Martin Green
Creative Director,
Exhibits

Paul Gilbert has created a new full-service communications design group based in Ottawa, with combined experience of over 30 years in:
• graphic and corporate design
• trade show and museum exhibit design
• photography and illustration

"Good design solves the customer's needs, not the designer's. Good design is based on the fullest possible understanding of the client and his/her market. Good design combines creativity, quality, flexibility, innovation and common sense. Good design succeeds by communicating to people."

Husky Oil

YOUR CAREER WITH US

EXPANDING OUR HORIZONS

Bell

Design

Ontario

xy typesetting services

197 Laird Drive
Toronto, Ontario
M4G 3W3

(416) 425-3343

Eugen Leonida
Production Manager

Founded in January 1978, *xy* typesetting services has grown and become known for its ability to produce demanding phototypesetting assignments for discriminating clients.

Technical catalogues and publications, sophisticated charts and diagrams, and foreign language texts are just some of the specialties, meticulously, quickly and economically produced for publishers and editors seeking near perfection.

The experience acquired in setting books of economics, accounting, statistics and mathematics, together with an extensive academic background have provided the skills to overcome the all too common troubles usually experienced in this specialized field.

over

typefaces available to fill the most demanding needs

TCA Design Ltd.
2807 Woodbine Drive
North Vancouver
British Columbia
V7R 2R9

(604) 685-2511
(604) 988-0685

Ian Mac Leod

Visual and corporate identity programs.
Graphic Design & Art Direction.
Illustration.

Clients include: The Providence of British Columbia, The Vancouver East
Cultural Centre, Fidelity Life Assurance Company, Simon Fraser
University, The Vancouver Playhouse, B.C. Hydro & Expo 86 Corporation

TCA Design Ltd.
2807 Woodbine Drive
North Vancouver
British Columbia
V7R 2R9

(604) 685-2511
(604) 988-0685

Ian Mac Leod

Visual and corporate identity programs.
Graphic Design & Art Direction.
Illustration.

Clients include: The Providence of British Columbia, The Vancouver East Cultural Centre, Fidelity Life Assurance Company, Simon Fraser University, The Vancouver Playhouse, B.C. Hydro & Expo 86 Corporation.

The AV House
409 King St. West
Toronto, Ontario
M5V 1K1

(416) 591-1770

Ben R. Wilson
President & Creative Director

"The House That Experience Built"
More than a decade ago, The AV House opened its doors for business. From the start, our basic foundation was **experience** – Experience to know how to effectively communicate the client's message, whether it is speaker support slides, filmstrips, motion film, videotape, or the multi-image, live multi-screen spectacular. Our experience proves it.

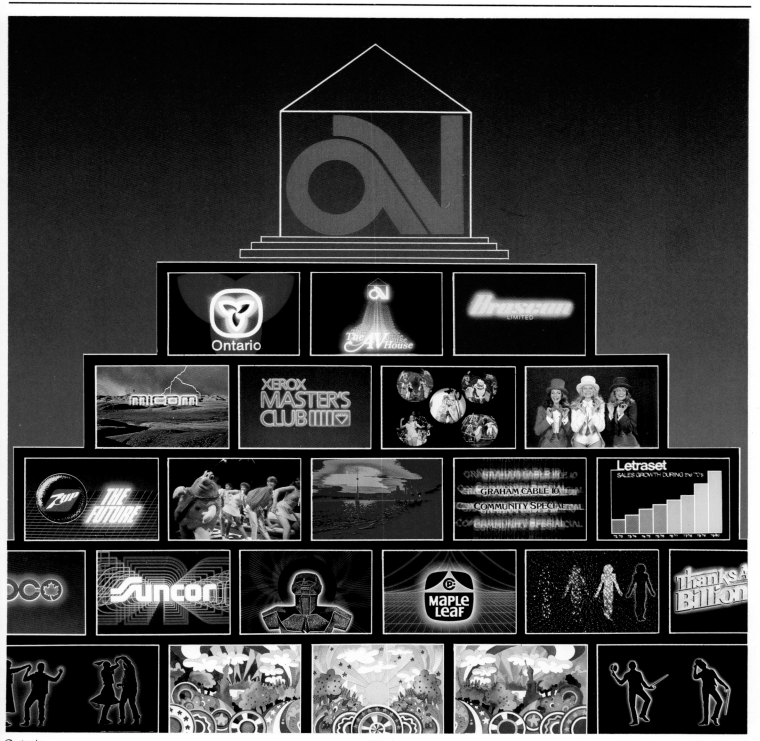

Peter Coney
Associates Limited

465 King Street East
Unit 7
Toronto, Ontario
M5A 1L6

(416) 363-3086

Transformation

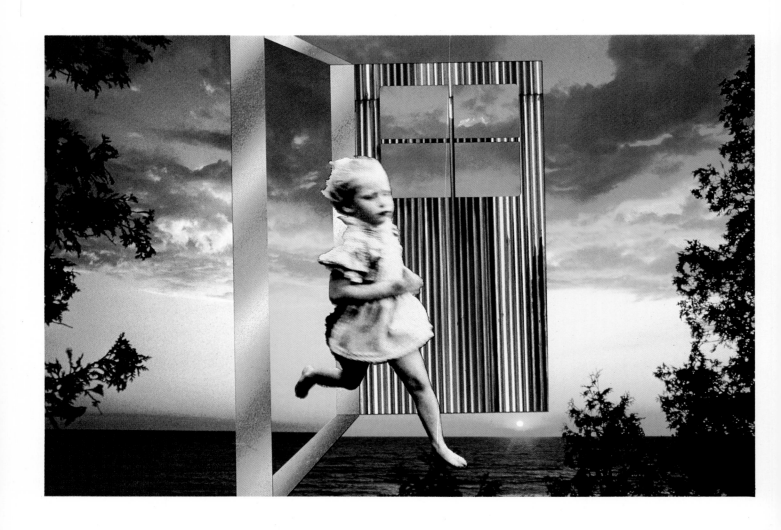

Discovery Productions
50 Widmer Street
Toronto, Ontario
M5V 2E9

(416) 596-8310

Bob Danylak
President

Discovery
Productions

M.S. Art Services Limited
410 Adelaide Street West
Toronto, Ontario
M5V 1S8

(416) 363-2621

Manolo Corvera
President

George Kveton
Creative Director

Since 1967 Producers of Fine Audio/Visuals & Animation.
M.S. Art Services Ltd. — A studio for People who Appreciate Quality.

Richard Brown
6 High park blvd
suite two
Toronto, Canada
M6R 1M4

(416) 535-8717

member A.S.M.P.
CAPIC

1967 Alexey Brodivitch Design Lab, N.Y.C.
1968 Opened my studio in Montreal. **National Ad's & Fashion**
1970 35,000 miles of **Travel & Editorial photography.**
1976 Olympics – the lighting of the flame in Olympia and it's run to Athens.
1977 Move to Toronto. New directions: **Audio Visual, Annual Reports, Food.**
1978 Two T.V. commercials for Montreal Gazette.
Food photographer for weekly cooking magazine Telecuisine
1982 Audio/Visuals: In Grand Bahama & Colombia for A.E.S.
In studio for Sears and The Bay, location and product photography for Johnson & Johnson.
Videotapes available....

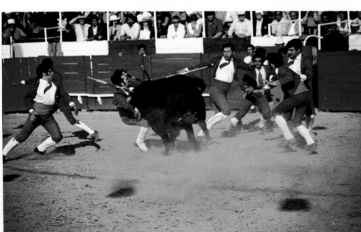

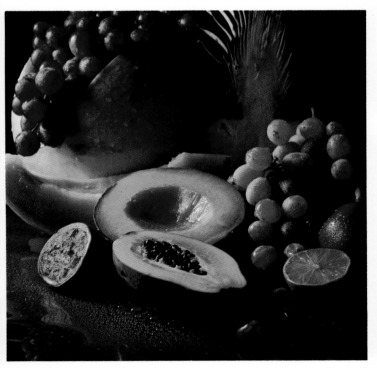

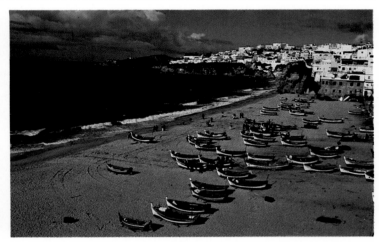

Omnibus Video Inc.
Transamerica Tower
2180 Yonge Street
Toronto, Canada
M4G 2T1

(416) 489-6020

Omnibus Video, specializing in computer animation and special effects unique to the world of advertising and television.

Now, for the first time in Canada, you can obtain virtually any special effect your client desires. Plus the advantages of convenience, fast turn-around and the economics of the Canadian dollar.

Omnibus creative staff orchestrates the latest state-of-the-art digital video equipment and with the exclusive New York Institute of Technology Computer Animation System, transforms your "Dreams for the Screen".

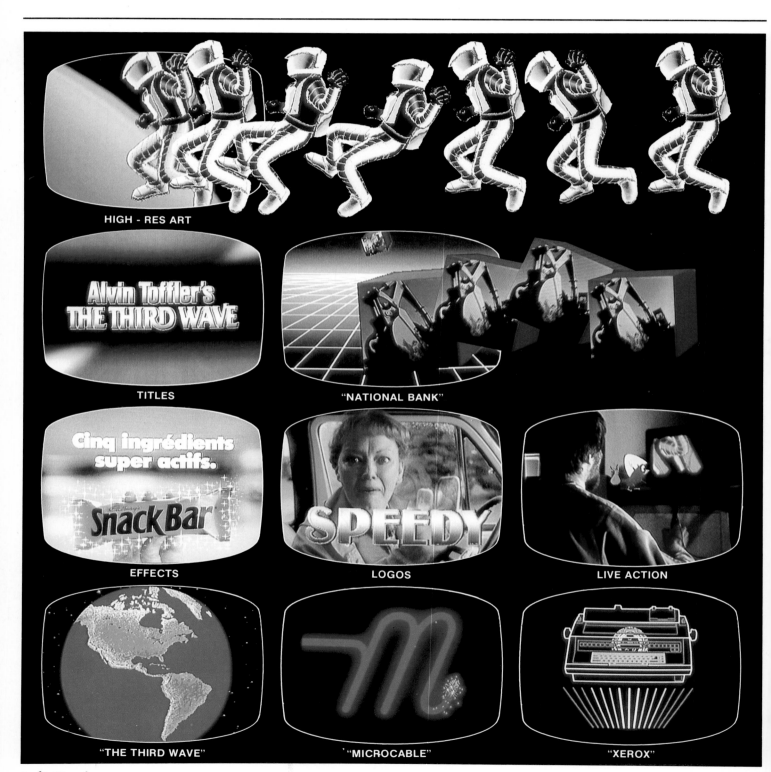

HIGH - RES ART

TITLES

"NATIONAL BANK"

EFFECTS

LOGOS

LIVE ACTION

"THE THIRD WAVE"

"MICROCABLE"

"XEROX"

Avcom International Ltd.
1401 Crown Street
North Vancouver, B.C.
V7J 1G4
(604) 986-1174

(Branch Office)
Avcom Productions Inc.
13256 Northrup Way, Suite 8
Bellevue, Wa. 98005

Harry H. Gehrmann
President.

"What you see is less than what you get". Our team of specialists are are experienced in all aspects of AV production, from creative direction and computer programming to controlling the bottom line.
Our Photographers, Writers and Graphic Artists are committed to creative excellence.

AVCOM is western Canada's most complete Audio Visual house. Our broad range of capabilities include **One Projector Slide Shows**, sophisticated **Multi-Image Presentations**, **Film Strips**, **Studio** and **Location Photography**, **Video** and **Motion Picture Production**. GET THE PICTURE? As a further service to our clients, **AVCOM** represents Kodak, LaBelle, AVL, Da-Lite and other top equipment manufacturers.
Nearly twenty years in the business working with small and large, national and international companies, **AVCOM** has earned a superior reputation among clients in both private industry and government.

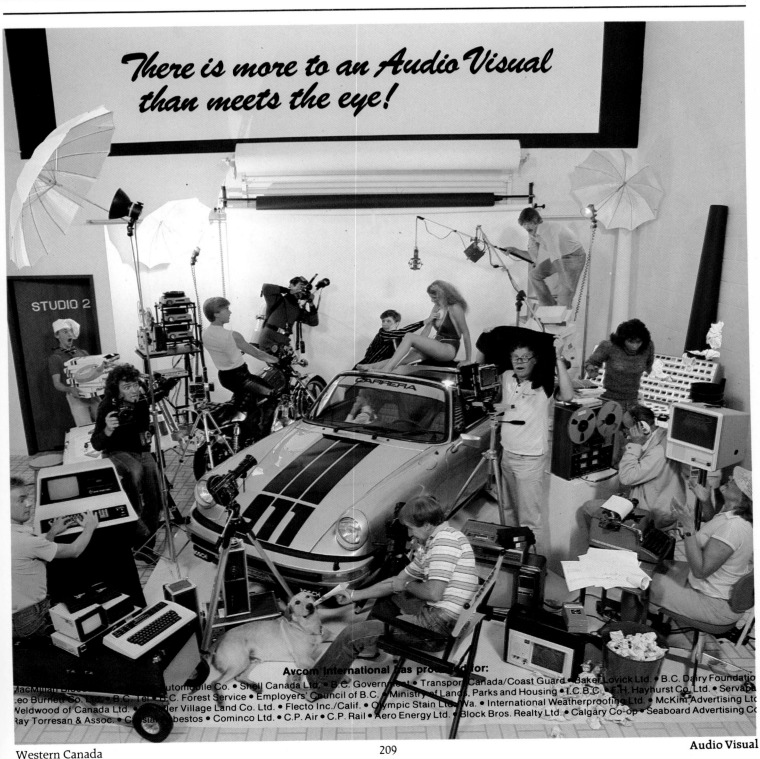

There is more to an Audio Visual than meets the eye!

Commercial Graphics Limited
144 Front St. West
Toronto, Ontario
M5J 2L7

(416) 597-0272

135 Rebecca St.
Hamilton, Ontario
L8R 1B9

(416) 522-1137

"Not all things are created equal" – and the same holds true when it comes to quality colour separations.

That's right where we come in.

Whether Commercial Graphics supplies simple engraving or complex separation work, we have the ability and experience to pick up on your creative concept and carry it through to completion. So your creative effort doesn't die on the drawing board or at the camera.

Commercial Graphics. Our separations equal your creative.

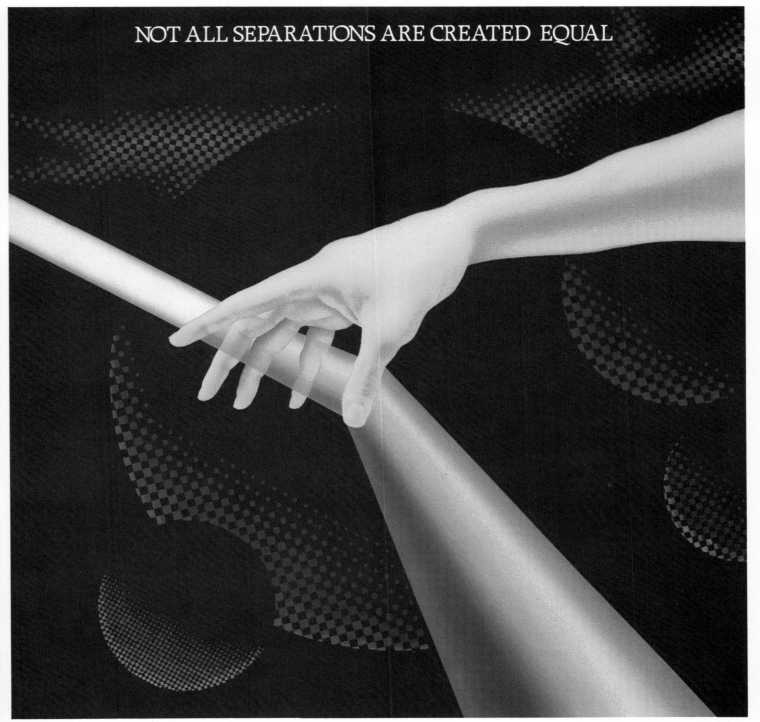

NOT ALL SEPARATIONS ARE CREATED EQUAL

Litho Plus Inc.
1361 Huntingwood Drive
Unit 2
Scarborough, Ontario
M1S 3J1

(416) 298-0528

Terry Dedopoulos
President

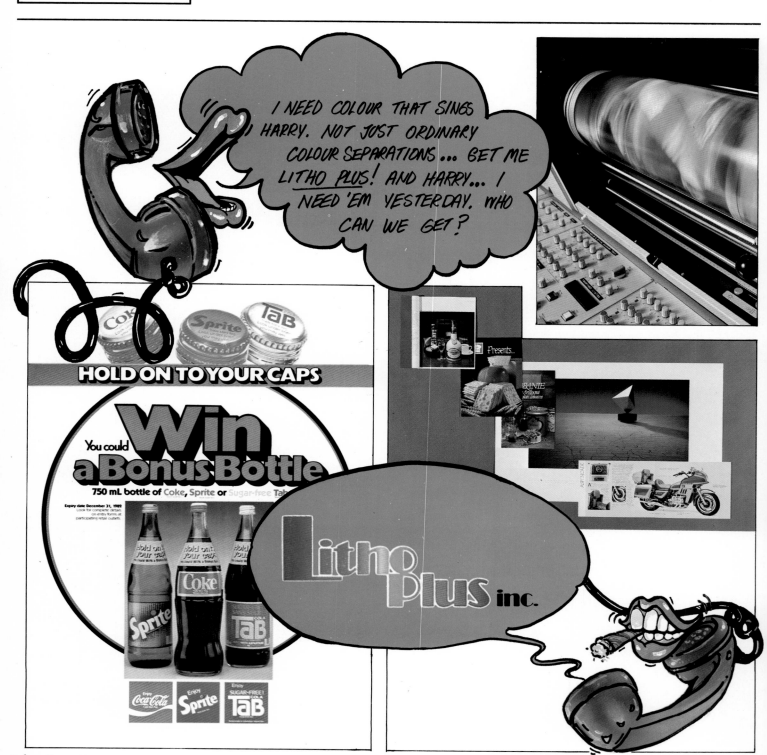

Alphaform Exhibits + Design

Alphaform Exhibits + Design Inc.
76 Richmond St. East
Toronto, Ontario

M5C 1P1

(416) 366-9403

The Alphaform group offers complete and totally integrated exhibit production services that have consistently proven successful in cost/benefit terms to our clients. Our group offers a complete service from concept, through design, production, transportation, installation and storage.

Utilizing the most sophisticated modular systems available in conjunction with total custom fabrication facilities, we are fully equipped to produce point of purchase displays, small exhibits and elaborate trade show booths.

Alphaform's portfolio includes exhibit work for corporations throughout the continent.

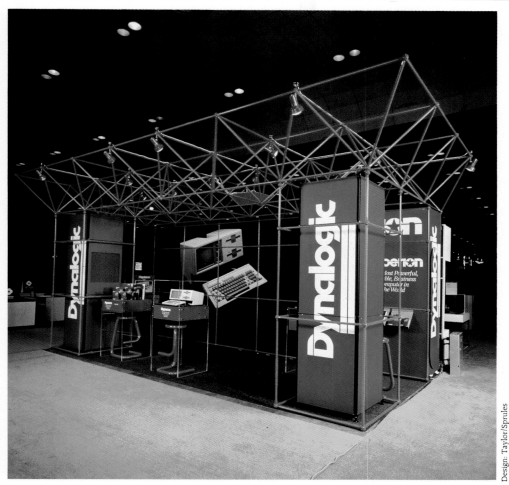

Design: Taylor/Sprules

Design: Scott Taylor

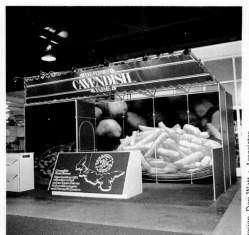

Design: Don Watt + Associates

Geron Associates Limited
20 Progress Avenue
Scarborough, Ontario
M1P 2Y4
(416) 293-2441

Members E.D.A.C.,
E.D. & P.A.

At Geron, we've been helping our clients stand out from the crowd for 24 years – with everything from one-man portable displays to shopping spectaculars.

Portable Displays. Self-contained in cases ready to fold out and plug in, for single, double or multiple booths.

Custom Exhibits. Complete design, graphics, prefabrication, assembly and takedown, anywhere in North America.

Showrooms. Permanent displays at your head office or sales offices, styled for a lasting first impression.

P.O.P. Free standing and counter displays, handsomely designed and built to trigger extra sales.

Write or phone for literature, whatever your display needs.

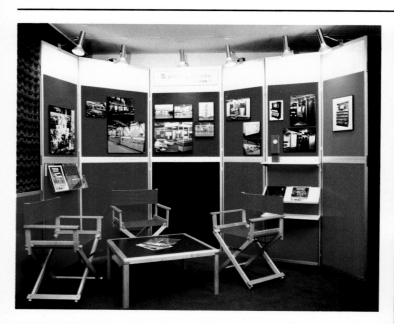

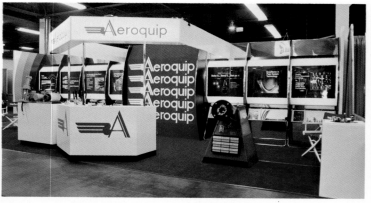

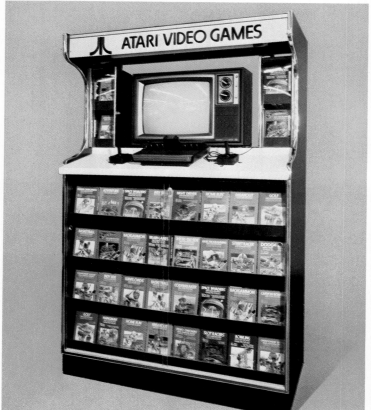

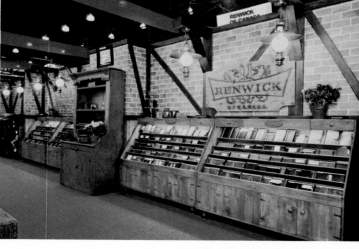

**Exposystems
division of
McNicol Stevenson Limited**
2161 Midland Avenue
Scarborough, Ontario
M1P 4T3

(416) 291-2932

Ross Perkins
Sales Manager

Exhibit structures can be laboriously created from scratch, that is, custom built. Or they can be assembled, easily, with no tools, from modular components.

Exposystems is the umbrella name for the largest range of modular display components available anywhere. The systems can provide a simple tabletop display or a comprehensive trade show exhibit of any size. Starting in 1969, **Exposystems** currently has a client list numbering more than 1800, which reads like a Who's Who of Canadian business and organizations.

Select from predesigned kits or use our house design expertise.

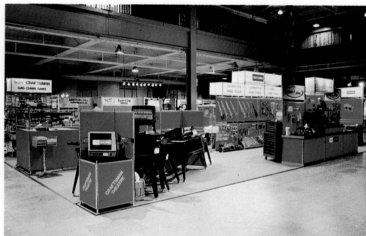

Screenad Limited
489 King St., West
Toronto, Ontario
M5V 1L3

(416) 593-0591

Peter L. Castle
President

Today... The market offers many exciting challenges.
We design and coordinate the manufacturing of disposable and
permanent P.O.P. materials.

Tomorrow... We're enthusiastic and prepared to work with *you*
on your promotional needs.

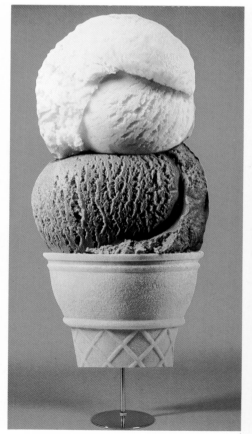

Screenad Limited
489 King St., West
Toronto, Ontario
M5V 1L3

(416) 593-0591

Dan Falconer
Representative

The most rewarding element to me is a satisfied client.
Our strength is flexibility, enthusiasm and versatility... in a word:
Screenteam +.

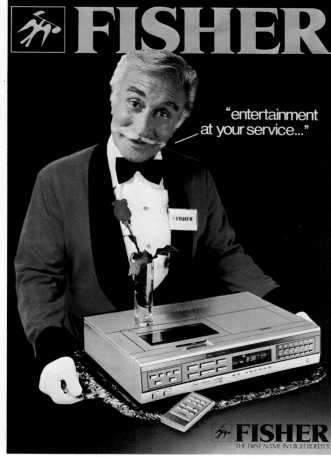

Typsettra Limited
94 Laird Drive
Toronto, Ontario
M4G 3V2

(416) 425-6510

Les Usherwood
President and Director

Typsettra Limited offers a complete graphic service to complement the Art Director or Graphic Designer. Established originally as a headline service, the company has expanded to include phototypesetting, creative art assembly, complete film assembly and modification services.
In recent years exclusive type design has increasingly played an important role in the company's growth. Les Usherwood has gained recognition as a type designer not only in North America but has designs marketed by Letraset International and the Berthold Type Foundry in Berlin, Germany. World-wide liason with these institutions broadens typographic horizons for Typsettra and translates to our customers having available the latest design trends in the typographic community. Superior quality is synonymous with Typsettra.

TYPS=

If you're shopping for humdrum, happy with ho hum, kindly ignore this page. But if a certain young serif can tickle your fantasies, an exotic italic tantalize, Typsettra is for you.
For years, Typsettra has been known for superior quality. Incomparable craftsmanship. A fanatical attention to detail. And…
Les Usherwood, a master type designer recognized across North America and Europe. Whose designs are marketed by TSI Typographical Systems International, The Berthold Type Foundry in Berlin, Germany & Compugraphic Corporation. And whose company, Typsettra, can offer you an international liason to animate your body face, expand your type horizons and stretch your print potential.
Typsettra. All of the above. Plus Les Usherwood.
Who could ask for more?

WE'RE TYPSETTRA MORE OR LES.

Typsettra Limited
94 Laird Drive
Toronto, Ontario
M4G 3V2

(416) 425-6510

Les Usherwood
President and Director

Two new Typeface Designs by Leslie Usherwood.

SAXONY ROMAN. Cool. Crisp. Classic with a large x height for excellent readability. That's the new Saxony Roman design. Available in 4 weights: Light, Book, Medium & Bold. Matching italics for Saxony Roman will be available March, 1983.

DENBY ROMAN. A warm, friendly soft serif typeface now available on Letraset dry transfer sheets and soon to be available in text composition from your favourite Typographer. 2 weights: Light and Medium. With 2 heavier weights forthcoming. Plus a full complement of italic fonts to match the Roman.

We always lead with our faces.

Typsettra Limited, 94 Laird Drive, Toronto, Ontario M4G 3V2 Canada. Telephone (416) 425-6510.
Typeface Designers for international markets e.g. The International Typeface Corporation,
The Berthold Type Foundry & Compugraphic Corporation.

**The Arthur Press
(1978) Limited**
1766 Weston Road
Weston, Ontario
M9N 1V8
(416) 241-4676

Take a closer look . . .
Are you boxed in by constant budget restraints?
Do you demand excellence?
Are you hammered with impossible deadlines?
Do your present suppliers measure up?
Remove the question marks from your purchasing puzzle!
. . . **Look no Further**

Westport Press Limited
75 West Drive
Bramalea, Ontario
L6T 2J6

(416) 457-7119

Ralph Walback
Paul Hannam

We are sales promotional printers satisfying the needs of both agencies and clients for matchless quality and service at controlled cost.

In house facilities to produce sales literature, custom presentation kits, point of sales posters, shelf talkers, counter displays and specialty promotions such as custom games and jigsaw puzzles for premiums and incentives.

Everything we do at Westport Press, be it design, printing, diecutting, lamination or assembly will always feature our matchless quality and service.

6

**Jones & Morris
Photo-Enlarging Limited**
24 Carlaw Avenue
Toronto, Ontario
M4M 2R7

(416) 465-5466

Tim Morris

Quality large format photographic work for Retail, Exhibit, Display and all other major installations.

State-of-the-art technology **and** environment
The ideal partnership

Jones & Morris have moved to a new, larger facility with easy routing to Lakeshore Blvd. and the Don Valley Parkway. A covered shipping area, fast-job, drop-off access area and parking facilities are available.

The entire production area is on one level to speed your project to completion. Processes, humidity, temperature and lighting levels are strictly controlled to help guarantee consistent, high-quality results on your order.

We believe that with the high technology available today, it is our duty to incorporate any sound principle into the manufacture of our products. We have attempted to do this as well as provide for future developments. In creating a quality-controlled, cost-efficient product with fast turn around, we will be here to serve you tomorrow and the day after.

Now full-colour photographic enlargements 72″ x any length in a single sheet.

This revolutionary new wide format is available to you. It is the first such installation in Canada. Until now, 48″ x 96″ was the industry standard. Routine production using same scale format on the new wide product is 72″ x 144″. Longer lengths when required. Be among the first to offer your clients a new larger format in a single sheet.

Jones & Morris 24

Ontario

Photo Laboratories

Aperture
Custom Black & White
Photo Labs
40 Lombard Street
Suite 203
Toronto, Ontario
M5C 1M1

(416) 368-0583

Howard Mandel

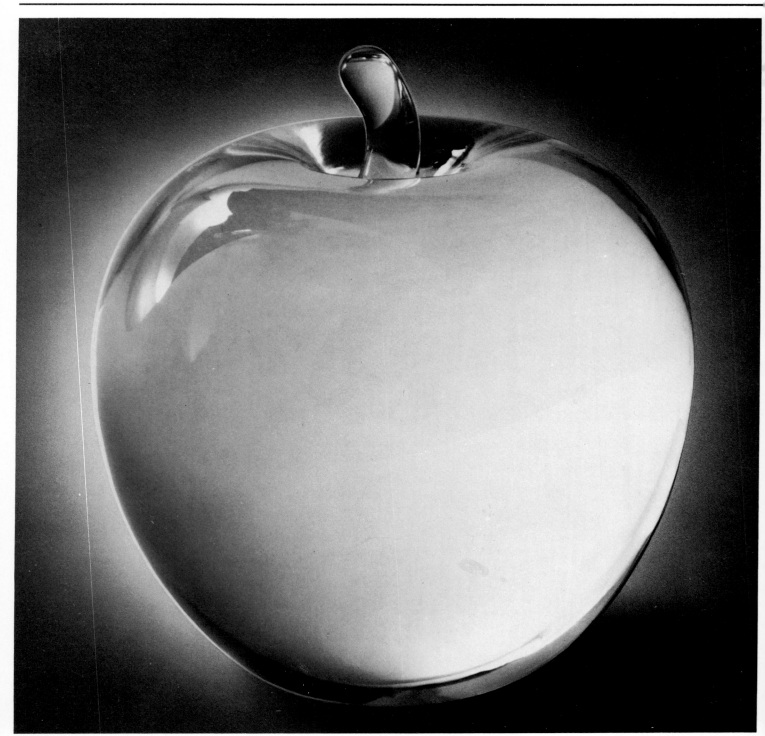

Henry Yee Photography
473 Cosburn Avenue
Toronto, Ontario
M4J 2N6
(416) 423-4883

Henry Yee
Studio Laboratories
473 Cosburn Ave.
Toronto M4J 2N6 (416) 423-4883

Henry Yee is a modest fellow who nevertheless runs possibly the best personal black & white lab in Canada. A list of Henry's clients is a Who's Who in the communications world. Photographers, art directors, editors, film producers—professionals who want and recognize excellence—are his best customers. Henry's lab is amazing. Films are individually inspected and prints are subject to his own rigid quality control. "I've got to satisfy myself before a print leaves my place." He offers **complete** black & white lab services: internegatives from B&W or colour, custom film processing, and precision printing with subtle tones and sparkling highlights that will bring joy to your eyes. Service and quality such as this comes only from someone who cares. His work proves it.

KODAK SAFETY FILM 5

27A → 28

Photo Laboratories

Ontario

**ABL Photographic
Techniques Ltd.**
1336-11 Avenue, S.W.
Calgary, Alberta
T3C 0M6

(403) 245-6626

Ron Berglund

A highly competitive photo lab in the Calgary commercial and industrial market, ABL provides quality next-day service, which has made it the premier choice for the city's result-oriented advertising and promotion industries.

Colorific Photo Labs Ltd.
(111 West 2nd Ave.)
P.O. Box 9550
Vancouver, B.C.
V6B 4G3

(604) 879-1511

Innovation. Knowledge. Experience. **COLORIFIC** offers new and exciting ideas in creative custom lab work. The staff at **COLORIFIC** recognizes both corporate and individual needs.

DURATRANS — latest display print film from Kodak
COLORGRAPHICS — unique process for individual creations
MURALS — our largest to date: 10' × 68'

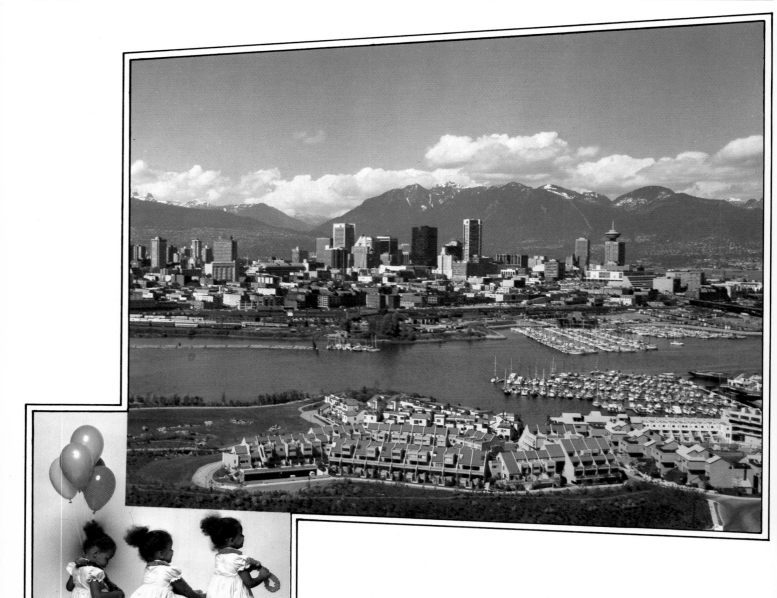

(613) 523-0925

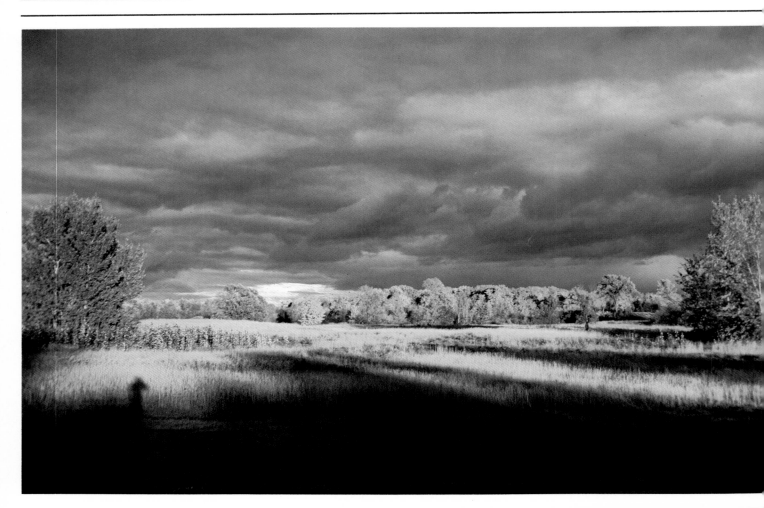

Hot Shots
Stock Shots Inc.
309 Lesmill Rd.
Toronto, Ontario
M3B 2V1

(416) 441-3281

HOT SHOTS *"Take One"*
20–second

ANNCR (VO): What's so *hot* about **HOT SHOTS**…?

Their diversified collection of superb stock photographs.

Their speed and efficiency in handling any photo request.

Their confidential and personalized approach to each project.

Their helpful staff, comfortable premises and easy access.

That's what is so *hot* about **HOT SHOTS.**

**Image Finders
Photo Agency Inc.**
134 Abbott Street
Suite 501
Vancouver, B.C., Canada
V6B 2K4

(604) 688-9818

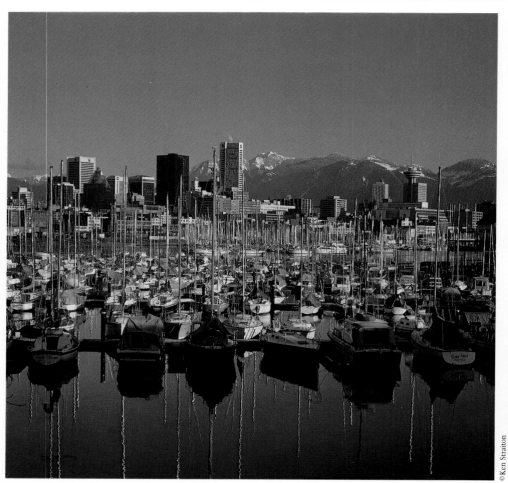

©Ken Straiton

©Chuck O'Rear

©Chuck O'Rear

Creativity. Selection. Outstanding quality. Immediate availability. Four practical reasons to call Image Finders. The other 300,000 reasons form one of the most extensive and creative stock photo libraries in North America, including the finest selection of Western Canadiana anywhere. Choose from 181 subject categories from Agriculture to Zoos; 62 countries from Andora to Zimbabwe. And we'll air express the material you need for next-day reviewing. Need an out-of-season shot? Facing an impossible deadline? Call us. Our phone lines are open 24 hours a day.

© Craig Aurness

© Craig Aurness

© Image Finders

© Robin Smith

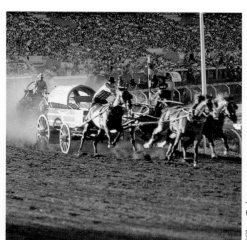

© Glenn Tooke

Western Canada

Stock Photography

The Stock Market Inc.
93 Parliament Street
Suite 228
Toronto, Ontario

(416) 362-7767

The Perfect Shot
You want it – we've got it!

Representing many of Canada's finest photographers
with images from around the world,
the Stock Market sets a new standard of excellence
in both photography and service.

The Perfect Shot
You want it – you've got it!

The Stock Market Inc.
a library of photographic excellence.

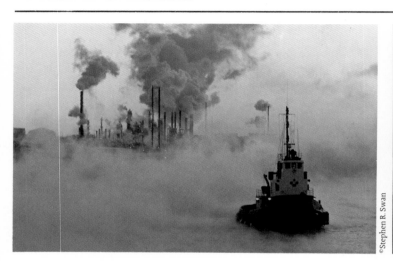

©Stephen R. Swan

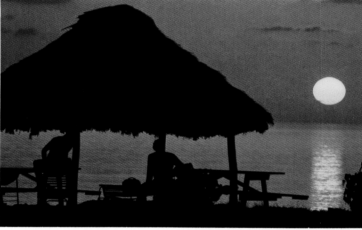

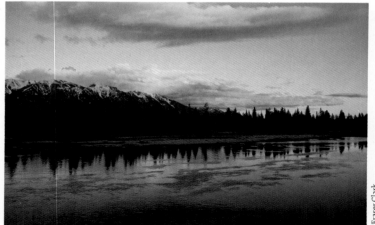

©Fraser Clark

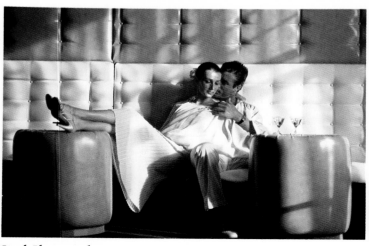

©Myron Zabol

The Stock Market Inc.
93 Parliament Street
Suite 228
Toronto, Ontario

(416) 362-7767

©Jeanette Dunke

©Cosmo Condina

©John J. Wood

©James R. Virgin

©Thom Burstyn

Stock Photography

236

Creative Source 4

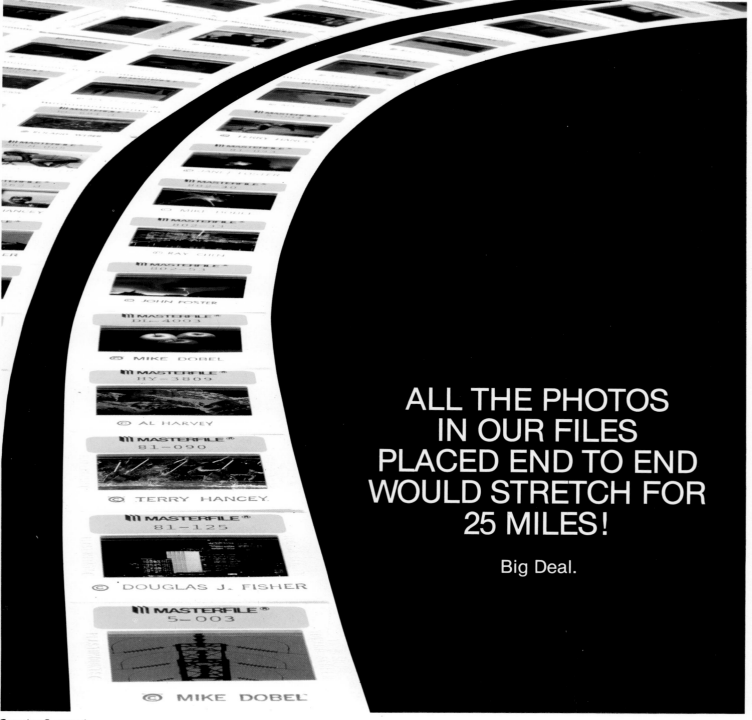

ALL THE PHOTOS
IN OUR FILES
PLACED END TO END
WOULD STRETCH FOR
25 MILES!

Big Deal.

Masterfile
Stock Photo Library
2 Carlton Street
Suite 617
Toronto, Ontario
M5B 1J3

(416) 977-7267

Japan
Imperial Press
Roppongi Plaza
1-1-26 Azabudai
Minato-Ku, Tokyo 106
Tel.: 585-2721
Attn.: Dave Jampel

United Kingdom
The Daily Telegraph
Colour Library
Gordon House
75-79 Farringdon Street
London EC4A 4BL
Tel.: 01-353-4242
Attn.: Helen Thorburn

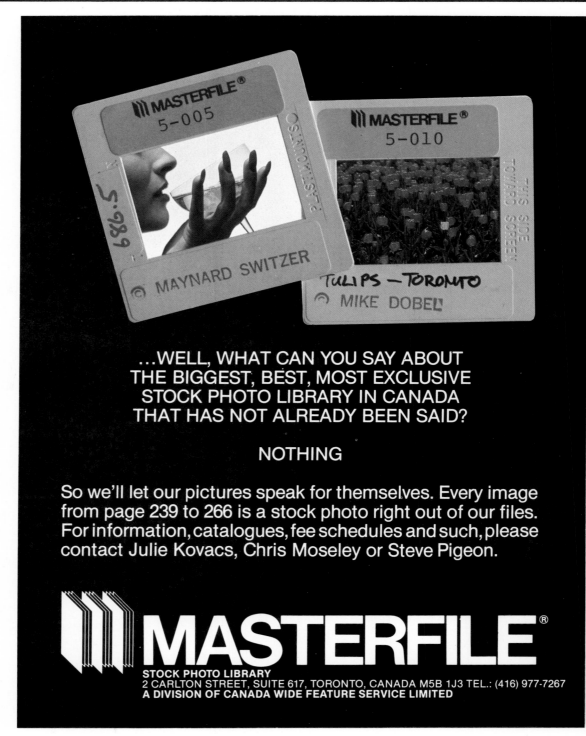

…WELL, WHAT CAN YOU SAY ABOUT
THE BIGGEST, BEST, MOST EXCLUSIVE
STOCK PHOTO LIBRARY IN CANADA
THAT HAS NOT ALREADY BEEN SAID?

NOTHING

So we'll let our pictures speak for themselves. Every image
from page 239 to 266 is a stock photo right out of our files.
For information, catalogues, fee schedules and such, please
contact Julie Kovacs, Chris Moseley or Steve Pigeon.

MASTERFILE®
STOCK PHOTO LIBRARY
2 CARLTON STREET, SUITE 617, TORONTO, CANADA M5B 1J3 TEL.: (416) 977-7267
A DIVISION OF CANADA WIDE FEATURE SERVICE LIMITED

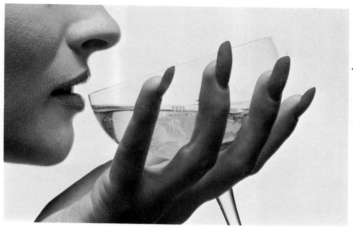

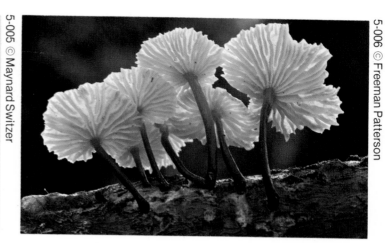

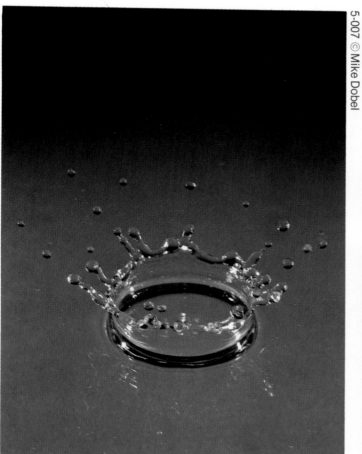

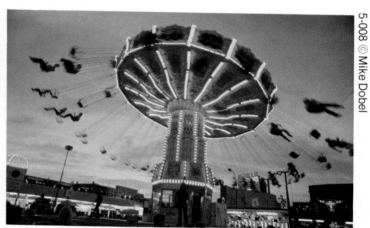

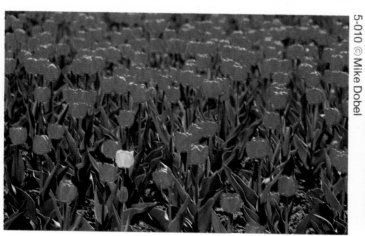

5-023 © Bill Staley

5-024 © Mark Tomalty

5-025 © Hans Blohm

5-026 © John Foster

5-027 © Bill Brooks

5-028 © Freeman Patterson

5-029 © Freeman Patterson

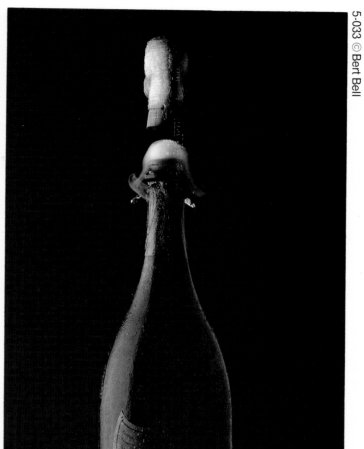

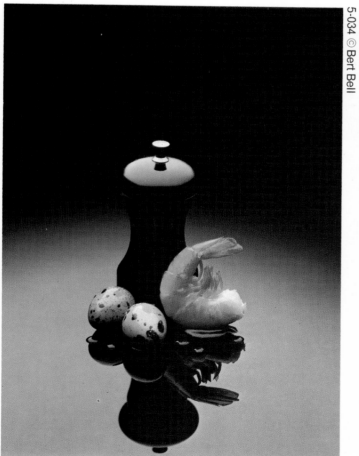

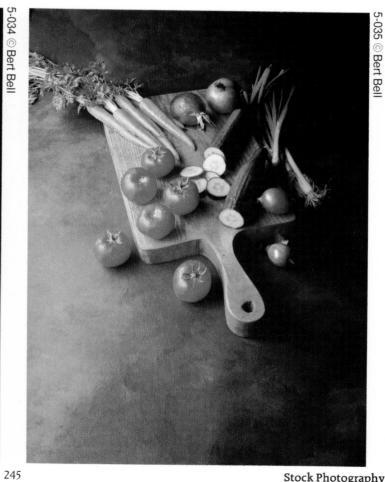

Stock Photography

5-036 © Mike Dobel

5-037 © Roland Weber

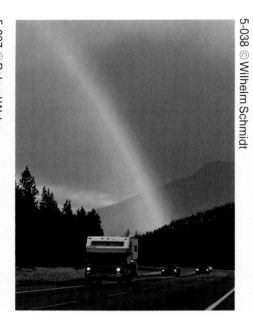

5-038 © Wilhelm Schmidt

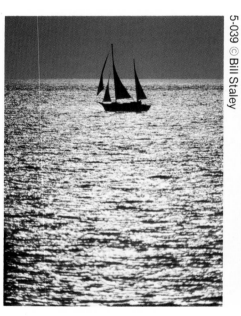

5-039 © Bill Staley

5-040 © Mike Dobel

5-041 © John de Visser

5-042 © Maynard Switzer

5-043 © Mike Dobel

5-044 © Mike Dobel

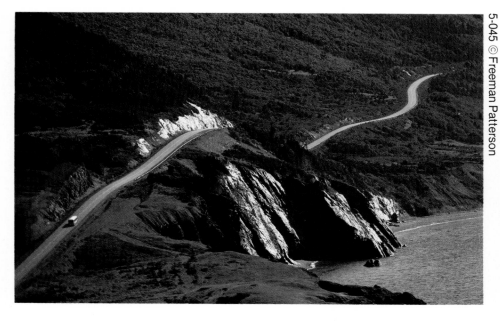

5-045 © Freeman Patterson

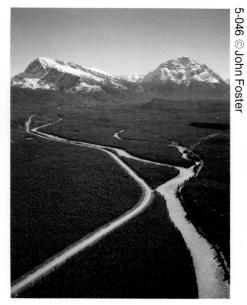

5-046 © John Foster

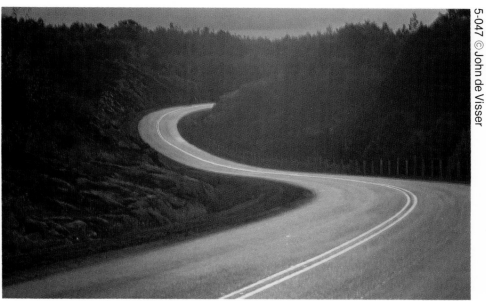

5-047 © John de Visser

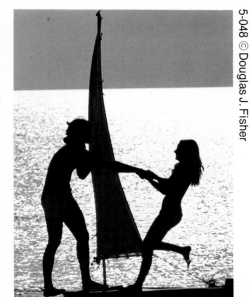

5-048 © Douglas J. Fisher

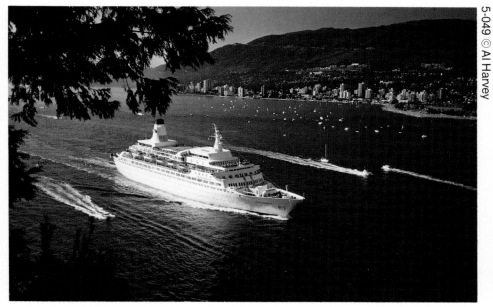

5-049 © Al Harvey

5-050 © Roland Weber

5-051 © Maynard Switzer

5-052 © John Foster

5-053 © Mike Dobel

5-054 © Roland Weber

5-055 © Mike Dobel

5-056 © Terry Hancey

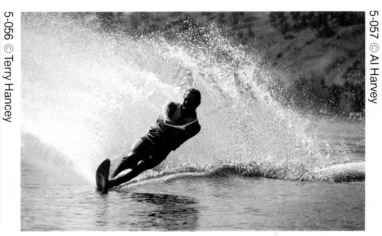

5-057 © Al Harvey

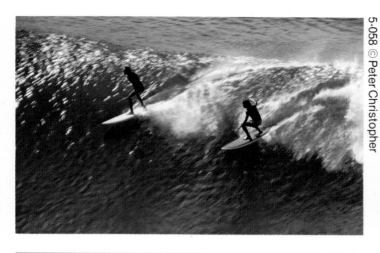

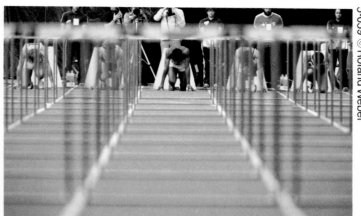

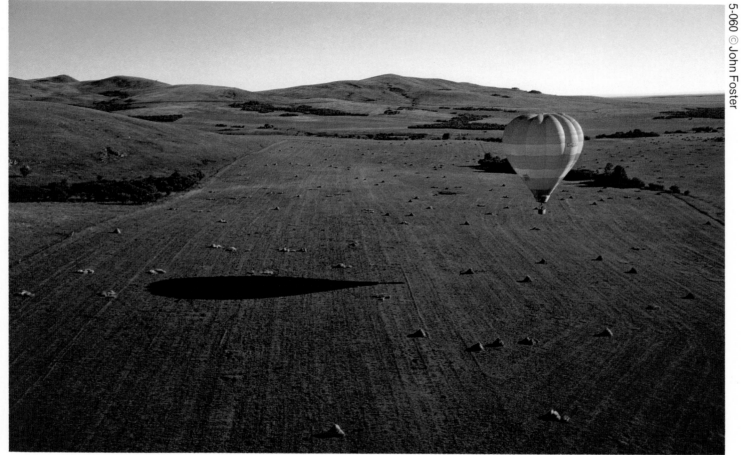

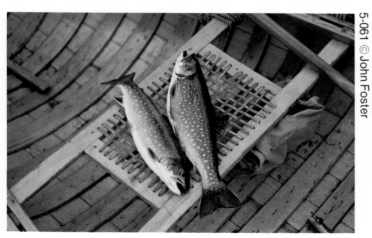

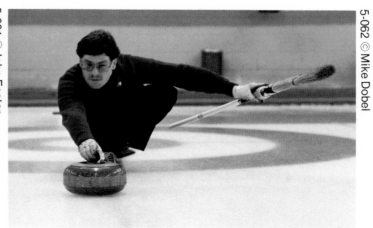

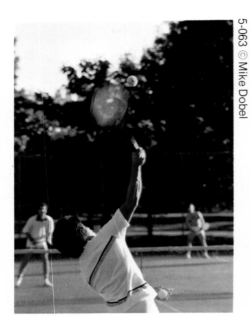

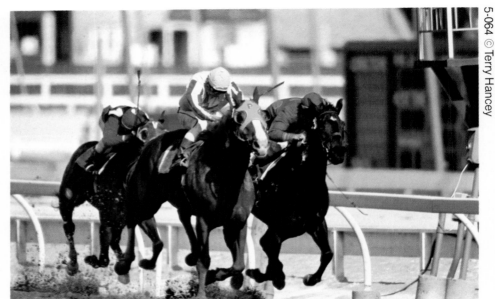

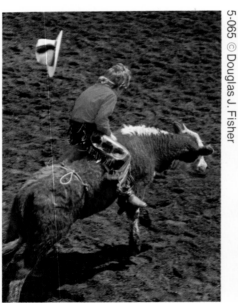

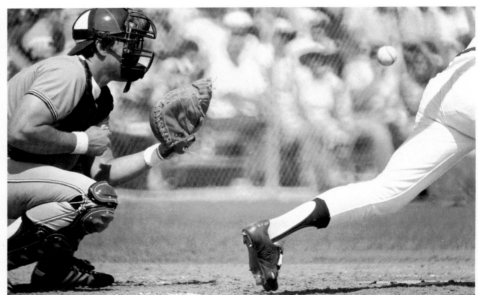

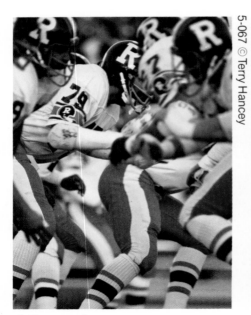

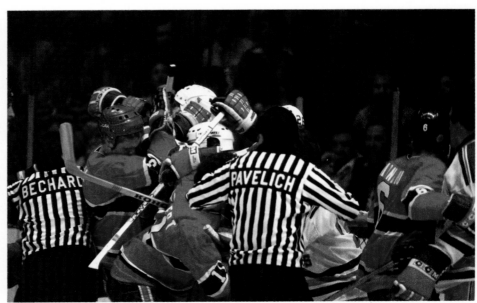

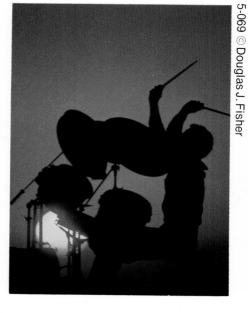

5-069 © Douglas J. Fisher

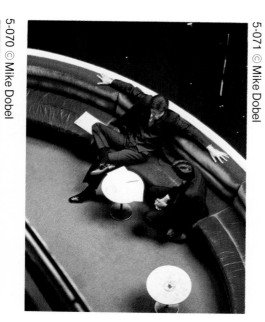

5-070 © Mike Dobel

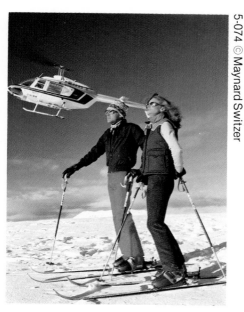

5-071 © Mike Dobel

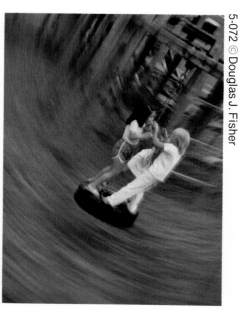

5-072 © Douglas J. Fisher

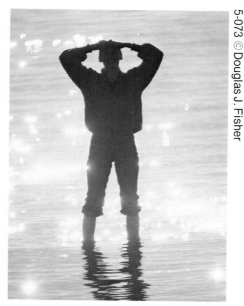

5-073 © Douglas J. Fisher

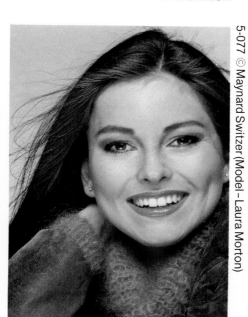

5-074 © Maynard Switzer

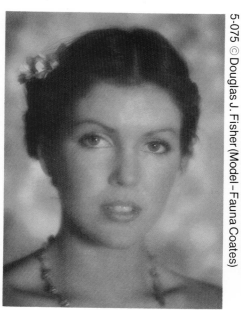

5-075 © Douglas J. Fisher (Model – Fauna Coates)

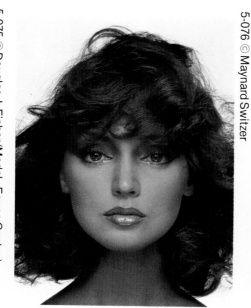

5-076 © Maynard Switzer

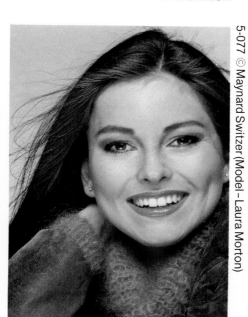

5-077 © Maynard Switzer (Model – Laura Morton)

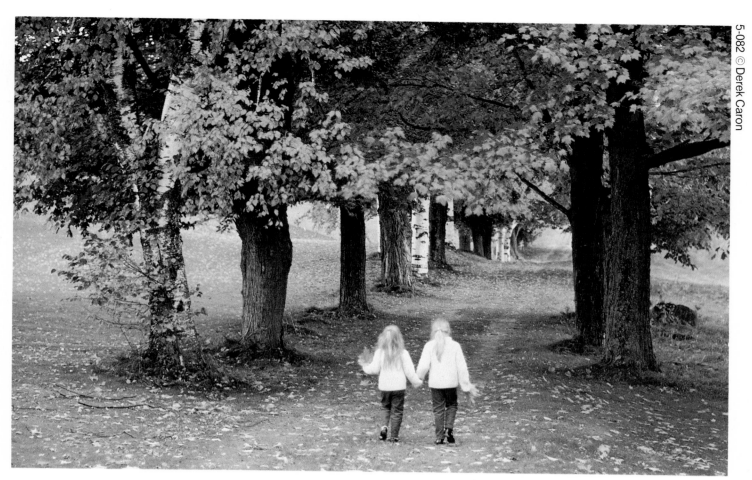

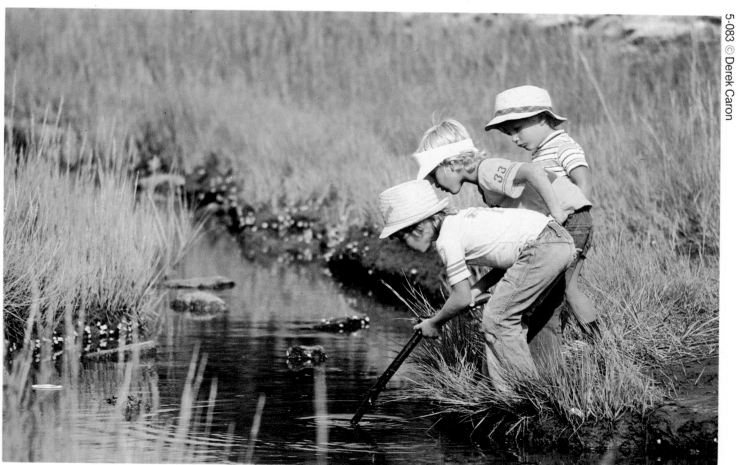

Masterfile, Toronto (416) 977-7267

Stock Photography

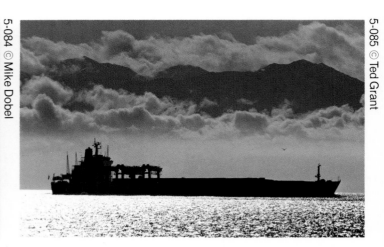

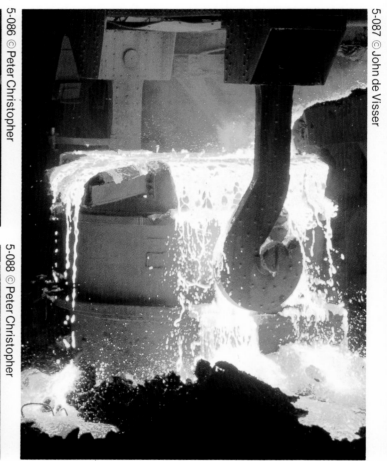

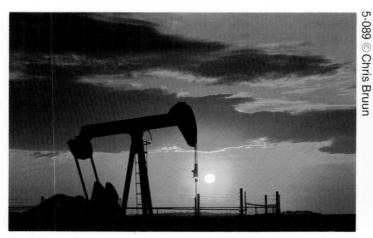

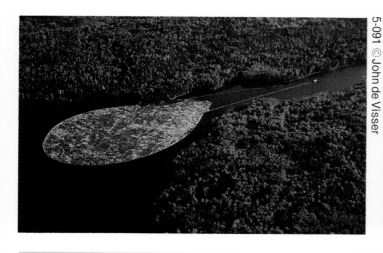

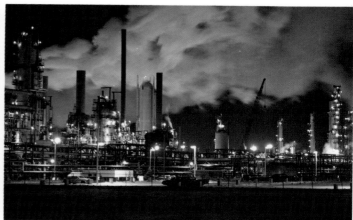

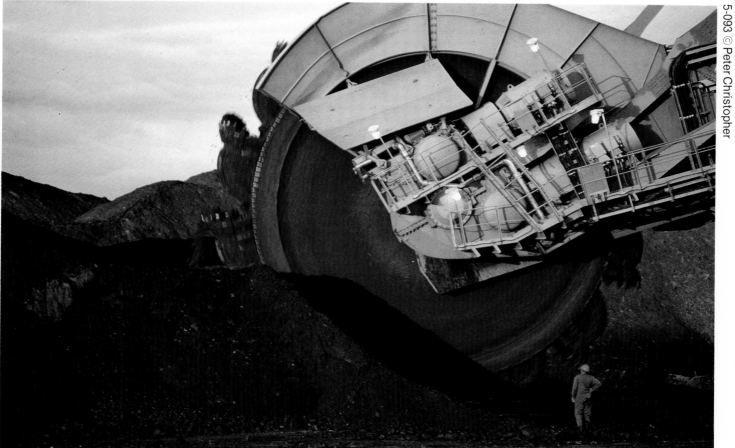

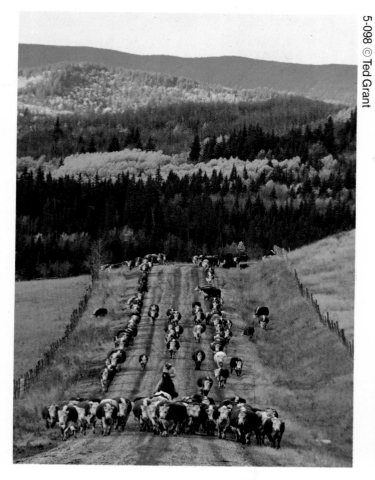

5-098 © Ted Grant

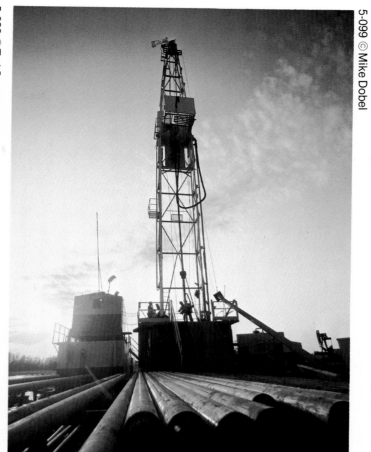

5-099 © Mike Dobel

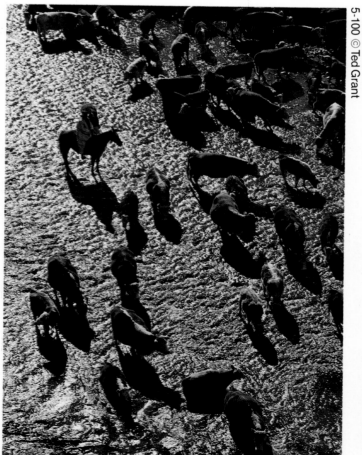

5-100 © Ted Grant

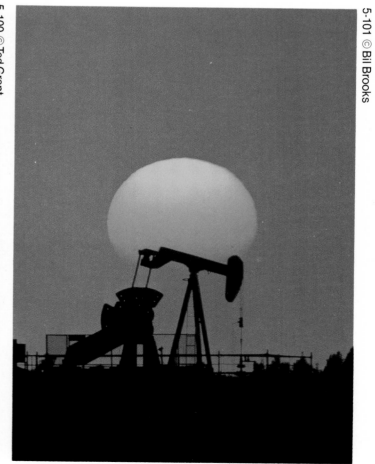

5-101 © Bil Brooks

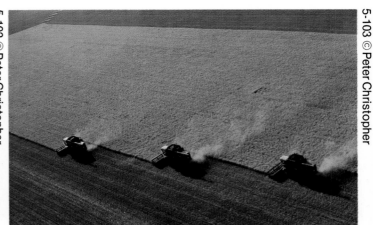

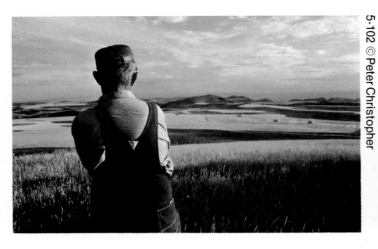

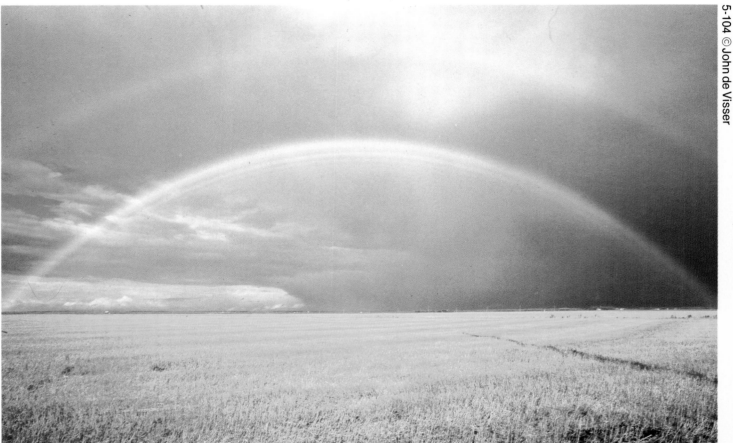

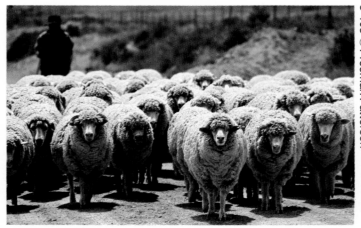

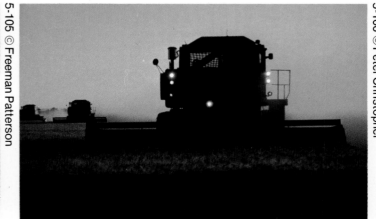

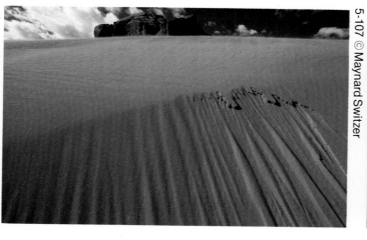

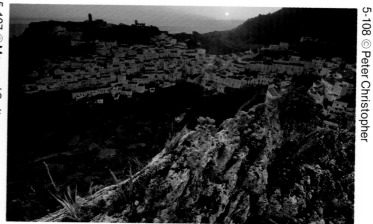

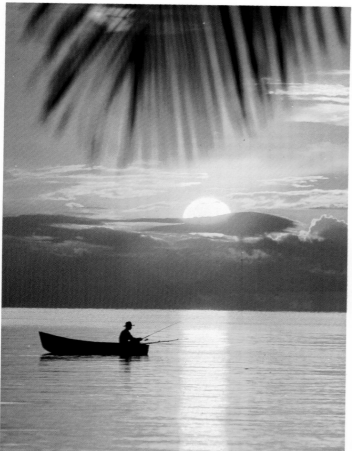

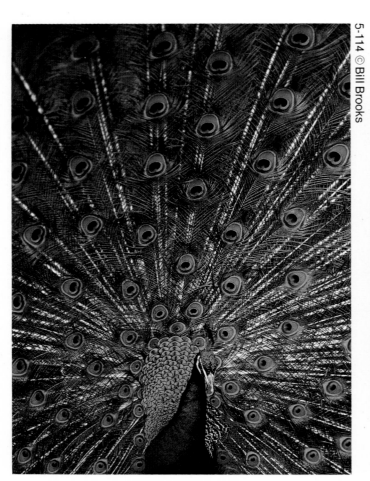

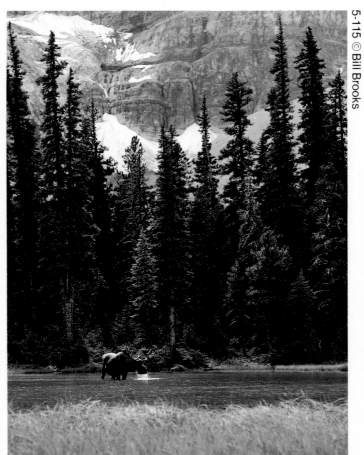

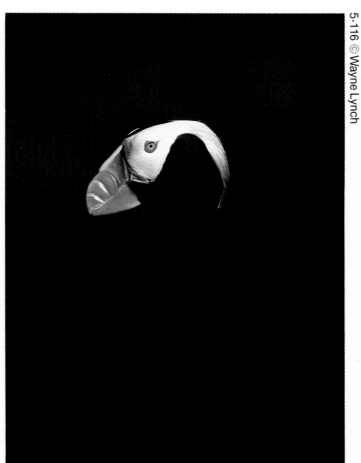

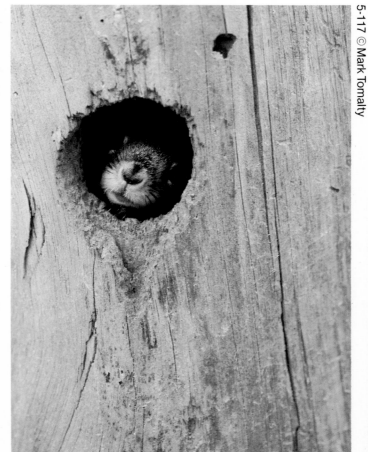

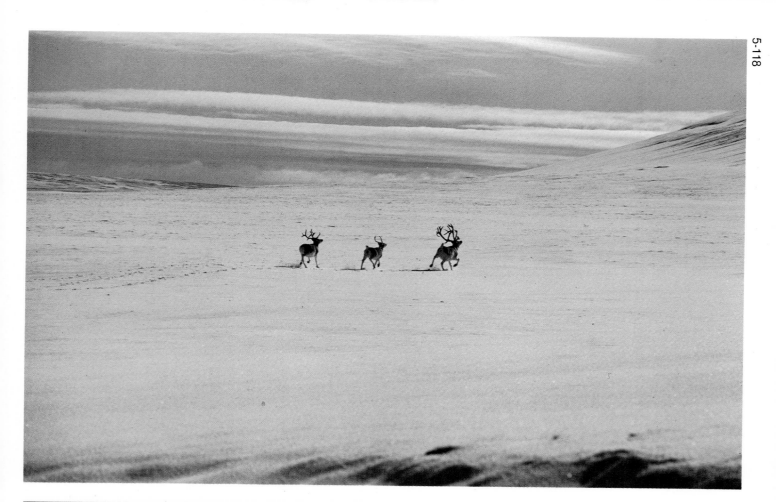

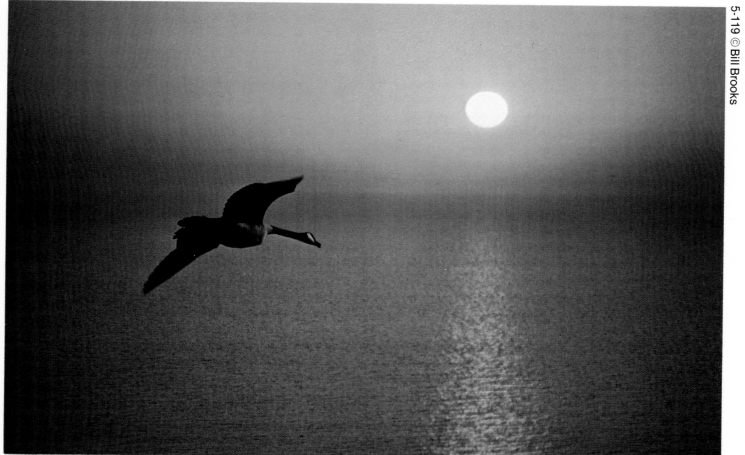

Stock Photography

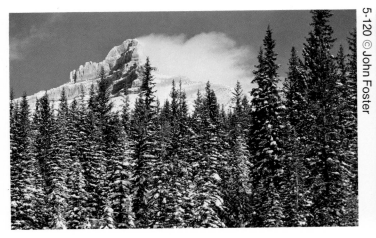

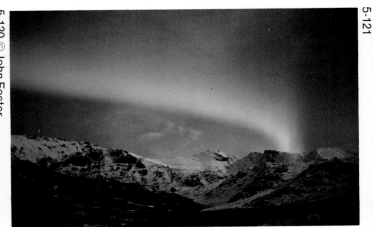

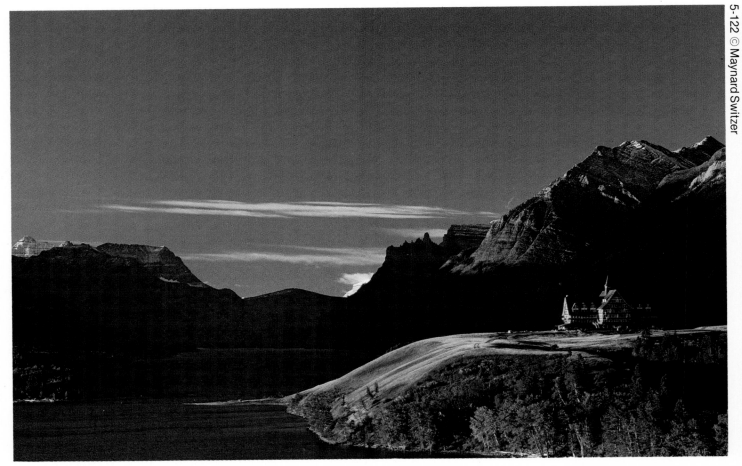

5-126 © John de Visser

5-125 © John de Visser

5-127 © Bill Brooks

5-128 © Derek Caron

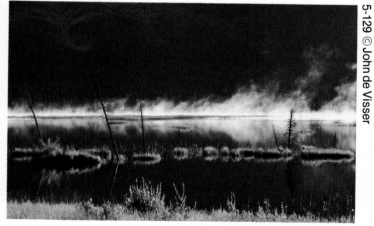

5-129 © John de Visser

5-130 © Freeman Patterson

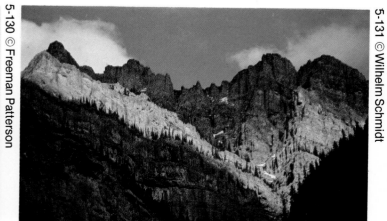

5-131 © Wilhelm Schmidt

Masterfile, Toronto (416) 977-7267

263

Stock Photography

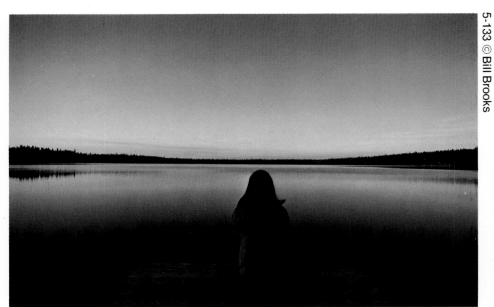

5-133 © Bill Brooks

5-132 © Barrett & MacKay

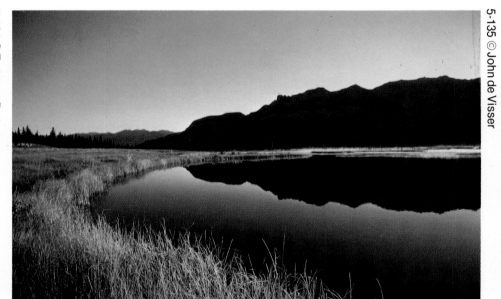

5-135 © John de Visser

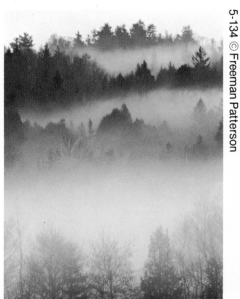

5-134 © Freeman Patterson

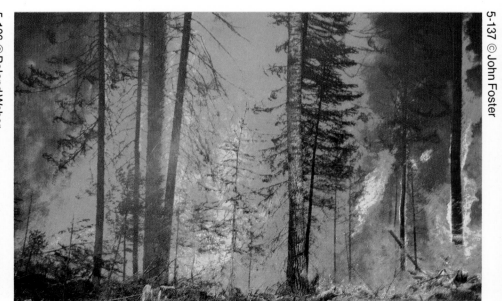

5-137 © John Foster

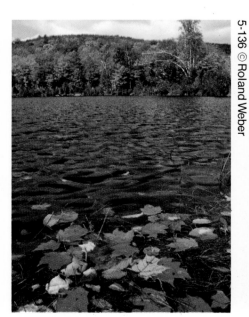

5-136 © Roland Weber

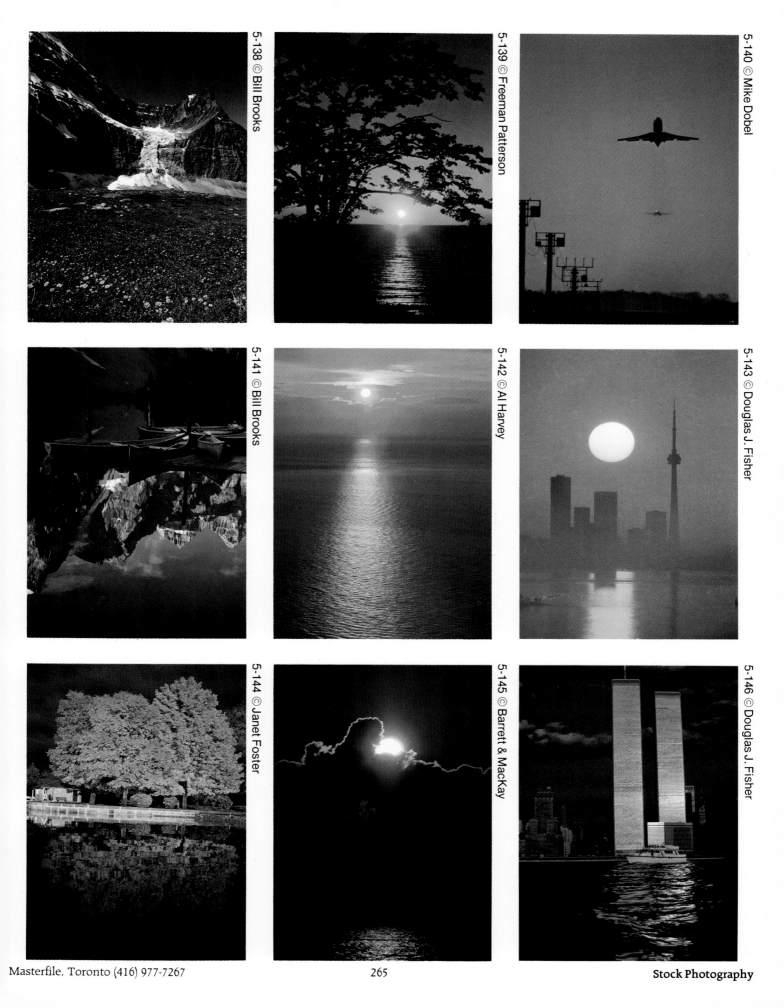

5-138 © Bill Brooks

5-139 © Freeman Patterson

5-140 © Mike Dobel

5-141 © Bill Brooks

5-142 © Al Harvey

5-143 © Douglas J. Fisher

5-144 © Janet Foster

5-145 © Barrett & MacKay

5-146 © Douglas J. Fisher

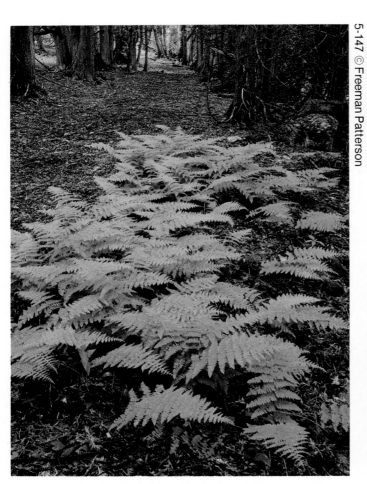

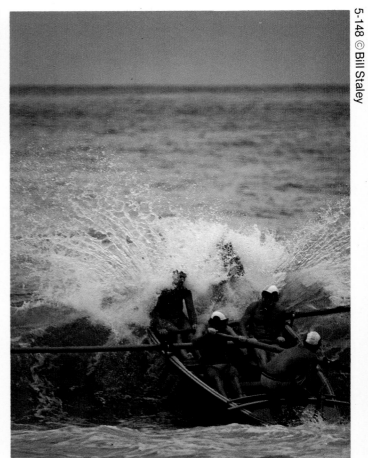

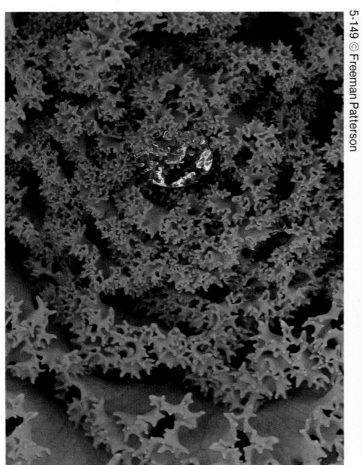

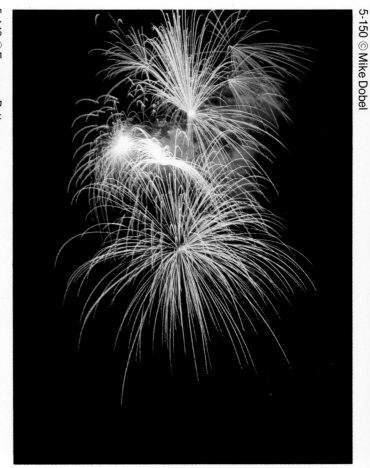

DIRECTIONS

The 1982
Toronto Art Directors
Show Annual

Each Annual of the Toronto Art Directors Show has recorded excellence, new directions, and something of the times in which it was produced. This year's is no exception, and clearly demonstrates the tremendous growth and change that have taken place in our industry since the beginning of the Art Directors Club of Toronto in 1947. Collected and bound are the best of the past year's advertising, editorial and graphic design as exhibited in the 1982 show *Directions*. The theme reflects the trend of the 80s, not a single dominating style but a variety of directions ranging from traditional to contemporary. The show and Annual are larger than ever before, an indication of the recognition of the importance of excellence in a very competitive and increasingly enlightened environment.

We would like to thank our judges:

- **John Berg**, Vice President at CBS Records in New York

- **David Davidian**, Creative Director at Foote, Cone & Belding in New York

- **Martin Pederson**, partner at Jonson, Pederson, Hinrichs & Shakery in New York

- **Tony Hillyard**, owner of Tony Hillyard Advertising in New York

- **Doug Linton**, Creative Director and partner at Ambrose, Carr, DeForest & Linton in Toronto

- **Louis Fishauf**, Art Director at Saturday Night Magazine, and partner at Reactor Art and Design in Toronto

- **Malcolm Waddell**, partner at Eskind Waddell in Toronto

- **Marlene Hore**, Creative Director at J. Walter Thompson in Montreal

and the following, for contributing their time and talents:

- Taylor & Browning Design Associates for designing all the *Directions* material

- Holland & Neil for printing our *Directions* poster

- Arthurs-Jones for printing the call for entries

- M.C. Charters for producing our awards certificates

- Cooper & Beatty for typesetting all the *Directions* material

- York University for providing facilities for the judging

- the students at York, particularly Peter Wong, for assisting at the judging

- Brian Smale for photographing our judges

- and last, but certainly not least, the hard working members of the Toronto Art Directors Club executive.

To all of you, our thanks!

Ursula Kaiser

President, The Art Directors Club of Toronto

John Berg

David Davidian

Martin Pederson

Tony Hillyard

Doug Linton

Louis Fishauf

Malcolm Waddell

Marlene Hore

1. **Magazine Cover**
Art Director: Derek Ungless
Illustrator: Marshall Arisman
Designer: Bruce Ramsay
Publication: Saturday Night Magazine
Company: Saturday Night Publishing

Gold

Gold

2. **Complete Book Design**
Designer: Howard Pain
Art Director: Howard Pain
Artist: Kenojuak
Company: Break Pain & Associates
Client: The Mint Mark Press

2

3. **Trade Magazine Ad**
Art Director: Gary Carr
Writer: Doug Linton
Photographer: Anzalone McLeod Shanoff
Creative Directors: G. Carr/D. Linton
Agency: Ambrose, Carr, DeForest & Linton
Client: Comac Communications Ltd.

Gold

IF YOU'RE SELLING COSMETICS, 'TOTAL READERS' AREN'T ALL THEY'RE MADE UP TO BE.

It's probably not news to you.

Especially if you're a media planner or account executive on a cosmetics account. Or a marketer at a cosmetics company.

If you're marketing cosmetics, you already understand the importance of targeting right at your audience. The more accurate you are at directing your message, the better off you'll be.

You want to reach contemporary, urban women with money to spend on your products.

You want to hit home with the Homemaker's Magazine reader.

Because Homemaker's reaches the top 33 urban markets where key department store and drug chains concentrate their activity.

Mid to upscale women in 1,640,000 Canadian households, the top Canadian households, receive Homemaker's/Madame au Foyer. 96% of our circulation is directed into population centres with over 100,000 people.

To be more specific: in Canada's top 24 urban markets with 100,000+ population, Homemaker's/Madame au Foyer's major market circulation is more than twice as high at Chatelaine/Châtelaine.*

Homemaker's is the largest circulation magazine directed to women. On a comparative basis, the Homemaker's reader offers a greater average income, higher major market concentration and a stronger 18-49 audience profile than either Chatelaine or Flare.**

As well, Homemaker's delivers the greatest concentration of Canada's working women. About 50% of Homemaker's women readers work out of home versus about 40% for Chatelaine.**

Homemaker's means primary readers in urban markets. And for the most part, you can't get to them in any other women's book. About 80% of Homemaker's readers don't read Chatelaine. Over 95% of them don't read Flare.**

If you'd like more women who care about the kind of face they show to the world, it's time you targeted at key major markets first, urban women before rural. It's time you make Homemaker's your base buy.

We've got an award winning fashion/beauty editorial environment for you to pick your position in.

Get in touch with us soon. Find out all about why Homemaker's/Madame au Foyer is your best way to reach more of the right women. We're just about all we're made up to be.

Homemaker's
IT HITS HOME.

COMAC COMMUNICATIONS LIMITED, PUBLISHERS OF HOMEMAKER'S MAGAZINE, MADAME AU FOYER, QUEST AND CITY WOMAN.

3

Gold

4. **Magazine Section**
Art Directors: James Ireland/
 Barbara Solowan
Photographers: Tom Skudra, Arnaud
 Maggs, Deborah Samuel, Masao Abe,
 Gordon Hay, Bert Bell
Designer: Barbara Solowan
Publication: Toronto Life Magazine
Company: Toronto Life Publishing
 Company

VISIONS OF SIX

For some unknown, and certainly undemocratic, reason, magazines traditionally award conspicuous bylines to their writers—and shove the photography credits off sideways on page borders, consistently in letters too small to read anyway. Finally, as part of the celebrations, we are happy to give credit and recognition to the artists whose visions of Toronto appear on the next six pages. Arnaud Maggs, 55, was an illustrator and graphic designer before he took up photography at 40. He was a leading fashion photographer during the '60s and now has a Canada Council grant to shoot portraits of major people in the arts. A recent subject: Yousuf Karsh. Tom Skudra, 35, is known for his excellent work in black and white photojournalism. He has exhibited photographs from the Canadian rodeo circuit and is now working on a series called Women in Cars to be shown in Toronto, England, France and Germany. Deborah Samuel, 25, has studied at the Limerick School of Art and Design in Ireland and is a graduate of Sheridan College's applied photography course. She specializes in fashion but also enjoys "being allowed to run with an idea" for a rock album cover. See the last three Rush covers for examples of her work. Masao Abe, 41, came to Toronto from Japan in 1967 and studied still photography at Ryerson. Known as a highly creative studio photographer, especially with food, Abe likes variety—as long as it doesn't include fashion. Gordon Hay, 43, came to Toronto in 1967 from England where he had studied photography in Liverpool. He has been a leader in Canadian fashion photography for ten years; a major recent project was *George Abbott's Women in Canada, as Photographed by Gordon Hay,* which features 100 glamorous makeovers of such celebrities as Margaret Atwood, Barbara Frum and Karen Kain. Bert Bell, 43, studied at the American Institute of Graphic Arts in New York City. He is versatile, strong with people and well-known for his elegant still lifes. Bell is now working on a series of black and white portraits for exhibition this fall.

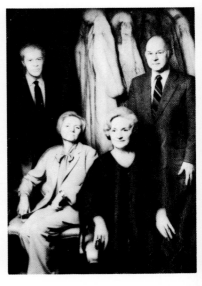

4

5. Advertising Poster Campaign
Designer: Michael McLaughlin
Art Director: Michael McLaughlin
Photographer: Stephen Yeates
Client: The Partners' Film Company

Gold

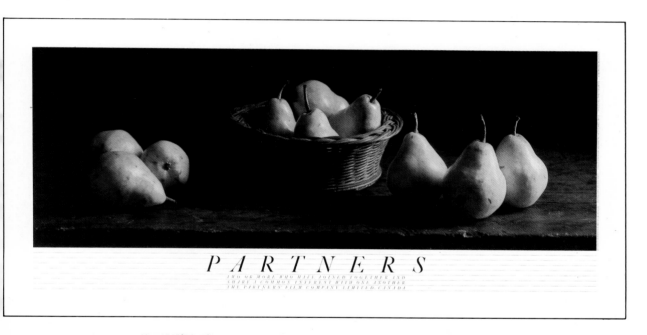

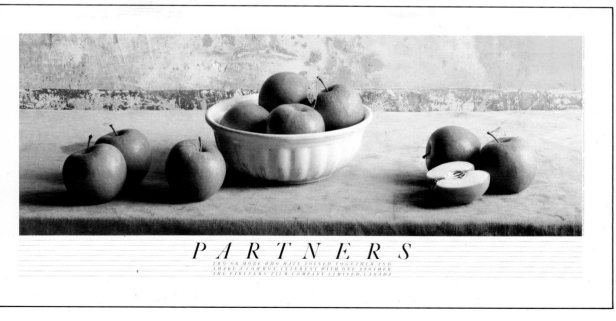

5

Gold

6. "Speaking Mimes"
Consumer Commercial

Art Director: Ben Stackhouse
Writer: Erik Copplestone
Creative Director: Tony Houghton
Agency Producer: George Archer
Agency: Ogilvy & Mather
Client: "Shell Helps" Books
Director: Ian Leech
Cameraman: George Morita
Production House: Partners'
Music/Sound: Les Mimes Electriques

7. Radio Commercial
Writer: Martin Keen
Creative Director: Martin Keen
Agency Producers: Marylu Jeffery
Client: CN Tower
Production House:
Street Noise Productions
Music/Sound: Stock

6. "Speaking Mimes"
Outdoor sounds. Birds. Car door opening.
Car door shuts. Car starting.
Caughing. Hesitating. Racing.
Backfiring. Conks out.
Car door opens and shuts. Scratching his
head. Muttering to himself.
Car hood opening. More muttering.
ANNCR. V.O.: If you want to improve
your engine's performance, and save
yourself money too...read the Shell Tune
Up book. Car hood shuts.
ANNCR. V.O.: Before a small noise
becomes a big expense.
Engine starts. Engine runs in perfect
tune. Engine running. Breakthrough.
ANNCR. V.O.: Shell helps.

7. "Mimico"
SITUATION: A 30 YEAR OLD COUPLE
HAVING DINNER.
MUSIC: QUIET DINNER MUSIC.
SFX: ELEGANT DINING SOUNDS.
MAN: More wine Charlene. It is
Charlene, isn't it? Oh look over there...
Mimico...it gets in your blood...it's
alive...it's everything a borough should
be...
GIRL: (Sings to tune of "Chicago")
Mimico...Mimico...it's my kind of town.
MAN: Making a little tune out of it...
that's great. Oh look...Mississauga...the
corner of Dixie and Bloor...the hustle-
bustle...the lights of the plaza...
GIRL: (Tune of "San Francisco")
I left my heart in Mississauga...
MAN: That's very good... you're getting
good at that. Oh look, you talk about
Paris, Rome...there's North York... the
theatres... the four-storey buildings...
I can't get enough of it.
GIRL: (Tune of "New York, New York")
If I can make it there, I'll make it
anywhere... it's up to you North York,
North York.
ANNCR: You haven't seen it all until
you've seen it from the CN Tower. The
Top of Toronto Restaurant. Sparkles
Nightclub. There is no place like it on
earth.
MAN: What can you do with Etobicoke?
GIRL: Don't say a word...
(To the tune of "Constantinopole") "It's
not Istanbul, it's Etobicoke".
MAN: Waiter...
GIRL: (To tune of "Wait a Minute Mr.
Postman") Wait a minute Mr. Waiter...
Is there a glass of wine for me...

8. Editorial Illustration
Art Director: Rob Melbourne
Illustrator: Joe Salina
Designer: Rob Melbourne
Publication: Today Magazine
Company: Southstar Publishers Ltd.

Silver

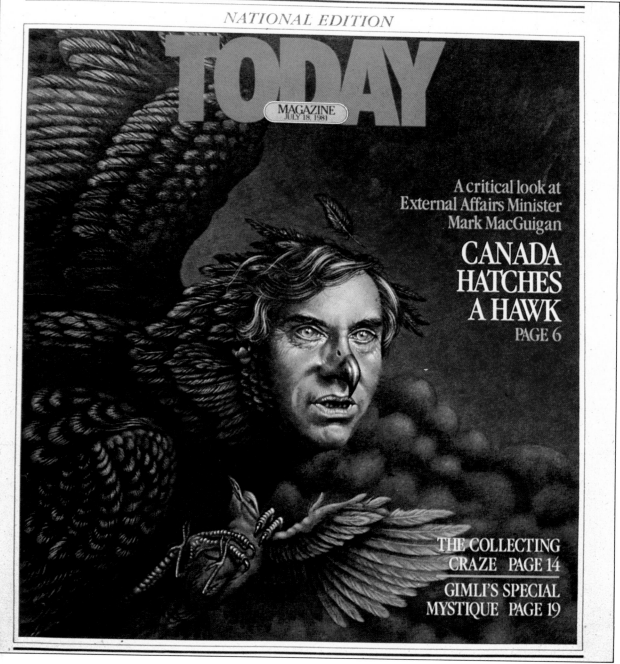

Silver

9. Editorial Illustration
Art Director: Stephen Costello
Illustrator: Anita Kunz
Designer: Arthur Niemi
Publication: Quest Magazine
Company: Comac Communications Ltd.

10. Editorial Illustration
Art Director: Arthur Niemi
Illustrator: Miro Malish
Designer: Mary Opper
Publication: Quest Magazine
Company: Comac Communications Ltd.

9

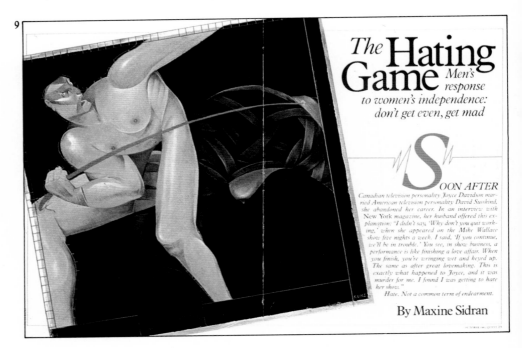

10

11. **Editorial Illustration**
Art Director: Stephen Costello
Illustrator: Donna Muir
Designer: Arthur Niemi
Publication: Quest Magazine
Company: Comac Communications Ltd.

Silver

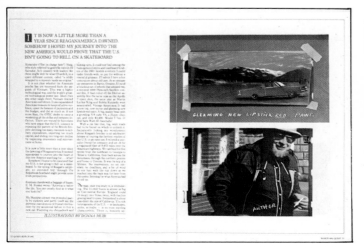

Silver

12. **Graphic Design Illustration**
Illustrator: Philippe Beha
Art Director: Philippe Beha
Client: Editions Québec/Amérique

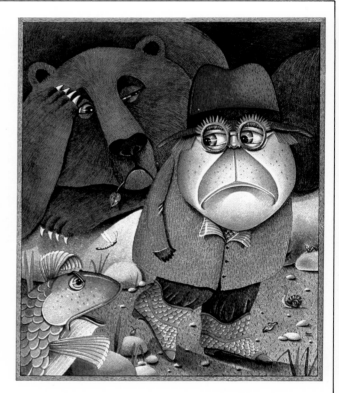

*I*L AVAIT
UN VISAGE
*qui ressemblait étrangement
à celui d'un poisson.
Son corps était parsemé d'écailles
et ses mains étaient velues
comme celles d'un ours.
Il portait souvent des lunettes,
car la lumière du jour l'aveuglait.*

*Tout le monde fuyait
cet homme-animal
qui n'avait pas de nom.
On le craignait,
on l'évitait.*

*— Tu ne sais même pas nager
et, en plus, tu détestes l'eau,
disaient tous les poissons.
— Tu adores l'hiver et la neige
alors que nous préférons
dormir dans une caverne
pendant toute la saison froide,
grognaient les ours.*

12

*Tout le monde
avait de bonnes raisons
et d'excellents prétextes
pour éviter cet être
qui n'était pas tout à fait
un homme
ni tout à fait une bête.*

*Alors il errait
de forêts en villages
et de villages en villes.
On ne voulait toujours pas
de lui
ni au restaurant, ni au zoo
ni au cinéma, ni au marché.*

13. Editorial Illustration

Art Directors: James Ireland/
 Barbara Solowan
Illustrator: Sandra Dionisi
Designer: Barbara Solowan
Publication: Toronto Life Magazine
Company: Toronto Life Publishing
 Company

Silver

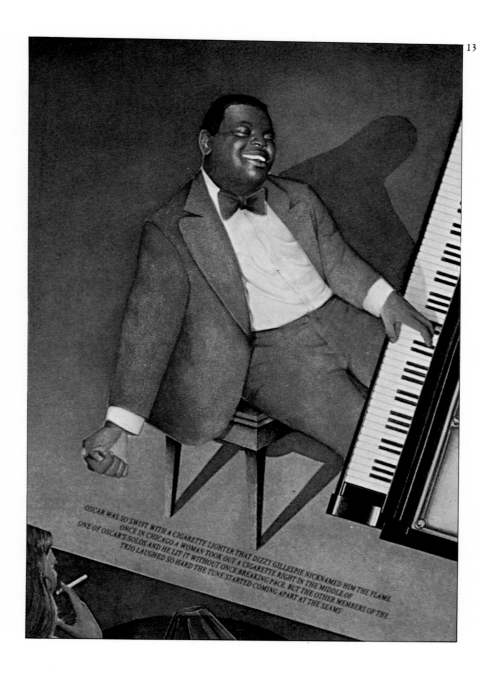

13

OSCAR WAS SO SWIFT WITH A CIGARETTE LIGHTER THAT DIZZY GILLESPIE NICKNAMED HIM THE FLAME ONCE IN CHICAGO A WOMAN TOOK OUT A CIGARETTE RIGHT IN THE MIDDLE OF ONE OF OSCAR'S SOLOS AND HE LIT IT WITHOUT ONCE BREAKING PACE. BUT THE OTHER MEMBERS OF THE TRIO LAUGHED SO HARD THE TUNE STARTED COMING APART AT THE SEAMS

14 **Editorial Illustration**
Illustrator: Julian Allen
Art Director: Derek Ungless
Designer: Bruce Ramsay
Publication: Saturday Night Magazine
Company: Saturday Night Publishing

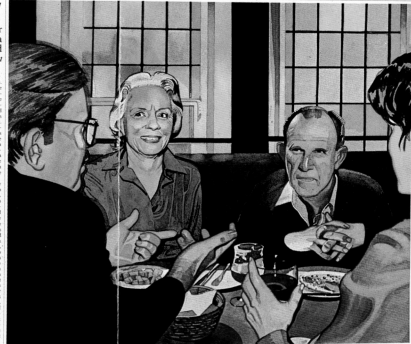

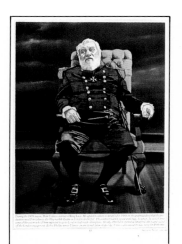

15. Advertising Illustration
Artist: Miro Malish
Art Director: Paul Cade
Writer: Allan Kazmer
Agency: Doyle Dane Bernbach
Client: Comac Communications Ltd.

Silver

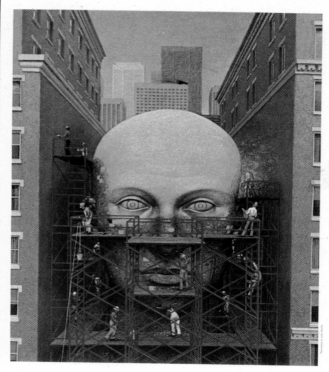

QUEST. URBAN RENEWAL FOR THE CITY MIND.

Of all the minds in the whole world, the city mind needs the most attention. The most care and feeding. The most stimuli. The most rest and relaxation. Failure to regularly renew the city mind can, if you're not careful, result in a myriad of negative syndromes, ranging from mental urban blight to split-level thinking. (Egads!)

Fortunately, antidotes do exist. And one of the most commonly used antidotes by the bulk of urbane, urban dwellers is a good session with Quest Magazine. Written to, for and sometimes about the very people who make our cities worth reading about, Quest is then delivered, by mail, to most of those selfsame people. And their numbers are vast. So vast, in fact, that Quest delivers a larger audience in all of this country's 21 major urban centres than any of our competition.

Definitely not a newsmagazine (news often being the very reason why the need for mental urban renewal), Quest deals primarily with issues. Social issues. Political issues. Aesthetic issues. Moral issues.

Human issues. And it deals with these issues in a thoughtful, probing and ofttimes whimsical manner. Not surprisingly, the level of Quest journalism accurately reflects the level of education of Quest readers, uncommonly high and usually enriched by a good dose of "street smarts". Income levels, travel and participation in the arts are also uncommonly high, making Quest readers eager recipients of essays on these and related areas.

Now, if by chance, you have a message about a product or service that logically relates to this vast yet special group and have heretofore not published that message within the pages of Quest, may we gently make this sugges-

tion. Perhaps, just perhaps, your media plan might profit from a little urban renewal of its own.

QUEST

15

Silver

16. Poster Illustration
Illustrator: Heather Cooper
Art Director: Heather Cooper
Agency: Burns, Cooper, Hynes Limited
Client: Stratford Festival

16

Silver

**CALENDAR
1983**

The EUROPEANS

Photographs by
Gernot Kuehn

17

February

Landau, Austria, 1976

July

Silver

18. Stamps
Designer: Theo Dimson
Art Director: Bill Danard
Illustrators: Cliff Douglas/
 Theo Dimson
Company: Dimson & Smith
Client: Canada Post

18

Silver

19

Silver

20. **Brochures**
Designer: Don Murray
Art Director: Don Murray
Photographer: Studio–Yoshi Wadano;
 Location Photo–Paul McCormick
Company: Art & Design Studio Ltd.
Client: Dept. of Fisheries & Oceans

20

21. **Direct Mail**
Art Director: Michael Wurstlin
Writer: Joyce Hegedus
Illustrator: Kim La Fave
Photographers: Silvio Calcagno
　　Sherman Laws Limited
Creative Director: Hans Aarden
Agency: Medicus Intercon Canada
Client: H.J. Heinz Company of Canada
　　Limited

Silver

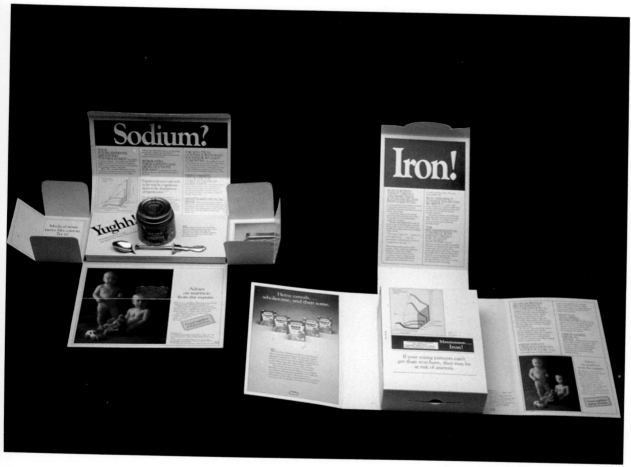

21

Silver

22. **Graphic Design Miscellaneous**
Designer: Kim Martin
Art Director: Bob Russell
Production: M.C. Charters
Company: Carverhill Russell &
 Timmerman Design
Client: Argyle Communications

22

23. Stationery
Designer: Scott Taylor
Art Director: Scott Taylor
Artists: Scott Taylor. Paul Browning
Company: Taylor & Browning Design
 Associates
Client: Speakman Design Associates Inc.

Silver

23

Silver

24. Poster Photography
Photographer: Stephen Yeates
Art Director: Stephen Yeates,
Photographer

24

25. Photography–Poster
Photographer: Yuri Dojc Inc.
Art Director: Malcolm Waddell
Agency: Eskind Waddell
Client: Yuri Dojc Inc.

Silver

25

Silver

26. Editorial Photography
Art Directors: James Ireland/
 Barbara Solowan
Photographers: Tom Skudra, Arnaud
 Maggs, Deborah Samuel, Masao Abe,
 Bert Bell, Gordon Hay
Designer: Barbara Solowan
Publication: Toronto Life Magazine
Company: Toronto Life Publishing
 Company

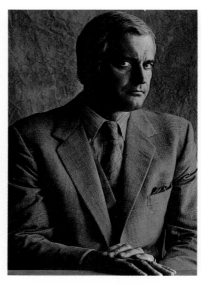

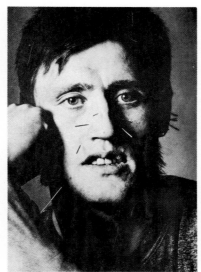

26

27. **Editorial Photography**
Photographer: Gillean Proctor
Art Director: Ursula Kaiser
Publication: Homemaker's Magazine
Client: Comac Communications

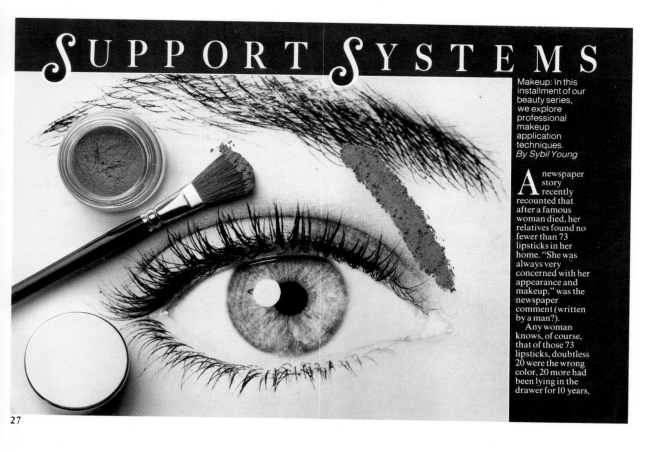

SUPPORT SYSTEMS

Makeup: In this installment of our beauty series, we explore professional makeup application techniques.
By Sybil Young

A newspaper story recently recounted that after a famous woman died, her relatives found no fewer than 73 lipsticks in her home. "She was always very concerned with her appearance and makeup," was the newspaper comment (written by a man?).

Any woman knows, of course, that of those 73 lipsticks, doubtless 20 were the wrong color, 20 more had been lying in the drawer for 10 years,

27

Silver

28. Advertising Poster
Designer: Michael McLaughlin
Art Director: Michael McLaughlin
Photographer: Stephen Yeates
Client: The Partners' Film Company

29. Transit Poster
Art Director: Peter Weis
Writer: Michael Hart
Photographer: Nancy Shanoff
Creative Directors: Michael Hart/
 Peter Weis
Agency: Ronalds-Reynolds & Company
 Limited
Client: T.G. Bright & Co. Limited

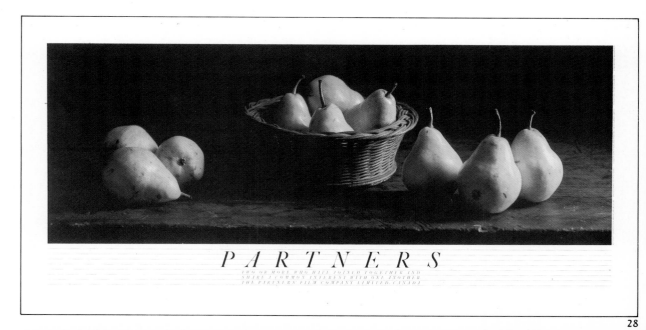

PARTNERS

28

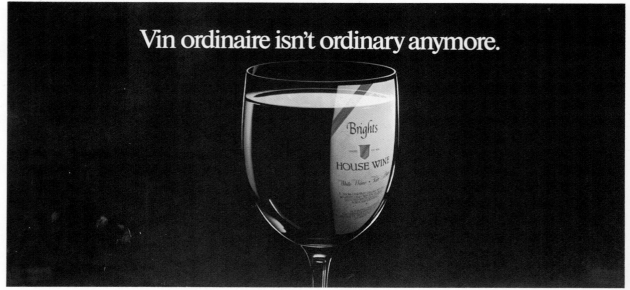

Vin ordinaire isn't ordinary anymore.

29

30. Graphic Design Poster
Art Director: Jim Carpenter
Designer: Jim Carpenter
Photographer: Masao Abe
Company: Carpenter & Co.
Client: Scollard Production

Silver

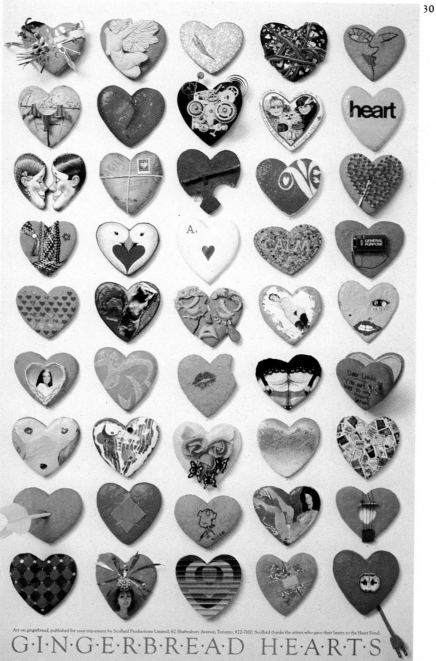

G·I·N·G·E·R·B·R·E·A·D H·E·A·R·T·S

Silver

31. Poster
Art Director: Shigeshi Aoki
Writer: Michael Paul
Photographer: Yoshi Inoue
Illustrator: Colin Gibson
Creative Director: Michael Paul
Agency: SMW Advertising
Client: Canadian Heart Foundation

31

If you quit now, your lungs will forgive you.

Your doctor can help you stop smoking. Just ask.
For further help in quitting, contact your local Lung Association.

32. Magazine Fashion Section
Art Director: Ursula Kaiser
Photographer: Jim Allen
Designer: Lindsay Beaudry/Shari Spier
Publication: Homemaker's Magazine
Company: Comac Communications

Silver

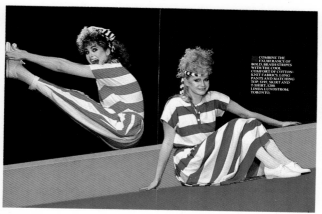

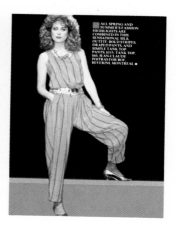

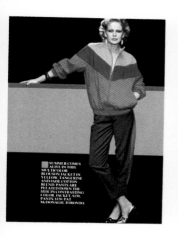

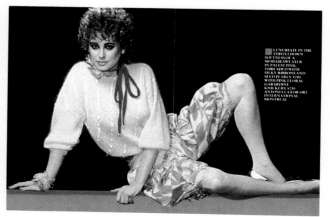

Silver

33. Magazine Cover
Art Director: B. J. Galbraith
Illustrator: Christine Bunn
Designer: B.J. Galbraith
Publication: Radio Guide
Company: Saturday Night Publications for CBC

34. Magazine Cover
Art Director: B. J. Galbraith
Illustrator: Anita Kunz
Designer: B.J. Galbraith
Publication: Radio Guide
Company: Saturday Night Publications for CBC

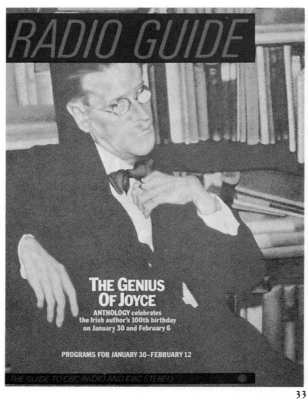

33

34

35. Magazine Cover
Art Director: B. J. Galbraith
Illustrator: James Tughan
Designer: B.J. Galbraith
Publication: Radio Guide
Company: Saturday Night Publications
for CBC

Silver

36. Magazine Cover
Art Director: Rob Melbourne
Illustrator: Joe Salina
Designer: Rob Melbourne
Publication: Today Magazine
Company: Southstar Publishers

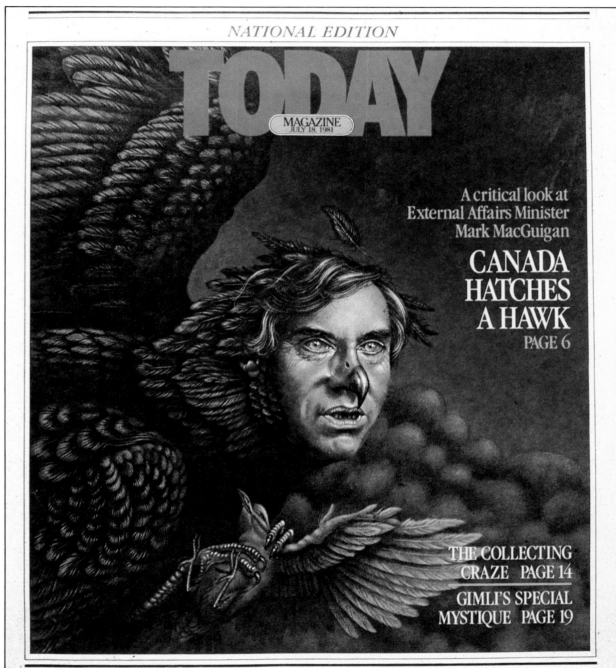

37. **Magazine Spread**
Art Director: Derek Ungless
Illustrator: Marshall Arisman
Designer: Bruce Ramsay
Publication: Saturday Night Magazine
Company: Saturday Night Publishing

Silver

THE UNFRIENDLY GIANT

In recent months, Canadian economic policy has been sharply at odds with the reassertion of American power and self-interest. Now that there are real differences between the countries, how long will they remain good neighbours?

A YEAR ago, you could get a free lunch at some American restaurants just for being Canadian. This year you'd be well advised to bring money and keep quiet about where you're from. The spontaneous outpouring of affection following the events in Iran is forgotten, and Ken Taylor is yesterday's hero.

Canadian-American relations have not just returned to normal; they've grown much worse. In the U.S. press, Canada has become a bad word. Long accustomed to carrying little if anything about this country, U.S. newspapers have recently printed almost daily stories, most of them negative. American readers are being told about a strident, self-confident, nationalistic menace to the north. The business pages growl with stories about Canadian takeovers of U.S. companies in Canada *and* in the United States. Last summer, *The New York Times* shivered at "The Chill From Dear Canada." Under the headline "Canadian Brass," *The Wall Street Journal* accused Pierre Trudeau of attempting "to hijack the Canadian investments of American oil companies." *U.S. News & World Report* in an editorial, "Friction With Canada," deplored the end of good neighbourliness to the north. Feature stories examined a rising tide of short-sighted Canadian nationalism. Sources in Washington spoke of retaliation. Without meaning to be ironic, cartoonists cast the Canadian Football League in a predatory role, though that was before ex-Los Angeles Ram Vince Ferragamo bombed as a Montréal Alouette. During the Expos-Philadelphia baseball showdown, Red Smith in *The New York Times* alluded to Ronald Reagan's low opinion of Trudeau. When Canadian-American relations make the sports pages, there's something desperately wrong.

This deteriorating relationship can't be attributed simply to a clash of personalities. John F. Kennedy thought John Diefenbaker was an SOB – later revised to "a prick" for the benefit of Ben Bradlee of *The Washington Post* – but they

It's tempting to think that if only they could call each other up on a Ron and Pierre basis, they could settle all the outstanding issues, as Mackenzie King and FDR allegedly did

managed to get essential work done. LBJ mistakenly referred to Harold Wilson when Lester Pearson came to town, but that didn't prevent them from getting down to business. In the privacy of his own office – with the tapes running – Richard Nixon made amusing anatomical references to Pierre Trudeau, but we have Henry Kissinger's word that they dealt with each other like professionals. Trudeau and Jimmy Carter shared the same pained sense of being unjustly buried under their respective troubles, but this brotherhood of distress did not noticeably alter relations between the two countries.

Indeed, it's tempting to think that if only the prime minister and the president could call each other up on a Ron and Pierre basis, they could settle all the outstanding issues, just as Mackenzie King and Franklin Roosevelt allegedly did. But personal relationships do not usually count much at this level of diplomacy, and they count for even less now. When there are real, deep-seated differences, it's impossible to eliminate them with a phone call and small talk. And the differences that strain Cana-

BY VIV NELLES

dian-American relations today are more profound than at any time in living memory.

During the 1970s the Canadian-American agenda bristled with vexing issues, but that did not precipitate the kind of breakdown we're now witnessing. Canada and the United States disagreed on a wide range of subjects, from beef imports to responsibility for transborder pollution. We seized each other's fishing boats for violating conflicting fishing regulations. Both countries concluded that the Auto Pact was unfair and both threatened to renegotiate it. Each accused the other of dumping beef. During the U.S.-inspired Soviet grain embargo, Canadian farmers screamed when American grain companies began invading Canada's markets with surplus wheat. Restrictive legislation on U.S. banks and the denial of Canadian status to the Canadian edition of *Time* offended Americans. The Foreign Investment Review Agency, a pussycat to Canadians, seemed at least a breach of good manners and perhaps even a direct threat to American investors. Energy issues were a constant source of irritation. First the Americans wouldn't take our oil and gas; then they wanted too much of it; then we wouldn't sell, certainly not at the discount they expected. Being forced to buy restricted quantities of oil and gas at OPEC prices from Canada to get by in an emergency annoyed Americans, especially because Canadians refused to pay world prices themselves. It seemed a bit mean, taking advantage of the U.S. when it was having its troubles – and it was.

The most vehement quarrels arose over television and the environment. The deletion of U.S. commercials on cable transmissions and the cancellation of tax deductions by Revenue Canada for advertisements on U.S. channels made border broadcasters apoplectic. Tanker routes and rail ports off the east and west coasts raised justifiable fears of calamitous oil spills affecting Canadian coastlines. The Canadian Parliament

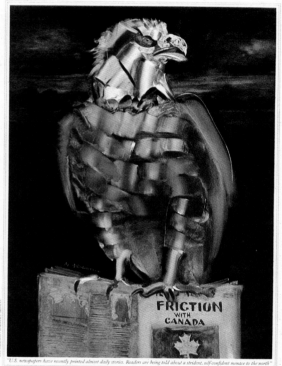

FRICTION WITH CANADA

"U.S. newspapers have recently printed almost daily stories. Readers are being told about a strident, self-confident menace to the north"

37

Silver

38. Magazine Section
Art Director: Ursula Kaiser
Photographer: Gillean Proctor
Designer: Lindsay Beaudry
Publication: Homemaker's Magazine
Company: Comac Communications

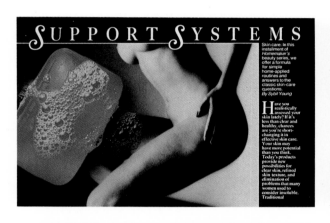

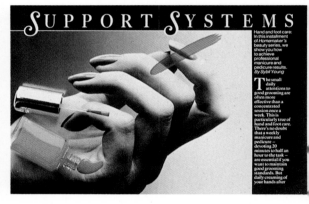

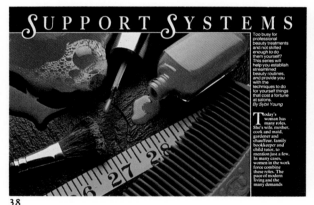

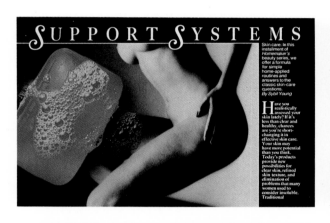

38

39. Magazine Section
Art Director: Louis Fishauf
Photographer: Carol Gibson
Designer: Louis Fishauf
Publication: City Women
Client: Comac Communications

Silver

BEAUTIFUL

Intimacies

SUMMER IS THE PERFECT TIME TO REASSESS YOURSELF. START BY SETTING STRICT NEW PRIORITIES IN PREPARING FOR YOUR GREATER EXPOSURE IN THE COMING MONTHS. FACE UP TO THE FACT THAT YOU HAVE A RESPONSIBILITY TO YOURSELF TO BE AS HEALTHY AND HAPPY AS POSSIBLE. YOU NEED NOT BE A FITNESS FANATIC TO ACHIEVE THIS, BUT, AS WE DIS-COVER IN THE FOLLOWING PAGES, THERE ARE BASIC STEPS YOU CAN TAKE TO ACHIEVE IMPROVED HEALTH AND BEAUTY.
● DONA SAUNDERS OF CHANGING IMAGES EXERCISE STUDIO RECOMMENDS REGULAR AEROBIC EXERCISES TO TONE THE CARDIOVASCULAR SYSTEM, AND THUS IMPROVE GENERAL HEALTH. SHE TELLS US HOW AND WHY TO DO IT CORRECTLY.
● DOCTOR RAYMOND RUPERT IS AN ADVOCATE OF THE PRITIKIN DIET AND EXERCISE PROGRAM. HE SAYS IT'S A SURE-FIRE WAY TO REDUCE WEIGHT AND LOWER THE RISK OF CARDIO-VASCULAR DISEASE. *CITY WOMAN* TALKS TO HIM ABOUT IT.
● CHIROPRACTOR AND NATUROPATH FRANCES SHRUBB SHARES HER CONCERNS ABOUT A DEVASTATING PROBLEM: OBESITY. HER HOLISTIC APPROACH INCLUDES FASTING, DIET THERAPY, HAIR ANALYSIS, MASSAGE AND AROMATHERAPY.
● ELEANOR FULCHER GIVES US *HER* ANSWER TO A NUTRITION-AL DIET AND PRECISE EXERCISE PROGRAM AT HER SPA ON LAKE MUSKOKA IN CENTRAL ONTARIO, AND WHY HER GUESTS RETURN TO THE CITY WITH A RENEWED ZEST FOR LIVING.
● *CITY WOMAN* BRINGS YOU NEW BEAUTY BASICS TO FOCUS ON IN THE PRIVACY OF YOUR OWN HOME. PUT ASIDE TIME FOR YOURSELF — STARTING NOW — AND TAKE RENEWED CONTROL OF YOUR LIFE. *YOU* AND YOUR HEALTH MUST TAKE PRIORITY.

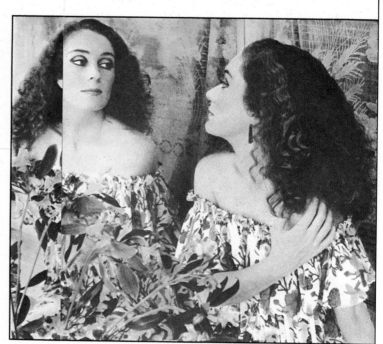

BY BEVERLEY ROCKETT ● PHOTOGRAPHS BY CAROL GIBSON

39

Nutrition

Spa diet

Bathing

Skin sweeping

Silver

40. Newspaper Ad
Creative Director: Paul R. Grissom
Art Director: Paul R. Grissom
Copywriter: Reet McGovern
Artists: Kim LaFave, Brian Boyd
Agency: McGovern & Grissom
 Creative Services
Client: The Equity Development Group
 Inc. – Heron Homes

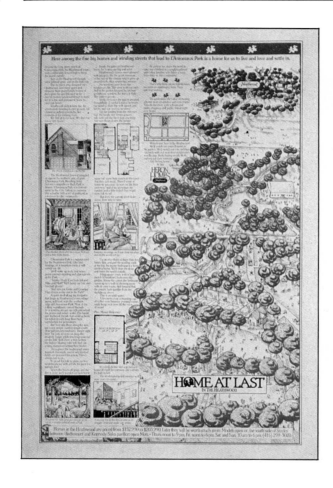

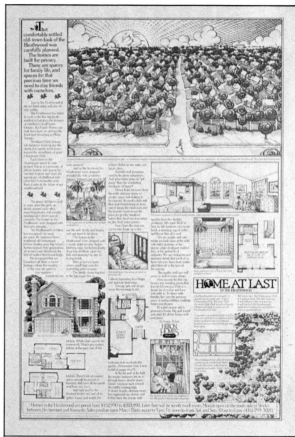

41. **Magazine Ad**
Art Director: Brian Harrod
Writer: Ian Mirlin
Illustrator: Kim LaFave
Creative Director: Harrison Yates
Agency: McCann-Erickson Toronto
Client: Christie Brown & Co.

Silver

41

(Bet you've opened
an Oreo cookie too.)

Mr. Christie, you make good cookies.

Silver

42. Newspaper Ad
Art Director: Gray Abraham
Writer: Mark Levine
Illustrator: Gray Abraham
Creative Director: Stewart Hood
Agency: The Jerry Goodis Agency Inc.
Client: Bank of Nova Scotia

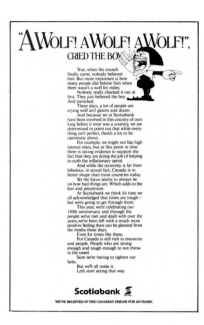

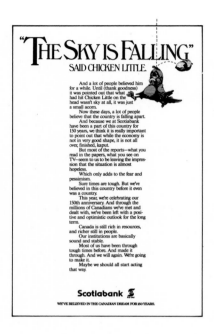

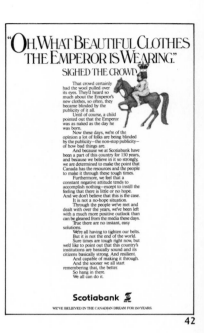

42

Silver

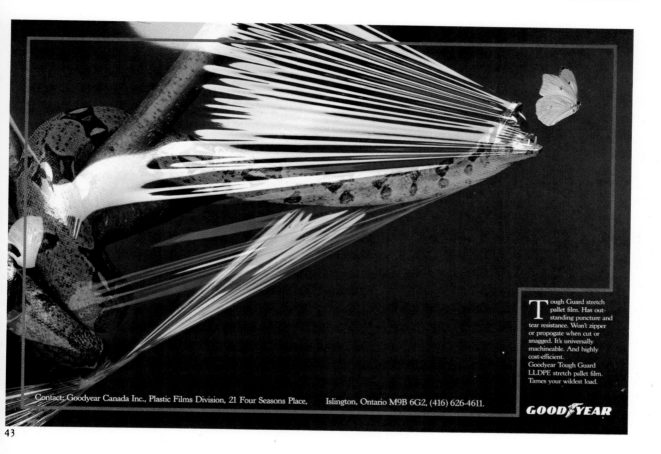

Tough Guard stretch pallet film. Has outstanding puncture and tear resistance. Won't zipper or propogate when cut or snagged. It's universally machineable. And highly cost-efficient. Goodyear Tough Guard LLDPE stretch pallet film. Tames your wildest load.

Contact: Goodyear Canada Inc., Plastic Films Division, 21 Four Seasons Place, Islington, Ontario M9B 6G2, (416) 626-4611.

GOOD **YEAR**

43

Silver

44. Trade Ad
Art Director: Paul Cade
Writer: Allen Kazmer
Illustrators: John Marten/Paul Cade/
Miro Malish
Creative Director: Allen Kazmer
Agency: Doyle Dane Bernbach
Client: Comac Communications Ltd.

45. Trade Ad
Art Director: Paul Cade
Writer: Allen Kazmer
Illustrator: Miro Malish
Creative Director: Allen Kazmer
Agency: Doyle Dane Bernbach
Client: Comac Communications Ltd.

46. Trade Ad
Art Director: Martin Shewcuk
Writer: Kathy Doherty
Studio: Marg Cousins
Creative Director: Ed Nanni
Agency: Leo Burnett Co. Inc.
Client: Leo Burnett Co. Inc.

AS Leo Burnett, himself, said, "There is nothing so dramatic as the truth simply told."

IN 1979, our agency reorganized itself to be in a strong position to meet the challenges our clients and our industry would face in the 1980's.

IN the past two years, we have worked hard and long doing what we know best: advertising our clients' products. The rewards have been many, with continual growth from our existing clients, and the addition of new clients who also believe advertising makes a sound and fundamental contribution to the growth of their businesses. These include: *The Adams Distillers Group Ltd., Boyle-Midway Canada Ltd./Ltée, Les Biscuits David, Canadian Tampax Corporation Ltd., Les Aliments F.B.I. du Canada Ltée, Fuji Photo Film Canada Inc., Hotels Régent International, International Maple Syrup Institute, Mitchum-Thayer Ltd., Joseph E. Seagram & Sons Limited, Spillers Foods Limited and VISA.*

THE simple truth is we are proud of what we've done and where we are going. And we still believe the best advertising for Leo Burnett is being run by our clients.

The Adams Distillers Group Ltd.
Allstate Insurance Companies
* of Canada*
Barreau du Québec
Beecham Products Overseas
Benson & Hedges (Canada) Inc.
Boyle-Midway Canada Ltd./Ltée
Les Biscuits David
Canadian Tampax Corporation Ltd.
Les Aliments F.B.I. du Canada Ltée
Fuji Photo Film Canada Inc.
Hotels Régent International
International Maple Syrup Institute
Kroehler Mfg. Co. Limited
Kellogg Salada Canada Inc.
The Maytag Company
Memorex Canada Limited
Mitchum-Thayer Ltd.
Nissan Automobile Company
* (Canada) Limited*
Pillsbury/Green Giant
* Canada Limited*
Procter & Gamble Inc.
RCA Limited
Joseph E. Seagram & Sons Limited
Spillers Foods Limited
Star-Kist Foods Inc.
Société Radio-Canada
Union Carbide Canada Limited
Vigoro
VISA

Leo Burnett Company Ltd.
TORONTO • MONTREAL • VANCOUVER

46

Silver

47. "Accidental Rice"

Consumer Commercial (Single)

Art Director: Terrance Iles
Writer: William Lower
Creative Director: Gary Prouk
Agency Producer: Lorre Jensen
Agency: Scali, McCabe, Sloves
 (Canada) Ltd.
Client: Thomas J. Lipton, Limited
Director: Ousama Rawi
Cameraman: Ousama Rawi
Production House: Rawifilm Canada Inc.

48. "Billboard"

Consumer Commercial (Single)

Art Director: Terrance Iles
Writer: William Lower
Creative Director: Gary Prouk
Agency Producer: Lorre Jensen
Agency: Scali, McCabe, Sloves
Client: Ralston Purina (Canada) Inc.
Directors: Ousama Rawi/Bob Fortier
Cameramen: Ousama Rawi/Bob Fortier
Production Houses: Rawifilm /Nelvana
Music: David Fleury

47. "Accidental Rice"
V.O.: Recently a young man invented
an intriguing new recipe…
V.O.: Quite by accident. He added rice…
MAN: Oh no!
V.O.: …to his Lipton onion mushroom
soup.
WOMAN: Irwin, it's good.
MAN: Yes, it's a recipe I stumbled on…
the tanginess of the onions enhances
the subtlety of the mushrooms… makes
the rice more… sumptuous…
V.O.: Try Lipton Onion Mushroom
Soup. For great onion mushroom rice.
MAN: The champagne…
V.O.: Onion Mushroom Rice…
A happy little accident from Lipton.

48. "Billboard"
SFX: MUSIC UNDER
V.O.: As dog travels through the envied
and often tempting world of man, there
is one thing, above all, that tempts him
most. The taste of meat…
nd that is why Purina makes Butcher's
Blend.
SFX: BAG RIPPING
Butcher's Blend is the first dry dog food
with three tempting meaty tastes. Beef.
Liver. Bacon. All in one bag.
So come on, deliver your dog from the
world of temptation…
…to the world of Butcher's Blend. The
first dry dog food with three meaty
tastes.

49. "Wilderness'
Consumer Commercial

Art Director: Peter Jones
Writer: John Kyriakou
Creative Director: Bob Neighbour
Agency Producer: John Auriemma
Agency: J. Walter Thompson
Client: Greb Industries Ltd.–Kodiak Boots
Director: Ian Leech
Cameraman: Stanley Mestel
Production House: The Partner's Film
Music/Sound: Kosinec/Lenz

50. "Close Encounters"
Consumer Commercial

Art Director¡Writer: Dan Peppler
Creative Director: Dan Peppler
Agency Producer: Chantal Houle
Agency: Needham. Harper & Steers
Client: Honda Canada Inc.
Director: Bob Canning
Cameraman: Nicholas Allen-Woolfe
Editor: John Kerns
Production House: T.D.F.
Music/Sound: Syd Kessler

49. "Wilderness"
SFX: THROUGHOUT
ANNCR: The new Wilderness Boot from Kodiak.
Wilderness.
Built Kodiak tough.
With steel plates and steel toes.
Resists the cold and repels the wet.
It's just got to be the
Wilderness boot…from Kodiak.
MAN: Thanks for the walk.

50. "Close Encounters"
SFX: NATURAL THROUGHOUT.
MUSIC: THROUGHOUT (ACCENTS ACTION AND LIGHT EFFECTS)
ANNCR. V.O.: The remarkable reputation of Honda's 1982 Accord holds a relentless curiosity for those who **do not** own one…
Accord's advanced engineering… incredible fuel economy… and the uncompromised styling and spacious luxury… all at an unbeatable price… certainly in this world, and possibly beyond…

Silver

51. "Eskimo"
Consumer Commercial

Art Directors: Dieter F. Kaufmann/
 Steve Chase
Writer: Brian Quennell
Creative Director: Dieter F. Kaufmann
Agency Producer: Dieter F. Kaufmann
Agency: G. Anderson Advertising
Client: Rayovac Canada
Director: Paul Herriott
Camera: Karol Ike
Music: Larry Trudel

52. "Laundromat"
Consumer Commercial (Campaign)

Art Director: André Morkel
Writer: Gary Prouk
Creative Director: Gary Prouk
Agency Producer: Lorre Jensen
Agency: Scali, McCabe, Sloves
Director: Alan Marr
Cameraman: George Morita
Production House: The Partners

53. "K-Tel"
Consumer Commercial (Campaign)

Art Director: André Morkel
Writer: Gary Prouk
Creative Director: Gary Prouk
Agency Producer: Lorre Jenson
Agency: Scali, McCabe, Sloves
 (Canada) Ltd.
Client: Cadbury, Schweppes, Powell Inc.
Director: Alan Marr
Cameraman: George Morita
Production House: The Partners

51. "Eskimo"
VOC: What's the emergency?
ESKIMO: No emergency.
VOC: But, you're using a RAYOVAC light because your electricity is out.
ESKIMO: No. No electricity.
VOC: Yes, no electricity. We call that an emergency.
ESKIMO: No. No emergency. No electricity.
VOC: No electricity.
ESKIMO: Yes.
VOC: That's an emergency.
ESKIMO: No.
SFX: SWITCH OF TABLE LAMP.
SFX: STRIKE OF MATCH.
ESKIMO: This is an emergency. Yes?
VOC: RAYOVAC puts any emergency in the right light.

52. "Laundromat"
WOMAN #1: Gee Madge, your snack looks brighter than mine. What's your secret?
MADGE: Well, I use Cadbury Snack Bar. Snack Bar has five active ingredients that get rid of the most stubborn snack pains and it tastes out of this world!
WOMAN #1: No snack bar can do all that.
MADGE: Snack Bar can!
MAN (VO): Madge is right. Watch. Snack Bar has crunchy peanuts, rice crisps, wafer biscuits, creamy caramel and a chocolatey coating.
WOMAN #1: (WITH GUY ON ARM) Gee Madge, you sure were right about Snack Bar.
MADGE: Let's keep it our little secret.

53. "K-Tel"
MAN: Tired of ordinary snacks? Snacks that don't satisfy you? Let you down? Well, for an **unlimited** time only, consider this amazing offer!
MAN: Cadbury's Snack Bar. Not an ordinary snack!
MAN: Snack Bar has crunchy peanuts, super crispy rice crisps, plus wonderful wafers!
MAN: But wait! We're not finished yet!
MAN: You also get creamy caramel, plus a delectable, scrumptious chocolatey coating.
MAN: How much would you expect to pay for this amazing Snack Bar? ...$5 ...$10 ...No! Act now, we'll include absolutely free of charge, ...
MAN: ...this colourful Cadbury Snack Bar wrapper!

54. Newspaper Ad
Creative Director: Paul R. Grissom
Art Director: Paul R. Grissom
Copywriter: Reet McGovern
Artists: Kim LaFave, Brian Boyd
Agency: McGovern & Grissom
 Creative Services
Client: The Equity Development Group
 Inc. – Heron Homes

55. Newspaper Ad
Creative Director: Paul R. Grissom
Art Director: Paul R. Grissom
Copywriter: Reet McGovern
Artists: Kim LaFave, Brian Boyd
Agency: McGovern & Grissom
 Creative Services
Client: The Equity Development Group
 Inc. – Heron Homes

56. Newspaper Ad
Creative Director: Paul R. Grissom
Art Director: Paul R. Grissom
Copywriter: Reet McGovern
Artists: Kim LaFave, Brian Boyd
Agency: McGovern & Grissom
 Creative Services
Client: The Equity Development Group
 Inc. – Heron Homes

Merit

57. Newspaper Ad
Art Director: Terrance Iles
Writer: William Lower
Illustrator: Margaret Hathaway
Studio: Reactor Art & Design
Creative Director: Gary Prouk
Agency: Scali, McCabe, Sloves
 (Canada) Ltd.
Client: Gilbey Canada Inc.

58. Newspaper Ad
Art Director: Michael Gregg
Writer: Dorothy Carr
Photographer: Nigel Dickson
Creative Director: John Speakman
Client: Sony of Canada Ltd.

59. Newspaper Ad
Art Director: Michael McLaughlin
Writer: Stephen Creet
Illustrator: Christine Middleton
Creative Director: Gary Gray
Agency: Vickers & Benson/Ayer
Client: H.J. Heinz

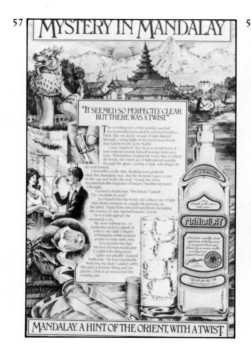

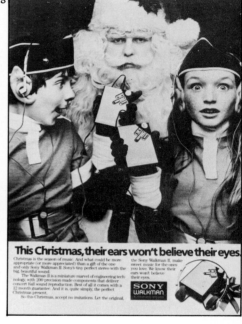

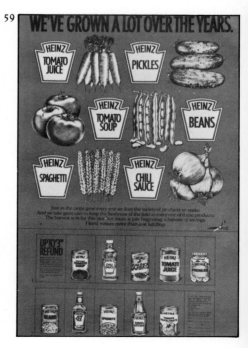

60 Newspaper Ad
Art Director: Jim Ronson
Writer: Su Bundock
Artist: Doug Panton
Creative Director: Bob Gardner
Agency: Young & Rubicam, Ltd.
Client: The Arrow Company

61. Newspaper Ad
Art Director: Mark Walton
Writer: Pamela Glynn
Illustrator: James Tugan
Creative Director: Denis Case
Agency: Case & Associates
Client: Ministry of Agriculture & Food
 Foodland Ontario Division

62. Magazine Ad
Art Director: Keith Hillmer
Writer: Ross Jarvas
Photographer: Bruce Horn
Creative Director: Allan Kazmer
Agency: Doyle Dane Bernbach
 Advertising Ltd.
Client: Volkswagen Canada Inc.

Merit

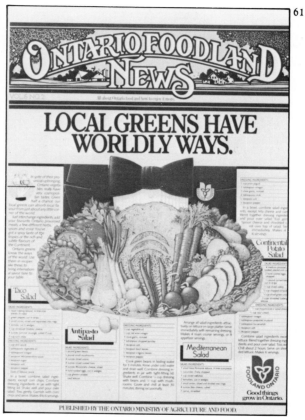

Merit

63. Newspaper Ad
Art Director: Terry Tomalty
Writer: Marlene Hore
Photographer: Fleming Gundel
Creative Director: Marlene Hore
Agency: J. Walter Thompson Co. Ltd.
Client: Kraft Foods Ltd.

64. Consumer Magazine Ad
Art Director: David Purser
Writer: Jochem Klosterman
Photographer: Gillean Proctor
Creative Director: Peter Tregale
Agency: Baker Lovick Limited
Client: William Neilson Ltd.

65. Consumer Magazine Ad
Art Director: Michael McLaughlin
Writer: Gary Gray
Illustrator: Christine Middleton
Creative Director: Gary Gray
Agency: Vickers & Benson/Ayer
Client: H.J. Heinz

63

64

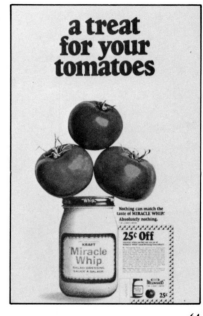

65

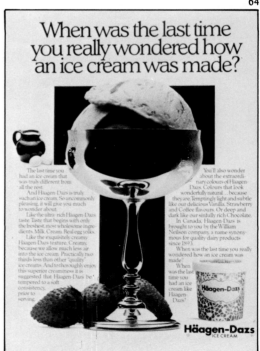

66. Newspaper Ad
Art Director: Larry Gordon
Writers: Laura Pollard/Diane Bracuk
Illustrators: Chris Middleton, Tony Kew,
Mike Cook, Clarence Porter
Creative Director: Warren Handley
Agency: McKim Advertising Ltd. Toronto
Client: CP Hotels/Royal York

67. Consumer Magazine Ad
Art Directors: John Speakman, Mike
Gregg
Writer: Dorothy Carr
Photographer: Ken Walley
Agency: Cockfield, Brown Co. Ltd.
Client: Sony of Canada Ltd.

68. Consumer Magazine Ad
Art Directors: David Purser/
Katherine Knox
Writer: Norm Sefton
Creative Director: Norm Sefton
Illustrator: Willy Mitschke
Agency: Ogilvy & Mather
Client: Mattel

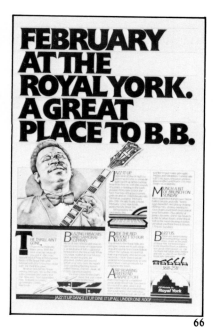

66

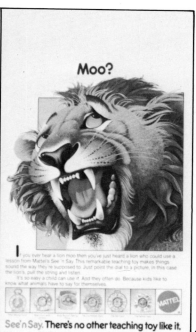

68

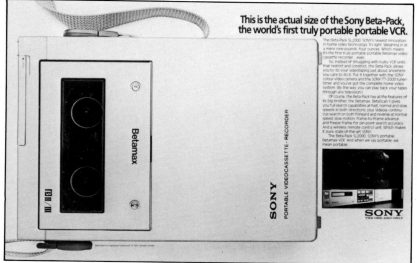

67

Merit

69. Newspaper Ad
Art Directors: Arnold Wicht/
 Larry Gordon
Writer: Peter Sellers
Illustrators: David Chestnutt
 Charles Adorjan, Nancy Eason
Creative Director: John McIntyre
Agency: Camp Associates Advertising
Client: St. Lawrence Parks Commission

70. Consumer Magazine Ad
Art Director: Brian Harrod
Writer: Ian Mirlin
Illustrator: Kim Lafave
Creative Director: Harrison Yates
Agency: McCann-Erickson Toronto
Client: Christie Brown & Co.

71. Consumer Magazine Ad
Art Director: Elvin Letchford
Writer: Brian Johnston
Photographer: Phillip Gallard
Creative Director: Daniel D. Peppler
Agency: Needham, Harper & Steers
 of Canada Ltd.
Client: Robin Hood Multifoods Inc.

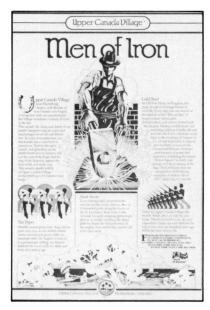

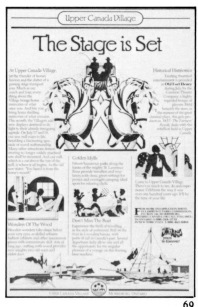

69

71

70

72. Newspaper Ad
Art Director: Randy Diplock
Writer: Rick Davis
Photographer: Anzalone McLeod Shanoff
Creative Directors: G. Carr/D. Linton
Agency: Ambrose, Carr, DeForest & Linton
Client: Bell Communications Systems Inc.

73. Consumer Magazine Ad
Art Director: Peter Weis
Writer: Michael Hart
Photographer: Nancy Shanoff
Creative Directors: Michael Hart/ Peter Weis
Agency: Ronalds-Reynolds & Company Limited
Client: T.G. Bright & Co. Limited

74. Consumer Magazine Ad
Art Director: David Sharpe
Writer: Allan Hatcher
Photographers: Brian Colleran/Bill Petro/ Terry Collier
Creative Director: Michael Paul
Agency: SMW Advertising
Client: Yamaha Motor Canada Limited

Merit

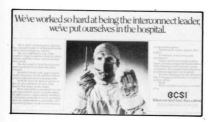

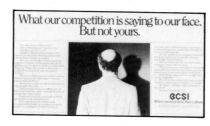

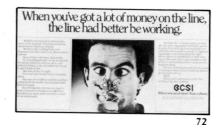

72

74

73

Merit

75. Consumer Magazine Ad
Art Director: Steve Thursby
Writer: Bob Hawton
Photographer: George Simhoni
Creative Director: Bob Hawton
Agency: F.H. Hayhurst Co. Limited
Client: Chesebrough-Pond's (Canada) Inc.

76. Consumer Magazine Ad
Art Director: John Adams
Writer: John Adams & J. Williams
Photographer: Steve Amini
Creative Director: Ted Bates
Agency: Consumers Print Advertising
Client: Nikon Canada Inc.

77. Consumer Magazine Ad
Art Director: Ken Boyd
Writer: Doug Moen
Photographer: Terry Collier
Creative Director: Harrison Yates
Agency: McCann-Erickson Toronto
Client: Suzuki

75

76

77

Merit

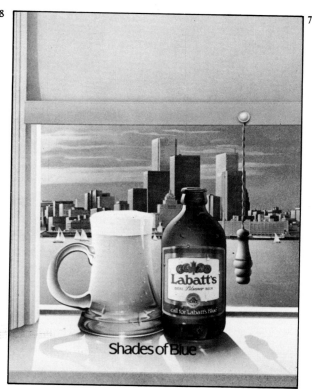

Merit

81. Newspaper Ad
Art Director: Michael Edwards
Writer: Jody Overend
Photographers: Gillean Proctor/
Ted Larson
Client: Fiberglass Canada Inc.

82. Consumer Magazine Ad
Art Director: Chris Crofton
Writer: Lesley Sanderson
Illustrator: James Tughan
Creative Director: Lesley Sanderson
Agency: Barbary Communications Inc.
Client: United Rum Merchants

83. Consumer Magazine Ad
Art Directors: John Speakman,
Mike Gregg
Writer: Dorothy Carr
Photographer: Ken Walley
Agency: Cockfield, Brown Co. Ltd.
Client: Sony of Canada Ltd.

81

82

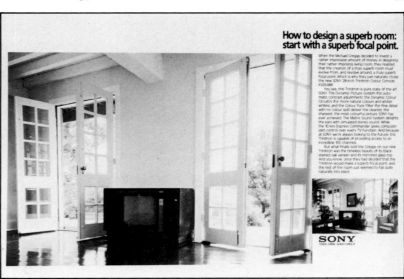

83

84. Consumer Magazine Ad
Art Director: Terry Tomalty
Writer: Leon Berger
Photographer: Larry Williams
Creative Director: Marlene Hore
Agency: J. Walter Thompson Co. Ltd.
Client: Remy Martin Amerique Inc.

85. Consumer Magazine Ad
Art Director: Bob Anderson
Writer: Peter Langmuir
Photographers: John Wild/Tracy Doyle/
John Renwick
Creative Director: Peter Langmuir
Agency: Benton & Bowles Canada
Client: Procter & Gamble

86. Consumer Magazine Ad
Art Director: Dean Raynor
Writer: Richard Kropp
Photographer: Frank Anzalone
Creative Director: David Van Fleet
Agency: Avenue Incorporated
Client: Marc Fidani Clothiers Ltd.

Merit

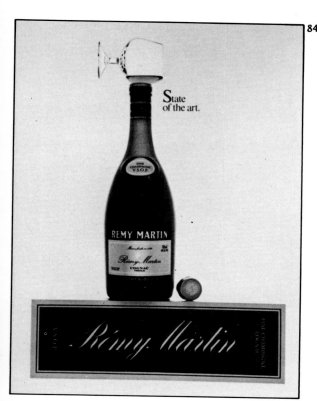

84

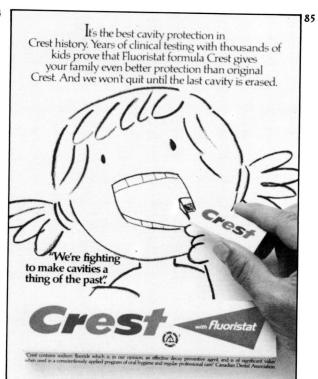

85

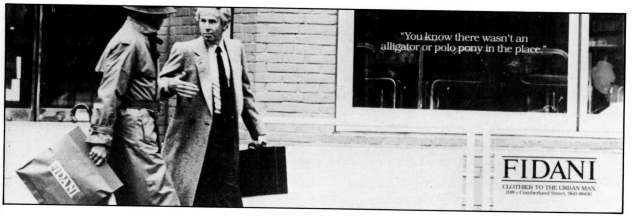

86

Merit

87. Consumer Magazine Ad
Art Director: Mark Walton
Writer: Pamela Glynn
Photographer: Ken Walley
Creative Director: Denis Case
Agency: Case & Associates
Client: Ministry of Agriculture & Food
Foodland Ontario Division

88. Trade Ad
Art Director: Jim Ronson
Writer: Don Gill
Artist: Ted Larson
Creative Director: Don Gill
Agency: Young & Rubicam, Ltd.
Client: Time Canada Ltd.

89. Trade Ad
Art Director: Billy Sharma
Writer: Jacqueline Palmer
Photographer: Gillean Proctor
Creative Director: Pat Harvie
Agency: Ogilvy & Mather
Client: Shell Marine

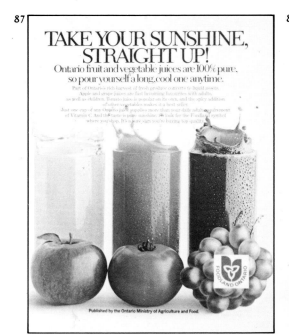

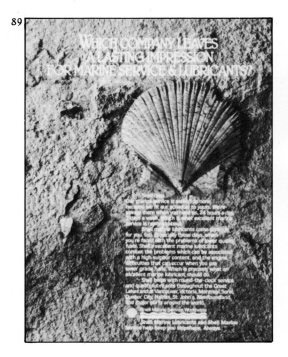

90. Trade Ad Campaign
Art Director: Gary Carr
Writer: Doug Linton
Photographer: Anzalone McLeod Shanoff
Creative Directors: G. Carr/D. Linton
Agency: Ambrose, Carr, DeForest & Linton
Client: Comac Communications Ltd.

91. Trade Ad Campaign
Art Director: Michael Wurstlin
Writer: Joyce Hegedus
Illustrators: David Eales, Dennis Noble
Photographer: Graham French
Creative Director: Hans Aarden
Agency: Medicus Intercon Canada
Client: Miles Pharmaceuticals
Division of Miles Laboratories Ltd.

92. Trade Ad
Art Director: Steve Chase
Writer: Brian Quennell
Photographers: Peter Baumgartner, Doug Lingard
Creative Director: Dieter F. Kaufmann
Agency: G. Anderson Advertising
Client: White-Westinghouse

Merit

90

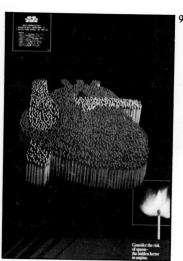
91

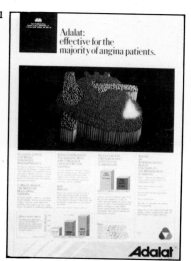

92

Merit

93. Trade Ad
Art Director: Angela Simpson
Writers: June Grant, Eng./
 Guy Belanger, Fr.
Photographer: John Foster/Masterfile
Creative Director: Steve Catlin
Agency: Publicité McKim Advertising
Client: T.C.T.S. Satellite

94. Trade Ad
Art Director: Leif Nielsen
Writer: Joanne Lehman
Photographer: Yosh Inouye
Creative Director: Joanne Lehman
Agency: Foster Advertising
Client: McNeil Pharmaceuticals

95. Trade Ad
Art Director: Raymond Lee
Writers: Leo Bautista/Raymond Lee
Photographer: Victor Maderspach
Creative Director: Raymond Lee
Agency: Raymond Lee Associates
 Limited

93

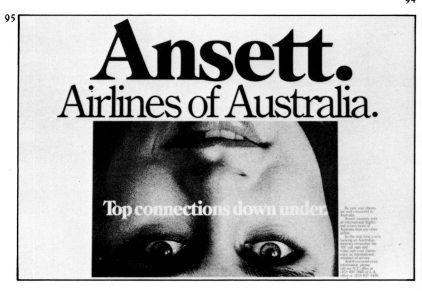

94

95

96. Trade Ad
Creative Director: Robin Field
Art Director: Paul R. Grissom
Copywriter: Robin Field
Artist: Jerzy Kolacz
Agency: Paul R. Grissom & Associates
Client: Product Initiatives
 Consulting Group Limited

97. Trade Ad
Art Directors: Howard Alstad/
 Stephen Yeates
Writer: Jonathan Grant
Photographer: Stephen Yeates
Creative Director: Jonathan Grant
Agency: Grant and DeNike Inc.
Client: Norcen Energy Resources Limited

98. Trade Ad
Art Director: Gary Carr
Writer: Doug Linton
Photographer: Anzalone McLeod Shanoff
Creative Directors: G. Carr/D. Linton
Agency: Ambrose, Carr, DeForest &
 Linton
Client: Comac Communications Ltd.

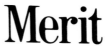

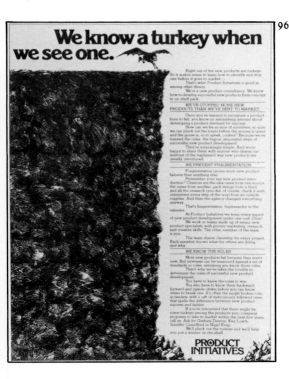

96

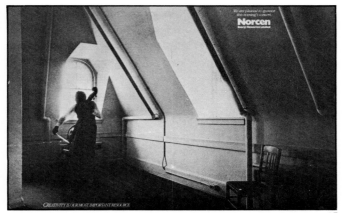

97

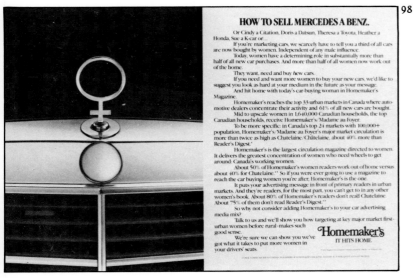

98

Merit

99. Trade Ad
Art Director: Louis Fishauf
Designer: Louis Fishauf
Studio: Reactor Art & Design
Client: Nelvana Animated Commercials

100. Trade Ad
Art Director: Richard Clewes
Writer: Bill Durnan
Photographer: Stephen Amini
Creative Director: John Cruickshank
Agency: MacLaren
Client: I.C.A.

101. Trade Ad
Art Director: Vickie Wild
Writer: Robyn MacGarva
Photographer: Pat Lacroix
Agency: The Gloucester Group
Client: Sara Lee

102. Trade Ad
Art Director: Robert Vosburgh
Writer: Julian Burford
Illustrator: Joe Salina
Agency: Adams Inc.
Client: Chemacryl Plastics Ltd.

103. Trade Ad
Art Director: Adrian Jacobs
Writer: Brian Quennell
Photographer: Peter Baumgartner
Creative Director: Dieter F. Kaufmann
Agency: Publicité Arsenault Anderson
Client: Le Groupe Radisson

104. Trade Ad
Art Director: David Kelso
Writer: Stephen Williams
Illustrator: Rick Fisher
Creative Director: Stephen Williams
Agency: J. Walter Thompson Co. Ltd.
Client: Northern Telecom

Merit

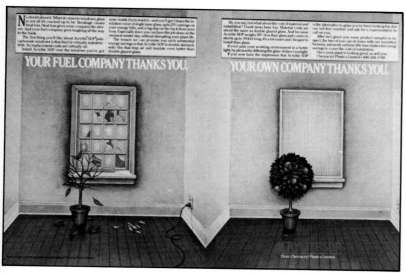

102

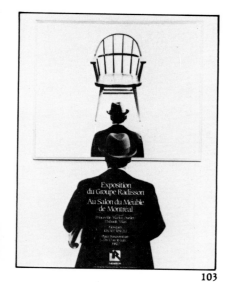

103

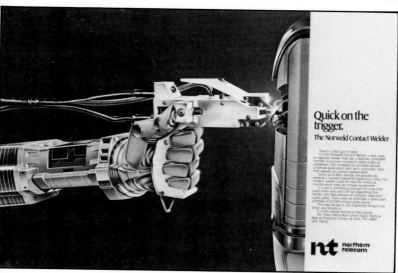

104

Merit

105. Consumer Magazine Ad
Art Director: Jane Pritchard
Writer: Bill Martin
Illustrator: Kent Smith
Creative Director: Jane Pritchard
Agency: J. Walter Thompson
Client: Labatt's Ontario Breweries

106. Poster Photography
Art Directors: Richard Rood/
　　Casimir Bart
Writer: Richard Rood
Photographer: Casimir Bart
Creative Director: Richard Rood & Assoc.
Client: Barber Ellis

107. Transit
Art Director: Brian Harrod
Writer: Ian Mirlin
Illustrator: Tony Kew
Creative Director: Harrison Yates
Agency: McCann-Erickson Toronto
Client: Levi Strauss Canada

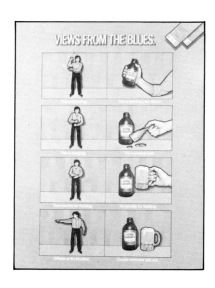

105

107

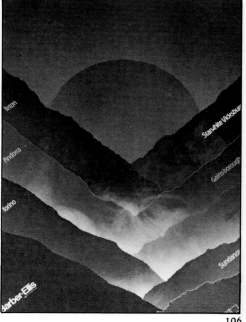

106

Merit

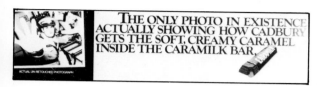

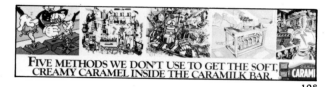

108

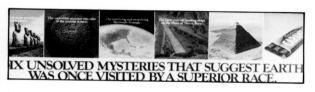

110

109

Merit

111

112

113. Magazine Spread
Art Director: Jacques Robert
Photographer: André Cornellier
Designer: Michele
Publication: Châtelaine French
Client: Châtelaine French

114. Magazine Spread
Art Director: Arthur Niemi
Illustrator: Miro Malish
Designer: Mary Opper
Publication: Quest Magazine
Company: Comac Communications Ltd.

115. Magazine Spread
Art Directors: James Ireland/
Barbara Solowan
Photographer: David Muench/
The Image Bank of Canada
Designer: Carol Young
Publication: Toronto Life Magazine
Company: Toronto Life Publishing
Company

Merit

113

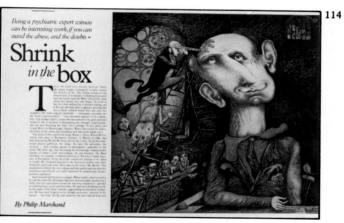

114

115

Merit

116. Complete Magazine Design
Art Director: Marian Mustard
Photographers: Various
Illustrators: Various
Publication: City & Country Home
Client: Maclean-Hunter Ltd.

117. Complete Magazine Design
Art Director: James M. Lawrence
Photographers/Illustrators: Various
Designer: Pamela McDonald
Publication: Equinox
Client: Equinox

118. Complete Magazine Design
Art Director: James M. Lawrence
Photographers/Illustrators: Various
Designer: Pamela McDonald
Publication: Equinox
Client: Equinox

116

SOUTHERN ONTARIO LIVING

CITY & COUNTRY
HOME

FALL 1982 $2.00

FIRST ISSUE

DECORATING · COLLECTING · ARTS & ANTIQUES
ONTARIO HERITAGE HOMES · SHOPPING
DESIGNER PROFILE · TRAVEL · CUISINE
GARDENS · FASHION ACCESSORIES

117

THE MAGAZINE OF CANADIAN DISCOVERY

EQUINOX
MAY/JUNE 1982

Imperilled Puffins
Quiet Famine Stalks Canada's Great Seabird Colonies

Turks & Caicos: Exploring Canada's Would-Be Caribbean Province
Orias Leduc Profile · Landsat Imagery · Aconcagua Expedition

118

THE MAGAZINE OF CANADIAN DISCOVERY

EQUINOX
JULY/AUGUST 1982

BEGUILING NEPAL: A Canadian Pilgrim in a Medieval Land
Cerebral Scanners · Lobsters · Gossamer Barnstormers

119. Complete Magazine Design
Art Director: James M. Lawrence
Photographers/Illustrators: Various
Designer: Pamela McDonald
Publication: Equinox
Client: Equinox

120. Complete Magazine Design
Art Director: James M. Lawrence
Photographers/Illustrators: Various
Designer: Pamela McDonald
Publication: Equinox
Client: Equinox

121. Complete Magazine Design
Art Director: Tim Forbes
Designer: Tim Forbes Design Inc.
Publication: Trace
Client: Architectural Magazine Society

Merit

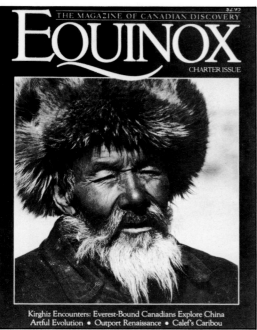

Merit

122. Complete Magazine Design
Art Director: Ursula Kaiser
Photographer/Illustrator: Various
Designer: Lindsay Beaudry/Shari Spier
Publication: Homemaker's Magazine
Company: Comac Communications

123. Magazine Cover
Art Director: Ursula Kaiser
Photographer: Ron Tanaka
Designer: Shari Spier
Publication: Homemaker's Magazine
Company: Comac Communications

124. Magazine Cover
Art Director: Steve Manley
Illustrator: Julius Ciss
Designer: Steve Manley
Publication: Canadian Business Magazine
Client: Canadian Business Magazine

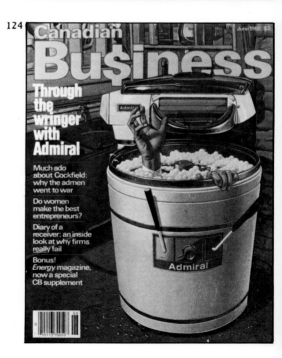

125. Magazine Cover
Art Directors: Rod Della-Vedova &
 Georges Haroutiun
Illustrator: Blair Drawson
Designer: Joanna Bain
Publication: Avenue Magazine
Company: Bloor Publishing

126. Magazine Cover
Art Director: B. J. Galbraith
Illustrator: Theo Dimson
Designer: B.J. Galbraith
Publication: Radio Guide
Company: Saturday Night Publications
 for CBC

127. Magazine Cover
Art Director: B. J. Galbraith
Illustrator: Bob Fortier
Designer: B.J. Galbraith
Publication: Radio Guide
Company: Saturday Night Publications
 for CBC

Merit

125

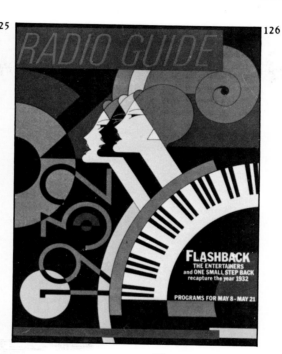

126

127

Merit

128. Magazine Covers
Art Director: Ann Ames
Photographer: Benjamin Rondel
Publication: Kanata Magazine
Client: C.P. Air/Aircom Publishing
Company: Ann Ames Design Inc.

129. Magazine Covers
Art Director: Jackie Young
Photographer: Tim Saunders
Model Maker: Daniel Izzard
Designer: Klaus Uhlig
Publication: Financial Post
Client: Financial Post

130. Editorial Illustration
Illustrator: James Tughan
Art Director: Jackie Young
Publication: Financial Post Magazine
Client: Financial Post Magazine

128

129

130

131. Magazine Spread
Art Director: Ursula Kaiser
Photographer: Pat LaCroix
Designer: Lindsay Beaudry
Publication: Homemaker's Magazine
Company: Comac Communications

132. Magazine Spread
Art Director: Ursula Kaiser
Photographer: Tim Saunders
Designer: Shari Spier
Publication: Homemaker's Magazine
Company: Comac Communications

133. Magazine Spread
Art Director: Ursula Kaiser
Illustrator: Doug Martin
Designer: Judy Hancock
Publication: Homemaker's Magazine
Company: Comac Communications

Merit

131

132

133

Merit

134. Magazine Spread
Art Director: Ursula Kaiser
Photographer: Michel Pilon
Designer: Lindsay Beaudry
Publication: Homemaker's Magazine
Company: Comac Communications

135. Magazine Spread
Art Director: Ursula Kaiser
Illustrator: Blair Drawson
Designer: Lindsay Beaudry
Publication: Homemaker's Magazine
Company: Comac Communications

136. Magazine Spread
Art Director: Ursula Kaiser
Photographer: Pat LaCroix
Designer: Shari Spier
Publication: Homemaker's Magazine
Company: Comac Communications

134
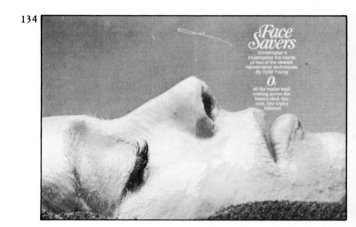

135
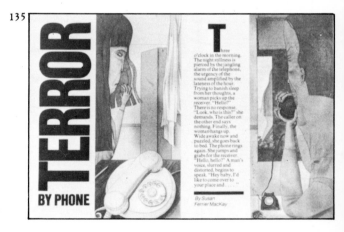

136
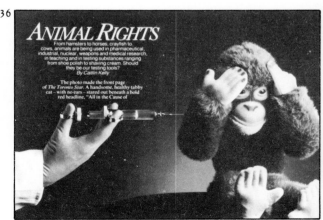

137. Magazine Spread
Art Director: Stephen Costello
Photographer: Carol Leflufy
Designer: Arthur Niemi
Publication: Quest Magazine
Company: Comac Communications Ltd.

138. Magazine Spread
Art Director: Steve Manley
Photographer: Olga Tracey
Designers: David Woodside/
Steve Manley
Publication: Energy Magazine
Client: Canadian Business Magazine

139. Magazine Spread
Art Director: Stephen Costello
Photographer: Pat Lacroix
Designer: Mary Opper
Publication: Quest Magazine
Company: Comac Communications Ltd.

137

138

139

Merit

140. Magazine Spread
Art Directors: James Ireland/
Barbara Solowan
Illustrator: Anita Kunz
Designer: James Ireland
Publication: Toronto Life Magazine
Company: Toronto Life Publishing
Company

141. Magazine Spread
Art Directors: James Ireland/
Barbara Solowan
Photographer: Bert Bell
Designer: Barbara Solowan
Publication: Toronto Life Magazine
Company: Toronto Life Publishing
Company

142. Magazine Spread
Art Director: Louis Fishauf
Illustrator: Robert Pryor
Designer: Louis Fishauf
Publication: Saturday Night Magazine
Company: Saturday Night Publishing

140

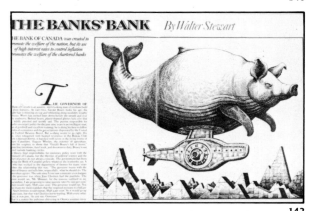

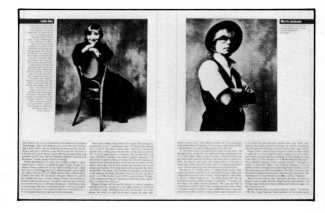

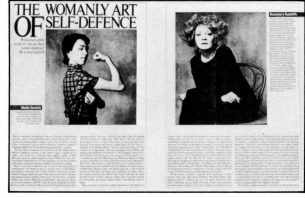

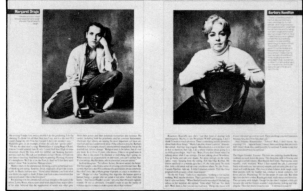

142

141

143. **Magazine Spread**
Art Director: Derek Ungless
Photographer: Michael Rafelson
Designer: Bruce Ramsay
Publication: Saturday Night Magazine
Company: Saturday Night Publishing

144. **Magazine Spread**
Art Directors: Rod Della-Vedova &
Georges Haroutiun
Photographer: Myron Zabol
Designer: Joanna Bain
Publication: Avenue Magazine
Company: Bloor Publishing

145. **Magazine Spread**
Art Director: Derek Ungless
Designer: Bruce Ramsay
Publication: Saturday Night Magazine
Company: Saturday Night Publishing

Merit

143

144

145

Merit

146. Magazine Page
Art Director: James M. Lawrence
Photographer: Baron Wolman
Designer: Pamela McDonald
Publication: Equinox
Client: Equinox

147. Magazine Section
Art Directors: James Ireland/
Barbara Solowan
Photographers: Various
Illustrators: Mark Tindale, Jeff Jackson,
Wendy Wortsman, Bill Boyko
Designer: Barbara Solowan
Publication: Toronto Life Magazine
Company: Toronto Life Publishing
Company

148. Magazine Spread
Art Director: Stephen Costello
Illustrator: Anita Kunz
Designer: Arthur Niemi
Publication: Quest Magazine
Company: Comac Communications Ltd.

 146

 148

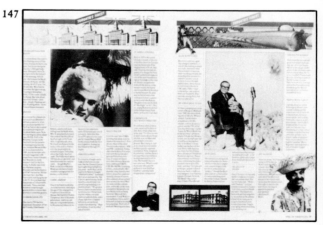 147

149. **Magazine Section**
Art Directors: James Ireland/
 Barbara Solowan
Photographers: Michele De La Sabliere,
 Ron Tanaka
Illustrators: Barbara Klunder,
 Sandra Dionisi
Designer: Barbara Solowan
Publication: Toronto Life Magazine
Company: Toronto Life Publishing
 Company

150. **Magazine Section**
Art Directors: James Ireland/
 Barbara Solowan
Photographers: David Ohashi, Jim Allen
Designer: Barbara Solowan
Publication: Toronto Life Magazine
Company: Toronto Life Publishing
 Company

151. **Magazine Section**
Art Directors: James Ireland/
 Barbara Solowan
Photographers: Various
Designer: James Ireland
Publication: Toronto Life Magazine
Company: Toronto Life Publishing
 Company

Merit

149

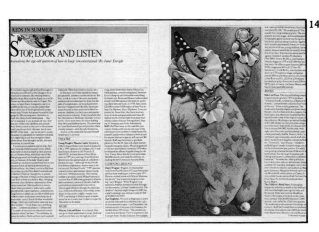

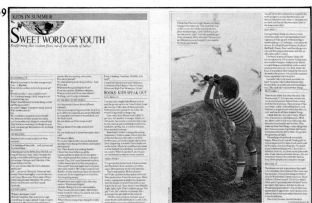

150

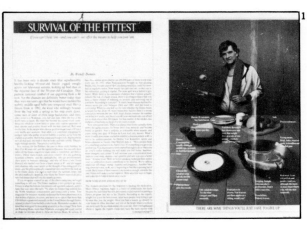

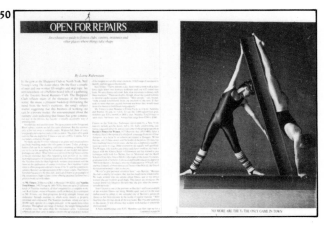

151

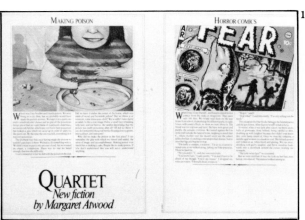

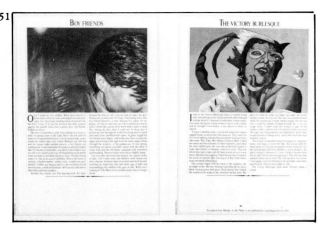

Merit

152. Magazine Fashion Section
Art Directors: Rod Della-Vedova &
Georges Haroutiun
Photographer: Myron Zabol
Designer: Joanna Bain
Publication: Avenue Magazine
Company: Bloor Publishing

153. Magazine Fashion Section
Art Director: Ursula Kaiser
Photographer: Tim Saunders
Designer: Shari Spier
Publication: Homemaker's Magazine
Company: Comac Communications

154. Magazine Fashion Section
Art Director: Lewis Fishauf
Photographer: Larry Miller
Designer: Lewis Fishauf
Publication: City Women
Client: Comac Communications

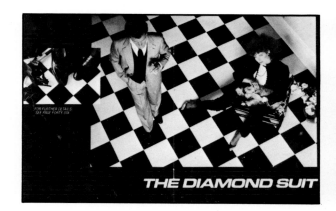

THE DIAMOND SUIT

THE CIVIL SUIT

152

153

154

Merit

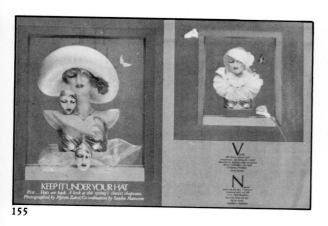

155

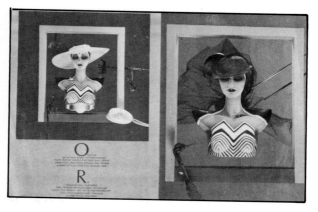

156

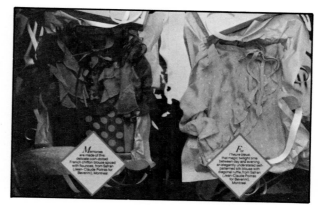

157

Merit

158. Magazine Section
Art Director: Ursula Kaiser
Photographer: Masao Abe
Designer: Avril Orloff
Publication: Homemaker's Magazine
Company: Comac Communications

159. Magazine Fashion Section
Art Director: Derek Szeto
Photographer: Taffi Rosen
Designer: Derek Szeto
Publication: Flair Magazine
Client: Flair Magazine

160. Magazine Fashion Section
Art Director: Ursula Kaiser
Photographer: Jim Allen
Designer: Lindsay Beaudry
Publication: Homemaker's Magazine
Company: Comac Communications

158

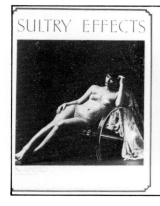
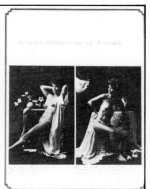
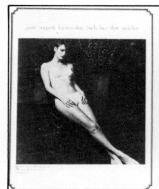
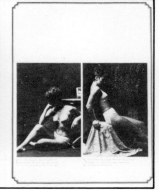

159

160

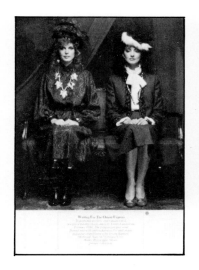
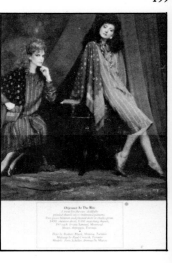

161. Magazine Fashion Section
Art Director: Barbara Solowan
Photographer: Debrah Samuel
Designer: Barbara Solowan
Publication: City Women
Client: Comac Communications

162. Magazine Section
Art Director: Nick Milton
Photographer: Nigel Dickson
Designer: Jeanne Gray
Publication: The Magazine That's All About SMALL BUSINESS
Company: Maclean Hunter Ltd.

163. Magazine Section
Art Directors: James Ireland/ Barbara Solowan
Photographer: Dudley Witney
Designer: Carol Young
Publication: Toronto Life Magazine
Company: Toronto Life Publishing Company

Merit

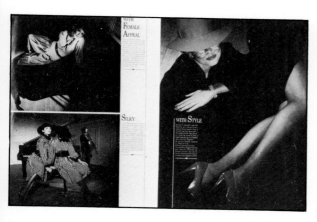

161

162

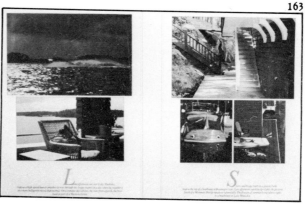

163

Merit

164. Magazine Section
Art Director: Stephen Costello
Illustrator: Donna Muir
Designer: Arthur Niemi
Publication: Quest Magazine
Company: Comac Communications Ltd.

165. Magazine Section
Art Director: Jackie Young
Illustrator: Jim Tughan
Agency: INK
Client: Financial Post Magazine

166. Graphic Design Poster
Designer: Bob Russell
Art Directors: Bob Russell,
 Derek Timmerman
Photographer: Matthew Wiley
Company: Boardwork Studios Limited
 (division of Carverhill Russell &
 Timmerman Design)
Clients: Boardwork Studios Limited,
 Sharpshooter Productions Ltd.

164

165

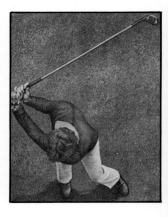

166
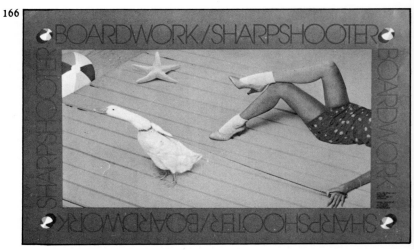

167. Graphic Design Poster
Art Director: Ken Burgin
Designer: Pam Burgin
Artist: Toshi Oikawa
Company: Sumari Design Inc.
Client: Keith K. Warne/
 Haughton Graphics Ltd.

168. Graphic Design Poster
Designer: Lawrence Finn
Art Director: Lawrence Finn
Photographer: Ronald Baxter Smith
Company: Lawrence Finn and
 Associates Limited

169. Advertising Poster
Art Director: Theo Dimson
Designer: Theo Dimson
Illustrator: Unknown Victorian
Company: Dimson & Smith
Client: Lipton's Fashions

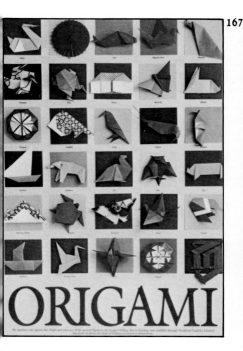

167

168

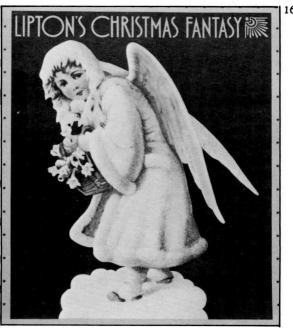

169

Merit

170. Design Poster
Designer: Louis Fishauf
Art Director: Louis Fishauf
Photography: Reactor Art & Design
Studio: Reactor Art & Design

171. Graphic Design Poster
Designers: Scott Taylor, Paul Browning
Art Director: Scott Taylor
Artist: Paul Browning
Company: Taylor & Browning Design Associates
Client: The Toronto Art Directors Club

172. Graphic Design Poster
Designers: Jean-Christian Knaff/ Aldo del Bono
Art Director: Jean-Christian Knaff
Illustrator: Jean-Christian Knaff
Company: Plumart Studio
Client: Groupe d'animation urbaine de Montréal

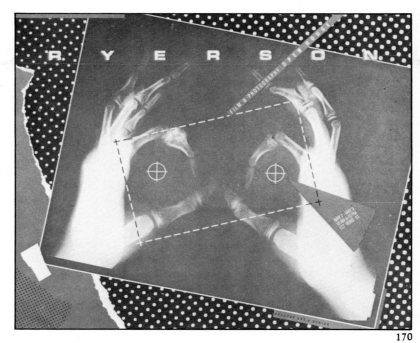

170

171

172

173. Graphic Design Poster
Art Director: Tim Forbes
Designer: Tim Forbes
Photographer: Deborah Samuel
Company: Murray Mamone Kingston
Client: Gallery Guan

174 Graphic Design Poster
Art Director: Louis Fishauf
Designer: Louis Fishauf
Photographer: Carol Gibson
Lettering: Karen Kheeseman
Reactor: Art and Design
Client: Bibi Caspari

175. Advertising Poster
Designer: Michael McLaughlin
Art Director: Michael McLaughlin
Photographer: Stephen Yeates
Client: The Partners' Film Company

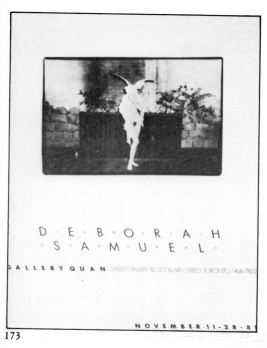

173

174

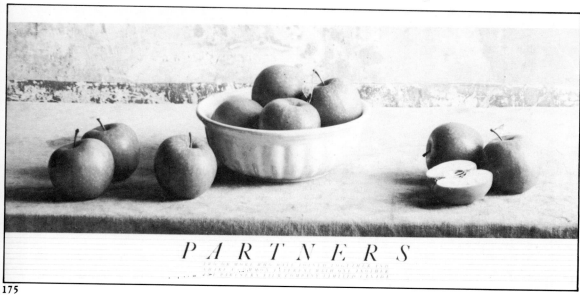

175

Merit

176. Graphic Design Poster
Designer: Robert Burns, Jennifer Gyles
Art Director: Robert Burns
Company: Burns, Cooper, Hynes
Limited
Client: C Channel

177. Graphic Design Poster
Designer: Gary Ludwig
Art Directors: Gary Ludwig,
 Paul Hodgson
Photographer: Jayme Odgers
Company: Fifty Fingers Incorporated
Client: Festival of Festivals

178. Advertising Poster
Art Director: Elvin Letchford
Writer: Vern Johansson
Photographer: Terry Collier
Creative Director: Daniel D. Peppler
Agency: Needham, Harper & Steers
 of Canada Ltd.
Client: Honda Canada Inc.

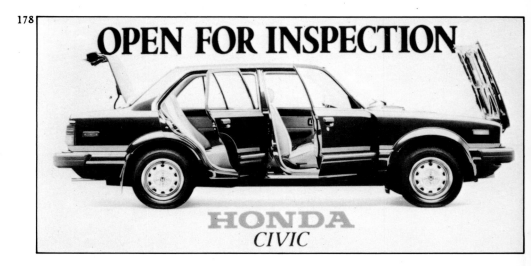

179. Advertising Poster
Designer: Heather Cooper
Art Director: Heather Cooper
Illustrator: Heather Cooper
Company: Burns, Cooper, Hynes Limited
Client: Stratford Festival

180. Advertising Poster
Art Directors: Harrison Yates/Brian
Harrod/Stephen So
Writer: Harrison Yates
Illustrator: Bob Karman/Leonardo
Da Vinci
Creative Director: Harrison Yates
Agency: McCann-Erickson Toronto
Client: Hedonism II

181. Magazine Spread
Art Director: Don McDonell
Photographer: Pat Lacroix
Designers: Don McDonell &
Les Usherwood
Publication: Yachting Magazine
Company: Enterprise Advertising
Writer: Cubby Marcus

Merit

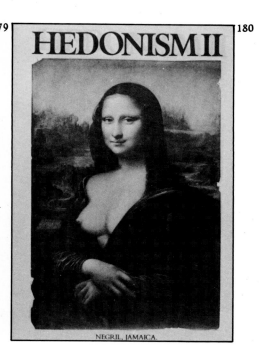

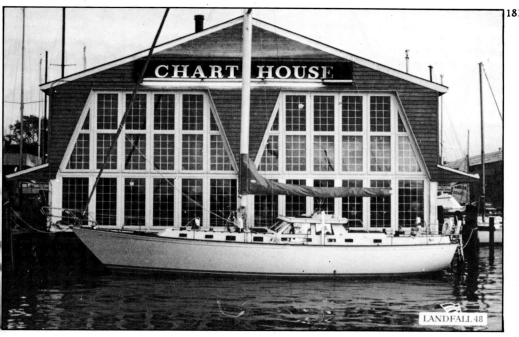

Merit

182. Advertising Poster
Art Director: Theo Dimson
Designer: Theo Dimson
Illustrators: Mr. Pickwick/
 Theo Dimson/Ken Jackson
Company: Dimson & Smith
Client: University of Toronto

183. Advertising Poster
Art Director: Theo Dimson
Designer: Theo Dimson
Illustrators: Ken Jackson/
 Theo Dimson
Company: Dimson & Smith
Client: University of Toronto

184. Outdoor Poster
Art Director: Graham Hallett
Writer: Gord Schwab
Photographer: Ken Walley
Creative Director: Michael Paul
Agency: SMW Advertising
Client: Canadian Heart Foundation

182

183

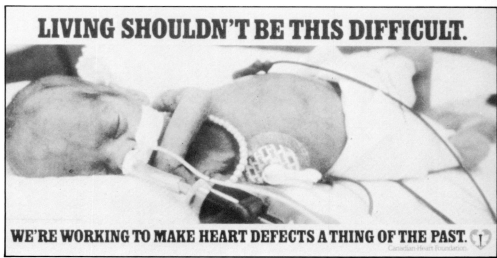

184

185. Outdoor Poster
Art Director: Jim Burt
Writer: Graham Watt
Photographers: Jim Burt, Peter
 Baumgartner, Shin Sugino
Agency: Watt Burt Advertising Inc. for
 McKim Advertising Ltd. Toronto
Client: Ontario Milk Marketing Board

186. Mall Poster
Art Director: David Purser
Writer: Jochem Klosterman
Photographer: Terry Collier
Creative Director: Peter Tregale
Agency: Baker Lovick Limited
Client: Kodak Canada Inc.

185

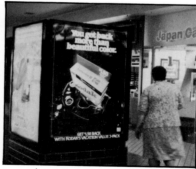

186

Merit

187. Transit Advertisement
Art Director: Terrance Iles
Writer: William Lower
Illustrator: Margaret Hathaway
Studio: Reactor Art & Design
Creative Director: Gary Prouk
Agency: Scali, McCabe, Sloves
 (Canada) Ltd.
Client: Gilbey Canada Inc.

188. Advertising Poster
Art Director: Arnold Wicht
Writer: Tim Heintzman
Photographer: Rudi Von Tiedemann
Creative Director: John McIntyre
Agency: Camp Associates Advertising
Client: Ontario, Ministry of the
 Attorney General

189. Outdoor Poster
Art Director: Dennis Bruce
Writer: Marty Myers
Photographer: Stephen Amini
Agency: The Gloucester Group
Client: Harvey Woods

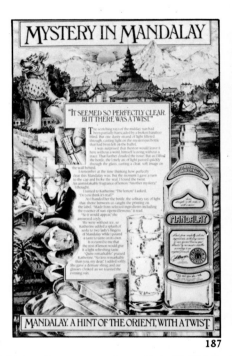

187

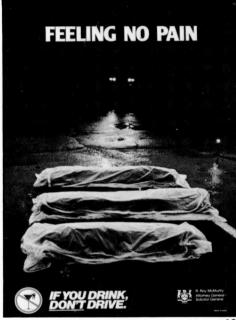

188

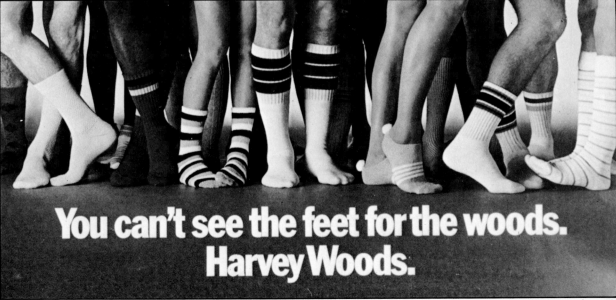

189

190. Outdoor Poster
Art Director: Randy Diplock
Writer: Rick Davis
Photographer: Barry Johnston, TDF
Creative Directors: G. Carr/D. Linton
Agency: Ambrose, Carr, DeForest & Linton
Client: Honda Canada Inc.

191. Transit
Art Director: Michael McLaughlin
Writer: Stephen Creet
Photographer: Stephen Yeates
Creative Director: Michael McLaughlin
Agency: Vickers & Benson/Ayer
Client: Nabisco Brands

192. Outdoor Poster
Art Director: Dennis Bruce
Writer: Marty Myers
Photographer: Stephen Amini
Agency: The Gloucester Group
Client: Harvey Woods

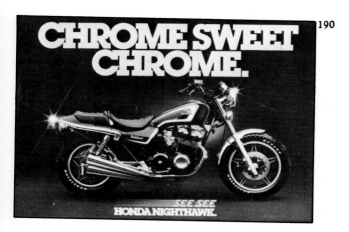

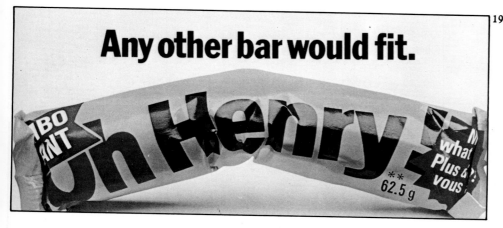

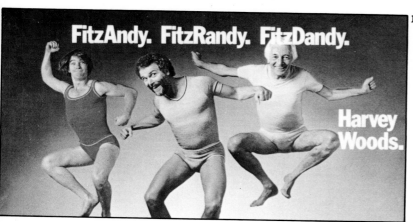

Merit

193. Editorial Illustration
Illustrator: Ann Vosburgh
Art Director: Gordon Sibley
Company: Maclean-Hunter Ltd.
Client: Chatelaine

194. Editorial Illustration
Art Director: Stephen Costello
Illustrator: Tom Hunt
Publication: Quest Magazine
Company: Comac Communications Ltd.

195. Editorial Illustration
Artist: Jerzy Kolacz
Art Director: Steve Manley
Client: Canadian Business Magazine

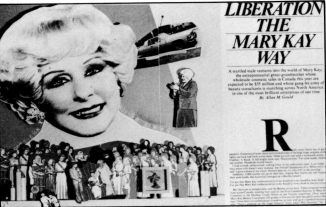

193

How to avoid the management trap

Your career strategy may be steering you right up against the wall. Here's how to change direction — before it's too late

BY FRANK MUSTEN

195

SPORTS

HIGHLAND GAMES, FLORIDA STYLE: HE WHO PAYS THE PIPER CALLS THE TUNE. IN THIS CASE, IT'S *KANSAS CITY*

BY HARRY BRUCE

194

196. Editorial Illustration
Art Director: Jim Ireland
Illustrator: Joe Salina
Publication: Toronto Life
Company: Key Publishers

197. Editorial Illustration
Illustrator: Miro Malish
Art Director: Louis Fishauf
Designer: Bruce Ramsay
Publication: Saturday Night magazine
Company: Saturday Night Publishing

198. Editorial Illustration
Illustrator: Julian Allen
Art Director: Derek Ungless
Designer: Bruce Ramsay
Publication: Saturday Night magazine
Company: Saturday Night Publishing

Merit

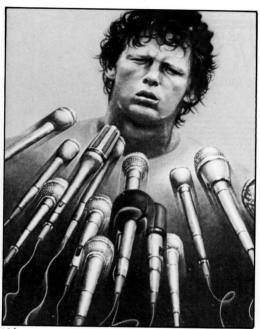

196

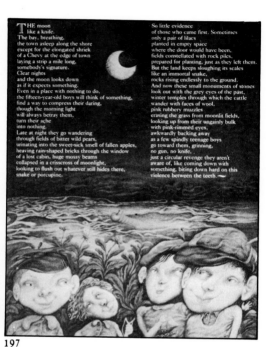

197

198

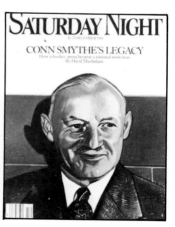

Merit

199. Editorial Illustration
Art Directors: James Ireland/
 Barbara Solowan
Illustrator: Dennis Noble
Designer: James Ireland
Publication: Toronto Life Magazine
Company: Toronto Life Publishing
 Company

200. Editorial Illustration
Art Directors: James Ireland/
 Barbara Solowan
Illustrator: Paul Dallas
Designer: Carol Young
Publication: Toronto Life Magazine
Company: Toronto Life Publishing
 Company

201. Editorial Illustration
Art Directors: James Ireland/
 Barbara Solowan
Illustrator: Christa Olgen
Designer: James Ireland
Publication: Toronto Life Magazine
Company: Toronto Life Publishing
 Company

199
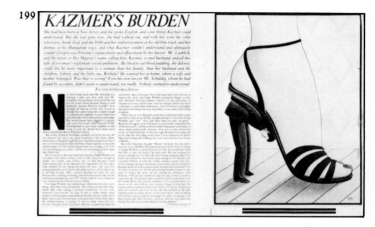

200

201
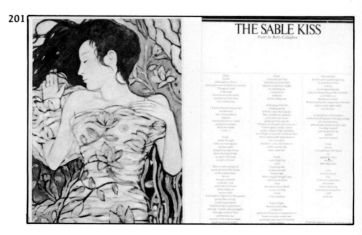

202. Editorial Illustration
Art Directors: James Ireland/
 Barbara Solowan
Illustrator: Bill Boyko
Designer: Barbara Solowan
Publication: Toronto Life Magazine
Company: Toronto Life Publishing
 Company

203. Editorial Illustration
Art Directors: James Ireland/
 Barbara Solowan
Illustrator: Dennis Noble
Designer: James Ireland
Publication: Toronto Life Magazine
Company: Toronto Life Publishing
 Company

204. Editorial Illustration
Illustrator: Janet Wooley
Art Director: Derek Ungless
Designer: Bruce Ramsay
Publication: Saturday Night magazine
Company: Saturday Night Publishing

Merit

202

203

204

Merit

205. Editorial Illustration
Illustrator: Jim Tughan
Art Director: Jackie Young
Publication: INK
Client: Financial Post Magazine

206. Editorial Illustration
Illustrator: Anita Kunz
Art Director: Derek Ungless
Designer: Bruce Ramsay
Publication: Saturday Night magazine
Company: Saturday Night Publishing

207. Editorial Illustration
Illustrator: John Martin
Art Director: Derek Ungless
Designer: Bruce Ramsay
Publication: Saturday Night magazine
Company: Saturday Night Publishing

205

206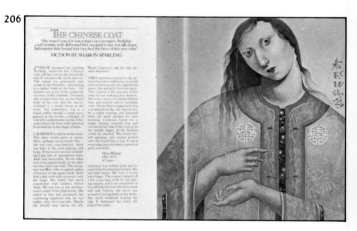

207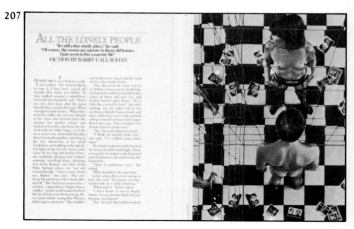

208. Editorial Illustration
Art Director: Steve Manley
Illustrator: Joe Salina
Publication: Canadian Business
Company: Key Publishers

209. Editorial Illustration
Illustrator: Roman Balicki
Art Director: Derek Ungless
Designer: Bruce Ramsay
Publication: Saturday Night magazine
Company: Saturday Night Publishing

210. Editorial Illustration
Illustrator: Julian Allen
Art Director: Louis Fishauf
Designer: Bruce Ramsay
Publication: Saturday Night magazine
Company: Saturday Night Publishing

Merit

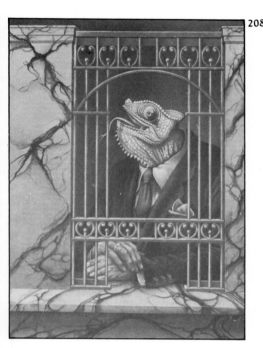

208

209

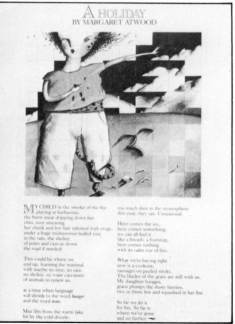

210

Merit

211. Graphic Design Illustration
Illustrator: Heather Cooper
Art Director: Heather Cooper
Agency: Burns, Cooper, Hynes Limited
Client: The Ethos Cultural
Development Foundation

212. Design Illustration
Art Director: Louis Fishauf
Artist: Jeff Jackson
Studio: Reactor Art & Design
Client: Gimlets

213. Advertising Illustration
Art Director: Laurie McGaw,
June Lawrason
Writer: John Beaudry
Illustrator: Joe Salina
Client: C.A.P.I.C.

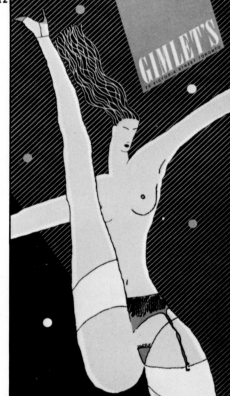

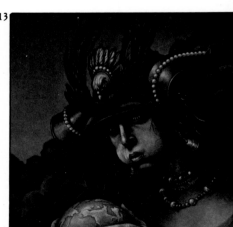

214. Editorial photojournalism
Photographer: Paul Orenstein
Art Director: Jim Ireland
Publication: Toronto Life Magazine
Client: Toronto Life Magazine

215. Poster Illustration
Artist: Jeff Jackson
Designer: David Manear
Creative Director: Stewart Hood
Agency: The Jerry Goodis Agency
Client: The Financial Post

216. Graphic Design Photography
Illustrator: James Tughan
Art Director: Jackie Young
Publication: INK
Client: Financial Post

Merit

214

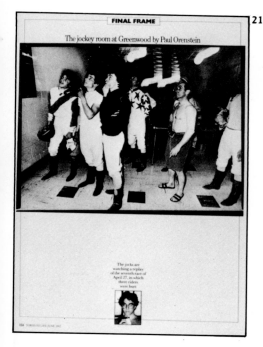

215

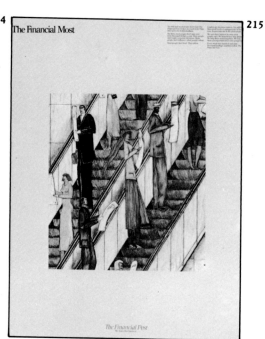

216

Merit

217. Poster Illustration
Illustrator: Bill Boyko
Art Director: Stephen Yates
Company: Mixed Nuts Inc.
Client: Maze Records

218. Poster Illustration
Art Director: Louis Fishauf
Artist: Blair Drawson
Studio: Reactor Art & Design
Client: Canadian Opera Company

219. Poster Illustration
Illustrator: Roger Hill
Art Directors: Rod Della-Vedova &
Georges Haroutiun
Agency: M.A.G. Graphics Limited
Client: Comac Communications Ltd.

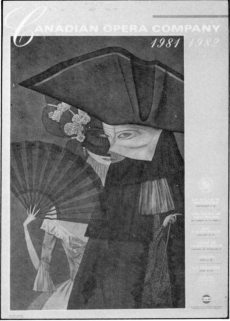

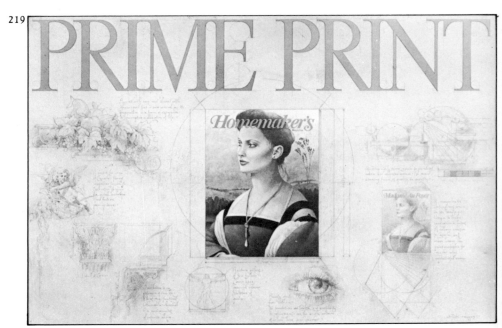

220. Poster Illustration
Illustrator: Bill Boyko
Art Director: Bill Boyko
Company: Mixed Nuts Inc.
Client: Canada Offshore Cinema Ltd. &
 Media Aids

221. Editorial Illustration
Artist: Blair Drawson
Art Director: Georges Haroutin
Studio: M.A.G. Graphics
Client: Avenue Magazine

222. Poster Illustration
Illustrator: Heather Cooper
Art Director: Heather Cooper
Agency: Burns, Cooper, Hynes Limited
Client: Stratford Festival

Merit

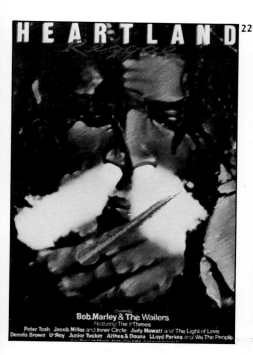

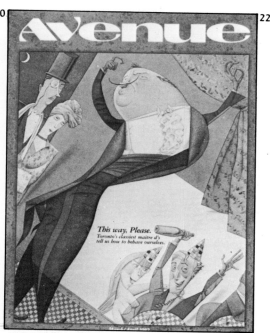

Merit

223. Graphic Design Illustration
Illustrator: Heather Cooper
Art Director: Peter Windett, client
Agency: Burns, Cooper, Hynes Limited
Client: Crabtree & Evelyn (Overseas)
 Limited, Scarborough Fair Inc.

224. Graphic Design Illustration
Illustrator: Heather Cooper
Art Director: Heather Cooper
Agency: Burns, Cooper, Hynes Limited
Client: Ruby Street, Inc.

223

224

225. Editorial Illustration
Illustratio: Martin Springett
Art Director: Kathryn Cole
Publication: Crackers Magazine
Client: Scholastic Tab Publications

226. Graphic Design Illustration
Illustrator: Robin Muller
Art Director: Kathryn Cole
Publication: Scholastic Tab Publications
Client: Scholastic Tab Publications

227. Editorial Photography
Art Directors: James Ireland/
 Barbara Solowan
Photographer: Masao Abe
Designer: Barbara Solowan
Publication: Toronto Life Magazine
Company: Toronto Life Publishing
 Company

Merit

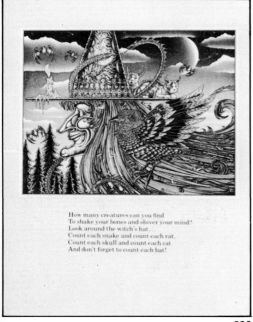

225

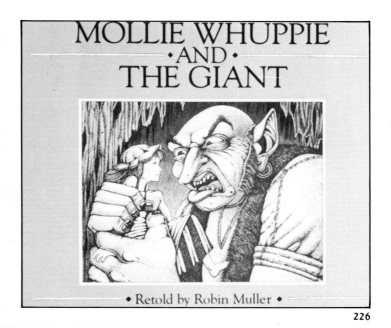

226

227

Merit

228. Editorial Photography
Photographer: Deborah Samuel
Art Director: Barbara Solowan
Publication: City Women
Client: Comac Communications

229. Editorial Photography
Art Directors: James Ireland/
Barbara Solowan
Photographer: Bert Bell
Designer: Barbara Solowan
Publication: Toronto Life Magazine
Company: Toronto Life Publishing
Company

230. Editorial Photography
Art Directors: James Ireland/
Barbara Solowan
Photographers: Various
Designer: Carol Young
Publication: Toronto Life Magazine
Company: Toronto Life Publishing
Company

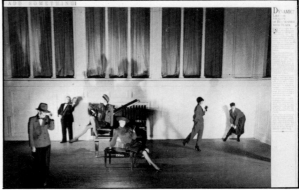

228

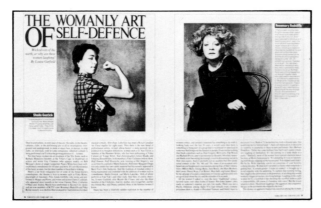

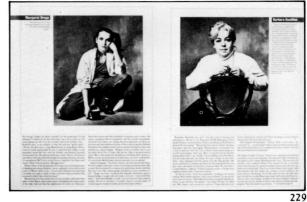

229

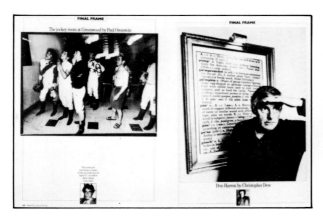

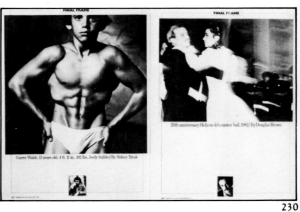

230

231. Editorial Photography
Photographer: Carol Gibson
Art Director: Louis Fishauf
Publication: City Women
Client: Comac Communications

232. Editorial Photography
Photographer: Nigel Dickson
Art Director: Derek Ungless
Designer: Bruce Ramsay
Publication: Saturday Night magazine
Company: Saturday Night Publishing

233. Editorial Photography
Art Directors: James Ireland/
Barbara Solowan
Photographer: George Whiteside
Designer: James Ireland
Publication: Toronto Life Magazine
Company: Toronto Life Publishing
Company

Merit

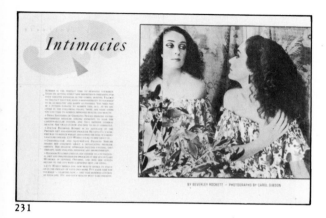

231

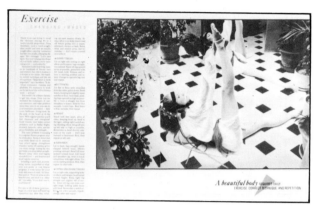

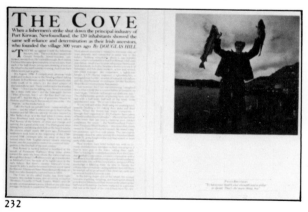

232

233

Merit

234. Editorial Photography
Art Directors: James Ireland/
Barbara Solowan
Photographer: Dudley Witney
Designer: Carol Young
Publication: Toronto Life Magazine
Company: Toronto Life Publishing
Company

235. Editorial Photojournalism
Art Directors: James Ireland/
Barbara Solowan
Photographer: Tom Skudra
Designer: James Ireland
Publication: Toronto Life Magazine
Company: Toronto Life Publishing
Company

236. Editorial Photography
Photographer: Arnaud Maggs
Art Director: Jackie Young
Agency: INK
Client: Financial Post

234

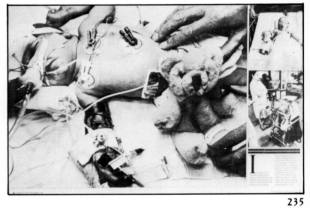

235

236

237. Editorial Photography
Photographer: Gillean Proctor
Art Director: Ursula Kaiser
Publication: Homemaker's Magazine
Client: Comac Communications

238. Editorial Photography
Photographer: Ron Cole
Art Director: Marg Stewart
Publication: The Review
Client: Imperial Oil Co. Ltd.

239. Editorial Photography
Photographer: Paul Gin
Art Director: Derek Ungless
Publication: Saturday Night Magazine
Client: Saturday Night Publishing

Merit

237

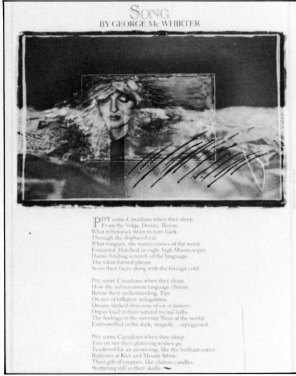

239

238

Merit

240. Editorial Photography
Photographer: Michael Rafelson
Art Director: Derek Ungless
Publication: Saturday Night Magazine
Client: Saturday Night Magazine

241. Magazine Section
Art Director: Louis Fishauf
Photographer: Peter Tatiner
Designer: Lewis Fishauf
Publication: City Women
Client: Comac Communications

242. Editorial Photojournalism
Art Director: Stephen Costello
Photographer: Delip Mehta
Designer: Arthur Niemi
Publication: Quest Magazine
Company: Comac Communications Ltd.

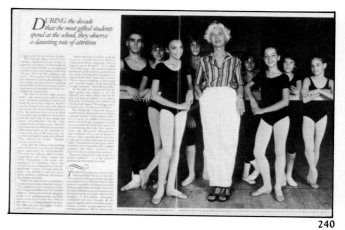

240

241

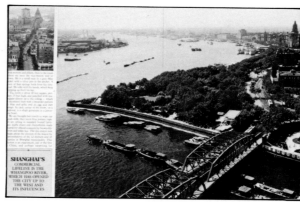

242

243. Advertising Photography
Photographer: Bill McLeod
Art Director: Dean Bradley
Agency: F.H. Hayhurst Co. Ltd.
Client: Andres Wines

244. Advertising Photography
Photographer: Gillean Proctor
Art Director: Raymond Lee
Agency: Raymond Lee & Associates
Client: Arthurs-Jones Lithographing Ltd.

245. Advertising Photography
Photographer: Nancy Shanoff
Art Director: Peter Weis
Agency: Ronald-Reynolds & Company
 Limited
Client: T.G. Bright & Co. Ltd.

Merit

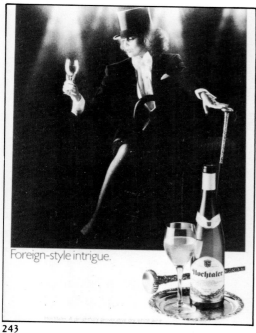

243

244

245

Merit

246. Graphic Design Photography
Photographer: Richard Sharabura
Art Director: Richard Sharabura
Company: Chatsworth Studios Limited
Client: Chatsworth Studios Limited

247. Graphic Design Photography
Photographer: Peter Christopher
Art Director: Scott Taylor
Company: Abbott, Jenkins, Taylor
Client: Cadillac Fairview

248. Graphic Design Photography
Photographer: Gillean Proctor
Art Director: Ted Larson
Company: OASIS
Client: Wilcord Publications

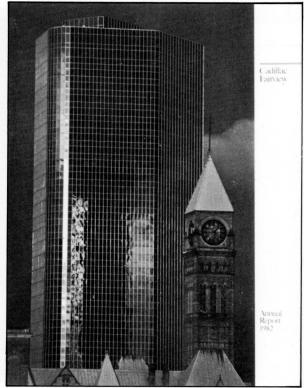

246

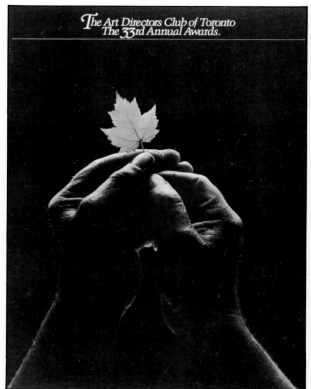

248

247

249. Graphic Design Photography
Photographer: Philip Rostron
Art Director: Robert Burns,
Heather Cooper
Agency: Burns, Cooper, Hynes Limited
Client: Imperial Oil Limited

250. Poster Photography
Photographer: Joseph Chiu
Art Director: Joseph Chiu
Company: Joseph Chiu Productions
Client: Joseph Chiu Productions

Merit

249

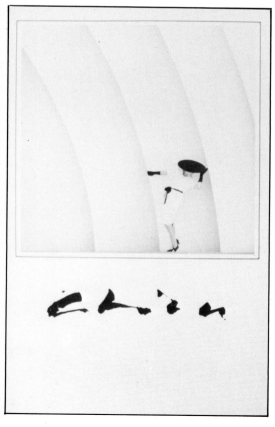

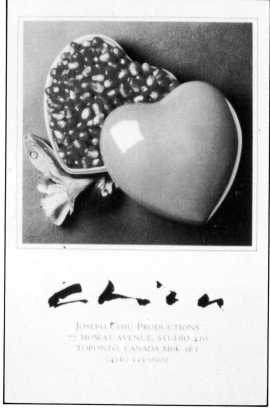

250

Merit

251. Poster Photography
Photographer: Stephen Yeates
Art Director: Michael McLaughlin
Client: The Partners' Film
　　Company Ltd.

252. Poster Photography
Photographer: Stephen Yeates
Art Director: Michael McLaughlin
Client: The Partners' Film
　　Company Ltd.

253. Photography–Poster
Photographer: Yuri Dojc Inc.
Art Director: Veronika Witterman
Agency: Eskind Waddel
Client: Yuri Dojc Inc./Lipman Publishing

251

252

253
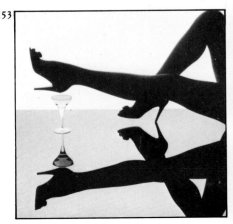

254. Symbols and Logotypes
Designer: Richard Male
Company: Richard Male Design
 Associates Ltd.
Client: Beaver Canoe Corporation

255. Symbols and Logotypes
Designer: Peter Durham Dodd
Art Director: Peter Durham Dodd
Artist: Peter Durham Dodd
Company: Creative Resources
 Company Limited
Client: Aberfoyle Fisheries

256. Symbols and Logotypes
Designer: Bob Russell
Art Director: Bob Russell
Illustrator: Bob Russel
Company: Carverhill Russell &
 Timmerman Design
Client: Airwave Records Inc.

Merit

254

255

256

Merit

257. Symbols and Logotypes
Designers: Jon Vopni and Bob Hyland
Art Directors: Jon Vopni and Bob Hyland
Artists: Jon Vopni and Larry Bloss
Studio: Robert Hyland Communications
Client: M.C. Charters & Co. Ltd.

258. Symbols and Logotypes
Designer: Lawrence Finn
Art Director: Lawrence Finn
Technical Artist: Paul Walker
Company: Lawrence Finn and
Associates Limited
Client: Meridian Technologies Inc.

259. Symbols and Logotypes
Designer: Jon Vopni
Art Directors: Bob Hyland and Jon Vopni
Artist: Jon Vopni
Studio: Robert Hyland Communications
Client: Synergex for Corona Jewellers

257

259

Meridian Technologies Inc.

258

260. Miscellaneous
Designer: Sandy Kennedy
Art Director: Marc Grossutti
Illustrator: Marc Grossutti
Company: Keith Rushton and
 Associates Ltd.
Client: Keith Rushton and
 Associates Ltd.

261. Graphic Design Self Promotion
Designer: Tim Forbes
Art Director: Tim Forbes
Company: Tim Forbes Design Ltd.
Client: Tim Forbes Design Ltd.

262. Stationery
Designer: Bev Tudhope
Company: Bev Tudhope Design
Client: Curtner Brown Architects

Merit

260

261

262

Merit

263. Annual Reports
Designer: Malcolm Waddel
Photographer: John Harquail
Illustrator: Bill Boyko
Company: Eskind Waddell
Client: Moore Corporation

264. Annual Reports
Designer: Scott Taylor
Art Director: Scott Taylor
Artist: Paul Abbott
Company: Abbott, Jenkins, Taylor
Client: Cadillac Fairview

265. Brochures
Designer: Paul Hodgson
Art Directors: Paul Hodgson,
 Jeannette Hanna
Photographer: Yuri Dojc
Company: Fifty Fingers Incorporated
Client: Harding Carpets

263

264

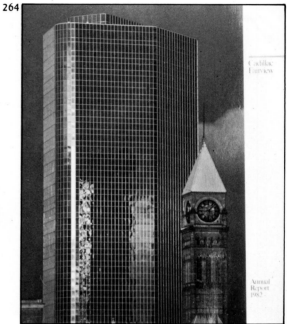

265

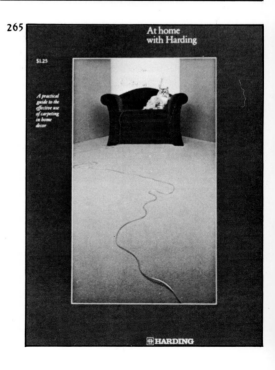

266. Book Covers
Art Director: Brian Harrod
Writer: Ian Mirlin
Illustrator: Jonathan Milne
Creative Director: Harrison Yates
Agency: McCann-Erickson Toronto
Client: Christie Brown & Co.

267. Brochures
Designer: Jim Carpenter
Art Director: Jim Carpenter
Photographer: Baron Wolman
Company: Carpenter & Co.
Client: Ultra Flight Sales Inc.

268. Stationery
Designer: Paul Hodgson
Company: Fifty Fingers Incorporated
Client: Dundas Valley School of Art

Merit

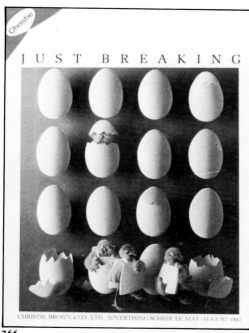

266

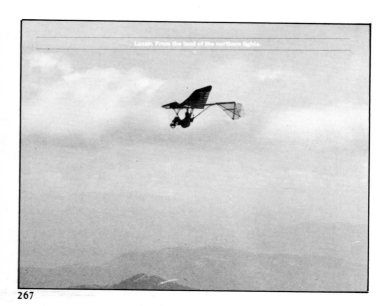

267

268

Merit

269. Book Covers
Designer: Paul Hodgson
Art Director: Paul Hodgson
Illustrator: Jeff Jackson
Company: Fifty Fingers Incorporated
Client: ECW Press

270. Package Design
Photographer: Philip Rostron
Designer: Heather Cooper, Dawn Cooper
Art Director: Heather Cooper
Company: Burns, Cooper, Hynes Limited
Client: Brydson Management Inc.

269

270

271. Complete Book Design
Designers: Jim Ireland/Wycliff Smith
Art Director: Wycliff Smith
Illustrators: Various
Company: Holt. Rinehart & Wilson of Canada
Client: Holt Rinehart & Wilson of Canada

272. Book Cover
Designer: Ted Larson
Art Director: Ted Larson
Photographer: Gillean Proctor
Company: OASIS
Client: Wilcord Publications

273. Graphic Design, Self Promotion
Designer: Joanne Olthuis
Art Director: Bob Russel
Illustrator: Barbara Klunder
Company: Boardwork Studios Ltd.
 (Division of Carverhill Russell & Timmerman Design)
Client: Sharpshooter Productions Ltd.

Merit

271

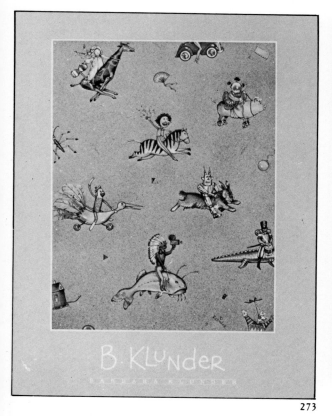

273

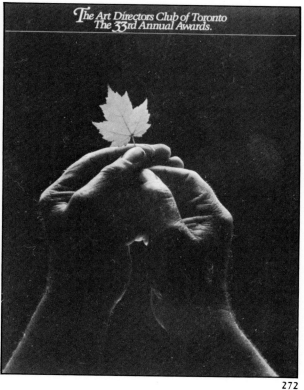

272

Merit

274. Graphic Design, Self Promotion
Designer: Joanne Olthuis
Art Director: Bob Russel
Photographer: Graham French
 (photo direction, Gillian Tsintziras)
Company: Boardwork Studios Ltd.
 (Division of Carverhill Russell &
 Timmerman Design)
Client: Sharpshooter Productions Ltd.

275. Graphic Design, Self Promotion
Designer: Joanne Olthuis
Art Director: Bob Russel
Illustrator: Bill Boyko
Company: Boardwork Studios Ltd.
 (Division of Carverhill Russell &
 Timmerman Design)
Client: Sharpshooter Productions Ltd.

276. Graphic Design Poster
Designer: Les Usherwood
Art Director: Les Usherwood
Artist: Typsettra Limited
Company: Typsettra Limited
Client: Typsettra Limited & "Caxton"
Writer: Jody Overend

274

275
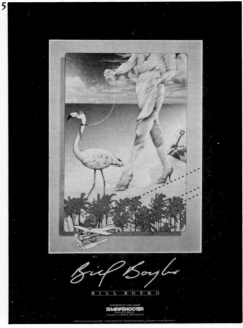

276
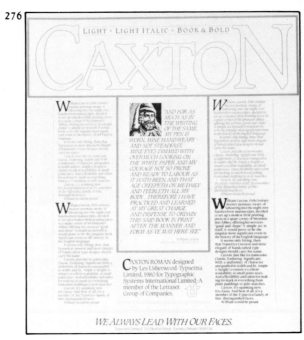

277. Complete Book Design
Designers: Richard Sharabura/
 Bob Torrans
Art Director: Tina Sharabura
Photographer: Richard Sharabura
Company: Chatsworth Studios Limited
Client: Chatsworth Studios Limited

278. Graphic Design, Self Promotion
Designers: Bob Hyland and Jon Vopni
Art Director: Bob Hyland
Photographer: Peter Christopher
Studio: Robert Hyland Communications
Client: M.C. Charters & Co. Ltd.

279. Complete Book Design
Designer: Kathryn Cole
Art Director: Kathryn Cole
Illustrator: Robin Muller
Publication: Scholastic Tab Publications
Client: Scholastic Tab Publications

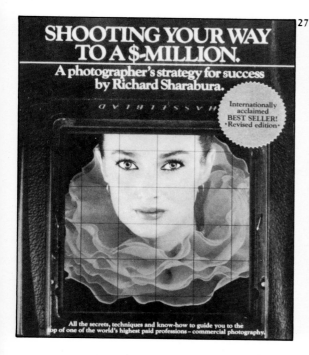

Merit

280. Graphic Design, Self Promotion
Designer: Zora Zoretich
Art Director: Zora Zoretich
Photographer: Silvio Calcagno
Company: Silvio Calcagno Photography
Client: Silvio Calcagno Photography

281. Graphic Design, Self Promotion
Designer: Joanne Olthuis
Art Director: Bob Russel
Illustrator: Brian Deines
Company: Boardwork Studios Ltd.
(Division of Carverhill Russell &
Timmerman Design)
Client: Sharpshooter Productions Ltd.

282. Record Album Cover
Designer: Bill Boyko
Art Director: Stephen Yates
Illustrator: Bill Boyko
Company: Mixed Nuts Inc.
Client: Maze Records

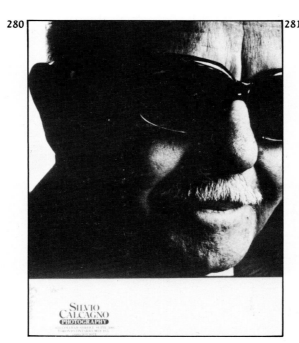

283. Graphic Design, Self Promotion
Art Director: Kalman J. Molnar
Designers: Kalman J. Molnar
 Barbara Griffin
Writer: Barbara Griffin
Artist: Barbara Griffin
Creative Director: Kalman J. Molnar
Agency: Kalman Molnar Limited
Client: Kalman Molnar Limited

284. Package Design
Designer: Amanda Finn
Art Director: Lawrence Finn
Illustrator: Amanda Finn
Technical Artist: Paul Walker
Company: Lawrence Finn and
 Associates Limited
Client: Hazelton Lanes

285. Miscellaneous
Designer: Claudia Shadursky
Art Director: Audrey Geldutis
Photographer: S.C. Dean
Company: Boa Design
Client: Skiad Inc.

Merit

283

284

285

Merit

286. Miscellaneous
Creative Director: Paul R. Grissom
Art Director: Paul R. Grissom
Copywriter: Reet McGovern
Artists: Kim LaFave, Brian Boyd
Agency: McGovern & Grissom
 Creative Services
Client: The Equity Development Group
 Inc. – Heron Homes

287. Miscellaneous
Designer: Howard Pain
Art Director: Howard Pain
Artist: Lucy Qinnuayuak
Company: Break Pain Associates Ltd.
Client: Dorset Fine Arts

288. Miscellaneous
Designer: Theo Dimson
Illustrators: Theo Dimson/Ken Jackson
Company: Dimson & Smith
Client: Lipton's Fashions

289. Complete Book Design
Designer: Keith Rushton
Art Director: Keith Rushton
Company: Keith Rushton and
 Associates Ltd.
Client: Colonial Life Insurance Co.

290. Miscellaneous
Designer: Raymond Majury
Art Director: Allen Gee
Illustrator: Ken Stampnick
Company: Glowinsky & Gee
Client: Mr. Greenjeans Restaurant

291. Miscellaneous
Designer: Andrew Smith
Art Director: Andrew Smith
Illustrator: Blair Drawson
Company: INK
Client: First Impressions

289

290

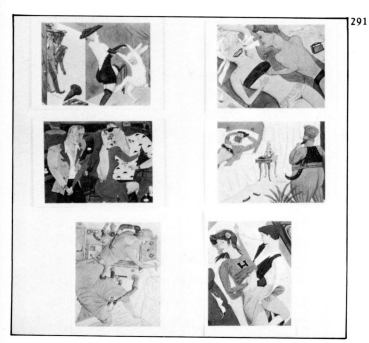

291

Merit

292. Miscellaneous
Designer: Veronika Witterman
Company: Eskind Waddell
Client: The Canada Council

293. Miscellaneous
Designer: Robert Vosburgh
Art Director: Robert Vosburgh
Illustrator: James Tughan
Company: Vosburgh Studios Inc.
Client: Ortho Pharmaceutical Ltd.

294. Miscellaneous
Designer: Andrew Smith
Art Director: Andrew Smith
Illustrator: Jeff Jackson
Company: INK
Client: First Impressions

292

293

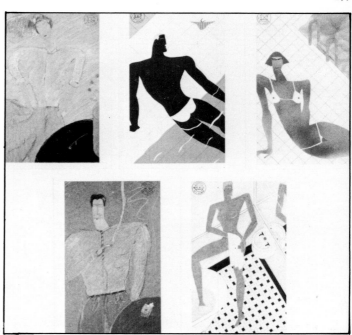

294

295. Invitation
Designers: Scott Taylor, Paul Browning
Art Director: Scott Taylor
Artist: Paul Browning
Photographer: Peter Paterson
Company: Taylor & Browning Design
Associates
Client: Rosenthal Furniture
Studio Line Limited

296. Direct Mail
Designer: Paul Browning
Art Director: Paul Browning
Artists: Paul Browning,
Carson Young, Lee Bridgeford
Company: Taylor & Browning Design
Associates
Client: Kinetics Furniture

297. Graphic Design Miscellaneous
Designer: Kim Martin
Art Director: Bob Russell
Illustrator: David Thauberger
Company: Carverhill Russell &
Timmerman Design
Client: Canada Post

297

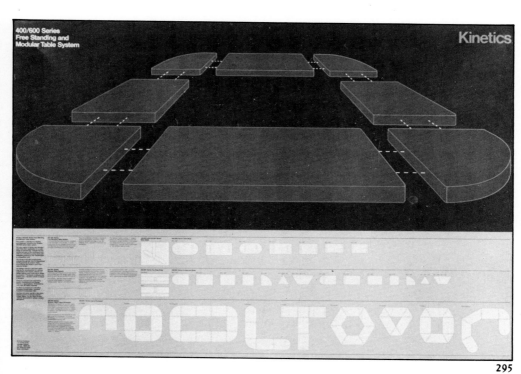

295

296

Merit

298. Miscellaneous
Designers: Pául Hodgson, Gary Ludwig
Art Director: Paul Hodgson
Company: Fifty Fingers Incorporated
Client: Ontario Hydro

299. Miscellaneous
Designer: Sandy Kennedy
Art Director: Marc Grossutti
Illustrator: Marc Grossutti
Company: Keith Rushton and Associates Ltd.
Client: Keith Rushton and Associates Ltd.

300. Miscellaneous
Designer: Paul Hodgson
Company: Fifty Fingers Incorporated
Client: Panasonic Canada

298

299

300

301. Newspaper Page
Art Director: Ian Somerville
Publication: Toronto Star
Client: Toronto Star Newspaper Ltd.

302. Newspaper Page
Art Director: Frank Tesky
Illustrator: Jennifer Stowell
Designer: Frank Tesky
Publication: Globe & Mail
Client: Globe & Mail

303. Newspaper Spread
Art Director: Keith Branscombe
Publication: Toronto Star
Client: Toronto Star Newspaper Ltd.

Merit

301

302

303

Merit

304. Newspaper Page
Art Director: James E. Harrison
Photographer: Erin Combs
Publication: Toronto Star
Client: Toronto Star Newspaper Ltd.

305. Newspaper Page
Art Director: Paul Haslip
Photographer: Carol Gold
Designers: Paul Haslip/Jolene Cugler
Publication: Newscience
Client: Ontario Science Centre

306. Newspaper Spread
Art Director: Eric Nelson
Designer: Eric Nelson
Publication: Globe & Mail
Client: Globe & Mail

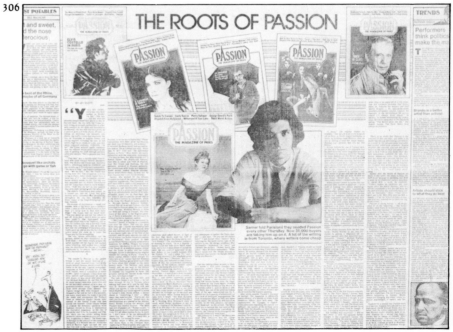

307. "Resistance"

Consumer Commercial (Single)

Art Director: Terrance Iles
Writer: William Lower
Creative Director: Gary Prouk
Agency Producer: Lorre Jensen
Agency: Scali, McCabe, Sloves (Canada) Ltd.
Client: Cadbury, Schweppes, Powell Inc.
Director: Ousama Rawi
Cameraman: Ousama Rawi
Production House: Rawifilm Canada Inc.

308. "Merlin"

Consumer Commercial (Single)

Art Director: André Morkel
Writer: Gary Prouk
Creative Director: Gary Prouk
Agency Producer: Lorre Jensen
Agency: Scali. McCabe, Sloves (Canada)
Client: Cadbury, Schweppes, Powell Inc.
Director: Eugene Beck
Cameraman: George Morita
Production House: The Partners Film Co.
Animated Effects: Film Opticals

309. "Jungle Fighter"

Consumer Commercial (Single)

Art Director: Michael Fromowitz
Writer: Peter Lanyon
Creative Director: Gary Prouk
Agency Producer: Nicole Tardif
Agency: Scali, McCabe, Sloves (Canada)
Client: Clairol Canada
Director: Graham Hunt
Cameraman: Harry Lake
Production House: Boardwalk
Music/Sound: Syd Kessler & Mastertrack

Merit

307. "Resistance"
Le Captain: Welcome to zee Resistance! This is la piece de resistance, Cadbury's Crunchie bar. You will be tempted to bite zee Crunchie bar...
SFX: SNAP
...but you will learn to resist. Zee thick dairy milk chocolate will tempt you...
...zee golden sponge tofee will tempt you...
But, no-no...
In zee Resistance we learn to make zee Crunchie bar last.
Subordinate: So, vive la Resistance!
Men: Vive la Resistance!
SFX: MUFFLED CRUNCH

308. "Merlin"
Two Fools: Merlin, Merlin.
Merlin: Go away!
First Fool: The King wants to know why you still haven't solved...
the secret of how Cadbury gets...
the soft creamy caramel inside the Caramilk bar.
Merlin: Begone, you monkeys!!!
SFX: SNAP, POOF
Merlin: Now where was I?
Witch: Merlin, oh Merlin...
Merlin: Not now you old crow!!
SFX: LIGHTNING; CROW
Merlin: The answer! Of course!

309. "Jungle Fighter"
SFX: Elevator doors opening; bell.
SFX: Phones, typewriters, office hubbub.
SFX: Radio News.
ANNCR: V.O.: Stress is why you should use Ultra Ban.
ANNCR: V.O.: With an extra strength formula...
SFX CROWD: Great idea. Ya, but we need it yesterday. Put a rush on it.
SFX: Radio News. (Under)
ANNCR. V.O.: ...Ultra Ban fights stress perspiration...
ANNCR. V.O.: ...in the jungle...
SFX: Door slam
ANNCR. V.O.: ...all day long.
ANNCR. V.O.: Ultra Ban.
ANNCR. V.O.: Jungle fighter.

Merit

310. "The Name Of The Game"
Consumer Commercial
Art Director: Ken Burgin
Writer: Katy Lonsdale
Creative Director: Ken Burgin
Agency Producer: Ken Burgin
Agency: Bowen & Binstock Advertising
Client: Bata Footwear/Power Shoes
Director: Colin McLaren
Cameraman: Bernie MacNeil
Production House: T.D.F.
Music/Sound: Harry Forbes

311. "Soften"
Consumer Commercial
Art Director: André Morkel
Writer: Gary Prouk
Creative Director: Gary Prouk
Agency Producer: Lorre Jensen
Agency: Scali, McCabe, Sloves (Canada)
Client: Bristol-Myers Canada Inc.
Director: Ousama Rawi
Cameraman: Ousama Rawi
Production House: Rawifilm Canada Inc.
Music/Sound: Doug Riley/ Trudel

312. "L'épaisrcussion"
Consumer Commercial
Art Directors: M. Fromowitz/ Yves Simard
Writer: Luc Merineau
Creative Director: Gary Prouk
Agency Producer: Lorre Jensen
Agency: Scali, McCabe, Sloves (Canada)
Client: Cadbury, Schweppes, Powell Inc.
Directors: George Morita/Bob Fortier
Cameramen: George Morita/Bob Fortier
Productions Houses: The Partners/Nelvana
Music/Sound: Doug Riley/ Trudel

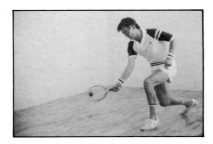

310. "The Name Of The Game"
SFX: NATURAL SOUND OF GAME IN ACTION.
ANNCR.: This is...
the **Power** of soccer.
SFX: NATURAL SOUND ON TENNIS COURT.
ANNCR.: This is...
the **Power** of tennis.
SFX: NATURAL SOUNDS OF A RAQUETBALL COURT.
ANNCR.: This is...
the **Power** of raquetball.
SFX: NATURAL SOUNDS OF GUY AND GIRL JOGGING.
ANNCR.: Whatever the sport, play it with Power. Because the name of the game... is **Power**.

311. "Soften"
SINGER: Nobody softens better.
...makes me feel sad for the rest.
...Nobody softens quite the way you do.
...Fleecy give me your best.
...The way that you soften, each time that you soften.
...Is there some gentle magic inside you.
...Your touch is so loving, so just keep it coming.
...Fleecy, how do you do the things you do?
...'cause nobody softens better...

312. "L'épaisrcussion"
MUSIC: VIBRAPHONE
SFX: THUNDER
SFX: UMBRELLA OPENING
SFX: RAIN
MUSIC: "BOSSA NOVA" TYPE MUSIC
SFX: WRAPPER UNWRAPPING
MUSIC: HOLLYWOOD "GALA" TYPE
SFX: BACKGROUND CROWD ROAR

313. "Charlie"

Consumer Commercial

Art Director: Terrance Iles
Writer: William Lower
Creative Director: Gary Prouk
Agency Producer: Lorre Jensen
Agency: Scali, McCabe, Sloves (Canada)
Client: Ralson Purina (Canada) Inc.
Director: Ousama Rawi
Cameraman: Ousama Rawi
Production House: Rawifilm Canada Inc.
Music: Griffiths-Gibson

314. "Rodeo"

Consumer Commercial

Art Directors: Gordon Price/
Frank Arundell
Writer: Peter Tannen
Creative Director: Phil May
Agency Producer: Philip Wiegand
Agencies: Dancer Fitzgerald Sample. Inc./
Ronalds-Reynolds & Company Ltd.
Client: Toyota Canada Inc.
Director/Cameraman: Peter James
Production House: The Partners Film
Music/Sound: John Lissauer/Craig Hazen

315. "Thérèse"

Consumer Commercial

Art Director: John Cruickshank
Writer: George Anketell
French Writer: Marie Josée Cardinal
Creative Directors: George Anketell/
John Cruickshank
Producer: Audrey Telfer
French Producer: Raymond Royale
Agency: MacLaren
Client: C.G.E.
Director/Cameraman: Ousama Rawi
Production House: Aisha Film Co. Ltd.

313. "Charlie"

SFX: MUSIC UNDER
GIRL (OC): Mommy, will Charlie live forever?
MOTHER (OC): No. dear. Charlie can't live **forever.**
GIRL (OC): Well, how long will he live?
MOTHER (OC): Oh, Charlie's going to live a long, long time.
GIRL (OC): But how long Mommy?
(VO): For over half a century, Ralston Purina has done extensive research on nutrition, searching to find ways to help dogs live longer lives. And we've succeeded. With Purina Dog Chow.
GIRL: I love you Charlie.
(VO): Purina Dog Chow. Helping dogs live longer lives.

314. "Rodeo"

(MUSIC: — Oh what a feeling theme, country arrangement)
ANNCR. V.O.: Next up, the new Toyota Tercel totally re-designed for 1983, with front-wheel drive handling, that's more responsive than ever... with clean aerodynamic lines to help give you great gas mileage
and, inside — more room than ever ...more than any other car in its class. The new Tercel: for a ride you'll never forget.
SINGERS: Oh, Oh. Oh, Oh, what a feeling...
COWBOYS: New Tercel.
SINGERS: Toy-ota!

315. "Thérèse"

SFX: Click of machine turning on and hum of motor and fan.
Vous voyez? La fumée et les odeurs entrent par ici... et du bon air frais sort par là. Très efficace! Tellement que... (vient ma Thérèse)... sans le purificateur d'air CGE,
l'atmosphère de cette maison deviendrait vite irrespirable.
(Turns up machine)
SFX: Click and increased hum of fan at higher speed.
MUSIC AND SINGERS: C.G.E. Les bonnes choses de la vie.

Merit

316. "Close Encounters"
Consumer Commercial

Art Director/Writer: Dan Peppler
Creative Director: Dan Peppler
Agency Producer: Chantal Houle
Agency: Needham, Harper & Steers
Client: Honda Canada Inc.
Director: Bob Canning
Cameraman: Nicholas Allen-Woolfe
Editor: John Kerns
Production House: T.D.F.
Music/Sound: Syd Kessler

317. "Wordsworth"
Consumer Commercial

Art Director: Brian Harrod
Writer: Ian Mirlin
Creative Director: Harrison Yates
Agency Producer: Vanessa Raven
Agency: McCann-Erickson Toronto
Client: Christie Brown & Co.
Director: Vlad Goetzelman
Cameramen: Leslie Koskoto/John Lions
Production House: Cinera Productions
Music/Sound: Syd Kessler

318. "The Greatest"
Consumer Commercial

Art Directors: Ian Mirlin/Brian Harrod/
Keith Hillmer
Writer: Ian Mirlin
Creative Director: Harrison Yates
Agency Producer: Vanessa Raven
Agency: McCann-Erickson Toronto
Client: Quaker Oats Co. Canada
Director: Phil Marco
Cameraman: Phil Marco
Production House: Phil Marco
Music/Sound: Syd Kessler

316. "Close Encounters"
SFX: NATURAL THROUGHOUT.
MUSIC: THROUGHOUT (ACCENTS
ACTION AND LIGHT EFFECTS)
ANNCR. V.O.: The remarkable
reputation of Honda's 1982 Accord
holds a relentless curiosity for those
who **do not** own one...
Accord's advanced engineering...
incredible fuel economy... and the
uncompromised styling and spacious
luxury... all at an unbeatable price...
certainly in this world, and possibly
beyond...

317. "Wordsworth"
ANNCR.: This is Wheatsworth. No, that's
Wordsworth, I said Wheatsworth.
Wheatsworth is the wholewheat...
cracker that's so delicious... it's probably
the best-tasting cracker in the world.
Well, perhaps not the world... maybe
Canada.
Wheatsworth is delightful... plain. I mean
plain... as in nothing on top.
Yet Wheatsworth is equally good with
any topping you choose.
Not watermelon... keep it to cheese,
peanut butter, or even soup. A few
seconds on the box so you'll recognize
Wheatsworth in the store:
3 seconds – 2 – 1

318. "The Greatest"
MUSIC UNDER:
V.O.: There is no pancake
like an Aunt Jemima pancake.
End of story.

319."Travelling Rule"
Consumer Commercial
Art Director: Brian Harrod
Writer: Ian Mirlin
Creative Director: Harrison Yates
Agency Producer: Vanessa Raven
Agency: McCann-Erickson Toronto
Client: Christie Brown & Co.
Director: Vlad Goetzelman
Cameramen: John Lions/Leslie Koskoto
Production House: Cinera Productions
Music/Sound: Trudel Productions

320."Yours to Discover"
Consumer Commercial
Art Director: Arnold Wicht
Writer: Roland Parliament
Creative Director: John McIntyre
Agency Producer: Tim Heintzman
Agency: Camp Associates Advertising
Client: Ontario, Ministry of Tourism & Recreation
Director: Peter James
Cameraman: Peter James
Production House: Rabko
Music: Wizard Productions

321."War And Peace"
Consumer Commercial
Art Director: Tony Cooper
Writer: Paul Gottlieb
Creative Directors: Peter Tregale/Paul Gottlieb
Agency Producer: Patti Honsberger
Agency: Baker Lovick Limited
Client: Black & Decker Canada Inc.
Director: Rick Okada
Cameraman: Fritz Spiess
Production House: Schulz Productions
Music/Sound: Syd Kessler

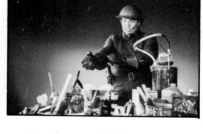

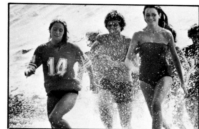

319."Travelling Rule"
SINGERS: hot hot hot hot hot hot
cold cold cold cold cold cold
ho-o-ot hot
co-o-old cold
hot hot hot hot hot hot
cold cold cold cold cold cold
ho-o-o-o-o-hot
co-o-o-o-o-cold
ANNCR.: Triscuit, a tight weaving of 100% whole wheat makes it the cracker you can have hot
 or cold
SINGERS: cold cold cold cold cold
SINGERS: hot!

320."Yours to Discover"
MUSIC THROUGHOUT
(Music) Start at the dawn of a new day
exploring the wide open road.
Follow the trail where its leading you
and discover Ontario.
You'll see the mist on the water
and feel the sun shining strong;
you'll find the smile of a friendly face
that says this is where you belong.
In Ontario... so get up and go!
See Ontario... a wonder to know
'cause its yours to discover and you're
going to love it so c'mon everybody get
up and discover your Ontario.
(Music)

321."War And Peace"
Consumer Commercial
SFX: MARTIAL MUSIC UNDER.
V.O.: Stripping paint has become a battle.
SFX: FLAMETHROWER.
V.O.: With firepower.
SFX: SURF.
V.O.: Chemical agents. Sprays. Hand to hand combat. Mopping up.
SFX: MUSIC – ANTICIPATORY "PEACE".
V.O.: Rejoice! Today, Black & Decker brings you the peaceful solution:
New Heat & Strip electric paint remover.
No flames, no chemicals, no big mess.
Just Heat & Strip.
You'll actually enjoy doing it!
New Heat 'n' Strip.
You've got it made with Black & Decker.

Merit

322. "More than a Cracker"
Consumer Commercial
Art Director: Steve Thursby
Writer: Bob Hawton
Creative Director: Bob Hawton
Agency Producer: Jo-Ann Purser
Agency: F.H. Hayhurst Co. Limited
Client: The Borden Company, Ltd.
Director: Derek VanLint
Cameraman: Derek VanLint
Production House: Derek VanLint
Productions

323. "Beef Sounds Good"
Consumer Commercial
Art Director: Steve Thursby
Writer: Bob Hawton
Creative Director: Bob Hawton
Agency Producer: Jo-Ann Purser
Agency: F.H. Hayhurst Co. Limited
Client: Beef Information Centre
Director: Derek VanLint
Cameraman: Derek VanLint
Production House: Scollard Productions
Music/Sound: Syd Kessler Productions

324. "Griswald"
Consumer Commercial
Art Director: Neil McGregor
Writer: Enn Purdmaa
Creative Director: Steve Catlin
Sr. Art Director: Gord Oglan
Agency Producer: Danièle Bourdages
Agency: Publicité McKim Ltée
Client: TransCanada Telephone System
Director: Alan Marr
Cameraman: Bill Gimmi
Production House: The Partners

322. "More than a Cracker"
BUTLER: (FORMAL BRITISH ACCENT):
When Lord Ponceby died...
...he bequeathed his title and his entire
fortune to Polly here.
No common crackers for Polly...
Polly prefers Old London Melba Toast.
Three snappy shapes...six super flavours..
Mmmmmmm
SFX: NATURAL TRAFFIC NOISES
BUTLER (OC): Of course, Old London is
so jolly nutritious.
Polly's in the pink!
POLLY (OC): In the pink!
BUTLER (OC): The little twerp could live
for years!
SFX: DING, DONG, DING, DONG.
ANNCR: Try Old London Melba Toast.
Decidedly more than a cracker.

323. "Beef Sounds Good"
SFX: THROUGHOUT
SOLO SINGER (VO): Beef sounds good.
Anyway you slice it.
Beef sounds good.
Anyway you slice it.
Beef sounds good.
Beef sounds good.
Anyway you slice it.
Beef sounds good.
Anyway you slice it.
SUPER: BEEF INFORMATION CENTRE
AND YOUR PROVINCIAL CATTLEMEN'S
ASSOCIATION.
Beef sounds good. YAH!

324. "Griswald"
LARRY: Off to put out another fire
Griswald?
GRISWALD: Well, Chief I thought I'd...
LARRY: I assume you called first?
GRISWALD: Right. The flight's booked.
LARRY: Oh?
GRISWALD: Car's rented...
LARRY: Uh, huh.
GRISWALD: ...got the best room in
town.
LARRY: I see.
GRISWALD: And Max has reserved my
usual table.
LARRY: And?
GRISWALD: And then I called our
customer and straightened out the
whole mess by long distance.
LARRY: Stick around, Griswald. You'll
go far.

325. "Broken Telephone"
Consumer Commercial

Art Director: Gray Abraham
Writer: Mark Levine
Creative Director: Martin Keen
Agency Producer: Marylu Jeffery
Agency: The Jerry Goodis Agency Inc.
Client: Bank of Nova Scotia
Director: Allen Marr
Cameraman: Bill Gimmi
Production House: The Partners

326. "Magic"
Consumer Commercial

Creative Director: Terry Bell
Art Director: Dean Raynor
Writer: Terry Bell
Producer: Cathy McLewin
Production House: Boardwalk
Client: Schweppes Canada Ltd.
Director: Graham Hunt
Cameraman: Harry Lake
Post Production: Editors Cut

327. "Shoe Machine"
Consumer Commercial

Art Director: Ann Urban
Writer: Barry Jones
Creative Director: Barry Jones
Agency Producer: Carlo Trulli
Agency: J. Walter Thompson
Client: Greb Industries Ltd. –
Bauer Athletic Footwear
Director: Bob Fortier
Cameraman: Lenora Hume
Production House: Nelvana
Music: Syd Kessler/Sounds Interchange

Merit

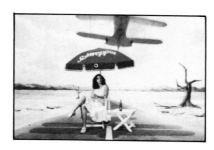

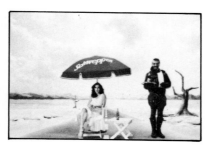

325. "Broken Telephone"
SFX: NATURAL SOUNDS THROUGHOUT
Frank: ...so that's why I need a loan.
#1: Good. Good. (gestures – wait).
V.O.: At some places, the person you
see for a loan is not necessarily the one
who says yes or no. He refers to
someone, who refers to another
someone. And so on. And so on.
However, Scotiabank helped lead the
way in consumer lending in this country.
We know you don't want to go through
all this to borrow money.
#1: We are definitely looking into it.
V.O.: So at Scotiabank the person you
see is the one who decides.

326. "Magic"
MUSIC/EFFECTS OF CICADA.
SFX: OF GINGER ALE FIZZ IN GLASS.
WOMAN: Suppose you're sitting where
I am and you're looking for a Ginger Ale
to quench your thirst.
What will you reach for? One called dry
as in the opposite of wet. Or one called
Schweppes as in the exhilarating taste
of Schweppervesence.
A lot of people, known for their good
taste, would be Schwepping in a situa-
tion like this.
WOMAN: Because like me, they know
that when it comes to Ginger Ale,
no one delivers quite like Schweppes.
That's Schwepping and there's nothing
dry about it.

327. "Shoe Machine"
SFX: A mix of traditional and synthetic
musical effects designed to augment the
excitement of the visual.
SINGERS: Bauer.

Merit

328. "Scratched Knee"
Consumer Commercial

Art Director: Dave Bouquet
Writer: Ron Caplan
Creative Director: Marelene Hore
Agency Producer: Rick Price
Director: Ian Leach
Cameraman: George Morita
Production House: The Partners' Film Co. Ltd.
Music/Sound: Kessler Productions

329. "Hoskins"
Consumer Commercial

Art Director: Michael Tott
Writer: Leon Berger
Creative Director: Leon Berger
Agency Producer: Rick Price
Director: Derek Van Lind
Cameraman: Derek Van Lind
Production House: McWaters Films
Music/Sound: Stock

330. "Big Rig"
Consumer Commercial

Art Director: Peter Jones
Writer: Hans Olaf Ein
Creative Director: Bob Neighbour
Agency Producer: Carlo Trulli
Agency: J. Walter Thompson
Client: Goodyear Canada Inc.
Director: Bob Lyons
Cameraman: Lazlo George
Production House: Dalton/Fenske & Friends
Music/Sound: Kosinec/Lenz

328. "Scratched Knee"
MUSIC: Simple, childlike (under throughout)
DAD OC: Now, let's have a look at your cut. Got it chasing monsters I bet? No. Hmmmm…you've been wrestling dinosaurs, haven't you? I've got something special for that.
VO: Elastoplast is the fabric bandage parents trust most…to protect the hurt and help heal it fast. Elastoplast. No hurt is too Little.
DAD OC: Alligator bite.

329. "Hoskins"
INCIDENTAL MUSIC
HOSKINS: 'Ere you go sir. Try this.
LIEUT: Ah, good man. What is it?
HOSKINS: Tea sir. **Canadian** tea.
LIEUT: Ugh.
HOSKINS: Er, this isn't just **any** Canadian tea, sir. This is Red Rose, a unique blend.
LIEUT: Red Rose?
HOSKINS: Yes, sir…(secretly) They do say as 'ow it's the perfect cup of tea.
LIEUT: What? Nonsense, man.
HOSKINS: Well, sir?
LIEUT: Well what?
HOSKINS: Is Red Rose as good as they say?
LIEUT: Better!
ANNCR: Red Rose…the perfect cup of tea

330. "Big Rig"
VO: This is a true story about a truck tire.
WE HEAR RADIO PLAYING COUNTRY MUSIC. SOME CB CHATTER:
"Breaker…Breaker… Amarillo Angel…look good…no chopper smokeys (FACE).
WE HEAR SOUND OF RIG RESPONDING TO GEAR SHIFTS.
RADIO: "…KRLK Nogales…the voice of the southwest…with another hit comin' your way (FADE).
WE HEAR THUNDER AND RAIN.
VO: A tire so strong nobody really knows how far it will go.
Some have gone over three hundred thousand miles. Three hundred thousand miles on one set of tires. Goodyear truck radials.

331. "Blow Away"
Consumer Commercial
Art Director: Brent Wickes
Writer: Pam Freir
Creative Director: Bruce McCallum
Agency Producer: George Archer
Agency: Ogilvy & Mather
Client: "Shell Helps" Books
Director: George Morita
Cameraman: George Morita
Production House: Partners'
Music/Sound: David Fleury

332. "Family Business"
Consumer Commercial
Art Director: David Sharpe
Writer: Allan Hatcher
Creative Director: Michael Paul
Agency Producer: Marla Digiacomo
Agency: SMW Advertising
Client: Yamaha Motor Canada Limited
Director: Bob Perks
Cameraman: Bob Perks
Production House: Dalton Fensk & Friends
Music: Burrows/Kitching

333. "Bunkhouse"
Consumer Commercial
Art Director: Michael McLaughlin
Writer: Stephen Creet
Creative Director: Gary Gray
Agency Producer: Roger Harris
Agency: Vickers & Benson/Ayer
Client: Nabisco Brands
Director: George Pastik
Cameraman: Andrew Welsh
Production House: Sincinkin
Music/Sound: Wilf Carter

Merit

331. "Blow Away"
Alright, alright so I didn't take proper care of her.
I never found me a service station I could be sure of, you know what I mean.
It's tough. Frankly I just wanna blow the old heap away.
SOUND OF TREMENDOUS EXPLOSION
ANNCR. V.O.: Shell recommends less drastic measures.
The Shell dealer book.
Helpful tips on how to find a good service station dealer.
How to get it together – with a little help from your friends –
– at Shell – Shell helps.
SFX: CRASH

332. "Family Business"
ANNCR: V.O.: When the Jarrets decided to modernize the family business, they added a fleet of Tri-Motos from Yamaha.
(BRING UP BANJO MUSIC UNDER)
With the new 4-stroke 200 for Billy Bob... the 175 for ol' Eb...
...and the 125 for little Luke, gettin' to the office was a whole lot easier.
'Specially since the office kept gettin' farther out of town.
They can even haul quite a load... or make deliveries.
But what they like best about their Tri-Motos (SIREN SOUND UP) is the feelin' of freedom you get from just... gettin' away.

333. "Bunkhouse"
(Six cowboys in bunkhouse. Gramophone record turning in foreground. Cowboys are chewing on Eatmore bars.)
MUSIC: I'm longing tonight
Once again to roam
In a beautiful valley
I could always call home.
(Old man studies picture in little book, wipws away tear)
MUSIC: There's a girl I adore
And I'm longing to see
In a beautiful
Yoho valley.
(Product shot and super. A GOOD CHEW AND PEANUTS TOO. The record sticks and the cowboys chew in time as the old man leans forward.)
MUSIC: My little Yoho lady-o
ady-o, ady-o, ady-o.

Merit

334. "Wild Chase"
Consumer Commercial
Art Director: Michael McLaughlin
Writer: Gary Gray
Creative Director: Gary Gray
Agency Producer: Sheila Moen
Agency: Vickers & Benson/Ayer
Client: H.J. Heinz
Director/Designer: Bob Fortier
Production House: Nelvana

335. "Don't Wait"
Consumer Commercial
Art Director: Geoff Smith
Writer: Ches Goluch
Creative Director: Ed Nanni
Agency Producer: Ken Rogers
Agency: Leo Burnett
Client: Boyle-Midway
Director: Doug Moshoian
Cameraman: Frank Tidy
Production House: Partners Film Co.

336. "Puttin' In Time"
Consumer Campaign
Art Director: Daniel D. Peppler
Writer: Brian Johnston/Daniel D. Peppler
Creative Director: **Daniel D. Peppler**
Agency Producer: Ann Govinda
Agency: Needham. Harper & Steers of Canada Ltd.
Client: Kraft Limited
Director: Ian Leech
Cameraman: Stanley Mestel
Production House: The Partners Film Co.
Music/Sound: Trudel Productions Ltd.

334. "Wild Chase"
SCARIOS GAND: Boo-o-o-o-o!!
BOY & GIRL: Boo to you too!
GANG: Yoips!
HATTIE WITCH: Look out Looney Moon!
GIRL: I see them. I see them.
LOONEY MOON: Help Pumpykin.
BOY: Catch 'em. Catch 'em.
Stop Hattie Witch!
HATTIE WITCH: CACKLES!
SOUND: RUNNING DOWNSTAIRS
KIDS: Yea Scarios!
GANG: Hurry up! Get in!
HATTIE WITCH: (ECHO) Scarios.
Spooky spaghetti... fron Heinz.
LOONEY MOON: Don't be a "Scaredy
Cat" Give Scarios a bite.
HATTIE WITCH: It's frightfully good.
GIRL: How you stay there 'til lunchtime.

335. "Don't Wait'
SFX: NATURAL OVER AND UNDER
THROUGHOUT
VO: See these 2 dirty ovens?...
SFX: MAN AND WOMAN'S FOOTSTEPS.
...these 2 oven cleaners will clean them...
SFX: CANS SPRAYING
...but only one's ready to wipe clean in
just 20 minutes. New Easy-Off.
New Easy-Off is the only oven cleaner
with such heavy duty cleaning power. it
cuts through grease and grime fast... but
with no harsh odour.
So your oven looks new again!
Why wait overnight? Get new Easy-Off...
and your oven's ready to clean in 20
minutes.

336. "Puttin' In Time"
SFX: NATURAL THROUGHOUT
MUSIC THROUGHOUT
A.J.: Psst... come over here
Theeze are my Handi-Snack Cheese &
Crackers for day **one**... (MUNCH)
Theeze are my Honey & Crackers for
day two... love you... (MUNCH)
and theeze are my Pizza Cheese &
Crackers for day **three**... (MUNCH)
and theeze are my Peanut Butter &
Crackers for day **four**... (MUNCH)
But theese... theese is day five!!!
...excuse me
(EXPLOSION)
ANNCR. V.O. Handi-Snack... the portable
little snacks from Kraft.
A.J.: Don't get cought without them.

337. "Mistaken I.D. – Honda"
Consumer Commercial

Art Director/Writer: Dan Peppler
Creative Director: Dan Peppler
Agency Producer: Chantal Houle
Agency: Needham, Harper & Steers
 of Canada Ltd.
Client: Honda Canada Inc.
Director: Doug Moshoian
Cameraman: Bill Gimmi
Production House: The Parners Film Co.
Music/Sound: Stock Music

338. "Puttin' In Time"
Consumer Campaign

Art Director: Daniel D. Peppler
Writer: Brian Johnston/Daniel D. Peppler
Creative Director: Daniel D. Peppler
Agency Producer: Ann Govinda
Agency: Needham, Harper & Steers
 of Canada Ltd.
Client: Kraft Limited
Director: Ian Leech
Cameraman: Stanley Mestel
Production House: The Partners Film Co.
Music/Sound: Trudel Productions Ltd.

339. "Dracula"
Consumer Campaign

Art Director: Daniel D. Peppler
Writer: Brian Johnston/Daniel D. Peppler
Creative Director: Daniel D. Peppler
Agency Producer: Ann Govinda
Agency: Needham, Harper & Steers
 of Canada Ltd.
Client: Kraft Limited
Director: Ian Leech
Cameraman: Stanley Mestel
Production House: The Partners Film Co.
Music/Sound: Trudel Production Ltd.

Merit

337. "Mistaken I.D. – Honda
SFX: NATURAL THROUGHOUT.
MUSIC: BACKGROUND THROUGHOUT.
OLD TIMER: Ain't that the new local
school teacher…?
ATTENDANT: Yep!
BURGESS V.O.: When you first set eyes
on Honda's new Civic 4-Door GL Sedan..
OLD TIMER: What kind of car is that
she's driving…?
ATTENDANT: Claims it's a Civic…
BURGESS V.O.: …You'll probably
mistake it for something else.
OLD TIMER: Sure don't look like no
Civic…
BURGESS V.O.: But even with such
dramatic changes inside and out…
ATTENDANT: Don't look like the last
school teacher neither…
BURGESS B.O.: It still remains. The
classic Honda Civic.

338. "Puttin' In Time"
SFX: NATURAL THROUGHOUT
MUSIC THROUGHOUT
A.J.: Psst… come over here
Theeze are my Handi-Snack Cheese &
Crackers for day **one**… (MUNCH)
Theeze are my Honey & Crackers for
day two… love you… (MUNCH)
and theeze are my Pizza Cheese &
Crackers for day **three**… (MUNCH)
and theeze are my Peanut Butter &
Crackers for day **four**… (MUNCH)
But theese… theese is day five!!!
…excuse me
(EXPLOSION)
ANNCR: V.O. Handi-Snack… the portable
little snacks from Kraft.
A.J.: Don't get cought without them.

339. "Dracula"
SFX: NATURAL THROUGHOUT
MUSIC THROUGHOUT
A.J.: Where are my Handi-Snack Packs…
time is flying, they must be here some-
where… there you are my little darlings…
Peanut Butter & Crackers… Pizza Cheese
& Crackers… Honey & Crackers… one of
you little critters is missing… oh there
you are Cheese & Crackers.
Snack time…
get you're own …these are mine.
ANNCR. V.O.: Handi-Snack from Kraft
A.J.: To help you make it through the
day.

Merit

340. "Upside Down"
Consumer Commercial Campaign

Art Director: Michael McLaughlin
Writer: Stephen Creet
Creative Director: Gary Gray
Agency Producer: Roger Harris
Agency: Vickers & Benson/Ayer
Client: Nabisco Brands
Director: Robert Young
Cameraman: Stan Mestel
Production House: The Partners'/A, B & C Film Co.

341. "Won't Get Fooled Again"
Consumer Commercial Campaign

Art Director: Michael McLaughlin
Writer: Stephen Creet
Creative Director: Gary Gray
Agency Producer: Roger Harris
Agency: Vickers & Benson/Ayer
Client: Nabisco Brands
Director: Robert Young
Cameraman: Stan Mestel
Production House: The Partners'/A, B & C Film Co.

342. "The Answer"
Consumer Commercial Campaign

Art Director: Michael McLaughlin
Writer: Stephen Creet
Creative Director: Gary Gray
Agency Producer: Roger Harris
Agency: Vickers & Benson/Ayer
Client: Nabisco Brands
Director: Robert Young
Cameraman: Stan Mestel
Production House: The Partners'/A, B & C Film Co.

340. "Upside Down"
(Open on John Cleese holding pack)
CLEESE: These are the new peanut butter cups from Lowney.
(Camera moves in, he tastes a cup.)
The peanut butter is perfect... fresh and smooth. The chocolatey coating is perfect. The cup is deep and thick and you get three cups.
The Package itself I can live with and the name, though dull, will do.
(Pulls cup, upside down, from wrapper.)
However, the cups are upside down. Look. Upside down! I mean how stupid can you get? I mean that is up —
(Points up) and that is...
(Young boy on tricycle, eating cup rides by upside down. SFX: Ding. Ding. Cleese looks up, realizes he is upside down and falls up out of screen. Package shot and super are upside down.)

341. "Won't Get Fooled Again"
(Open on John Cleese upside down)
CLEESE: These peanut butter cups from Lowney, peanut butter, chocolatey coating, deep, thick cups... all perfect. And the perfect number of cups... three.
(He pulls cup out of wrapper.)
But, the silly fools have still got them upside down. Upside down! And they won't fool me again. Because I'm upside down, so I'm right side up so these cups are upside down...right? Am I ri...
(Boy from first spot on tricycle, eating cup, rides by rightside up. SFX: Ding. Ding. Cleese looks down, realizes that again he is upside down and falls out of screen. Package and super are upside down.)

342. "The Answer"
(Open on Cleese rightside up. He drops cup and catches it.)
CLEESE: Whew! Just testing gravity. Now, these Lowney Peanut Butter Cups. Everything's perfect: peanut butter, chocolatey coating, deep, thick cups, the number of cups — 3, even the fact that these cups are upside down. (He takes out second cup) Because, you see, I finally worked out why. They're upside down so that they land...
(Drops cup and catches it in hand. Close-up.) The right side up. (He holds up third cup.) Look. Watch again. (Cup exists top of frame. Cleese watches cup, grimaces. SFX: Ding. Ding. He falls up, out of screen. Boy from previous spots appears, upside down, eating cup. Pack and super upside down.)

343. "Family Tree"
Consumer Commercial
Art Director: Gord Oglan
Writers: Steve Catlin/Gord Oglan
Creative Director: Steve Catlin
Agency Producer: Danièle Bourdages
Agency: Publicité McKim Ltée
Client: TransCanada Telephone System
Director: John Sebert
Cameraman: Harry Lake
Production House: Boardwalk
 Motion Pictures
Music/Sound: Kosinek/Lenz

344. "Hello Again"
Consumer Commercial
Art Director: Gord Oglan
Writers: Steve Catlin/Gord Oglan
Creative Director: Steve Catlin
Agency Producer: Danièle Bourdages
Agency: Publicité McKim Ltée
Client: TransCanada Telephone System
Director: John Sebert
Cameraman: Harry Lake
Production House: Boardwalk Motion
 Pictures
Music/Sound: Kosinek/Lenz

345. "Ancient Eyes"
Consumer Commercial
Art Director: Gord Oglan
Writers: Steve Catlin/Gord Oglan
Creative Director: Steve Catlin
Agency Producer: Danièle Bourdages
Agency: Publicité McKim Ltée
Client: TransCanada Telephone System
Director: John Sebert
Cameraman: Harry Lake
Production House: Boardwalk
 Motion Pictures
Music/Sound: Kosinec/Lenz

Merit

343. "Family Tree"
LYRICS
I can see brother Jimmy's eyes
Building cardboard mansions in the sky.
Hold the rope for sister Alice.
Can you touch that tiny palace now?
And aren't they still the grandest crowd
And can you touch them now.
The family tree is small and strong
Like an old familiar song
The leaves are changing colours
Far away they fly
And aren't they still the grandest crowd
And can you touch them now.
It's good to hear your voice again
So good to hear your voice again.

344. "Hello Again"
LYRICS
Radio's been singing
'bout how love has gone away
That only makes me feel the rain
I know it's late
I know I said goodbye
I guess I called to hear you say
Hello again.
After all the tears.
After all the days that feel like years.
It's so good to hear your voice again
You sound so close to me –
My closest friend.
It's so good to hear your voice again.

345. "Ancient Eyes"
LYRICS
My father gave me hands
To fashion memories
We carved our visions free
From branches that we cut from trees.
My mother is my heart
She taught me how to see
Riddles in an aging book
And how to feel in poetry.
Hello, ancient eyes
Do you miss a smile, so many miles
Good to hear your voice again
Father, my closest friend
Mother, my dearest friend
It's so good to hear your voice again.

Merit

346. "Cribbage"
Consumer Commercial (Campaign)

Art Director: Ron Lockhart
Writer: Bruce McCallum
Creative Director: Bruce McCallum
Agency Producer: June Whibley
Agency: Ogilvy & Mather
Client: Moosehead Breweries' Alpine
Lager
Director: Brian Mindel
Cameraman: Brian Mindel
Production House: Mindel Films
Music/Sound: Larry Trudel

347. "Recruiter"
Consumer Commercial (Campaign)

Art Director: Ron Lockhart
Writer: Bruce McCallum
Creative Director: Bruce McCallum
Agency Producer: June Whibley
Agency: Ogilvy & Mather
Client: Moosehead Breweries' Alpine
Lager
Director: Brian Mindel
Cameraman: Brian Mindel
Production House: Mindel Films
Music/Sound: Larry Trudel

348. "Porch"
Consumer Commercial (Campaign)

Art Director: Ron Lockhart
Writer: Bruce McCallum
Creative Director: Bruce McCallum
Agency Producer: June Whibley
Agency: Ogilvy & Mather
Client: Moosehead Breweries' Alpine
Lager
Director: Brian Mindel
Cameraman: Brian Mindel
Production House: Mindel Films
Music/Sound: Larry Trudel

 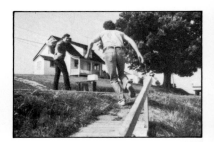

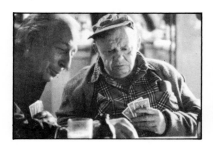 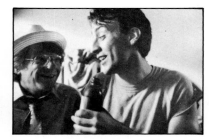 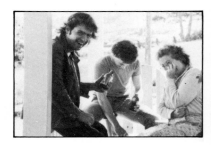

 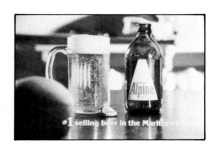 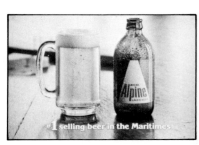

346. "Cribbage"
(NATURAL SFX THROUGHOUT)
Al: Remember that time we went up to
Toronto, Harry? '53 wasn't it? We had
some laughs, didn't we?
I always did like Toronto.
HARRY: (DEADPAN) I remember there
wasn't any Alpine.
AL: (AFTER REFLECTIVE PAUSE) That's
right...no Alpine. Six.
HARRY: Fifteen for two.
AL: Hmm. Come to think of it I never
did like Toronto. Folks ain't the same as
here. Twenty...one. Ooh!
HARRY: Maybe that's 'cause they
haven't got Alpine.
(MUSIC UP)
ANNCR. V.O.: Alpine Lager Beer. The
number one selling beer in the
Maritimes.

347. "Recruiter"
RECRUITER: Hey Hey Hey. Just sign
right there Mike.
MIKE: Right here? (indicates)
RECRUITER: On the dotted line.
Then we'll see you at training camp in
three weeks.
MIKE: Three weeks eh?
RECRUITER: Yeah.
MIKE: Say, will I be able to get Alpine
up there?
RECRUITER: Alpine? Hey kid, you'll be
drinking champagne.
MIKE: No Alpine?
RECRUITER: No Alpine.
MIKE: I see. (Pause) I think we have a
problem with the tax ramifications of
clause 13B.
RECRUITER: Uh...well...
ANNCR (VO): Alpine Lager Beer. The
number one selling beer in the Maritimes.

348. "Porch"
(NATURAL SFX & MUSIC THROUGHOUT
UNDER)
GRANDFATHER: Jimmy! Jimmy! How
come's you didn't like it out West?
JIMMY: The West is alright, Grandpa,
but...
BROTHER: Mum, leave him alone!
JIMMY: ...well for one thing there's no
Alpine!
GRANDFATHER: No Alpine?
JIMMY: No.
GRANDFATHER: No Alpine?
JIMMY: No!
GRANDFATHER: Ha! I wonder why so
many people would live there!
(LAUGHTER)
ANNCR. VO: Alpine Lager Beer. The
number one selling beer in the Maritimes.
(MUSIC THEME UP AND OUT)

349. "Chopthicks"
Consumer Commercial (Campaign)
Art Director: Michael Fromowitz
Writer: Gary Prouk
Creative Director: Gary Prouk
Agency Producer: Lorre Jensen
Agency: Scali, McCabe, Sloves (Canada)
Directors: George Morita/Bob Fortier
Cameramen: George Morita/Bob Fortier
Production Houses: The Partners/Nelvana
Music/Sound: Doug Riley/Trudel Prod.

350. "Monolithick"
Consumer Commercial (Campaign)
Art Director: Michael Fromowitz
Writer: Gary Prouk
Creative Director: Gary Prouk
Agency Producer: Lorre Jensen
Agency: Scali, McCabe, Sloves
Client: Cadbury, Schweppes, Powell Inc.
Directors: George Morita/Bob Fortier
Cameramen: George Morita/Bob Fortier
Productions Houses: The Partners Film
Company/Nelvana Animated Commercials
Music/Sound: Doug Riley/ Trudel

351. "Early Morning"
Consumer Commercial
Art Director: Lisa Atkins
Writer: Lisa Atkins
Creative Director: Warren Handley
Agency Producer: Pat White
Agency: McKim Advertising
Client: Kimberly-Clark
Director: Ron Rich
Cameraman: George Morita
Production House: Partners
Music/Sound: Trudel Productions

Merit

349."Chopthicks"
MUSIC: ORIENTAL
MUSIC: ROCK MUSIC
SFX: SQUEEKY WHEELS
MUSIC: SPANISH GUITAR
SFX: SIGH OF PLEASURE AS WOMAN
BITES INTO BAR
SFX: THUNDERING FOOTSTEPS:
HYSTERICAL LAUGHTER.

350."Monolithick"
MUSIC: DRAMATIC "2001"–TYPE
MUSIC.
MUSIC: PORTION OF "BARBER OF
SEVILLE"
SFX: SWOOP OF ARROW
MUSIC: PORTION OF "BEETHOVEN'S
FIFTH SYMPHONY" PLAYED ON
PIANO OUT OF KEY.
SFX: VARIOUS UNUSUAL BIRD
SOUNDS: FLAPPING OF WINGS.

351."Early Morning"
SFX: EARLY MORNING SOUNDS.
SFX: DOOR OPENING.
SINGER: (CHILD) There's nothing like
softness: early in the morning
We all need smoothness
Each and everyday
There's nothing like the soft touch of
velour.
There's nothing like the touch so soft
and pure.
There's nothing like the touch...
SFX: DOOR CLOSING ..of new Velour.
ANNCR: Bathroom Tissue.
at a real nice price.

Merit

352. "Water Ski – Woman"
Consumer Campaign

Art Director: Jim Burt
Writer: Graham Watt
Producer: Gary Warwick
Agency: Warr Burt Advertising Inc. for McKim Milk Marketing Board
Directors: Graham Watt/Jim Burt
Cameraman: George Morita
Production House: Partner's Film Co.
Music: David Fleury Music

353. "Tobogan"
Consumer Campaign

Art Director: Jim Burt
Writer: Graham Watt
Producer: Gary Warwick
Agency: Warr Burt Advertising Inc. for McKim Milk Marketing Board
Directors: Graham Watt/Jim Burt
Cameraman: George Morita
Production House: Partner's Film Co.
Music: David Fleury Music

354. "Cross Country"
Consumer Campaign

Art Director: Jim Burt
Writer: Graham Watt
Producer: Gary Warwick
Agency: Warr Burt Advertising Inc. for McKim Milk Marketing Board
Directors: Graham Watt/Jim Burt
Cameraman: George Morita
Production House: Partner's Film Co.
Music: David Fleury Music

352. "Water Ski – Woman"
Anncr: There is no taste like it
No look like it.
No feel like it, cold in your mouth
on a hot tiring day.
No other drink goes as well with a sandwich.
Delicious, satisfaing, irreplaceable.

353. "Tobogan"
ANNCR: Who was your best friend growing up?
With you every day.
Every meal, next to the cookies.
Reached for after school,
smasher down or hungry thirst.
Surprisingly smooth.
Delicious, snowy fresh and absolutely irreplaceable.

354. "Cross Country"
ANNCR: If you're not drinking all the milk you used to, you're not getting all the milk benefits you used to.

Amazing milk. Over 96% fat-free, low in natural sugar, high in taste, cold, deliciou, snowy fresh, irreplaceable.

355. "Canoe"

Consumer Campaign

Art Director: Jim Burt
Writer: Graham Watt
Producer: Gary Warwick
Agency: Warr Burt Advertising Inc. for McKim Milk Marketing Board
Directors: Graham Watt/Jim Burt
Cameraman: George Morita
Production House: Partner's Film Co.
Music: David Fleury Music

356. "Ark"

Public Service

Art Director: Ron Lockhart
Writer: Eric Copplestone
Creative Director: Pat Harvie
Agency Producer: Trev Watkins
Agency: Ogilvy & Mather
Client: World Wildlife Fund
Director: Terry Collier
Cameraman: Ludek Bogner
Production House: Editor's Cut

357. "Countdown"

Radio Commercial Campaign

Writer: Joanna Schmida
Creative Director: Bruce McCallum
Agency Producer: June Whibley
Agency: Ogilvy & Mather
Client: American Express Travellers' Cheques
Production House: Morgan Earl

357. "Countdown"
SHE: And so how was your trip to the coast?
HE: Oh...fine. Great holiday
SHE: A perfect 10?
HE: Yeah, 'cept when I arrived and rented a car and someone stole it.
SHE: Oh, no. More like a 9 then.
HE: My jacket was in the car with my travellers cheques.
SHE: An 8 maybe?
HE: And my I.D.
SHE: A 7?
HE: I had no money...
SHE: Ohhhh,....a 3!
HE: Even my plane ticket was gone!
SHE: What a bummer! A minus 1.
HE: No, actually. I just called American Express.
SHE: About your travellers cheques?
HE: About everything. Now they've got this vacation protection package.
SHE: Yeah?
HE: Yeah, they helped cancel my credit cards and get a new airline reservation.
SHE: Great!
HE: Cashed my Canadian cheque for $200, and replaced my travellers cheques.
SHE: Wow!
HE: Am I glad I asked for American Express travellers cheques!
SHE: So your trip **was** a 10!
HE: Yeah. But they couldn't do anything about my sunburn.
SHE: All right, a 9.
HE: Or the fire coral itch...
SHE: An 8?
HE: The hurricane.
SHE: 7...(FADE)
HE: And there was this shark...
SHE: 6?
HE: My surf board got hijacked when I was on it...
ANNCR: For extra vacation protection in Canada and the U.S. ask for American Express Travellers Cheques by name.

355. "Canoe"
ANNCR: There sometimes comes a thirst no ordinary drink can cure.
Not a little pipsqueak thirst.
a roaring hungry thirst, filling you with emptiness.
When it comes, one drink can always bring you back. One dring.
Flowing cold and satisfying.
Delicious, absolutely irreplaceable.

356. "Ark"
This ark we call Planet Earth is in serious trouble.
We lose one Wildlife species every single day.
By the end of the '80's it could be one an hour. In Canada 15 Wildlife species are on the brink of extinction.
And the list is growing.
Contribute to the World Wildlife Fund today. We'll see that every single cent saves Wildlife.
Together we can help keep the animals on the ark.
World Wildlife Fund
Box 2500 – Station Q, Toronto, Ontario

358. "Peachy Keen"
Radio Commercial

Writer: Terrence N. Hill
Art Director: John Hoffmann
Creative Director: Terrence N. Hill
Agency Producer: Johanne Tur
Client: General Foods
Production House:
　　Applebaum & Applebaum
Music/Sound: Skywave Studios

359. "Night Ride"
Radio Comercial

Writer: Rick Davis
Creative Director: G. Carr/D. Linton
Agency Producer: Pat Lyons
Agency: Ambrose, Carr, DeForest &
　　Linton
Client: Honda Canada Inc.
Production House:
　　Streetnoise Productions
Music/Sound: Rick Sherman, Kerr
　　Krawford, Jonathan Goldsmith,
　　Steve Convery

360. "Talking House"
Radio Commercial Campaign

Writer: Mary Jane Palmer
Creative Director: Glenn Arscott
Agency Producer: Patricia Leech
Agency: Vickers & Benson Ltd.
Client: McDonald's
Production House: Streetnoise
Music/Sound: Streetnoise

358. "Peachy Keen"
JOHN: A peach drink, huh? Mmm, this is really delicious.
BOB: New peach Quench flavour crystals. We're so sure you'll like it — we'll give your money back if you don't.
JOHN: I don't like it. Where's my money?
BOB: No. You like it. You just said you liked...
JOHN: What's this? A trick guarantee? Fine print, legal weasels and all that?
BOB: No. Anyone who tries Quench Peach will get their money back if they don't like it.
JOHN: I don't like it.
BOB: How can you **say** that?
JOHN: I lied.
(FADE)
ANNCR: New Quench Peach. If you think it's the pits, send us what you haven't used and we'll send you your money. But please be honest.
(FADE)
BOB: What d'you think?
JOHN: I think it's the pits.
BOB: Look! You already said you liked it.
JOHN: Alright. I like it in the abstract.
(FADE)

359. "Night Ride"
SFX: (WIND SOUNDS OFF THE TOP. MUSIC FADES IN UNDER ANNCR. BUILDS IN STAGES THROUGHOUT.)
ANNCR: (SOFTLY/DRAMATICALLY) On a moonlit night, Nighthawk takes flight.
(MUSIC BUILDS FROM HERE.)
Come along...and soar with Honda Nighthawk... (SFX: FLUTTERING) Sit... sit low... let her cradle you in a plush, low-riding, stepped seat (APPROPRIATE SFX)... let handlebars reach back to meet you over a gleaming teardrop tank (APPROPRIATE SFX)... stars sparkle on chrome (APPROPRIATE SFX)... touch the electric start (SFX SYNTHESIZED START)... twist the throttle (REV SFX)... faster (REV SFX)... listen to the power sing (SFX: TAKE OFF)...
Fly with the new Honda Nighthawks... 450, 650 and 750 Nighthawk... Take hold... (ALL MUSIC STOPS ABRUPTLY. SFX: PASS BY) and she'll take hold of you.
ANNCR: See See Honda

360. "Talking House"
MUSIC: (UNDER)
WOMAN: How about we phone Grandpa tonight and I'll tell him how you are.
WOMAN: Hey, I've got some good news for you. Your brother is coming to spend the weekend with us.
GIRL: Oh your room is so pretty. Come and see ours. It's nice too.
MAN: I don't know where we'd be if this place wouldn't be here.
ANNCR: In the heart of Toronto, there's a house with a heart: Ronald McDonald House. It's a home away from home for people from out-of-town who have a child being treated for leukemia or other cancer related disease at the Hospital for Sick Children.
WOMAN: Well, tell me. What did the doctor say?
MAN: He's being so good and so brave about it all.
WOMAN: Susie's looking much better today.
ANNCR: You can help support Ronald McDonald House. When you buy the new Ronald McDonald Colouring Calendar at participating McDonald's for 75¢, 40¢ goes to Ronald McDonald House. The calendar makes a great gift for kids, with a coupon to redeem each month for a McDonald's treat.
BOY: We're going home Saturday.

PHOTOGRAPHY / Ontario

Art & Design Studios Ltd pages 17, 18, 19 — (416) 481-6461
68 Merton St., Toronto, Ontario M4S 1A1

AGS Photography page 20 — (416) 441-3444
309 Lesmill Rd., Toronto, Ontario M3B 2V1

Action Photographics Incorporated page 21 — (416) 968-0000
466 Bathurst St. #4, Toronto, Ontario M5T 2S6

Allen, David Photography/Format — (416) 363-7081
56 The Esplanade, Toronto, Ontario M5E 1A7

Amini, Stephen Photography — (416) 533-3506
77 Mowat Ave., #305, Toronto, Ontario M6K 5E3

Appleby, Paul Photography — (416) 366-7000
69 Sherbourne St., #522, Toronto, Ontario M5A 3X7

Bart, Casimir Photography pages 22, 23 — (416) 598-3577
246 Adelaide St., W., Toronto, Ontario M5H 1X6

Bell, Bert pages 24, 25 — (416) 961-9304
4 New St., Toronto, Ontario M5R 1P6
Stock photography available through Masterfile

Bird, Fred & Associates Ltd. — (416) 421-4259
202 Parkhurst Blvd., Toronto, Ontario M4G 2G3

Blohm, Hans — (416) 977-7267
c/o Masterfile, 2 Carlton St. #617, Toronto, Ontario M5B 1J3

Bradshaw Photography/Format — (416) 363-7081
56 The Esplanade, Toronto, Ontario M5E 1A7

Brooks Bills — (416) 977-7267
c/o Masterfile, 2 Carlton St. #617, Toronto, Ontario M5B 1J3

Brown, Richard page 26 — (416) 535-8717
6 High Park Blvd. #2, Toronto, Ontario M6R 1M4

Bruun, Richard — (416) 977-7267
c/o Masterfile, 2 Carlton St. #617, Toronto, Ontario M5B 1J3

Campbell, Ian Photography pages 28, 29 — (416) 593-9266
524 Wellington St. W., Toronto, Ontario M5V 1H5

Canapress Photo Service — (416) 364-0321
36 King St. East, Toronto, Ontario M5C 2L9

Caron, Derek — (416) 977-7267
c/o Masterfile, 2 Carlton St. #617, Toronto, Ontario M5B 1J3

Chard, Rick — (416) 533-6634
1179A King St. W. #109, Toronto, Ontario M6K 3C5

Chau, Leo — (416) 923-3800
4 New Street, Toronto, Ontario M5R 1P6

Chiu, Joseph Photography page 27 — (416) 535-0302
77 Mowat Ave., #410, Toronto, Ontario M6K 3E3

Christopher, Peter — (416) 977-7267
c/o Masterfile, 2 Carlton St. #617, Toronto, Ontario M5B 1J3

Clark, Harold Photography Ltd. — (416) 743-6008
55 Harlow Cres., Rexdale, Ontario M9V 2Y8

Coons, Peter Photo Design — (416) 665-2042
300 Antibes Dr., #2015, Toronto, Ontario

Croydon, Peter Photography Ltd — (416) 463-6230
70 McGee St., Toronto, Ontario M4M 2L1
Portrait, Annual Report, Food & Product Illustration

Crysler, Ian — (416) 864-1858
25 Brant St., Toronto, Ontario, M5V 2L9

Davies, Ken page 30 — (416) 531-8290
67 Mowat Ave., #335, Toronto, Ontario M6K 3E3

Davidson Samson Group, The — (416) 534-4816
76 Howland Ave., Toronto, Ontario M5R 3B3

Day, Fraser page 31 — (416) 463-9052
345 Carlaw Ave., Toronto, Ontario M4M 2T1

Day, Michael Studio Inc. page 36 — (416) 596-6773
49 Spadina Ave., Toronto, Ontario M5V 2J1

de Visser, John — (416) 977-7267
c/o Masterfile, 2 Carlton St. #617, Toronto, Ontario M5B 1J3

Dean Photographic Inc. pages 32, 33 — (416) 530-1147
67 Mowat Ave., #143, Toronto, Ontario M6K 3E3

Dickson, Nigel pages 34, 35 — (416) 597-0767
15 Elm St., Toronto, Ontario M5G 1H1

Dobel, Mike — (416) 977-7267
c/o Masterfile, 2 Carlton St. #617, Toronto, Ontario M5B 1J3

Dojc, Yuri Inc. page 37 — (416) 366-8081
66 Portland St., Toronto, Ontario M5V 2M8

Duff, Joseph Photography Ltd./Format — (416) 363-7081
56 The Esplanade, Toronto, Ontario M5E 1A7

Elliott, Ken page 50 — (416) 363-2974
56 The Esplanade #403, Toronto, Ontario M5E 1A7

Elmy, Ron Photography/Format — (416) 363-7081
56 The Esplanade, Toronto, Ontario M5E 1A7

Fisher, Douglas J — (416) 977-7267
c/o Masterfile, 2 Carlton St. #617, Toronto, Ontario M5B 1J3

Fisher, Warren Photography pages 38, 39 — (416) 425-2404
1515 Matheson Blvd. #11, Mississauga, Ontario L4W 2P5

Foster, Janet (Green) — (416) 977-7267
c/o Masterfile, 2 Carlton St. #617, Toronto, Ontario M5B 1J3

Foster, John — (416) 977-7267
c/o Masterfile, 2 Carlton St. #617, Toronto, Ontario M5B 1J3

French, Graham pages 40, 41, 42, 43 (416) 596-6439
443 King St. W., Toronto, Ontario M5V 1K4

Futura Photographic Company Ltd pages 44, 45 (416) 593-9362
296 Richmond St. W., Toronto, Ontario M5V 1X2

G/W Photography Ltd. pages 46, 47 (416) 537-1225
67 Mowat Ave., #449, Toronto, Ontario M6K 3E3

Garnet McPherson – CAPIC – ASMP (416) 686-1144
1850 Champlain Ave., Boc 363 Whitby, Ontario L1N 5S4
Editorial & A.V. Location, Aerial & Underwater

Gierszewski, John Photography (416) 624-1668
1515 Matheson Blvd #C11, Mississauga, Ontario L4W 2P5

Gilbert Studio pages 48, 49 (416) 923-1995
170 Davenport Rd., Toronto, Ontario M5R 1J1

Gooderham, George page 51 (416) 925-0774
51 Borden St., Toronto, Ontario M5S 2M5

Grant, Ted (416) 977-7267
c/o Masterfile, 2 Carlton St. #617, Toronto, Ontario M5B 1J3

Green, Sharon page 52 (416) 681-0512
682 North Shore Blvd., E., Burlington, Ontario L7T 1X2

Greer, Brian R., Photography (416) 829-5765
#23 – 1045 Morrison Dr., Ottawa, Ontario K2H 7L2
Flexible-Effective-Responsive-Let's discuss

Grieve, Anne Photography (416) 366-0994
69 Sherbourne St. #401, Toronto, Ontario M5A 3X9

Hancey, Terry (416) 977-7267
c/o Masterfile, 2 Carlton St. #617, Toronto, Ontario M5B 1J3

Harquail, John (416) 535-1620
Studio 340, 67 Mowat Ave., Toronto, Ontario M6K 3E3
Annual Report, Publicity, Location and Aerial

Harvey, Al (416) 977-7267
c/o Masterfile, 2 Carlton St. #617, Toronto, Ontario M5B 1J3

Hill, Dave Photography Ltd. pages 54, 55 (416) 365-1660
296 King St. E., Toronto, Ontario M5A 1K4

Hill, Richard Photographer page 53 (416) 533-6634
1179A King St. W., #109, Toronto, Ontario M6K 3C5

Hines, Sherman (416) 977-7267
c/o Masterfile, 2 Carlton St. #617, Toronto, Ontario M5B 1J3

Horan Photography page 56 (416) 729-0724
584 Melbourne Ave., Ottawa, Ontario K3A 1W8

Infinity Graphics Limited (416) 363-3251
744 Dundas St. East, Ontario M5A 2C3
Doug Johnson: Product, fashion, studio or location

Insight Photographics Inc. (416) 686-1144
1850 Champlain Ave., Box 363 Whitby, Ontario L1N 5S4
Corporate Editorial – Location, Aerial & Underwater

Kineblok Inc. page 57 (416) 947-0169
398 King St. E., Toronto, Ontario M5A 1K9

Kohn, Michael/Oyster Studio page 65 (416) 368-9212
155 George St., Toronto, Ontario M5A 2M8

LaCroix, Pat Photography Ltd. page 58 (416) 864-1858
56 The Esplanade #502, Toronto, Ontario M5E 1A7

Leith, Ian Associates pages 60, 61 (416) 625-2410
1515 Matheson Blvd., #C11, Mississauga, Ontario L4W 2P5

Leon Sait Photographer (416) 451-2627
43 Grange Dr., Brampton, Ontario L6X 2H1

Long, David Harper Photography page 59 (416) 625-4531
1515 Matheson Blvd., #C-11, Mississauga, Ontario L4W 2P5

Lynch, Wayne (416) 977-7267
c/o Masterfile, 2 Carlton St. #617, Toronto, Ontario M5B 1J3

Macaulay, Bruce Photography (416) 960-1399
75 Oriole Rd. #2, Toronto, Ontario M4V 2E9

McLaren, Hugh Photography (416) 535-1557
77 Mowat Ave., #106, Toronto, Ontario M6K 3E3

McLeod, Bill (416) 366-4977
107 Niagara St., Toronto, Ontario M5V 1C3

Mellows, Iain Photographer (416) 363-7081
56 The Esplanade, Toronto, Ontario, M5E 1A7

Miller, Larry Photography page 64 (416) 461-5013
821 Queen St. E. #204, Toronto, Ontario M4M 1H5

Moore, Anthony Photography Ltd. /Format (416) 363-7081
56 The Esplanade, Toronto, Ontario M5E 1A7

Noto, Rino Photography (416) 961-3139
625 Yonge St., #301, Toronto, Ontario M4T 1Z5

Oasis (416) 461-7518
5 Polson St., Toronto, Ontario M5A 1A4

Orenstein, Paul Photography Ltd. pages 62, 63 (416) 593-9200
317 Adelaide St. W., #603, Toronto, Ontario M5V 1P9

Patterson Freeman (416) 977-7267
c/o Masterfile, 2 Carlton St. #617, Toronto, Ontario M5B 1J3

Phase One Photography & Design Ltd. (416) 475-6785
300 Steelcase Rd. W., #35, Markham, Ontario L3R 1B3

Pierre, Richard page 66 (416) 466-4063
21 Fairview Blvd., Toronto, Ontario M4K 1L8

Piton White Photography (416) 977-0315
263 Adelaide St. West, 5th floor, Toronto, Ontario M5H 1Y2
Timewise, moneywise: Piton White Photography

Plum Studio page 67 (416) 593-1433
P.O. Box 456, Station A, Toronto, Ontario M5V 1H5

Rafelson, Michael Photographics (416) 368-2487
530 Richmond St. West, (Rear) Toronto, Ontario M5V 1Y4

Ragsdale, Robert C. Limited (416) 967-3326
21 Avenue Rd. (Four Seasons Hotel), Toronto, Ont. M5R 2G1

Rosen, Taffi Photography page 68 (416) 593-9266
524 Wellington St. W., Toronto, Ontario M5V 1H5

Rostron, Philip Studio Inc. pages 70, 71 (416) 596-6587
443 King St. W., Toronto, Ontario M5V 1K4

Samuel Deborah Photography page 69 (416) 593-9200
317 Adelaide St. W., Toronto, Ontario M5V 1P9

Saunders, Tim & Associates pages 72, 73 (416) 368-1611
163A Manning Ave., Toronto, Ontario M6J 2K9

Schmidt, Wilhelm (416) 977-7267
c/o Masterfile, 2 Carlton St. #617, Toronto, Ontario M5B 1J3

Sharp, Ivor Inc. pages 74, 75 (416) 363-3991
60 Sumach St., Toronto, Ontario M5A 3J7

Simhoni, George page 76 (416) 365-1660
296 King St. E., Toronto, Ontario M5A 1K4

Sloane Square Studio (416) 368-5535
93 Parliament St. #324, Toronto, Ontario M5A 3Y7

Smith & Smith Studio (416) 465-3831
2 Matilda St., Toronto, Ontario M4M 1L9

Staley, Bill (416) 977-7267
c/o Masterfile, 2 Carlton St. #617, Toronto, Ontario M5B 1J3

Strada Photography Inc. (416) 533-5132
87 Mowat Ave., #305, Toronto, Ontario M6K 3E3

Struan Photography Inc. (416) 923-9311
4 New Street, Toronto, Ontario M5R 1P6
Chicago Studio: 612 S., Clinton St., U.S. Agent: Kurt Jeske (312) 922-9210

Studio Two Photographers Inc.	(416) 624-6333
1297 Matheson Blvd., Mississauga, Ontario L4W 1R1	
60 Sumach pages 78, 79	(416) 864-1314
60 Sumach St., Toronto, Ontario M5A 3J7	
Switzer, Maynard	(416) 977-7267
c/o Masterfile, 2 Carlton St. #617, Toronto, Ontario M5B 1J3	
TDF Artists Ltd	(416) 924-3371
980 Yonge St., Toronto, Ontario M4W 2J9	
Tabak, Sidney A. Photography page 83	(416) 363-3428
40 Lombard St., #203, Toronto, Ontario M5C 1M1	
Tanaka, Ron	(416) 864-1858
25 Brant St., Toronto, Ontario M5V 2L9	
Tasca, Sandra	(416) 532-1716
72 Pauline Ave., 2nd floor, Toronto, Ontario M6H 3M8	
Tomalty, Mark	(416) 977-7267
c/o Masterfile, 2 Carlton St. #617, Toronto, Ontario M5B 1J3	
Thomas, Anthony	(416) 864-1858
25 Brant St., Toronto, Ontario M5V 2L9	
Vogue Photographic Services	(416) 741-9889
214 Oakdale Rd., Downsview, Ontario M3N 2S5	
Watson, Robert	(416) 864-1858
25 Brant St., Toronto, Ontario, M5V 2L9	
Weber, Roland	(416) 977-7267
c/o Masterfile, 2 Carlton St. #617, Toronto, Ontario M5B 1J3	
Webster, Clive Photography Inc./Format	(416) 363-7081
56 The Esplanade, Toronto, Ontario M5E 1A7	
Wigington, Robert Photographer pages 80, 81	(416) 533-7938
4 Clinton Place, Toronto, Ontario M4G 1J9	
Williamson, John Photography	(416) 361-0980
224 Palmerston Ave., Toronto, Ontario M6J 2J4 Adv. edit. Ind/Corp. Travel, Film Strips/Stills	
Yarkun, Stephen page 82	(416) 366-8081
66 Portland St., Toronto, Ontario M5V 2M8	
Yarwood, Ted Photographer	(416) 363-7081
56 The Esplanade, Toronto, Ontario M5E 1H7	
Aerial Photo Graphics of Canada	(416) 686-1144
1850 Champlain Ave., Box 363, Whitby, Ontario L1N 5S4	

PHOTOGRAPHY / Western Canada

ABL Photographic Techniques Ltd. page 93	(403) 245-6626
1336 – 11 Ave., S.W., Calgary, Alberta T3C 0M6	
Aardvark Photography Ltd	(403) 233-7373
401 – 9 Ave., S.W., Calgary, Alberta T2P 3K5	
Accent Photography Ltd.	(403) 264-7964
19-11625 Elbow Dr. S.W., Calgary, Alberta T2W 1G8	
Angus of Calgary Photography Ltd.	(403) 246-0888
5-605 Spruce Drive S.W., Calgary, Alberta T3C 3B3	
Bako/Becq Inc. pages 94, 95	(403) 243-9789
3047 – 4th St. S.W., Calgary, Alberta T2S 1X9	
Boden Photography	(403) 274-1642
Bay 105, 5621-11th St. N.E., Calgary, Alberta T2E 6Z7	
Commercial Illustrators Ltd.	(403) 287-1731
1317 Hastings Cr. S.E., Calgary, Alberta T2G 4C8	
Grootveld, Belinda Photographer	(403) 230-9389
Box 3216, Stn. B, Calgary, Alberta T2N 4L7	

Henning, George Photography	(403) 274-0004
P.O. Box 3129, Olds, Alberta	
Image House, The	(403) 276-7021
3304 Centre St. N., Calgary, Alberta T2E 3A1	
Mach 2 Film Productions Ltd.	(403) 230-9006
824C Edmonton Trail N.E., Calgary, Alberta T2E 3J6	
PNE Photographic Services	(403) 281-1091
2719 Cedarbrae Dr. S.W., Calgary, Alberta T2W 1Y1	
Phoebus Photography for Communications	(403) 277-5089
6-4339 14 St. N.E., Calgary, Alberta T2E 7A9	
Pictures Taken By Norbert Ltd.	(403) 272-4900
3917 17 Ave. S.E., Calgary, Alberta T2A 0S5	
Picture This Photography page 97	(403) 280-9709
4928 Rundlewood Rd. N.E., Calgary, Alberta T1Y 1B4	
Ranson & Nodwell Photographers Ltd.	(403) 277-4646
3, 1255 – 45th Ave. N.E., Calgary, Alberta T2E 2P2	
Salus, John Photographer	(403) 269-4224
1434 9 Ave. S.E., Calgary, Alberta T2G 0T5	
Triad Productions Ltd.	(403) 253-3777
105, 6036 3rd St. S.W., Calgary, Alberta T2H 0H9	
United Graphic Services Ltd.	(403) 276-7876
4402 10th St. N.E., Calgary, Alberta T2E 6K3	
Agrapha Photo-Productions	(403) 424-6711
10535 – 108 St., Edmonton, Alberta T5H 2Z8	
Bissell, Christopher & Associates Ltd.	(403) 425-5101
10565 – 115 St., Edmonton, Alberta T5H 3K4	
Compor Photography Ltd.	(403) 484-3929
9444 – 149 St., Edmonton, Alberta T5R 1C6	
Garneau Studio	(403) 433-4491
10909 – 86 Ave., Edmonton, Alberta T6G 0W8	
Goertz Studios Ltd.	(403) 428-6262
10171 – 109 St., Edmonton, Alberta T5J 3M4	
Henderson Photography	(403) 483-8049
10612 – 172nd St., Edmonton, Alberta T5S 1H8	
Logan Graphics Limited	(403) 429-7751
10711 – 102 St., Edmonton, Alberta T5H 2T8	
Paterson Photography	(403) 436-6511
4422 – 97 St., Edmonton, Alberta T2E 5R9	
Prosofsky, Merle Photography Ltd.	(403) 468-5585
106, 8905 – 51 Ave., Edmonton, Alberta T6E 5J3	
Puckrin's Production House Ltd.	(403) 451-3660
12644 – 126 St., Edmonton, Alberta T5L 0X7	
Ranson Photographers Ltd.	(403) 454-9674
26 Airport Rd., Edmonton, Alberta T5G 0W7	
Rudolf Photography Ltd. page 100	(403) 455-8138
15006 – 116 Ave., Edmonton, Alberta T5M 3T4	
Challenge Group	(604) 873-4914
117 East – 2nd Avenue, Vancouver, B.C. V5T 1B4	
Commercial Illustrators Ltd.	(604) 684-8467
910 Beach Avenue, Vancouver, B.C. V6Z 1C8	
Eligh, Gregg T.	(604) 682-8164
1134 Homer St., Vancouver, B.C. V6B 2X6 Bang, Bang, Shoot, Shoot	
G.M. Studios	(604) 872-3214
59 West – 7th Ave., Vancouver, B.C. V5Y 1L4	
Hersee, Philip Photography page 96	(604) 687-2921
155 Water St., Gastown, Vancouver, B.C. V6B 1A7	

Little, Paul (604) 925-1959
107 – 2247 Folkstone Way, West Vancouver, B.C. V7S 2Y6

Mountain Moments Custom Photography (604) 932-3274
Box 165, Whistler, B.C. V0N 1B0

Murray, Derik Photography Inc. pages 98, 99 (604) 688-6830
1128 Homer St., Vancouver, B.C. V6B 2X6

Ward, Stirling Photographic Design page 101 (604) 687-3554
1020 Hamilton St., Vancouver, B.C. V6B 2R9

Wedgwood, Colin (604) 926-9879
2446 Haywood, West Vancouver, B.C. V7V 1Y1
Photographic Concepts and Designs

Wong, Stanley Pictures Inc. (604) 685-4815
1066 Seymour St., Vancouver, B.C. V6B 3M6

Zenuk, Alan (604) 733-8271
P.O. Box 3531, Vancouver, B.C. V6B 3Y6

PHOTOGRAPHY / Quebec

Arsenault, Peter (514) 274-2738
5221 St. Laurent #300, Montréal, Québec H2T 1S4

Baumgartner, Peter (514) 849-0991
365 St. Paul St. W., Montréal, Québec H2Y 2A7

Chen, Ray pages 84, 85 (514) 931-2203
1430, rue Notre-Dame ouest, Montréal, Québec H3C 1K9

Coshof, Karen page 86 (514) 842-1393
63, Prince Arthur Est, Montréal, Québec H2X 1B4

Darby, Mike (514) 861-3087
1221 St. Laurent Blvd., Montréal, Québec H2Y 2W5

Delbuguet, René (514) 932-1630
1209 Guy Street, Montreal, Quebec H3H 2K5

Duey, Adrien page 87 (514) 879-1848
1030 St. Alexander #812, Montréal, Québec H2Z 1P3

Edge, Dennis (514) 989-1714
1155 Wellington St., Monteal, Quebec H3C 1V9

Eigenmann, Dany (514) 288-4823
1583, blvd. St. Laurent, Montréal, Québec H2X 2S9

Foldes, Peter D. (514) 694-1820
17226 CH St. Marie, Kirkland, Quebec H9J 2R2

Laporta, Robert (514) 844-9706
1411 Crescent St. #601, Montreal, Quebec H3G 2B3

Les Production Lumière page 88 (514) 879-1848
1030 St. Alexander #812, Montréal, Québec H2Z 1P3

Lipton, Warren (514) 845-2404
177 St. Paul St. W., Montreal, Quebec H2Y 1Z5

Martinot, Raymond (514) 671-4237
7450, rue Tessier, Brossard, Québec J4W 2H5

Morel, Sylvain (514) 387-7513
10820 Avenue Durham, Montréal, Québec H2C 2G9

O'Hara, John page 89 (514) 737-4872
P.O. Box 276, Montréal, Québec H3P 3C5

Poirier Michel (514) 744-5205
565, rue Gohier, Saint-Laurent, Québec H4L 3H6

Singer, Danny Animotion Inc. page 90 (514) 935-8749
1850 Notre Dame Ouest, Montréal, Québec H3J 1M3

Sperling, Glay (514) 849-2351
P.O. Box 617, Montreal, Quebec H3C 2T8

Travers, David Photography Inc. page 91 (514) 861-9107
980 St. Paul Ouest, #208, Montréal, Québec H3C 1M9

ILLUSTRATION / Ontario

Art & Design Limited page 104 (416) 481-6461
68 Merton St., Toronto, Ontario M4S 1A1

Anderson, Don pages 106, 107 (416) 496-1467
65 Forest Manor Rd., #1811, Toronto, Ontario M6R 1M5

Anodos Studio page 105 (416) 977-4477
30 Duncan St., Toronto, Ontario M5V 2C3

Bardell, Graham (416) 699-0314
56 Scarborough Beach Blvd. Toronto, Ontario M4E 2X1

Baviera/Morin Illustration & Design page 108 (416) 824-1291
3098 Keynes Cres., Mississauga, Ontario L5N 3A1

Berger, Bob (416) 485-8555
52 McNairn Ave., Toronto, Ontario M5M 2H5

Bertuss-Lapsa Ltd. (416) 534-4227
67 Mowat Ave., #343, Toronto, Ontario M6K 3E3

Biddle, William Illustration Ltd. (416) 364-5096
85 Front St. E., Toronto, Ontario M5E 1B8

Black, T.S. (416) 534-9715
1179A King St. W., #315, Toronto, Ontario M6K 3C5

Blackshaw & Associates Ltd. page 109 (416) 922-8182
52 Hayden St., Toronto, Ontario M4Y 1V8

Bjarnason, Tom Inc. pages 110, 111 (416) 960-0834
63 Yorkville Ave., Toronto, Ontario M5R 1B7

Bui, Thach page 175 (416) 694-8147
128 Stephenson Ave., Toronto, Ontario M4C 1G4

Ciss, Julius Illustration Inc. pages 112, 113 (416) 534-5268
73 Pauline Ave., Toronto, Ontario M6H 3M7

Chapman, Bill page 114 (416) 485-1679
175 Roslin Ave., Toronto, Ontario M4N 1Z5

Chestnutt, David (416) 921-8700
9 Metcalfe St., Toronto, Ontario M4X 1R6

Commins Associates page 115 (416) 535-8145
31 Brock Ave., #206, Toronto, Ontario M6K 2L1

Collis, James Illustration Ltd. (416) 363-4700
85 Front St. E., Toronto, Ontario M5E 1B8

Craig, David pages 116, 117 (416) 275-6693
267 Wellington St. W., Toronto, Ontario M5V 1E1

Csakany, Gabriel page 118 (416) 276-9373
Represented by Fleming & Associates

Cusack, Marie Louise (416) 222-3495
61 Whittaker Crescent, Willowdale, Ontario M2K 1K9

Daigneault, Sylvie page 119 (416) 961-0681
340 Walmer Rd., Toronto, Ontario M5R 2Y4

Davies, Will pages 120, 121 (416) 925-8191
63 Yorkville Ave., Toronto, Ontario M5R 1B7

Dobbs, Linda Kooluris (416) 960-8984
50 Prince Arthur Ave., #601, Toronto, Ontario M5R 1B5

Durban, Paul/Live Brush (416) 591-1770
409 King St. W., 2nd floor, Toronto, Ontario M5V 1K1

Fernandes, Henry (416) 423-8849
85 Thorncliffe Park Dr., #2201, Toronto, Ontario M4H 1L6

Fischer, Rick pages 122, 123 (416) 593-0920
369 Queen St. W., 3rd floor, Toronto, Ontario M5V 2A4

Flemington, Gale pages 124, 125 (416) 977-0776
96 Gerrard St. E., #17A1, Toronto, Ontario M5B 1A7

Freire, Carlos Illustration	(416) 766-6604	Marvin, Dick Illustrator Incorporated page 140	(416) 822-9378
71 Mavety St., Toronto, Ontario M6P 2L7		RR #1, Moffat, Ontario L0P 1J0	
Furmanczyk, Greg	(416) 531-8440	Mason, Tim-Illustration page 141	(416) 651-0676
608 Markham St., #5, Toronto, Ontario M6G 2L8		1034 St. Clair Ave. W., Toronto, Ontario M6E 1A4	
Geras, Audra Illustration/Design page 126	(416) 928-2965	McCusker, Paul pages 142, 143	(416) 469-4314
44 Charles St. W., #4505, Toronto, Ontario M4Y 1R8		689 Pape Ave., Toronto, Ontario M4K 3S6	
Gourbault, Martine Design Ltd.	(416) 921-9252	McGaw, Laurie page 144	(416) 363-0767
122 Winchester St., Toronto, Ontario M4X 1B4		69 Berkeley St., Toronto, Ontario M5A 2W5	
Grainge, Ian Designer/Illustrator	(519) 471-6852	McGraw, Sheila page 145	(416) 465-8274
280 Southcrest Dr., London, Ontario N6J 1N4		259 Broadview Ave., Toronto, Ontario M4K 2N5	
Hammond, Franklin	(416) 533-7745	McGraw, Pauline	(416) 964-2241
67 Mowat Ave., #336, Toronto, Ontario M6K 3E3		40 Alexander St., #812, Toronto, Ontario M4Y 1B5	
Hill, James page 127	(416) 276-9373	McKee, Jon	(416) 537-0464
Represented by Fleming and Associates		620 Crawford St., Toronto, Ontario M6G 3K2	
Hill, Roger Inc.	(416) 923-5933	McKeever, Mike pages 146, 147	(416) 465-4013
63 Yorkville Ave., Toronto, Ontario		137 Broadview Ave., Toronto, Ontario M4M 2E9	
High Noon Studios page 130	(416) 699-2210	McLaughlin, Gary page 148	(416) 651-7228
1957 Queen St. E., Toronto, Ontario M4L 1H7		541 Blackhorn Ave., #910, Toronto, Ontario M6M 5A6	
Holdcroft, Tina Page 128, 129	(416) 968-3697	McNeely, Tom Limited page 149	(416) 925-1929
100 Spadina Rd. #803, Toronto, Ontario M5R 2T7		63 Yorkville Ave., Toronto, Ontario M5R 1B7	
Jaffe, Charles	(416) 926-1561	Michener, Ted Limited page 150	(416) 596-8420
65 Ulster St., Toronto, Ontario M5S 1E6		12 Sullivan St., Toronto, Ontario M5T 1B9	
Jenkins, Sarie page 131	(416) 535-6911	Miller, Jean page 151	(416) 883-4114
325 Clinton St., Toronto, Ontario M6G 2Y7			
Jones, Danielle page 132	(416) 977-7357	Milne, David page 152	(416) 431-0254
20 St. Patrick St., #620, Toronto, Ontario M5T 2Y4		79 Orton Park Rd., Scarborough, Ontario M1G 3G7	
Kempkes, Jim	(416) 489-9814	Milne, Jonathan	(416) 366-5161
1052 Mt. Pleasant Rd., Toronto, Ontario M4P 2M4		56 Esplanade E., #205A, Toronto, Ontario M5E 1A7	
Klunder, Barbara page 133	(416) 530-4981	Mixed Nuts Inc. page 153	(416) 593-0845
14 Fernbank Ave., Toronto, Ontario M6H 1W1		320 Queen St. W., 2nd floor, Toronto, Ontario M5V 3G7	
Kovalski, Maryann	(416) 923-6542	Molnar, Kalman Limited page 154	(416) 488-5062
16 Monteith St., Toronto, Ontario M4Y 1K7		234 Eglinton Ave. E., #501, Toronto, Ontario M4P 1K5	
Kucharski, Zigi Illustrator	(416) 822-2912	Oasis	(416) 461-7518
965 Iverhouse Dr., #601, Mississauga, Ontario L5J 4B4		5 Polson St., Toronto, Ontario M5A 1A4	
Kunz, Anita page 136	(416) 925-6816	Okada & Csafordi Incorporated page 155	(416) 530-1951
135 Winchester St., Toronto, Ontario M4X 1B3		2 Clinton Place, Toronto, Ontario M6G 1J9	
LaFave, Kim	(416) 962-8441	Ormond, Rick Illustrator page 156	(416) 484-6645
32 Hawthorn Ave., Toronto, Ontario M4W 2Z2		42 Portland Cres., Newmarket, Ontario L3Y 6A5	
Lau, Bernadette	(416) 491-6753	O'Young, Leoung page 157	(416) 967-4660
25 Redheugh Crescent, Scarborough, Ontario M1W 3C4		272 Berkeley St., Toronto, Ontario M5A 2X3	
Lawrason, June pages 134, 135	(416) 368-4134	Panton, Doug Inc. page 158	(416) 920-5612
69 Berkeley St., Toronto, Ontario M5A 2W5		341 Wellesley St. E., Toronto, Ontario M4X 1H2	
Lesynski, Loris Illustration/Design	(416) 461-2232	Paper Works Productions page 160	(416) 463-4721
655 Broadview Ave., #1814, Toronto, Ontario M4K 2P3		2069 Salvator Blvd., Oakville, Ontario L1L 1M9	
Lilly, Wendy	(416) 259-9597	Pilsworth, Graham	(416) 690-4573
8 First St., Toronto, Ontario M8V 2W9		283 Silverbirch Ave., Toronto, Ontario M4E 3L6	
Lowe, Wes page 137	(416) 284-2522	Quinlan, Stephen Illustration Inc. page 159	(416) 593-1375
46 Murison Blvd., Scarborough, Ontario M1B 2B2		88 University Ave., 9th floor, Toronto, Ontario M4J 1V5	
Lowenthal, Myra	(416) 789-2577	RPB Associates page 161	(416) 595-1880
33 Rosehill Ave., #2502, Toronto, Ontario M4T 1G4		627A Bay St., Toronto, Ontario M5G 1M7	
Mardon, John page 138	(416) 881-5854	Reactor Art & Design Ltd. page 162	(416) 362-1913
27 Colonsay Rd., Thornhill, Ontario L3T 3E9		51 Camden East, Toronto, Ontario M5V 1V2	
Mark, Susan Design/Illustration page 139	(416) 767-6484	Row, Richard Illustrator page 163	(416) 466-9069
2001 Bloor St. W., #203, Toronto, Ontario M6S 1M6		3 Victor Avenue, Toronto, Ontario M4K 1A7	
Martin, Doug	(416) 362-4245	Ryan, Ken page 164	(416) 633-3555
51 Camden St., 2nd floor, Toronto, Ontario M5V 1V2		4 Hartham Place #10, Toronto, Ontario M3k 1P3	

Sakr, Hassan page 165 (416) 921-4815
30 Gloucester St., #1908, Toronto, Ontario M4Y 1L6

Salina, Joe Illust. Inc. (416) 699-4859
182 Wineva Avenue, Toronto, Ontario M4E 2T4

Shaw, David & Associates (416) 487-2019
2586A Yonge St., Toronto, Ontario M4P 2J3

Sherwood, Stewart pages 166, 167 (416) 925-8528
625 Yonge St., #303, Toronto, Ontario M4Y 1Z5

Shoffner, Terry Illustrator Inc. page 168 (416) 967-6717
11 Irwin Ave., Toronto, Ontario M4Y 1L1

Springett, Martin Illustration (416) 463-9189
657 Logan Ave., Toronto, Ontario M4K 3C4

Sullivan Studios Inc. page 169 (416) 368-3219
51 Bulwer St., Toronto, Ontario M5T 1A1

Summers, Mark page 170 (416) 681-0907
477 Elizabeth St., #904, Burlington, Ontario L7R 2M3

Syme, Hugh Inc. page 171 (416) 363-9788
195 Church St., Toronto, Ontario M5B 1Y7

TDF Artists Limited (416) 924-3371
980 Yonge St., Toronto, Ontario M4W 2J9

Taylor, Tom page 172 (416) 924-8183
Represented by: SCF Limited

Terry, Wayne Illustration (416) 924-4008
495 Davenport Rd., Toronto, Ontario M4V 1B7

Tonkin, Murray Illustration (416) 425-2401
98 Parklea Drive, Toronto, Ontario M4G 2J8

Tughan, James (416) 535-9149
87 Mowat Ave., #204, Toronto, Ontario M6K 3E3

Vakharia, Anees (416) 923-2478
224 St. George St., Suite 304, Toronto, Ontario M5R 2N9
Architectural, Edit. & Portrait for Annual Reports

Van Nood, Robert (416) 844-4707
1260 Marlboro Court, #1106, Oakville, Ontario L6H 3H5

Vosburgh, Ann (416) 533-7745
67 Mowat Ave., #336, Toronto, Ontario M6K 3E3

Waller, Leslie Illustration (416) 593-0347
267 Wellington St. W., Toronto, Ontario M5V 1L1

Whitemore, Wendy page 173 (613) 828-8914
28C Forester Cres., (Nepean), Ottawa, Ontario K2H 8W8

Wood, Muriel page 174 (416) 276-9373
Represented by Fleming & Associates

ILLUSTRATION / Western Canada

Gilbert, John Martin page 177 (604) 925-1049
4797 Highway, West Vancouver V7W 1J6

Leier, Grant W. Illustration pages 178, 179 (403) 289-6502
1615 7A St. N.W., Calgary, Alberta T2M 1J6

ILLUSTRATION / Quebec

Ludmilla page 176 (514) 932-3715
2335 Sherbrooke St. W., 3rd floor, Montreal, Quebec H3H 1G6

Leimanis, Andris (514) 694-4648
126 Winthrop Avenue, Pte. Claire, Québec H9R 3W7

DESIGN / Ontario

AES Company (416) 484-0650
120 Eglinton Ave. E., #800, Toronto, Ontario M4P 1E2

Aitken, Nick Design Studio Ltd. (416) 844-2638
315 Lakeshore Road E., Oakville, Ontario L6J 1J3

AMA Graphics Incorporated (416) 665-8220
1111 Finch Ave. W., #7, Downsview, Ontario M3J 2E5

Anderson, R. Suzanne (519) 885-5453
250 Glenridge Dr., Waterloo, Ontario N2J 4H8

Bell, Cheryl (613) 534-2156
39 Johnson Cresc., Long Sault, Ontario K0C 1P0

Bell, Desmond (613) 544-3816
227 Victoria St., Kingston, Ontario K7L 3Y9

Biron, Yolanda Deniz (416) 967-9195
239 Gainsborough Rd., Toronto, Ontario M4L 3C7

Black, Donna May (705) 728-3795
18 Wellington St. W., #4, Barrie, Ontario L4M 2B8

Caplan, Kenneth (416) 489-7723
120 Eglinton Ave. E., 4th floor, Toronto, Ontario M4P 1E2

Capon & Austin Assoc. Ltd (416) 297-5357
205 Main St., Unionville, Ontario L3R 2G8

Carefoot, Irene (416) 762-2690
35 Ormskirk Ave., #203, Toronto, Ontario

Cheng, Rowennie Design page 182 (416) 861-1339
334 King St. E., #224, Toronto, Ontario M5A 1K8

Chu, Alice (416) 486-9562
273 St. Clements Ave., Toronto, Ontario M4R 1H3

Clearlight Inc. (416) 423-1413
23 Brentcliffe Rd., Toronto, Ontario M4G 4B7

Coates, Peter (416) 690-6039
71 Spruce Hill Rd., Toronto, Ontario M4E 3G2

Computer Visuals Inc. (416) 362-7633
417 Queen's Quay West, Toronto, Ontario M5V 1A2

Connelly, Joan (705) 742-1164
908 Elmdale Cresc., Peterborough, Ontario K9H 6G3

Cole, Philip (705) 325-5022
387 Talwood Dr., Orillia, Ontario L3V 2H1

Cooper, Joanne (416) 485-6223
30 Millbank Ave., Toronto, Ontario M5P 1S5

Cooper, Spearing & Stone Advertising (416) 527-8611
460 Main St. E., #301, Hamilton, Ontario L8N 1K4

Creative Resources Company Ltd. (416) 925-9690
30 Hillsboro Ave., #1506, Toronto, Ontario M5R 1S7

Cuyler, Haslip Design Consultants (416) 977-8958
455 Spadina Ave., #304, Toronto, Ontario M5S 2G8

Danzig, Mark (416) 636-7784
7 Gladiola Ct., Downsview, Ontario M3H 5Y5

Deangelis-Leslie, Lisa (519) 439-7148
359 Princess Ave., #1, London, Ontario N6B 2A7

Dimson & Smith Ltd (416) 923-2427
172 Davenport Rd., Toronto, Ontario M5R 1J2

Douglas, Cameron & Assoc. Inc. (416) 920-0953
34 Park Rd., Toronto, Ontario M4W 2N4

Dragon's Eye Press, The (416) 535-9053
103 Lisgar St., 2nd floor., Toronto, Ontario M6J 3G4

Dunjko, Carmen & Associates 120 Adelaide St. E., Toronto, Ontario M5C 1K9	(416) 363-2166
Dutton Advertising One St. Clair Ave. E., #602, Toronto, Ontario M4T 2V7	(416) 962-3384
Ebsen, Alf K. 60 Logandale Rd., Willowdale, Ontario M2N 4H4	(416) 222-4556
EGR Graphics Ltd. 195 Bartley Dr., Toronto, Ontario M4A 1E6	(416) 751-2024
Eugen Advertising 586 Eglinton Ave. E., #608, Toronto, Ontario M4P 1P2	(416) 488-3441
Finesilver, Martin D. 4000 Yonge St., #231, Toronto, Ontario M4N 2N9	(416) 482-0073
Finucci, Vic 108 Parliament St., Toronto, Ontario M5A 2Y8	(416) 363-0441
First Avenue Communications Inc. 264 Seaton St., #204, Toronto, Ontario M5A 2T4	(416) 923-7051
Forbes, Tim Design Inc. 263 Adelaide St. W., #502, Toronto, Ontario M5H 1Y2	(416) 593-5040
Freeman Communications page 183 **11 Gloucester St., Toronto, Ontario M4Y 1L8**	**(416) 967-6970**
42nd Productions Inc. 69 Sherbourne St., #401, Toronto, Ontario M5A 2P9	(416) 368-7121
Foster, Paul C 545 Enfield Dr., Burlington, Ontario L7T 2X5	(416) 639-5106
Full Moon Audio-Visual Productions 183 Pearson Ave., Toronto, Ontario M6R 1G4	(416) 531-1360
Geremia, Sonia M. 41 Owen Street, Barrie, Ontario L4M 3G9	(705) 728-4936
Godin, Gina 40001 – 300 Hedonics Rd., Peterborough, Ontario K9J 7T1	(705) 742-9427
Gottschalk & Ash Ltd. 322 King St. W., Toronto, Ontario M5V 1J2	(416) 977-1879
Grainge, Ian Designer/Illustrator **280 Southcrest Dr., London, Ontario N6J 1N4**	**(519) 471-6852**
Graphic Directions Ltd. page 184 **663 Carlaw Ave., Toronto, Ontario M4W 3K7**	**(416) 465-3403**
Graphic Network, The page 105	**(416) 977-4477**
Hathaway, Norman B. & Associates 99 Charles St. E., Toronto, Ontario M4Y 1V2	(416) 925-4158
Henry, Bernice 65 Harbour Square, #3402, Toronto, Ontario M5J 2L4	(416) 368-2266
Hyland, Robert Design/Communications **#3 – 453 Rosewell Ave., Toronto, Ontario M4R 2B6**	**(416) 489-1124**
Infinity Graphics Limited page 185 **744 Dundas St. E., Toronto, Ontario M5A 2C3**	**(416) 363-3251**
Intermark Design Inc. 294 Richmond St. E., Toronto, Ontario M5A 1P5	(416) 363-5101
Jackson, Michael B. 501-63 Widdicombe Hill Blvd., Weston Ontario M9R 4B2	(416) 922-1929
Jaeger Graphics page 186 **961 Eglinton Ave. E., Toronto, Ontario M4G 4B5**	**(416) 421-5227**
Johns, David C. 130 Oriole Parkway, #107, Toronto, Ontario M5P 2G8	(416) 484-9768
Kerr Graphics Limited 44 Wellington Steet E., Toronto, Ontario	(416) 366-3401
Kennedy, Colin 160 Luscombe, Hamilton, Ontario L9A 2K3	(416) 389-3522
Lil Kennedy 240 Airdrie Rd., Toronto, Ontario M4G 1N1	(416) 422-3773
Kyron Marketing Limited page 187 **247 Frederick St., Kitchener, Ontario N2H 2M7**	**(519) 743-2631**
Lakoseljac Loretta 15 Millicent St., Toronto, Ontario M6H 1W3	(416) 531-2172
Laskoski, Stephen Designers Inc. page 188 **120 Cumberland St., 3rd floor, Toronto, Ontario M5R 1A6**	**(416) 928-9090**
Laughlin, Gary P.O. Box 473, 60 Wellington St. E., Alliston, Ontario L0M 1A0	(705) 435-7917
Logos, Identity by Design Ltd. page 189 **3146 Lakeshore Blvd., Toronto, Ontario M8O 1L5**	**(416) 259-4834**
M.A.G. Limited 67 Mowat Ave., #431, Toronto, Ontario M6K 3E3	(416) 534-1106
Magee, Robert Designer Consultants 2161 Yonge St., #706, Toronto, Ontario M4S 3A6	(416) 484-6606
Male, Richard Design Associates Limited pages 190, 191 **120 Adelaide St. E., Toronto, Ontario M5C 1K9**	**(416) 362-1646**
Markle Brothers Ltd., The 226 Steelcase West, Markham, Ontario L3R 1B3	(416) 495-6900
Martel, Sandra M. 38 Sylvia St., Barrie, Ontario L4M 5J4	(705) 726-5596
McMillan, Judith E. 149 Church St., Stratford, Ontario N5A 2R4	(519) 271-3109
Miller, Eric Graphic Designs Limited 12 Sibley Ave., Toronto, Ontario M4C 5E7	(416) 699-8968
Molnar, Kalman Limited page 192 **234 Eglinton Ave. E., #501, Toronto, Ontario M4P 1K5**	**(416) 488-5062**
Moniz, Frank 198 Gladstone Ave., Toronto, Ontario M6J 3L4	(416) 532-8093
Mono Lino Typesetting Ltd. 420 Dupont St., Toronto, Ontario M5R 1W4	(416) 537-2401
Montag, Terry 20 Crane Ave., Weston, Ontario M1P 1T9	(416) 827-3477
Nash, Rodney 43 Fairleigh Cresc., Toronto, Ontario M6C 3S1	(416) 782-5824
Naus, Edward 2384 Bloor St. W., Toronto, Ontario M6S 1P5	(416) 766-1947
Newsbreakers 170 Degrassi St., Toronto, Ontario M4M 2K7	(416) 361-1233
Oasis 5 Polson St., Toronto, Ontario M5J 1A8	(416) 366-2919
Onat Graphic 147 Robert Hicks Dr., Willowdale, Ontario M2R 3R3	(416) 665-4827
O'Rourke, Patti RR #4, Seaforth, Ontario N0K 1W0	(519) 345-2075
Ove Design Toronto Inc. 515 Queen St. E., Toronto, Ontario M5A 1V1	(416) 367-0669
Parson, David Associates Ltd. 169 Cambria St., Stratford, Ontario N5A 1H6	(519) 273-1691
Pike, Catherine 90 Beech Ave., Toronto, Ontario M4E 3H6	(416) 766-6533
Price, Brian 33 – 52 Blue Springs Dr., Waterloo, Ontario N2J 4M4	(519) 885-6323

Price-Bennett, Linda (416) · 842-6469
262 Reynolds St., #13, Oakville, Ontario L6S 3L4

Promocom Graphics (416) 496-1976
150 Consumers Rd., #504, Willowdale, Ontario M2J 1P9

Quentien, Herbert (416) 846-3220
128 Fanshaw Dr., Brampton, Ontario L6Z 1B1

Reichert, Adell (416) 787-2201
140 Elmridge Dr., Toronto, Ontario M6B 1B1

Richter, Juergen (416) 292-6784
105 Agincourt Dr., Agincourt, Ontario M1S 1M7

Ritchie, Lianne (416) 497-5888
24 Castledene Cresc., Agincourt, Ontario M1T 1S1

R.K. Studios Ltd. page 193 **(416) 964-6991**
410 Dundas St. E., Toronto, Ontario M5A 2A8

Reactor Art Design Limited page 194 **(416) 362-1913**
51 Camden St., Toronto, Ontario M5V 1V2

Rood, Richard & Assoc. (416) 245-8515
2592 Weston Road, Weston, Ontario M9N 2A9

Roth, George (519) 885-4325
212 Willowdale Ave., Waterloo, Ontario N2J 3M1

Rous Mann & Brigdens Ltd. (416) 363-6321
384 Richmond St. E., Toronto, Ontario M5A 1P9

RSW Marketing Communications Ltd. (416) 686-2377
107 Kingston Rd. E., Pickering, Ontario L1V 1Z8

Saffer, Cravit & Freedman Advertising Ltd. (416) 449-7961
180 Duncan Mill Rd., Don Mills, Ontario M3B 1Z6

Savage Sloan Ltd. (416) 961-5444
3 Rowanwood Ave., Toronto, Ontario M4W 1Y5

Smart, Leslie & Associates (416) 363-0441
108 Parliament St., Toronto, Ontario M5A 2Y8

Stacey, John T. (416) 766-3140
121 Evans Avenue, Toronto, Ontario M6S 3V9

Studio Works (519) 836-7451
291 Woodlawn Rd. W., Unit #2, Guelph, Ontario N1H 7L6

Styles, Leslie D. (416) 225-0321
8 Yorkridge Rd., Willowdale, Ontario M2P 1R7

Taylor, James (416) 279-9796
332 Pathfinder Dr., Mississauga, Ontario L5A 1C9

Thompsett, Clare A. (416) 729-3306
Box 377, 13 Macpherson Ct., Beeton, Ontario L0G 1A0

Tomcik, Andrew (416) 482-7082
48 Parkhurst Blvd., Toronto, Ontario M4G 2C9

University of Toronto Press (416) 978-2501
Design Unit, Toronto, Ontario M5S 1A6

Unny, Gerhild (519) 699-5313
RR #1, St. Agatha, Ontario N0B 2L0

van Kampen, Jan & Associates (416) 484-1271
3281A Yonge Street, Toronto, Ontario M4N 2L6

VS Design Ltd. (416) 962-6500
420 Parliament St., 2nd floor, Toronto, Ontario M5A 3A2

Wallis Studios Inc. **(416) 967-0333**
78 Scollard St., Toronto, Ontario M5R 1G2

Warren Advertising Graphics page 195 **(416) 922-8388**
720 Spadina Ave., #404, Toronto, Ontario M5S 2T9

Weinstock, Barry Design and Photography page 196 **(416) 960-3423**
111 Avenue Rd., 8th floor, Toronto, Ontario M5R 3J8

Werle Design Limited page 197 **(416) 923-6614**
740 Huron Street, Toronto, Ontario M4V 2W3

Wong, Peter Charn C. (416) 633-7669
46 Ronfield Dr., #28, Downsview, Ontario M3J 1K3

Woodman, Deborah (416) 632-7527
192 Cullum Ct., Burlington, Ontario L7T 4A9

Wright, Doug (416) 598-4460
79 Gosford Blvd., #9, North York, Ontario M3N 2G9

Yaneff, Chris Limited (416) 924-6677
119 Isabella St., Toronto, Ontario M4Y 1P2

Young, Janet (416) 634-4780
377 Beechwood Cresc., Burlington, Ontario L7L 3P7

Yorkville Press (416) 291-7951
355 Nugget Ave., Scarborough, Ontario M1F 4J2

Kuyper Adamson Norton Ltd. (416) 362-7737
76 Richmond St. East, Toronto, Ontario M3C 1P1

Omniplan Design Group Limited (416) 364-2408
91 Yonge St., Toronto, Ontario M5C 1S8

Savage Sloan Limited (416) 961-5444
3 Rowanwood Ave., Toronto, Ontario M4W 1Y5

DESIGN / Ottawa

B B & H Graphic Communications Ltd. (613) 233-5773
155A MacLaren St., Ottawa, Ontario K2P 0K8

Becker, David (613) 224-1508
68B Chesterton, Nepean, Ontario K2E 5S9

Bevan, David (613) 235-2674
105 Flora St., Ottawa, Ontario K2P 1A7

Brule, Peter P. (613) 729-5600
818 Boyd Ave., Ottawa, Ontario K2A 2C7

Dalphond, Francine (613) 238-5773
546 St. Patrick, Ottawa, Ontario K1N 5L3

Danylewich, Heather (613) 733-9918
349 Marshal Court, Ottawa, Ontario K1H 6A3

Danylevwich, Morris (613) 733-9918
349 Marshal Court, Ottawa, Ontario K1H 6A3

Desmarais, Donald (613) 745-6277
9 Lenore Place, Vanier, Ontario K1L 7X8

Emori, Eiko (613) 521-1135
2036 Cabot St., Ottawa, Ontario K1H 6J8

Giesler, Patricia (613) 521-8977
1317 – 2870 Cedarwood Dr., Ottawa, Ontario K1V 8Y5

Gilbert, Paul Design Ltd. page 198 **(613) 233-6259**
334 MacLaren St., Ottawa, Ontario K2P 0M4

Gregory, Judith (613) 523-5912
690 Coronation Avenue, Ottawa, Ontario K1G 0M6

Gregory, Ian (613) 731-1831
690 Coronation Avenue, Ottawa, Ontario K1G 0M6

Hewitt, John (613) 235-3301
151 Bay St., #905, Ottawa, Ontario K1R 7T2

Hewson, Don (613) 238-7108
59 Hutchinson Ave., Ottawa, Ontario K1Y 4A3

Huggins, Rod (613) 993-2333
7 Noel St., #2, Ottawa, Ontario K1M 2A4

Kramer, Wendy (613) 232-5667
475 Elgin St., #709, Ottawa, Ontario K2D 2E6

Krusberg, Glenda (613) 993-2333
26 Woodlawn Avenue, Ottawa, Ontario K1S 2S9

Labarthe, Christian (613) 746-0657
105 Putman Ave., Ottawa, Ontario K1M 1Z5

MacLeod, James B. (613) 593-4153
526 Gladstone Ave., Ottawa, Ontario K1R 5P1

Martin, Gerald R. (613) 998-9006
748 Eastvale Dr., Gloucester, Ontario K1V 6Z6

Maruska, Mary Ann (613) 235-9306
969 Bronson, #200, Ottawa, Ontario K1S 5B6

McKenzie, George (613) 741-7467
2022 Kingsgrove Cresc., Ottawa, Ontario K1J 7Z1

McMaster, Marie (613) 731-1831
83 Java St., Ottawa, Ontario K1Y 3L5

McMillan, Susan (613) 996-4033
25 Strathcona Ave., Ottawa, Ontario K1S 1X3

Muli, Charles (613) 544-5400
St. Lawrence College, Portsmouth Ave., Kingston, Ontario

Niven, Don (613) 546-3604
509 – 334 Queen Mary Rd., Kingston, Ontario K7M 7E7

Petty, Patricia (613) 820-3526
20 Moorcroft Rd., Nepean, Ontario K2G 0M7

Popelar, Jitka (613) 993-0570
Exposition Centre, 440 Coventry Rd., Ottawa, Ontario

Rolfe, Shelagh (613) 731-1831
32 Kennear St., Ottawa, Ontario K1Y 3R6

Rolfe, George (613) 998-8987
32 Kinnear St., Ottawa, Ontario K1Y 3R6

Sheff, Diana (613) 224-1313
506 – 1140 Fisher Ave., Ottawa, Ontario K1Z 8M6

Smith, Gordon (613) 238-7108
31 Grange Ave., Ottawa, Ontario K1Y 0N8

Smith, Jackie (613) 995-1323
612 Chadburn Ave., Ottawa, Ontario K1G 0Y7

Smith, Neville (613) 234-4275
250A Lyon St., Ottawa, Ontario K1R 5W2

Steele, Peggy (613) 233-6077
409 Queen St., #2, Ottawa, Ontario K1R 5A6

Takeuchi, Norman (613) 998-9485
310 Lindsay St., Ottawa, Ontario K1G 0L5

Tietz, Carola (613) 749-0090
1924 Oakdean Cres., Ottawa, Ontario K1J 6H3

Veilleux, Michele (613) 996-4313
3 – 354 Waverley St., Ottawa, Ontario K2P 1R8

Way, Alan (613) 996-8005
712 – 1375 Prince of Wales, Ottawa, Ontario K2C 3L5

Whitemore, Wendy page 173 **(613) 828-8914**
28C Forester Cresc. (Nepean), Ottawa, Ontario K2H 8W8

DESIGN / Alberta

Bartl, Peter (403) 433-3629
10928 – 84 Avenue, Edmonton, Alberta T6G 0V4

Broadbent, Jane (403) 432-1069
#6, 10924 – 87 Avenue, Edmonton, Alberta

Cassel, Donalda (403) 475-2574
7919 – 132 Avenue, Edmonton, Alberta T5C 2B3

Chapman, Keith (403) 487-4036
15108 – 77 Avenue, Edmonton, Alberta T5R 3B3

Clark, Warren (403) 474-4892
7322 – 111 Avenue, Edmonton, Alberta

Egler, G. James B. **(403) 422-6141**
802, 11135 – 83 Avenue, Edmonton Alberta T6G 2C6

Fedoruk, Hilary (403) 487-8702
RR #5, Edmonton, Alberta T5P 4B7

Fodi, Annemarie (403) 429-0965
10953 – 92 Street, Edmonton, Alberta T5H 1W2

Frascara, Jorge (403) 466-9213
6719 – 88 Street, Edmonton, Alberta T6E 4Y4

Freadrich, Doris (403) 437-3006
11431 – 75 Avenue, Edmonton, Alberta T6G 0H8

Goodman, Herb (403) 481-2307
#304, 8210 – 182 Street, Edmonton, Alberta T5T 1X3

Jungkind, Walter (403) 469-2033
6304 – 109 Avenue, Edmonton, Alberta T6A 1S2

Kunz, Bernard (403) 468-1374
7217 – 84 Avenue, Edmonton, Alberta T6B 0H9

Lalonde, Pier F. (403) 233-8754
307, 333 – 5 Avenue N.E., Calgary, Alberta

Lamontagne, Doris (403) 439-2804
9821 – 90 Avenue, Edmonton, Alberta T6E 2T2

Lieberman, Cheryl (403) 488-1463
13807 Valleyview Dr., Edmonton, Alberta T6B 0H9

Lightfoot, Patricia (403) 451-1586
10433 – 136 Street, Edmonton, Alberta T5N 2E7

Luckhurst, John (403) 488-1289
11403 – 100 Avenue, Edmonton, Alberta T5K 0J5

Mah, Jim (403) 438-3162
267 Brookside Terrace, Edmonton, Alberta T6H 4J6

McHardy, Lenore (403) 465-4628
7523 – 94 Avenue, Edmonton, Alberta T6C 1V9

O'Neil, Glen (403) 288-1784
4114 – 140 Silvergrove Dr. N.W., Calgary, Alberta T3B 4W7

Ozubko, Cathy (403) 439-4139
10812 – 72 Avenue, Edmonton, Alberta T6E 1A3

Penny, Virginia (403) 437-3545
7601 Saskatchewan Dr., Edmonton, Alberta T6G 2A6

Quek, Yin
3A, 9114 – 112 Street, Edmonton, Alberta T6G 2C5

Peel, Brian (403) 432-0661
21, 10839 University Avenue, Edmonton, Alberta, T6E 4R1

Ruppel, Gunther (403) 462-1690
2080 – 74 Street, Edmonton, Alberta T6K 2L4

Tate, Steve (403) 469-5984
9750 – 92 Street, Edmonton, Alberta

Vaitkunas, George (403) 439-9230
11023 – 90 Avenue, Edmonton, Alberta T6G 1A6

Warren, Kerry (403) 233-0590
6A, 515 – 17 Avenue S.W., Calgary, Alberta T2R 0M5

Armstrong, Dan/Pigweed Press (604) 226-7726
R.R. #1 Winlaw, B.C. V0J 2J0

Bach, Peter (604) 521-5623
6396 Griffiths Avenue, Burnaby, B.C. V5E 2W7

Bickford, Chris (604) 738-2312
1695 West 7th Avenue, Vancouver, B.C. V6J 1S4

Bishop, Bob (604) 733-5656
#205 – 2055 York Street, Vancouver, B.C. V6J 1E5

Boake, Kathy (604) 874-4773
#8 – 2043 Stainsbury Ave., Vancouver, B.C. V5N 2M9

Burnham, Rosemary (604) 435-9566
7988 Kaymar Drive, Burnaby, B.C. V5J 3N1

Clifford, David R. (604) 731-5903
2524 West 1st Avenue, Vancouver, B.C. V6K 1G7

Clinton Carter, Derrick (604) 684-3061
#13 – 845 Davie Street, Vancouver, B.C. V6Z 1B7

Coe Campbell, Linda (604) 228-9237
4544 West 4th Avenue, Vancouver, B.C. V6R 1R4

Cochrane, Bruce (604) 946-0903
4725 – 48B Street, Delta, B.C. V4K 4C1

Corporate Communications Ltd. (604) 327-7731
7705 Thornhill Drive, Vancouver, B.C. V5P 3T4

Dickson, Don **(604) 731-0240**
#203 – 1534 West 2nd Avenue, Vancouver, B.C. V6J 1H2

Doherty, Dennis (604) 438-4910
4762 Garden Grove Drive, Burnaby, B.C. V5G 3V3

Drecshel, T (604) 936-2617
324 – 533 Cottonwood Ave., Coquitlam, B.C. V3J 2R7

Faulkner, Allyson (604) 681-7976
603 – 1270 Nicola Street, Vancouver, B.C. V6G 2E9

Ferreiro Design Ltd. **(604) 732-0717**
201 – 1768 West 3rd Avenue, Vancouver, B.C. V6J 1K4
Marketing and Corporate Communications

Foster, Jerry (604) 681-4416
#200 – 1111 Homer Street, Vancouver, B.C. V6B 2Y1

Gilbert, John Martin **(604) 925-1049**
4797 Highway, West Vancouver, B.C. V7W 1J6

Graphic Industries (604) 681-4174
566 Hornby Street, Vancouver, B.C. V6C 2E7

Grout, Nancy (604) 922-2588
4565 Keith Road, West Vancouver, B.C. V7W 2M7

Haest, Wilfried (604) 464-7921
7327 Flynn Crescent, Coquitlam, B.C. V3E 1Y1

Haynes, Jim/Ideation (604) 669-1673
310 – 1152 Mainland St., Vancouver, B.C. V6B 2T9

Hrynkow, Casey (604) 874-5672
296 West 16th Avenue, Vancouver, B.C. V5Y 1Y9

Hrynkow, Ray (604) 874-5672
296 West 16th Avenue, Vancouver, B.C. V5Y 1Y9

Johnston, Nola (604) 251-3761
2234 Grant Street, Vancouver, B.C. V5L 2Z7

Keeven, Huubert (604) 253-0888
2820 East 6th Avenue, Vancouver, B.C. V5M 1R8

Llewellyn, Marion (604) 522-4980
6947 Cariboo Road, Burnaby, B.C. V3N 4A5

Lim, Andre (604) 434-6019
3060 East 19th Avenue, Vancouver, B.C. V5M 2S9
Design, Consulting, Illustration

Lim, David (604) 255-2792
2569 Cambridge Street, Vancouver, B.C. V5K 1L3

Long, John (604) 522-4980
6947 Cariboo Road, Burnaby, B.C. V3N 4A5

Makara Graphic Arts and Design Co-op (604) 253-8931
1011 Commercial Drive, Vancouver, B.C. V5L 3X1

Martin, Dick (604) 681-1618
#304 – 1039 Richards Street, Vancouver, B.C. V6B 3E4

Middleton, Robert (604) 590-3758
13015 – 68th Avenue, Surrey, B.C. V3W 2E5

Monterey, Larry E. (604) 383-1986
3258 Wicklow Street, Victoria, B.C. V8X 1C9

Nagy, Dennis (604) 669-6755
#804 – 1501 Haro Street, Vancouver, B.C. V6G 1G4

Paul, Bardolf/Dharma Design (604) 687-7701
5th floor, 134 Abbott St., Vancouver, B.C. V5B 1E5

Posener, Margaret (604) 261-3771
1392 West 45th Avenue, Vancouver, B.C. V6M 2G9

Power, Anne (604) 266-3036
1685 West 68th Avenue, Vancouver, B.C. V6P 2V6

Rosen, Peter R. (604) 526-6711
P.O. Box 2067, Vancouver, B.C. V6B 3S3

Salazar, Enrique (604) 734-1617
1625 West 5th Avenue, Vancouver, B.C. V6J 1N5

Salazar, Santiago (604) 734-1617
1625 West 5th Avenue, Vancouver, B.C. V6J 1N5

Samuel Graphic Arts Ltd. **(604) 682-1801**
418 – 788 Beatty Street, Vancouver, B.C. V6B 1A2

Smith, Karsten/Dharma Design (604) 687-7701
5th floor, 134 Abbott St., Vancouver, B.C. V6B 1E5

Smith, Paul/VIEW (604) 687-7177
1500 West Georgia St., Vancouver, B.C. V6G 2Z6

TCA Design Ltd. pages 200, 201 **(604) 685-2511**
#1015 – 837 West Hastings St., Vancouver, B.C. V6C 1C4

STOCK PHOTOGRAPHY

Canapress Photo Service (Div. The Canadian Press) (416) 364-0321
36 King St. E., Toronto, Ontario M5C 2L9
News, Historical, Color Creative Images

Davies, Darryl T. page 230 (613) 523-0925
3377 McCarthy Rd., Ottawa, Ontario K1V 9G4

Four by Five Photography (514) 849-2181
417 St-Pierre St., Montreal, Quebec H2Y 2M4

Hot Shots Stock Shots Inc. page 231 (416) 441-3281
309 Lesmill Rd., Toronto, Ontario M3B 2V1

Image Finders Photo Agency Inc. pages 232, 233 (604) 688-9818
134 Abbott St., Vancouver, B.C. V6B 2K4

Masterfile pages 236–266 (416) 977-7267
2 Carlton St. #617, Toronto, Ontario M5B 1J3

Miller Services (416) 925-4323
45 Charles St. E., Toronto, Ontario M4Y 1S6

Photo/Graphics (604) 984-9932
1 – 431 Mountain Highway, North Vancouver, B.C. V7J 2L1

Stock Market Inc., The pages 234, 235 (416) 362-7767
93 Parliament St., #228, Toronto, Ontario M5A 3Y7

PHOTO LABORATORIES

Aperture pages 224, 225 — (416) 368-0583
40 Lombard St., #203, Toronto, Ontario M5C 1M1

B & R Productions — (416) 475-6853
380 Esna Park Dr., Markham, Ontario L3R 1H5
Custom visual software, studio & location photography

Black & White Custom Photo Labs — (416) 368-3840
155 George St., Toronto, Ontario M5A 2M8

Jones & Morris Photo-Enlarging Ltd. page 223 — (416) 465-5466
24 Carlaw Ave., Toronto, Ontario M4M 2R7

Macam Studio Limited — (416) 368-0404
69 Berkeley St., Toronto, Ontario M5A 2W5
Consultants-Training of stripping transparencies to industry

Qualicolor Systems Ltd. — (416) 962-4111
4 New Street, Toronto, Ontario M5R 1P6

Steichenlab Ltd. — (416) 366-8745
465 King St. E., #17, Toronto, Ontario M5A 1L6

System 4 Photo Finishing Lab. — (416) 741-5542
216 Oakdale Rd., Downsview, Ontario M3N 2S5

Yee, Henry Photography page 226 — (416) 423-4883
473 Cosburn Ave., Toronto, Ontario M4J 2N6

ABL Photography Techniques Ltd. page 227 — (403) 245-6626
1336 – 11th Avenue S.W., Calgary, Alberta T3C 0M6

Colorific Photo Labs Ltd. page 228 — (604) 879-1511
111 W., 2nd Avenue, Vancouver, B.C. V6B 4G3

RETOUCHERS

Colour Collaborators Int'l Ltd. — (416) 368-3073
114 Parliament St., Toronto, Ontario M5A 2Y8

Macam Studio Limited — (416) 368-0404
69 Berkeley St., Toronto, Ontario M5A 2W5
B & W–Color retouching/Transparencies stripping & bleaching

McRae Custom Colour — (416) 368-3401
76 Stafford, Toronto, Ontario M6J 2S1

Partners III — (416) 425-5162
10 Brentcliffe Rd., #211, Toronto, Ontario M4G 3Y2

AUDIO VISUAL / Ontario

AV House, The page 203 — (416) 591-1770
409 King St. W., 2nd floor, Toronto, Ontario M5V 1K1

Ad-Venture Sight & Sound — (416) 362-1268
512 King St. East, #303, Toronto, Canada M5A 1L9

Advertel Productions Ltd. — (416) 868-1171
46 Power St., Toronto, Ontario M5A 3A6

Artistic Productions Ltd. — (416) 861-1685
775A Queen St. West, Toronto, Ontario M5J 1G1

Avcom Productions Ltd. — (416) 346-6238
465 King St. East, Unit 6, Toronto, Ontario M5A 1L6
Total audio visual services

Brown, Richard page 207 — (416) 535-8717
6 High Park Blvd., #2, Toronto, Ontario M6R 1M4

Ciniverse Ltd. — (416) 863-0661
567 Queen St. W., 3rd floor, Toronto, Ontario M5V 2B6

Coney, Peter Associates Limited page 204 — (416) 363-3086
465 King St. E., #7, Toronto, Ontario M5A 1L6

Discovery Productions page 205 — (416) 869-0681
50 Widmer St., Toronto, Ontario M5V 2E9

Evergreen Audio-Visual Limited — (416) 489-8003
250 Merton St., 3rd floor, Toronto, Ontario M4S 1B1

Frischkorn Associates — (416) 675-2608
262 Galaxy Blvd., Rexdale, Ontario M9W 5R8
Show staging and rentals

Holman Production Services Ltd. — (416) 362-7563
417 Queen's Quay West, Toronto, Ontario M5V 1A2

Huchm Productions — (416) 755-4151
793 Pharmacy Ave., Toronto, Ontario M1L 3K2

Insight Communications — (416) 686-1144
1850 Champlain Ave., Box 363, Whitby, Ontario L1N 5S4
Slide Shows, Film Strips, Multi-Images & Sound

Kineblok Inc. — (416) 947-0169
398 King St. E., Toronto, Ontario M5A 1K9

M.S. Art Services Limited page 206 — (416) 363-2621
410 Adelaide St. West, Toronto, Ontario M5V 1S8

NJN Productions — (416) 366-7657
114 Sherbourne St., Toronto, Ontario M5A 2R2

Omnibus Video Inc. page 208 — (416) 489-6020
Transamerica Tower, 2180 Yonge St., Toronto, Ont., M4G 2T1

Pathe Video Inc. — (416) 364-6720
720 King St. W., #1002, Toronto, Ontario M5V 2T3

Synergex — (416) 484-6275
124 Merton St., 5th floor, Toronto, Ontario M4S 2Z2

VCG Visual Communications Group Inc. — (416) 368-1192
103 Church St., #401, Toronto, Ontario M5C 2G3

Viscom Ltd. — (416) 366-6400
99 Sumach St., Toronto, Ontario M5A 3J8

Westminster Films Ltd. — (416) 929-3166
259 Gerrard St. E., Toronto, Ontario M5A 2G1

AUDIO VISUAL / British Columbia

Avcom International Ltd. page 209 — (604) 986-1174
1401 Crown St., North Vancouver, B.C. V7J 1G4

Changing Images Productions Ltd. — (604) 681-4391
100 – 873 Beatty St., Vancouver, B.C. V6B 2M6

Creative House — (604) 688-5696
340 – 1152 Mainland St., Vancouver, B.C. V6B 2T9

FILM

Ampersand Film & Videotape Productions Ltd. — (416) 534-4104
32 Barton Ave., Toronto, Ontario M6G 1P1

Amulet Pictures — (416) 596-1411
1 Dundas St. West, #2102, Ontario M5G 1Z3

Animation Group — (416) 593-0473
312 Adelaide St. W., #801, Toronto, Ontario M5V 1R2

Artistic Productions Ltd. — (416) 861-1685
775A Queen St. W., Toronto, Ontario M6J 1G1

Atlantis Films Limited — (416) 960-1503
449 Church St., Toronto, Ontario M4Y 2C5

Allen, Barry Productions Ltd. — (416) 598-3821
425 University Ave. 3rd floor, Toronto, Ontario M5G 2B9

Boardwalk Motion Pictures Ltd. — (416) 968-1204
264 Seaton St., Toronto, Ontario M5A 2T4

Century One Films Inc.	(416) 862-8100	Stewart, Al Enterprises Ltd.	(416) 429-4400
100 Adelaide St. W., #802, Toronto, Ontario M5H 1S3		218 O'Connor Dr., Toronto, Ontario M4J 2T4	
Chetwynd Films Ltd.	(416) 421-8820	Sunrise Films Ltd.	(416) 532-2330
10 Bannigan Dr., Toronto, Ontario M4H 1E9		120 Wells St., Toronto, Ontario M5R 1P3	
Jack Chisholm Film Production	(416) 366-4933	TDF Film Productions Ltd.	(416) 924-3371
229 Niagara St., Toronto, Ontario M6J 2L5		980 Yonge St., Toronto, Ontario M4W 2J4	
Corporate Dimensions International	(416) 967-5407	Trayton Adair Productions Ltd.	(416) 922-2930
801 Yorkmills Rd., #201, Toronto, Ontario M3B 1X7		103 Charles St. East, Toronto, Ontario M4Y 1V2	
Dundas Group, The	(416) 923-1950	Trio Films Ltd.	(416) 868-1115
416 Dundas St. E., Toronto, Ontario M5A 2A8		187 Church St., Toronto, Ontario M5B 1Y7	
Hamilton-Brown Film Productions	(416) 365-0388	Twenty-Fifth Frame Film Production Co.	(416) 862-0044
43 Britain St., Toronto, Ontario M5A 1R7		115 Berkeley St., Toronto, Ontario M5A 2W8	
Haverand Productions Ltd.	(416) 922-3746	Venture Film Productions	(416) 691-4985
3 Charles St. W., #203, Toronto, Ontario M4Y 1R4		47 Fallingbrook Rd. Scarborough, Ontario M1N 2T5	
Heartstar Productions Ltd.	(416) 596-8305	Yorkville Studios	(416) 968-1809
439 Wellington St. W., 4th floor, Toronto, Ontario M5V 1E7		47 Scollard St., Toronto, Ontario M5R 1G1	
International Cinemedia Ltd.	(416) 361-0333	Mako Films Ltd.	(416) 960-3228
49 Bathurst St., 4th floor, Toronto, Ontario M5V 2P2		25 St. Mary's St., Toronto, Ontario M4Y 1R3	
Keillor Film Industries Inc.	(416) 465-9767	Magder Film Productions	(416) 752-8850
68 Broadview Ave., 3rd floor, Toronto, Ontario M4M 2E6		793 Pharmacy Ave., Toronto, Ontario M1L 3K2	
Knightbridge Film Ltd.	(416) 923-2787	Showline Limited	(416) 977-1661
18 Gloucester St., 5th floor, Toronto, Ontario M4Y 1L5		308 Jarvis St., Toronto, Ontario M5B 2C5	
Kuper Productions Ltd.	(416) 961-6609	Studio 523	(416) 862-0523
179 Carlton St., Toronto, Ontario M5A 2K3		523 Richmond St. E., Toronto, Ontario M5A 1R4	
Magder Film Productions	(416) 752-8850	Yorkville Studio	(416) 968-1809
793 Pharmacy Ave., Toronto, Ontario M1L 3K2		47 Scollard St., Toronto, Ontario M5R 1G1	
Mammoth Pictures	(416) 534-4229	**Gilbert, John Martin**	**(604) 925-1049**
67 Mowat Ave., #146, Toronto, Ontario M6K 3E3		**4749 Highway, West Vancouver, V7W 1J6**	
Mediavision	(416) 762-8107	International Rocketship Ltd.	(604) 681-2716
1709 Bloor St. W., 2nd floor, Toronto, Ontario M6P 1B2		1227 Richards St., Vancouver, B.C. V6B 3G3	
Mijo Productions Ltd.	(416) 964-7539	Reusch Pictures	(604) 731-5821
1407 Yonge St., #401, Toronto, Ontario M4T 1Y7		1747 West. 3rd Avenue. Vancouver, B.C.	
Millard Film Services	(416) 363-1076		
425 Adelaide St. W., #200, Toronto, Ontario M5V 1S4			

COLOUR SEPARATION

Northern Sound Studio Ltd.	(416) 977-140	Batten Graphics Limited	(416) 863-1355
65 Granby Ave., 2nd floor, Toronto, Ontario M5B 1H8		553 Richmond St. W., Toronto, Ontario M5V 1Y6	
Oscar Films Ltd.	(416) 366-0280	Bomac Batten Limited	(416) 598-3071
69 Front St. W., Rm 6, Toronto, Ontario M5E 1B5		240 Richmond St. W., Toronto, Ontario M5V 1W1	
Owl Film Ltd.	(416) 923-1191	**Commercial Graphics Limited page 211**	
416 Dundas St. East, Toronto, Ontario M5A 2A8		**144 Front St. West, Toronto, Ontario M5J 2L7**	**(416) 597-0272**
PM Film Productions	(416) 593-2550	**135 Rebecca St., Hamilton, Ontario L8R 1B9**	**(416) 522-1137**
82 Peter St., #205, Toronto, Ontario M5V 2G5		Colour Separations of Canada Limited	(416) 366-1692
Paragon Motion Pictures	(416) 961-0994	333 Adelaide Street West, Toronto, Ontario M5A 1N2	
86 Bloor St. W., #500, Toronto, Ontario M5S 1M5		Leading Graphics Limited	(416) 495-7310
Partners' Film Co. Ltd.	(416) 966-3500	400 Esna Park Drive, #510, Toronto, Ontario L3R 3K2	
508 Church St., Toronto, Ontario M4Y 2C8		**Litho Plus Inc. page 212**	**(416) 298-0528**
Playing With Time Inc.	(416) 466-6170	**1361 Huntingwood Drive, #2, Scarborough, Ontario M1S 3J1**	
935 Queen St. E., Toronto, Ontario M4M 1J6		Cleland-Kent Western Ltd.	(604) 681-1351
Rawifilm (Canada) Inc.	(416) 366-7881	538 Cambie Street, Vancouver, B.C. V6B 2N8	
567 Queen St. W., 2nd floor, Toronto, Ontario M5V 2B6		Graphic Industries Ltd.	(604) 681-4174
Rivercourt Productions	(416) 363-4444	566 Hornby St., Vancouver, B.C. V6C 2E7	
469 Queen St. E., 2nd floor, Toronto, Ontario M5A 1T9		Tri Scan Graphics Ltd.	(604) 255-7343
Schulz Productions	(416) 961-3000	1426 East Pender St., Vancouver, B.C. V5L 1V8	
9 New Street, Toronto, Ontario M4Y 1V2		Zenith Graphics Ltd.	(604) 682-4521
Shooters Film Co., The	(416) 862-1955	898 Richards St., Vancouver, B.C. V6B 3B3	
272 George St., Toronto, Ontario M5A 2N1			

EXHIBIT & DISPLAY

Alphaform Exhibits + Design Inc. page 213 — (416) 366-9403
76 Richmond St. East, Toronto, Ontario M5C 1P1

Bratton/Crews/Cumming & Associates Ltd. — (416) 622-2651
1 Westside Drive, Toronto, Ontario M9C 1B2

Display + (Div. of Blackshaw & Associates Ltd.) — (416) 922-8182
52 Hayden St., Toronto, Ontario M4Y 1Y8

Geron Associates Limited page 214 — (416) 293-2441
20 Progress Avenue, Scarborough, Ontario M1P 2Y4

H. Harding & Son Ltd. — (416) 475-6850
380 Esna Park Drive, Markham, Ontario L3R 1H5
Display Mfgr., Cardboard, Corrugated, Plastics, Metal

McNicol Stevenson Limited page 215 — (416) 291-2932
2161 Midland Avenue, Scarborough, Ontario M1P 4T3

Gilbert, John Martin — (604) 925-1049
4749 Highway, West Vancouver, B.C. V7W 1J6

SCREEN PRINTING

Cameron Advertising Displays Ltd. — (416) 752-7220
763 Warden Ave., Scarborough, Ontario M1L 4B7

Canada Decalcomania Company Limited — (416) 751-6522
400 Midwest Road, Scarborough, Ontario M1P 3B6

Canadian Offset & Screen Inc. — (416) 759-6733
195 Bartley Dr., Toronto Ontario M4A 1E6
Decal & all pressure sensitive products

Holland and Neil — (416) 625-1323
1330 Fewster Dr., Mississauga, Ontario L4W 1A4

McNicol Stevenson Limited — (416) 291-2932
2161 Midland Ave., Scarborough, Ontario M1P 4T3

Print Bi-Screen Ltd. — (416) 661-1180
4291 Steeles Ave. W., Downsview, Ontario M3N 1V9

Screenad Limited pages 216, 217 — (416) 629-1353
5178 Everest Dr., Mississauga, Ontario L4W 2R4

Tonge & Ellam Ltd. — (604) 879-6535
130 West 4th Avenue, Vancouver, B.C. V5Y 1G6

TRANSLATORS

Adelaide Translation & Bi-Lingual Services Ltd. — (416) 596-8174
294 Adelaide St. W., Toronto, Ontario M5V 1P6

All Languages Ltd. — (416) 361-0303
69 Yonge St., #805, Toronto, Ontario M5E 1K3

Arabey & Arabey — (416) 633-9802
65 Wild Gingerway, Downsview, Ontario M3H 5W9

Artico — (416) 364-3684
159 Bay St., Suite #1017, Toronto, Ontario M5J 1J7

Canadian Bilingual Services — (416) 947-0211
364 King St. East, Toronto, Ontario M5A 1K9

Dussault Translation Ltd. — (416) 366-5405
100 Adelaide St. West, Toronto, Ontario M5H 1S3

Lillie Translations — (416) 494-8148
37 Bards Walkway, Toronto, Ontario M2J 4T8

Translation Company of Canada, The — (416) 481-5261
2323 Yonge St., #201, Toronto, Ontario M4P 2C9

Traductor — (514) 284-1957
666 rue Sherbrooke ouest, Montréal, Québec H3A 1E7

TYPOGRAPHY

AES Company — (416) 484-0650
120 Eglinton Ave. E., #800, Toronto, Ontario M4P 1E2

Adcomp Graphics — (416) 461-9204
3 Carlaw St., Toronto, Ontario M4M 2R6

Alpha Graphics — (416) 365-0150
720 King St. West, #1011, Toronto, Ontario M5V 2T3

Art Composition & Associates — (416) 366-3041
500 King St. W., Toronto, Ontario M5V 1L9

Attic Typesetting — (416) 221-8495
5453 Yonge St., Willowdale, Ontario M2N 5S1

Better Creative Services — (416) 421-7944
197 Laird Drive, Toronto, Ontario M4G 3W3

Circle Graphics — (416) 595-1618
243 College St., Toronto, Ontario M5T 1R5

Clientelle Graphics — (416) 977-3890
244 Adelaide St. W., Toronto, Ontario M5H 1X6

Commercial Studios Ltd. — (416) 429-2435
109 Vanderhoof, Toronto, Ontario M4G 2H7

Compart Ltd. — (416) 675-2320
215 Carlingview Dr., #204, Toronto, Ontario M9W 5X8

Computer Typesetting — (416) 593-6942
445 King St. W., Toronto, Ontario M5V 1K4

Cooper & Beatty, Ltd. — (416) 593-7272
401 Wellington St. W., Toronto, Ontario M5V 1E8

EGR Graphics Ltd. — (416) 751-2024
195 Bartley Dr., Toronto, Ontario M4A 1E6

East End Graphics — (416) 699-6711
577 Kingston Rd., Toronto, Ontario M5E 1R3

Francis Graphics Ltd. — (416) 977-2348
214A Adelaide St. W., Toronto, Ontario M5H 1W7

Gandalf Typographers Inc. — (416) 481-2246
112 Merton St., Toronto, Ontario M4S 2Z7

Harrison Graphics — (416) 593-7538
212 King St. W., Toronto, Ontario M5H 1KS

•Infinity Graphics Limited — (416) 363-3251
744 Dundas St. E., Toronto, Ontario M5A 2C3
Jan Dorland: advertising; tabular; magazine setting.

Mono Lino Typesetting Co. Ltd. — (416) 537-2401
420 Dupont St., Toronto, Ontario M5R 1N4

Prince & Smith Type Foundry — (416) 461-0469
1 Carlaw Ave., Toronto, Ontario M4M 2R6

Rapid Typesetting Co. Ltd. — (416) 366-8944
589 King St. W., Toronto, Ontario M5V 1M5

Shervil-Dickson Ltd. — (416) 425-7408
25 Overlea Blvd., #4, Toronto, Ontario M4H 1B1

Trade Typesetting Ltd. — (416) 977-4477
30 Duncan St., Toronto, Ontario M5V 2C3

Typemark Inc. — (416) 593-0252
318 Richmond St. W., Toronto, Ontario M5V 1X2

Typsettra Ltd. pages 218, 219 — (416) 425-6510
94 Laird Dr., 2nd floor, Toronto, Ontario M4G 3V2

Word for Word, Inc. — (416) 960-5050
587A Yonge St., Toronto, Ontario M4Y 1Z4

XY Typesetting Services page 199 — (416) 425-3343
197 Laird Drive, Toronto, Ontario M4G 3W3